ART AND POLITICS IN LATE MEDIEVAL AND
EARLY RENAISSANCE ITALY: 1250–1500

NOTRE DAME CONFERENCES IN MEDIEVAL STUDIES

Number II

Institute of Medieval Studies
University of Notre Dame
John Van Engen, Director

Art and Politics in Late Medieval and Early Renaissance Italy: 1250–1500

Edited by Charles M. Rosenberg

UNIVERSITY OF NOTRE DAME PRESS

NOTRE DAME LONDON

Library of Congress Cataloging-in-Publication Data

Art and politics in late medieval and early Renaissance Italy,
1250–1500 / edited by Charles M. Rosenberg.
p. cm. — (Notre Dame conferences in medieval studies ; no. 2)
ISBN 0-268-00627-X
1. Arts, Italian — Political aspects — Congresses. 2. Arts,
Medieval — Political aspects — Italy — Congresses.
3. Arts, Renaissance — Political aspects — Italy — Congresses.
I. Rosenberg, Charles M. II. Series: Notre Dame conferences in
medieval studies ; 2.
NX552.A1A726 1990
700'.1'03 — dc20
 89-40744

Contents

Preface

IN APRIL 1988, the University of Notre Dame sponsored a conference entitled "Art and Politics in Late Medieval and Early Renaissance Italy: 1250–1500." The essays included in this volume were delivered at those meetings. The conference was organized into four sessions: "Italy and the Kings," "Models of Rulership," "Rome and the Papacy," and "Venice." A commentator presented prepared remarks at three of the four sessions. I served as moderator of the fourth.

The aim of the Notre Dame conference was to consider the relationship between politics and the literary and visual arts. Although only one paper, Joseph Berrigan's, deals specifically with literary texts, other contributions, particularly that of Debra Pincus, include significant observations concerning the relationship between texts and political goals and actions. The visual arts considered in this volume range from the traditional fine arts categories of painting, sculpture, and architecture, to minor art objects such as medals, badges, banners, and seals, to the creation of an ephemeral celebration.

The conference which occasioned this volume received generous support from the Notre Dame Institute for Scholarship in the Liberal Arts and the Alice B. Tully Endowment for the Arts. Numerous people assisted in bringing the conference to fruition. Special thanks go to the staff of the Snite Museum of Art, Professors John Van Engen and Craig Adcock, Barbara Bartosik, Elizabeth Garrett and Beverly Newcomer, and to my wife, Carol, for her unflagging assistance and patient moral support.

Introduction

CHARLES M. ROSENBERG

IN GENERAL TERMS, the study of politics denotes the study of power relationships. Within this larger framework political scientists and anthropologists have chosen to focus on the institutions and structures which express these relationships and/or the actions which are undertaken by individuals and groups to define, alter, or reinforce them. In this volume, it is the symbolic expression of political power in objects and actions that takes center stage.

Within the political arena, power may be won and exercised by means ranging from coercion to persuasion to consensus. Political anthropologists note that political power may be *expressed* in several ways: in practical, ritualistic, and symbolic forms.[1] The visual and literary arts played a significant role in acquiring, retaining, and expressing power in late Medieval and Renaissance Italy, through the creation and manipulation of symbolic objects, actions, and environments.

During this period, almost all forms of interaction were characterized by an imbalance of power, a situation complicated by the rapid and immense changes taking place in political, cultural, and economic institutions. Urban centers evolved into self-governing mercantile communes. These communes, new independent polities, needed mechanisms of governance and means of self-definition. In order to survive in the larger political arena, they were forced to respond to both the internal pressures of familial factionalism and economic stress, and the external pressures of such expansionist states as Venice, Naples, and Milan. The arts constituted one avenue of response.

During this same period, a number of smaller competing despotisms emerged. Based in cities such as Ferrara, Urbino, Mantua,

1

and Rimini, these political entities, too, were forced to develop new institutional and expressive responses to internal and external pressures. In particular, each new ruler sought to create an image of political legitimacy so as to establish and maintain internal control over his lands and people while simultaneously acquiring influence and retaining independence in the larger political arena. Several methods were employed. First, in both despotisms and such larger autocratic polities as Milan and Naples, medieval feudal obligations were transformed into institutionalized bureaucratic relationships.[2] Second, some rulers used the genre of the chivalric romance to create personal genealogical mythologies. Despotic families such as the Gonzaga and the Este adopted Carolingian and/or Arthurian ancestors in contemporary literary and visual epics,[3] deriving a sort of virtue by association. Finally, as Jonathan Boulton points out, the foundation and proliferation of heraldic orders, complete with badges and emblems, offered a new means of establishing a public identity.

During the late medieval and early modern period, even the venerable sacro-political institution of the Catholic Church experienced some of its greatest challenges since the Investiture Controversy. These challenges came from two principal sources. First, there were repeated attempts from within and without to fracture the centralized nature of papal control by means of the democratizing reforms of the conciliar movement and the nationalization of regional churches. Second, the very fabric of the Church itself was challenged by the broader threat to Christian hegemony posed by the continued expansion on its eastern borders of Islam, a threat which culminated in the fall of Constantinople. The former challenges ultimately led to the Babylonian Captivity and the Great Schism; the latter forced the Church to invest energy and resources in an almost continuous effort to marshal economic and political support for crusades against the infidel. Julian Gardner examines the question of the extent to which the growth of the power of the French clergy in the curia, which ultimately led to the translation of the papacy to Avignon, resulted in the importation of a Frankish style into Italy in the thirteenth century. Did French patrons of the arts import a set of stylistic expectations which they then imposed on the Italian environment, or did they accept the indigenous stylistic language in their patronage? Analyzing Signorelli's San Brizio frescoes, Jonathan Riess considers the impact of the continuing threat

of Islam and the general chiliastic fervor which prevailed in Orvieto at the end of the fifteenth century. Significantly, he interprets these images as reflecting, at least in part, a struggle between the Church and secular authorities for the ultimate allegiance of the faithful.

Individuals continued to be tied to a variety of traditional consortial and lineal groups. However, the older forms of solidarity and obligation were often in conflict with the demands of newly emerging social and political entities. This meant that neither law nor custom could always be relied upon to guide action. Though an individual's place in an established or evolving political hierarchy might theoretically be clearly demarcated, in reality, overlapping spheres of influence and competing obligations meant that power relationships and rights and demands were no longer clearly defined.[4] Certain literary and/or visual devices were employed to persuade individuals as to where their loyalties should lie and how they should act.

The political landscape in the early modern period was further complicated by the fact that an individual's or group's political power and influence were also affected by the concepts of honor and reciprocity, factors which had particular weight in the shadowy areas of patronage (*patrocinio*) and diplomacy. The maintenance of individual or group honor and the mutual trust necessary for reciprocity were themselves at the mercy of appearance. As a result, cultivating an appropriate public image was of paramount importance. The effective practice of the art of self-definition, or as Stephen Greenblatt has called it, "self-fashioning," became a critical skill for both individuals and states.[5] One of the most common and powerful uses of the arts in this period was in this critical process of self-definition.

The visual and literary arts, bolstered by the study and application of epideitic rhetorical principles, became progressively more important weapons in the arsenal of politics and political persuasion. Their efficacy lay in the manner in which they could convey multivalent messages quickly and forcefully to a public accustomed to thinking in terms of images and allegories, and persuade the audience of the truth and significance of their arguments. The cultural elite who utilized these tools placed a high value on literary discourse and style both as symbols of status and as effective means of persuasion. Skillfully orchestrated literary texts, given a cachet of authority through reference to ancient or chivalric models, were

used to carry political messages, particularly among members of the hegemonic class. A broader spectrum of the population could be persuaded by the spoken word, rhetorical gesture, solemn and splendid ritual, and impressive permanent and ephemeral visual display. Among these more directed modes of persuasion, the visual arts held a singular position. Painting, sculpture, and architecture offered a patron unusual advantages: unparalleled immediacy, actual presence, and permanence. They could transform what was only a dream into what appeared to be a realizable and concrete reality which would endure forever.

During the later Middle Ages, in a wedding of the symbolic and practical, cities were transformed to accommodate and express the social, economic, and political changes which were occurring. Partly in response to the great expansion of population during the twelfth and thirteenth centuries, and partly as concrete images of protection and present and future prosperity, cities extended their spheres of direct control by constructing massive new encircling walls. The expanding civic landscape was embellished with new structures, many of which rose in a symbolic manner out of the ruins of the old. Streets and squares were straightened and regularized, and building laws were enacted to transform the cityscape into a mirror of communal control and the new political order. Communes and despots alike engaged in ambitious public building projects, creating new town halls as emblems of civic government, palaces as markers of aristocratic power, and lavish new churches and cathedrals as symbols of communal wealth, solidarity, and piety. These new architectural structures were also banners proclaiming the public honor, visible not only to the local citizenry, but, just as important, to visitors.

The newly created town halls and palaces such as the Palazzo Pubblico in Siena or the Palazzo Schifanoia in Ferrara were decorated with complex images meant to promote a particular form of government and/or legitimate an individual ruler. In the communal setting, one of the most important goals of these decorations was to convey to those enmeshed in the web of familial factionalism the need to place communal interests above personal ones. This is most clearly illustrated in the Lorenzetti frescoes which adorn the Sala della Pace in Siena,[6] and the lost Giotto paintings which once decorated the Palazzo del Podestà in Florence.[7]

Within the despotisms, these types of decorative complexes were devoted mainly to celebrating the ruler's benevolence and legitimacy. In the Palazzo Schifanoia in Ferrara, for example, frescoes depict an elegantly attired Duke Borso d'Este variously riding and hunting in a bountiful countryside, and benevolently dispensing justice and largess to grateful subjects beneath an encircling band of ancient gods and goddesses. These sophisticated scenes picture a just and perfectly ordered state ruled over by a benevolent despot, Borso. His realm is shown to have mirrored the divine sphere depicted above it. Any of his superiors, equals, or subjects who entered the Sala dei mesi could not have ignored the clear, visual expression and affirmation of the virtue and legitimacy of Borso's reign.[8] Similarly, in Naples, as Joanna Woods-Marsden observes, the Aragonese arch leading to the Castelnuovo immortalized Alfonso of Aragon, permanently preserving the memory of an ephemeral event celebrating his virtue.[9] To some extent, both the Schifanoia cycle and Aragonese arch were visual equivalents of the panegyrics written by such poets as Panormita, Francesco Filefo, and Tito Vespasiano Strozzi.[10] In these celebratory epics — Sforziads and Borsiads — the events of a ruler's life and ancestry were elevated to the level of divinely orchestrated heroic mythology. In both the visual and literary examples of this panegyric genre, a ruler's individual legitimacy typically was represented as a matter of divine providence.

In both republican and despotic settings, art could also function as a warning. The fate of tyrants and malefactors was publicly proclaimed in such images as the painted depiction of the expulsion of the Duke of Athens in the Palazzo Vecchio in Florence or the *pitture infamanti* which appeared on the exterior of the Bargello.[11] These paintings of the infamous were often accompanied by scurrilous and satirical descriptions, with the literary and visual arts combining to accentuate the public humiliation of criminals and enemies of the state.[12] The arts, both literary and visual, were important means of guiding individuals in the pursuit of the common good and demonstrating the consequences which awaited those who might violate law or custom for private gain.

One common means of enhancing the public honor and image of an individual or group for broad political ends was to attribute to them specific virtues such as piety, justice, and, as Woods-Marsden shows in the case of Alfonso of Aragon, liberality and magnanim-

ity. Among these virtues, one which was widely promoted in fifteenth-century political theory and commonly attributed by apologists to the powerful was "magnificence."[13] In a blatant identification of virtue and honor with wealth, magnificence served to justify extravagant lifestyles. However, it also encouraged the liberal expenditure of money not only for such displays of ostentation, but also for literary patronage and charity, including the construction, embellishment, and endowment of chapels, churches, and monasteries. Extravagant acts of charity toward ecclesiastical institutions also served as powerful symbols of piety, public testimony not only to an individual's wealth, but also to his concern with the salvation of both his own soul and that of the larger community.[14]

In Venice, individuals and the state made particularly sophisticated use of both secular and sacred symbolic actions and objects. The image of Venice as mistress of the seas and special dominion of Justice and the Virgin was widely promoted in paint, stone, and living ritual.[15] Rona Goffen's essay examines several ways in which divine images were utilized for political ends in the Venetian environment: as political gifts; as symbols of the presence of the sacred in secular environments; and as testimonies to the divine protection of the state, the dogado, and the individual occupants of that office.

Another common literary and visual device used in the early modern period for political ends was the identification of an individual or group with an archetype. Powerful positive or negative associations could be evoked through the identification of a patron or his enemies not only with specific virtues or vices, but with highly charged historical and/or fictional individuals. As Joanna Woods-Marsden illustrates, comparing a prince like Leonello d'Este or Alfonso of Aragon to Julius Caesar or another Roman emperor would conjure up the image of an enlightened, literate, and immensely powerful ruler; one who brought prosperity to his people. If the public perceived its ruler as the spiritual heir to Caesar or Lancelot, it would tacitly acknowledge that individual's right to govern by reason of his symbolic lineage. Conversely, branding one's adversary as a servant of the Devil or the very Antichrist himself was a means of marshaling public opinion against him, of questioning a ruler's or a pretender's motives and legitimacy. Joseph Berrigan illustrates a powerful use of this archetype of evil in Albertino Mussato's Senecan tragedy, *Ecerinis*. In this play, a clarion call for vigilance against the

Veronese tyrant Can Grande della Scala was sounded by identify-
ing Can Grande's spiritual predecessor, Ezzolino de Romano, with
the Antichrist. Jonathan Riess argues that in Signorelli's San Brizio
Chapel frescoes, a more general identification of the secular politi-
cal order with the Antichrist is used to assert the power of spiritual
values over secular ones.[16]

Examining the motif of "the fourth magus," Richard Trexler
elucidates a different use of the positive archetypal reference. Delv-
ing into the broader political significance of the triumphal image
of the Journey and Adoration of the Magi, which he terms "icono-
graphs," Trexler traces the actual and implied presence of a
number of patrons in a series of representations of this biblical
story. The direct participation of the donor in this religious and
triumphal context links that individual to the sacred, regal, and
mystically inspired Magi. This identification both suggests the
donor's salvation in the next world and testifies to his honor and
piety in this.

In discussing the ivory triptych of the Certosa at Pavia and the
Bolognini Chapel in San Petronio in Bologna, Trexler also illus-
trates how Magi imagery was used to comment on and commemo-
rate specific historical events such as the investiture of Gian Galeazzo
Visconti as Duke of Milan. Moving from works of art that com-
memorated significant events to those which also recast history to
make it conform to a particular political program, Debra Pincus
demonstrates how Andrea Dandolo used both images and words to
redefine the historical position and contributions of the Venetian
doge as a means of enhancing the functioning power of that office.
In this same vein, Charles Stinger, discussing the Capitoline cele-
brations surrounding the investiture of Lorenzo de' Medici with
Roman citizenship, reveals the way in which the past was mythol-
ogized to suggest common historical roots for Florence and Rome as
a rationale for the triumph of the Medici papacy. As John O'Malley
observes in his commentary, this position was strengthened through
an appeal to the authority of classical rhetoric and imagery.

The use of emblems such as the Medici *palle* or the sun and
yoke of Leo X as metaphors for the participants themselves was
another very important visual and rhetorical device in the Capitoline
celebrations. Jonathan Boulton explores the origins, taxonomy, and
use of these familial and individual symbols, along with the older

category of heraldic badges and emblems. Heraldic and "para-heraldic" symbols were most often used in political contexts, particularly as a public means of defining allegiance and ownership. Wearing livery demonstrated subservience and obligation, whereas sporting the badges of aristocratic chivalric or neo-chivalric orders proclaimed acceptance by the members of highly select and powerful groups, and constituted an obvious expression of political status.

The essays in this volume approach the issue of the interaction of art and politics from a number of different points of view. They are united, however, by a common acknowledgment of the functional nature of the arts and the integral role which they played in expressing both existing and potential power relationships in the continually changing political landscape of late Medieval and early Renaissance Italy.

NOTES

1. This analysis is derived from H. J. M. Claessen's summary of the field of political anthropology. See his "Introduction," in *Political Anthropology: The State of the Art*, ed. S. L. Seaton and H. J. M. Claessen (The Hague, Paris & New York, 1979), 7–28.

2. For the exploitation and bureaucratization of feudal forms by the Este from the fourteenth and fifteenth centuries, see R. M. Tristano, "Ferrara in the Fifteenth Century: Borso d'Este and the Development of the New Nobility" (Ph.D. diss., New York University, 1983); and T. Dean, *Land and Power in Late Medieval Ferrara: The Rule of the Este, 1350–1450* (Cambridge and New York, 1988).

3. Cf. Boiardo's *Orlando Inamorato* and Ariosto's *Orlando furioso*, in the literary sphere, and Pisanello's Arthurian frescoes in the Palazzo ducale in Mantua in the visual realm.

4. Ronald Weissman describes competing obligations which existed in republican Florence very clearly in his article "Taking Patronage Seriously: Mediterranean Values and Renaissance Society," *Patronage, Art, and Society in Renaissance Italy*, ed. F. W. Kent and P. Simons (Canberra and Oxford, 1987), 25–45. The Florentine phenomenon of the *ricordanza*, a record not only of patrimony and familial alliances, but also frequently a storehouse of advice on how to navigate the treacherous waters of political and social intrigue, may be one acknowledgment of and reaction to this changing and uncertain situation.

Perhaps the best way to characterize this concept of shifting obligations is in terms of what political anthropologists have called "segmentary lineage systems." Middleton and Tait have noted that these types of systems are defined by " . . . a balance of power, maintained by competition between [the local groups]. . . . Relations at one level are competitive in one situation, but in another the formerly competitive groups merge in mutual alliance against an outsider group." (*Tribes without Rulers*, ed. J. Middleton and D. Tait [London, 1958], quoted in *Political Anthropology*, 11.) These sort of shifting alliances certainly seem to describe the reality of Italian intracommunal politics.

The situation in early modern Italy was also complicated by the fact that these segmentary lineage systems often existed within larger centralized political units. Though the Empire or Church or royal dominion of France or Spain might be seen as overarching structures, the continuous shifting of alliances on both the micro- and macro-levels was really the driving political force.

In more circumscribed circumstances, in the highly stratified political environment of Venice, for example, an individual's influence and power was defined by his nobility or lack thereof, rights to citizenship, family and lineage, confraternal membership, parish, mercantile associations, political office, etc. Which of these particular associations would have had the strongest claim on one's loyalty varied from situation to situation. Similarly, different alliances among these various types of groups were formed in response to diverse situations. Because of competing loyalties, an individual might have to express his support for or condemnation of a particular set of actions in an ambiguous or allusive manner. On the Venetian system and its complex and often conflicting demands, see D. Romano, *Patricians and Popolani* (Baltimore and London, 1987).

Even in a feudal situation such as that which existed in Ferrara, where ultimate political power resided in the hands of the duke because of tradition and coercive force, individuals still had to thread their way cautiously through a maze of potentially conflicting patterns of association just as the Venetians and Florentines did.

5. S. Greenblatt, *Renaissance Self-Fashioning: More to Shakespeare* (Chicago, 1980).

6. For a particularly cogent discussion of these frescoes and their roots in the literary tradition of communal political literature such as Brunetto Latini's *Tesoro*, see Q. Skinner, "Ambrogio Lorenzetti: The Artist as Political Philosopher," *Proceedings of the British Academy* 72 (1986): 1–56, where earlier bibliography is cited.

7. See G. Vasari, "Giotto," *Le vite de' piú eccellenti pittori, scultori ed architettori*, in G. Milanesi, *Le opere di Giorgio Vasari*, I (Florence, 1906), 399–400.

8. A collection of essays concerning the Palazzo Schifanoia and its decorations (*Atlante di Schifanoia*) is currently being edited by R. Varese.

9. For a discussion of the later political use of art in Naples, see G. L. Hersey, *Alfonso II and the Artistic Renewal of Naples, 1485–1495* (New Haven, Conn., 1969).

10. For an edition and discussion of T. V. Strozzi's *Borsiad*, see Tito Strozzi, *Die Borsias*, ed. Walther Ludwig (Munich, 1977). For its relationship with Schifanoia frescoes, see S. Macioce, "La *Borsiade* di Tito Vespasiano Strozzi e gli affreschi della 'Sala dei Mesi' di Palazzo Schifanoia," *Annuario del'Istituto di Storia dell'Arte*, Facoltà di Lettere, Università di Roma, 1983; and C. Rosenberg, "Borsian and Ferrarese Imagery in the Heavenly Zone in the *Sala dei Mesi*," *Schifanoia* 5 (1989): 43–49.

11. On the *pitture infamanti*, see G. Ortalli, *La pittura infamante: " . . . pingatur in Palatio"* (Rome, 1977); and S. Y. Edgerton, *Pictures and Punishment* (Ithaca and London, 1985).

12. On the verses which accompanied the images, see P. Burke, *Culture and Society in Renaissance Italy, 1420–1540* (London, 1972), 119–20.

13. The concept of "magnificence" and the role which it played in art patronage in the fifteenth century and after has been much discussed. One seminal article is A. D. Fraser Jenkins' "Cosimo de' Medici's Patronage of Architecture and the Theory of Magnificence," *Journal of the Warburg and Courtauld Institutes* 33 (1970): 162–70.

14. For one example of the significance of such an act of ecclesiastical patronage, see C. M. Rosenberg, *"Per il bene di . . . nostra ciptà*: Borso d'Este and the Certosa of Ferrara," *Renaissance Quarterly* 29 (1976): 329–40.

15. For a recent discussion of the visualization of the myth of Venice, see D. Rosand, " '*Venetia*': The Figuration of the State," in *Artistic Strategy and the Rhetoric of Power: Political Uses of Art from Antiquity to the Present*, ed. D. Castriota (Carbondale, Ill., 1986), 67–86.

16. On the use of a similar sort of analogy as a means of political persuasion, see H. Baron's classic work on Florentine and Milanese humanist propaganda, *The Crisis of the Early Renaissance* (Princeton, N.J., 1955).

Art and Political Identity in Fifteenth-Century Naples: Pisanello, Cristoforo di Geremia, and King Alfonso's Imperial Fantasies*

Joanna Woods-Marsden

The INFLUENCE OF the revival of classical art and literature on Renaissance works of art is traditionally investigated either in terms of sources, whether visual or literary, and how they were used, or from the standpoint of the artist — that is, the degree to which he succeeded in assimilating the essence of classicism as well as imitating its forms. In this paper I shall instead investigate the impact that the patron may have had on the iconography and style of his own commissions, by exploring the clout — political, dynastic, social — that classical antiquity could offer the Quattrocento prince. Specifically, I shall consider the *signori*'s appropriation of Roman imperial motifs as potent symbols of the power to which they themselves aspired, by focusing on bronze medals commissioned from the court artists Pisanello of Verona and Cristoforo of Mantua by King Alfonso V of Naples. Not coincidentally, it was at this southern court that the humanist potential offered by this new and classically inspired art form was first fully exploited.[1]

The first experiment in a cast Quattrocento medal was made for the Emperor of Constantinople by the painter Antonio Pisanello at the court of Leonello d'Este of Ferrara in 1438–39 (Fig. 1).[2] I shall not here explore its genesis beyond noting the arrival of the humanist Guarino da Verona in Ferrara in 1429; the frequent visits to court of the humanist and theorist Leon Battista Alberti, the con-

11

tinuous presence through the 1430s of Pisanello, who had returned from Rome with drawings of ancient monuments and the beginnings of his own collection of Roman coins; and Leonello's own passionate interest in classical antiquity.[3] The prince's great hero was Julius Caesar. Pisanello painted a portrait of *Divus Iulius Caesar* for him, and Guarino translated *De Bello Gallico* and dedicated to the prince the treatise in which the humanist took the side of Caesar in his Caesar-Scipio polemic with Poggio Bracciolini.[4] Leonello's interest in the first Caesar must have been increased by the visits to Ferrara of the modern Western and Eastern Caesars, Emperor Sigismund in 1433, and John VIII Palaeologus for the Church Council in 1438. Since in antiquity only emperors and their immediate family could place their portraits on coins and medallions, Palaeologus' imperial presence in Ferrara may well have been the catalyst necessary for the development of the first medal.[5]

As developed in the Renaissance, the reverse of these double-sided portable objects normally allowed the commissioner, whose likeness was portrayed on the obverse, consciously to project an image of his circumstances, achievements, and enthusiasms and, unconsciously, his fantasies and illusions. The iconography of the first medal reverse shows an uneasy compromise between the emperor's amply documented passion for the hunt and some sense that the image should show the ostensible reason for his presence in Italy.[6] He appears to pause between two gallops to say a prayer at a roadside shrine.

Once in existence, the Quattrocento medal immediately ceased to be an exclusively Imperial phenomenon. Leonello, who acknowledged how much he enjoyed contemplating the faces of the Caesars on the Roman coins in his collection,[7] proceeded to commission as many as nine medals from Pisanello alone, on which he placed his own face and his own name in imitation of ancient imperial practice—or so Flavio Biondo thought.[8]

The only medal made for Leonello that can be directly connected to an event in his life celebrates the prince's marriage alliance in 1444 to Maria of Aragon, illegitimate daughter of the new King of Naples (Fig. 2).[9] The allegory on the reverse features Leo, king of beasts and symbol of Fortitude, identified as the current ruler of Ferrara by the emblem of sail billowing from the column-mast just above his head.[10] The conceit shows LEOnello singing—or

at least opening his mouth — before the notations — obviously a love song for his new bride — held by a winged cupid. On the obverse the prince, with a suitably leonine hair style,[11] is presented as if Pisanello were depicting an actual marble bust seen in profile.[12] This kind of bust, however, was not to be created in monumental sculpture until the next decade — 1453, to be precise — when our earliest dated portrait bust, a likeness of Piero de' Medici, was created by Mino da Fiesole (Fig. 3).[13] Both Mino's 1453 marble sculpture and Pisanello's 1444 bronze low relief depiction of a sculpture display what Irving Lavin has shown to be a new creation of the Quattrocento in that the busts, each of which depicts someone who was still alive, were fully modeled in the round, were cut horizontally at a point between the shoulder and elbow, and were presented without a base.[14] The type owes little to classical sources which, as we shall see, followed a different set of conventions.

The inscription on Pisanello's work — the titles "LEONELLVS MARCHIO ESTENSIS, lord of Ferrara, Reggio and Modena" — is located on the bottom half of the medal in such a way as to emphasize the roundel's lower curve and embrace the prince's body while allowing his facial features to dominate the central field. If Heiss' imaginative interpretation of the letters above is correct — that GE R AR stands for GENER REGIS ARAGONUM — the Este prince here exploited the inscription to proclaim his status as the son-in-law of the new king of Naples.[15]

A sense of the huge land mass represented by the Kingdom of Naples (Fig. 4) — basically the southern half of the Italian peninsula — explains why Alfonso, King of Aragon and Sicily since 1416, should have devoted his ambitions and energies for twenty years to its conquest, finally triumphing over his Angevin rival in 1442.[16] The new king of Naples was, if anything, even more enthusiastic than his son-in-law about the literary and artistic remains of classical antiquity. Like the prince of Ferrara, Alfonso collected "coins of the illustrious Emperors but especially Caesar," as Panormita wrote, which he kept like relics in an ivory casket. Aeneas Sylvius Piccolomini tells us how pleased the king was when a golden coin bearing Nero's face was found at Pozzuoli; a survival of Roman greatness, it inspired him, he informed Panormita, to virtue and glory.[17] Nonetheless, Alfonso's new Neapolitan subjects, his papal overlord, and other Italian rulers must have been somewhat startled

when the conqueror of the kingdom sought their recognition in the stance not just of a victor but a victor in the classical style. A familiar motif of Roman imperial propaganda was the procession of the triumphant general as post facto proof of victory over a foreign enemy. Anticipating Flavio Biondo's written account of such events in *Roma Triumphans*, Alfonso staged his own triumphal entry into Naples in 1443, "come triunfante a modo degli antichi," as Vespasiano da Bisticci put it.[18] Figure 5 shows a detail of the version of the triumphal entry that was carved on the triumphal arch — itself a symbol, as the Renaissance knew, of military conquest[19] — that was erected in the 1450s between two towers of the Castelnuovo.[20]

The *sculpted* version of the triumphal entry does not depict one of the highlights of the actual event in Naples: the arrival of Julius Caesar in person to legitimize Alfonso's usurpation of Italian soil. In armor and laurel wreath, Caesar recognized the king, whom he called "Alfonso, Re di pace," as an alter ego, a second Caesar, and presented him with the throne and crown of his new kingdom.[21] The *condottiere*-king must often have dreamed, in the words of Isabella d'Este, "what it was like when a victorious general celebrated his triumph."[22] We can imagine his sentiments when, dressed in embroidered toga and golden wreath, he sought to validate the crossing of his own Rubicon by passing under the first triumphal arch of the modern age and accepting the endorsement of the legendary figure who founded the Roman empire. Indeed, the humanist Porcellio later articulated the king's sentiments in a poem in which Alfonso appeared as the new Caesar and the Kingdom of Naples as the new Roman Empire.[23]

Alfonso did not, however, restrict himself to Roman history in his search for exemplars. He also identified with a fictive chivalric hero. Both written and visual versions of the triumphal procession in 1443 liken the second Caesar to a second Galahad. In Arthurian romance a permanently vacant seat at the Round Table, the Siege Perilous or dangerous chair, was destined to be occupied by the particular Arthurian knight who would later accomplish the quest for the Holy Grail. In the opening pages of the early thirteenth-century French prose romance, *Queste del Saint Graal*, Lancelot's son, Galahad, known for his physical beauty, his invincible prowess, his chastity, and his serene perfection, was led forward to occupy this very Siege Perilous and, because he was neither consumed by the

leaping flames that usually occupied the chair nor horribly wounded by invisible hands, was immediately recognized as the future hero of the Grail quest.[24] Contemporaries were expected to liken Alfonso's accomplishments to those of the paragon Galahad. "No one [else]," wrote a Spanish observer of the procession in 1443, "was worthy of sitting in this Siege Perilous except the lord who subjugated this Kingdom [of Naples],"[25] and on the Arch relief the subjugator of the Kingdom has indeed displaced the flames from the Siege Perilous on which he sits to the floor in front of his feet.[26] Chivalric and classical exemplars were accordingly fused to the extent that Galahad's successor could be welcomed by Julius Caesar and take part in a classical triumph. The event and the art it inspired confirm that fifteenth-century princes saw no intellectual conflict between the continuing lure of French chivalric romance and their newfound interest in classical studies.[27] Alfonso made extensive use of the Siege Perilous as an emblem and it can be seen in the margins of many manuscripts ordered for his library, such as the volume of Cicero's *Epistolae ad Familiares* (Fig. 6),[28] where the Siege was invariably depicted with the seat covered in leaping flames, that is, *before* Galahad, or his equally perfect successor Alfonso, had arrived to sit in it.

In a letter written that same year to Alfonso, Flavio Biondo argued the importance of "history" for men of action who wanted the memory of their deeds to survive.[29] "Only those adorned by letters deserve to be called true kings and princes," he wrote, and Jerry Bentley has recently shown how the Spanish king mobilized the intellectual resources of an entire generation of Italian humanists to serve the political cause of his new dynasty.[30] It was their task to compose histories that portrayed Alfonso's deeds in the most favorable light possible. Needless to say, the king also turned to the visual arts for persuasive interpretations of his newfound Caesarian self as well as his Arthurian persona. He probably sought Pisanello's services as soon as the artist's work was brought to his attention during the marriage negotiations with Leonello in April 1443, but five years passed before Pisanello left Northern Italy, probably the court of Mantua, for Naples.[31]

In a bronze medal of 1449 (Fig. 7) he interpreted the king's features at the age of fifty-three in terms similar to those used by Aeneas Sylvius Piccolomini: small build, aquiline nose, shin-

ing eyes, hair reaching his ears — although the pale complexion and black hair turning grey mentioned by Aeneas can only be guessed at.[32]

Just as the medals made for Sigismondo Malatesta of Rimini had been larger than those created earlier for Leonello d'Este, and those for Lodovico Gonzaga of Mantua larger yet again, so Alfonso's medals were on a still grander scale, among the biggest to be created in the fifteenth century.[33] To date, Pisanello's obverses had included only a portrait and an inscription, but the new scale employed permitted the significant additions of crown and helmet on either side of Alfonso's likeness. The changes made between the preparatory drawing for the obverse, of which figure 8 is a copy by a follower, and the medal as eventually cast are instructive.[34] The crown that mattered so much to the sitter has been emphasized by the letters of the date placed like brackets above and below it. Instead of fantastic classicizing armor, Alfonso chose to be represented in the contemporary Italian armor that he had just worn during his unsuccessful campaign to unite the duchy of Lombardy with the Kingdom of Naples. Instead of an elaborate bat crest that competed in importance with the king's profile, a smaller plainer helmet was used; it displays another Alphonsine device, a sun shining on an open book seen from the cover.[35] Paolo Giovio suggested, among other possible interpretations for the king's use of this device, that it signified the "perfection of the human intellect which consists in the recognition of science and the liberal arts, *delle quali sua Maestà fu molto studioso.*"[36] Indeed, Alfonso's love of learning seems to have been genuine. He read voraciously, carried Caesar's *Commentaries* on all expeditions, and allowed no day to pass without perusing it with close attention.[37] Asked whether he owed more to arms or to letters, the king gave the standard Renaissance reply that he had learned about arms from books.[38] Here, the wisdom symbolized by the book and the skill in arms represented by the helmet — the *vita contemplativa* contained within, and therefore encouraging, the *vita activa*, so to speak — can be seen as having earned him the crown.[39] A similar message of equal skill in arms and letters is conveyed by the first full-length independent portrait painted in Italy that has come down to us, depicting Federico da Montefeltro and his son, probably by Joos van Ghent around 1476, in which the Duke presented himself as fully prepared for battle in a complete

suit of uncomfortable armor while he earnestly pursued his studies (Fig. 9).[40]

In a letter addressed to King Alfonso, Guarino da Verona stated his personal preference for the literary over the visual arts as a means of transmitting one's fame to posterity. The humanist sensibly objected to the use of painting and sculpture for this purpose, among other reasons, because they were *sine litteris*, an expression imaginatively translated by Michael Baxandall as "unlabelled."[41] Obviously these qualifications would not have applied to the new art form which encouraged *lettere* as much as *immagini*, to use contemporary parlance.[42] Indeed, the possibilities offered by words must have been one of the great attractions of medals for the princes. We saw that Leonello's medal had mentioned his connection to the Aragonese king as well as his inherited titles (Fig. 2). More common were the additions made by Sigismondo Malatesta and Lodovico Gonzaga of their current military titles.[43] Alfonso was thus following his son-in-law's lead when he went beyond the titles of territorial lordship and military rank on medals by using the inscription: DIVVS ALPHONSVS REX TRIVMPHATOR ET PACIFICVS.

Alfonso was probably the first Renaissance ruler to associate himself with the term *divus*, which was occasionally used in the second half of the fifteenth century, and more frequently in the sixteenth, to mean "saint" or "holy." He was certainly the first to use it on a work of art. In antiquity from the Emperor Claudius on, the word signified "man made into a god" or, alternatively, "god who was previously a mortal." The inscription DIVUS AUGUSTUS PATER forming a halo around the head of the Emperor Augustus, on a coin minted by Tiberius after his predecessor's death, indicates the emperor's posthumous deification (Fig. 10).[44] In the Roman world, of course, only the emperor or a member of the imperial family could be so deified. Furthermore, apotheosis as a *divus* could only take place after death and then only by decree of the Roman Senate.[45] As Tacitus, a historian well known to the sixteenth century, put it, when commenting on Nero's refusal to permit the erection of a temple dedicated to Divus Nero, "the honor of deification cannot be paid to the emperor until he has ceased to live and move among men."[46] Alfonso's self-deification thus implies that he claimed the same homage — indeed, worship — from his subjects while still alive as that rendered to *Divus Iulius Caesar* and *Divus Augustus Pater* after

death. This interpretation is reinforced by Francesco Sforza's bitter characterization of Alfonso after his old enemy's death: "La sua arroganza, il suo orgoglio erano tali che si teneva degno non solo di essere onorato tra gli homini, ma anche adorato tra gli dei," (his arrogance and his pride were such that he believed himself worthy not only of being honored among men but also adored among the gods).[47] Sforza may well have had in mind a medal such as this, which he would certainly have known, when he spoke of Alfonso believing himself worthy of being "adorato tra gli dei."

By using the words TRIVMPHATOR E PACIFICVS, the king who spent most of his life at war in pursuit of his imperialist ambitions and who had just returned from an unsuccessful campaign to add Lombardy to his conquests — with, as a result, a somewhat damaged reputation — presents his deified self as peace-loving, as well as victorious, perhaps because, as Borso d'Este reminded him, "la pace é caxone de farve amare dali subditi de questo reaume."[48] The Neapolitan *divus*, however, is not only dressed in contemporary Renaissance armor but also, like his son-in-law, presented as if a portrait bust from the next decade of the fifteenth century. The classicizing content of the work is accordingly carried not by the visual image but by the inscription, in short by Guarino's all important "label."

On the reverse Alfonso did not, like Sigismondo Malatesta or Lodovico Gonzaga, present himself as a *condottiere* actively engaging in war but followed his son-in-law's venture into allegory. We see an eagle, attribute of Jupiter and symbol of supreme imperial power. Placed in the same central position as the portrait on the obverse, the king of birds conveys his imperial largesse or LIBERALITAS AVGVSTA in a medieval *exemplum*. The eagle supposedly always left a part of his prey to lesser birds who waited at his feet until he finished his meal.[49] The visual source for the eagle was undoubtedly an Augustan coin, such as the aureus minted in 27 B.C. to celebrate Octavian's new name of Augustus, where the eagle, symbol of apotheosis, appears with oak crown, emblem of Jupiter, and laurel branches, symbol of permanent triumph (Fig. 11).[50] However, as Hersey and others have suggested, Alfonso's use of the eagle also presents him as successor to Frederick II Hohenstaufen — another foreign *Triumphator* whose dream of universal power two centuries

earlier had caused him to build his own triumphal arch and under-
take his own triumphal processions.[51]

In the Quattrocento "liberality" was regarded as a means of
consolidating a given ruler's position, since it was believed that in
antiquity "giving much and giving often" connoted regal behav-
ior.[52] Alfonso, as we might have guessed from this medal, cultivated
a style of generosity, one which Vespasiano da Bisticci defined admir-
ingly as "liberalissimo in infinito."[53] Hence, the king's handouts to
his humanists — 20,000 ducats, if Vespasiano is to be believed — and
to artists — a handsome annual salary of 400 ducats, for instance, for
Pisanello — rendered him *famoso et amabile*, as Pontano put it, in con-
temporary eyes, and earned him the title of "Magnanimous" that
has stuck with him ever since.[54] But not everyone agreed with
Vespasiano's estimation of the king's reputation. Borso d'Este, for
one, was critical of Alfonso's generosity because, he said, "Your
Majesty . . . can never find even *una minima moniciunzella di dinari*"
in emergencies.[55] Devoting a whole chapter of *The Prince* to this
thorny problem of generosity versus parsimony, Machiavelli also
stressed the dangers of a given ruler's propensity for liberality:

> If you [the Prince] do in fact earn a reputation for generosity,
> you will come to grief. . . . [because] you have to be ostenta-
> tiously lavish; and a prince acting in that fashion will soon
> squander all his resources, only to be forced in the end . . . to
> lay excessive burdens on the people, to impose extortionate
> taxes, and to do everything else he can to raise money.[56]

And indeed, this seems to have been precisely what happened in
Naples, if Pontano is to be believed: "We know that Alfonso . . .
after very great expenses . . . was reduced to such a point and
accumulated so many debts that he was no longer able to satisfy his
creditors. In the end he went bankrupt and, seized with dismay and
anger, stripped most of the Treasury officials of almost all their
estates on the pretence of fining them."[57] In the case of Spain, the
king's incessant demands on Valencia, Catalonia, and Aragon for
funds with which to underwrite his Italian campaigns resulted in
such a "continual hemorrhage" of resources from the peninsula to
Italy that at one point the Corts refused to vote him any further
funds unless he returned to Spain.[58]

In classical Rome *liberalitas*, ostensibly a way of thinking and behaving worthy of a free man, came to symbolize the emperor's generosity to the people of Rome and his care for their food supply. Under these circumstances, *liberalitas* was never conveyed on Roman coins by a bird—even an eagle. The donor was represented rather by a human emperor seated on the right of a platform watching a deserving donee mount a flight of steps on the left, as on the reverse of a sestertius minted under Marcus Aurelius (Fig. 12).[59] This left-right orientation of the composition remained standard until the fourth century when a more symmetrical composition organized around a frontal and centralized emperor evolved. The prime example known to the Renaissance was, of course, the *liberalitas* register on the Arch of Constantine, and the ideology underlying the dominant donor, worshipped by the grateful donees, may perhaps be reflected in Pisanello's medal reverse.[60]

Alfonso would certainly have considered the demeanor of the lesser birds, clustered humbly at the eagle's feet, to be entirely appropriate for the Neapolitan barons over whom he now ruled. The king's self-apotheosis on works of art has to be seen against a background that was far from peaceful, a kingdom that was still divided between Aragonese partisans and Angevin sympathizers. Suspicious of the kingdom's well-entrenched feudal aristocracy, which was impatient of royal control, Alfonso seized every opportunity to weaken their challenge to his authority. His attempt to exercise unfettered sovereign power and his wholesale appointment of Spaniards to offices which Italians claimed for themselves further alienated his new subjects.[61] Thus, far from being "adorato tra gli dei" by his barons as he must have hoped, Alfonso was instead told by a well-informed Borso d'Este, that "la Vostra Maestà in questo Reaume non è amata per niente, anci è plu tosto odiata," (in this kingdom your majesty is not at all loved, on the contrary, you are rather hated).[62] Pisanello's medal, suggesting that all the Neapolitan barons needed was a vehicle through which to express their homage to their new king, and hence adherence to his regime, accordingly allowed—even encouraged—Alfonso to ignore opposition to his rule.

In 1443 Flavio Biondo was gratified by the idea that the princes were imitating ancient imperial practice by placing their own faces and their own names on their modern coins.[63] Nonetheless, he had to wait fifteen years for medals to display more than the general

concept of antiquity. This quantum leap occurred in Naples in the second half of the 1450s when Alfonso imported another artist from the Mantuan court, Cristoforo di Geremia, who had also worked in Rome for Cardinal Pietro Barbo during the exciting years of Nicholas V's pontificate.[64] No doubt influenced by Barbo's collection of Roman imperial coins and medallions, Cristoforo was sufficiently knowledgeable in classical sculpture to act as an agent for his court patrons.[65] In 1462, for instance, he sent "iiij teste o capi antiqui le quali sono da li intendenti reputati boni" to Lodovico Gonzaga.[66] Although largely unknown today, Cristoforo was another court artist who attracted considerable humanist attention. The antiquarian Felice Feliciano addressed two sonnets to him, and Filarete praised him, in the same breath as Donatello and Desiderio da Settignano, as a most worthy master who made "certe cose benissime" in bronze.[67] Artist of a younger generation than Pisanello, Cristoforo was able to create an *all'antica* medal for Alfonso on which the classical content was, for the first time, carried by the image (Fig. 13).[68]

We saw that Pisanello's likenesses of Alfonso and Leonello d'Este anticipated the way in which actual portrait busts would present sitters in the 1450s. Cristoforo's obverse, on the other hand — a remarkably realistic portrait of the king as an older man — imitates the form taken by Roman portrait busts, such as a second-century marble of Hadrian (Fig. 14).[69] Cristoforo first clad Alfonso in a classical cuirass, decorated with two winged putti or victories holding a medallion with a head — a motif taken from classical funerary iconography — and a large medallion showing a nymph astride a centaur, and below a Medusa head. He then treated the bust differently, presenting it as if hollowed out at the back, rounded off at the bottom, set on a base formed by a crown, and, like the Roman work, conceived to be seen only from the front.[70]

"Spain alone," wrote Panormita, "was accustomed to giving Rome and Italy her emperors and kings. And what emperors and what kings! Trajan, Hadrian, Theodosius, Arcadius, Honorius, Theodosius II, and finally Alfonso, living image of all virtue who, not inferior to his predecessors in any kind of praise, . . . is by far the most famous."[71] Having dictated to Panormita a list of Spanish rulers prominent in ancient and modern Italian history, Alfonso proceeded to place busts on the court stairs of the Hispanic

Hadrian and — the emperor whose conquests marked the height of
Roman power — Trajan.[72] Cristoforo likened Alfonso to these Span-
ish imperial exemplars — both of whom, needless to say, had been
deified — by presenting the king literally as if he were another Roman
emperor, even to the *paludamentum* hanging over his left shoulder.
The inscription or "label" expands on the Imperial visual message:
ALPHONSVS REX REGIBVS IMPERANS ET BELLORVM VICTOR, "King
Alfonso, ruler of the princes and victor of the wars," not a message
likely to appeal to other Italian rulers.

Figure 15 shows Cellini's magnificent monumental bronze of
Duke Cosimo I de' Medici dating from the 1540s.[73] At the begin-
ning of the sixteenth century, copies of Roman imperial busts were
made by such court artists as Antico,[74] but it was not until the mid-
Cinquecento that free-standing sculpted portraits from life revived
the canonical form of the classical bust, as we see it on Cristoforo's
relief created some ninety years earlier, whereby a living contempo-
rary, dressed in the armor of pagan antiquity, was also portrayed in
the guise of a Roman Caesar.[75]

Cristoforo's reverse offered one of the first full-length por-
traits of a ruler in Quattrocento art. Wearing a military cuirass
with short tunic, Alfonso is seated in contrapposto — a pose perhaps
reminiscent of the crowned and seated Frederick II on the gate at
Capua[76] — on a throne decorated with sphinxes, symbols of wisdom.
In his left hand he holds the orb of empire; in his right, the sword
that created it. He is being crowned by not one but two proponents
of war. Like a winged victory, Bellona stands behind his throne,
and a helmeted but nude Mars reaches his hand up to support
the crown while carrying a trophy. The inscription, CORONANT
VICTOREM REGNI MARS ET BELLONA, "Mars and Bellona crown the
victor of the kingdom [of Naples]," presents Alfonso's takeover of
the southern half of the Italian peninsula as a major military feat of
Quattrocento Italy.

The medal has numerous connotations. The iconography
probably derives from reliefs on Roman cuirassed statues which
commonly show two victories crowning an emperor.[77] The gods'
gestures however also evoke the act of coronation, as on the reverse
of a *coronato* minted for Alfonso's son Ferrante where, in place of
Mars and Bellona, a bishop with gospel and a cardinal with crown
flank the next king of Naples who, like his father, is shown seated

and holding a crowned orb (Fig. 16).[78] The crowns, however, differ. Unlike his son's coin, Alfonso's medal shows him being crowned not with a traditional medieval crown but with a crown of the sun's rays. It is, of course, the radiate crown of Apollo, the sun god.[79] To don a radiate crown, which in antiquity was usually only placed on the heads of gods and deified heroes, was yet another way of bestowing divine honors on oneself.[80] *Divus Augustus Pater*, for instance, normally wears the radiate crown of Sol-Apollo on coins minted after his death and deification (Fig. 10). Indeed, Pisanello had once sketched such a coin showing Augustus sporting this headgear, as can be seen in the copy by a follower in figure 17, although he borrowed only the *divus* inscription when he came to create his own medal of Alfonso.[81] Renaissance rulers frequently adopted solar imagery, as in the sun shining on Alfonso's book emblem in figure 7 or the medal made in 1457 by Marescotti for Galeazzo Maria Sforza, where the thirteen-year-old heir to the duchy of Milan (Fig. 18) was also called a *divus*, but no prince had previously shown himself being awarded the radiate crown of Sol-Apollo — by the god and goddess of war to boot.[82]

Cristoforo's presentation of Alfonso was followed on a small marble medallion that shows the king deified as DIVVS ALPHONSVS REX and wearing antique military dress and *paludamentum* as well as crown of Sol (Fig. 19).[83] Identifying with Roman imperial pretensions and masquerading in the guise of a divinity, the king has been completely assimilated to the deified Augustus in a fully fledged appropriation of classical iconography and style as well as classical inscription.[84]

Seventeen casts survive of Cristoforo's medal indicating that it was widely circulated by Alfonso. In the age before printing, medals were the only art form that could be quickly replicated for distribution to one's peers.[85] Perhaps the multiple copies and the double-sided format of this new art form — a badge of modernity because of its seeming antiquity — encouraged artistic innovation. Certainly, artists seem to have felt free to experiment with style and iconography in ways that were unique to the fifteenth century and which would not be explored in monumental work until well into the sixteenth.

However, despite the freedom with which artists used the medium, it is striking that the humanist potential of medals were

not initially explored until Pisanello's arrival in Naples. As it happens, Pisanello's revival of *all'antica* inscriptions and Cristoforo's revival of *all'antica* iconography and style were specifically produced for the only ruler in Italy whose empire and whose titles — the kingdoms of Aragon, Naples, Sicily, Valencia, Sardinia, Corsica, and Maiorca — provided an outward justification, at any rate, for his determination to be regarded as heir to the Roman emperors.

I do not think that it was coincidence that the medal, with its inherent imperial connotations for the Renaissance, was first developed and then assiduously cultivated by monarchical regimes. The Republic of Florence is traditionally seen as *the* innovative artistic center in the Quattrocento, but it was not until 1465 that the first Florentine medals were created and then, significantly, for the Medici.[86] It is not hard to understand why, in the words of Hans Baron, "the cult of Caesar should have flourished at the tyrant courts."[87] For these princes Caesar was not only a renowned author, not only the greatest general who had ever lived, but, above all, founder of an empire. The first Roman emperors, heroes who had really lived and really triumphed on Italian soil, must have had an overwhelming emotional reality for these rulers whose mania for territorial expansion, not to mention their humanist educations, made them peculiarly susceptible to the myth of Roman imperial greatness.[88] In an age of *artistic* realism, historical figures took on the glamor that had previously belonged exclusively to fictional chivalric heroes, and the imaginative power of the legendary Augustus started to rival that of the legendary Galahad.

As Lauro Martines has astutely observed, the controversy between Guarino da Verona and Poggio Bracciolini in 1430s over the relative merits of Julius Caesar and Scipio Africanus unconsciously reflected the signorial and republican ideologies of the regimes, Ferrara and Florence, that each humanist supported.[89] We need, therefore, feel no surprise that the aspects of Caesar's life that Florentine humanists such as Poggio purported to find repugnant — the ambitious military dictator whose lust for power plunged the country into civil war, destroyed the *libertas* of the Republic and therefore its freedom of expression and literary culture[90] — should not have concerned the *signori*. Caesar and Augustus would have had nothing but appeal for a prince like Alfonso whose own search for "hegemony over Italy" — adumbrated in a grand plan for uniting

Milan with Naples — is clearly reflected in his inscription "Alphonsus Rex . . . Italicus" on the triumphal arch.[91]

The works commissioned by a given regime are likely to reflect its basic ideology. Florentine artistic formulations of absolutism would, for example, be provided in the next century by Vasari's portraits of the living Cosimo de' Medici in the guise of a deity, as Kurt Forster has convincingly argued.[92] But a skilled court artist will not only reflect a given ideology, he will also articulate it in ways that — surely — must have clarified it for the patron.[93] We can imagine the pleasure with which Alfonso — who wrote that art was a source of "contentment and delight not only to the physical senses but also to the spirit"[94] — must have received Pisanello and Cristoforo's classicizing interpretations of his Caesarian fantasies. The antiquarian Cyriacus of Ancona had idealistically claimed that the study of antiquity would reveal their "own names" to his contemporaries, that is, they could discover their true selves only through study of the Roman past.[95] Whatever the truth of his dictum, the early Roman Empire served the political needs of this new Neapolitan Caesar by providing his artists with effective symbols of legitimacy and power.[96]

NOTES

*The research for this essay was undertaken as an Andrew W. Mellon Fellow at the American Academy at Rome in 1986–87. I wish to express my deep gratitude to the Mellon Foundation and the Academy, and to the following who greatly helped in various ways: Gino Corti, Charles T. Davis, Susan Downey, Richard Gergel, William Harris, Gary Ianziti, Mark Jones, Ioli Kalavrezou-Maxeiner, Gerhart Koeppel, Alison Luchs, Ronald Mellor, Elinor Winsor-Leach, and David Wright. I also wish to thank the participants in the Notre Dame conference, especially Jonathan Boulton, Julian Gardner, Rona Goffen, Diane Owen Hughes, John Larner, Debra Pincus, Charles Rosenberg, and Charles Stinger, for their many helpful comments on this essay as first written.

1. The essay represents initial research toward a book, *How Quattrocento Princes Used Art*, that will explore why Italian rulers commissioned certain works but not others, and what they expected or wanted from the art.

2. G. F. Hill, *A Corpus of Italian Medals of the Renaissance before Cellini* (London, 1930), no. 19; R. Weiss, *Pisanello's Medallion of the Emperor John*

VIII Palaeologus (London, 1966). See also M. Salmi, "Appunti su Pisanello medaglista," *Annali dell'Istituto Italiano di Numismatica* 4 (1957): 13–23.

For *struck* medals in Trecento Padua, with obverse (based on Roman *sesterzi*) showing Francesco II da Carrara as if he were a Roman emperor, see F. Cessi, "Una medaglia di Francesco Novello da Carrara coniato in un sesterzio Antoniano," *Padova e la sua Provincia*, fasc. 11–12 (1965): 9–11; *idem*, "Monetazione e medaglistica dei Carraresi" in *Da Giotto a Mantegna* (Padua, 1974), 88–89. For the lack of influence of these medals, see R. Weiss, "Le origini franco-bizantine della medaglia italiana del Rinascimento," in *Venezia e l'Oriente fra Tardo Medioevo e Rinascimento*, ed. A. Petrussi (Florence, 1966), 340. See also M. Jones, "The first cast medals and the Limbourgs," *Art History* 2 (1979): 35–44.

3. For Pisanello's career, see J. Woods-Marsden, *The Gonzaga of Mantua and Pisanello's Arthurian Frescoes* (Princeton, N.J., 1988), ch. 3. For Leonello, see W. L. Gundersheimer, *Ferrara: The Style of a Renaissance Despotism* (Princeton, N.J., 1973), ch. 4.

4. Guarino's letter to Poggio, written in 1435, is translated by E. Garin, *Prosatori Latini del Quattrocento* (Milan-Naples, 1952), 315–77; M. Salmi, "La 'Divi Iulii Caesaris Effigies' del Pisanello," *Commentari* 8 (1957): 91–95.

5. G. F. Hill, *Medals of the Renaissance* (Oxford, 1920), 15; *idem*, "Classical Influences on the Italian Medal," *Burlington Magazine* 18 (1911): 259–68. For the argument that "i cosiddetti medaglioni romani non sono medaglie nell'accezione moderna del termine," see F. Pavini Rosati, *Medaglie e Placchette italiane dal Rinascimento al XVIII secolo* (Rome, 1968), 8; *idem*, "Ispirazione classica nella medaglia italiana," in *La Medaglia d'arte. Atti del Primo Convegno di Studio, Udine, 1970* (Udine, 1973), 95–105.

6. M. Vickers, "Some Preparatory Drawings for Pisanello's Medallion of John VIII Palaeologus," *Art Bulletin* 60 (1978): 418–19; J. Gill, *Personalities of the Council of Florence* (Oxford, 1974), 113–14.

7. "Tum Leonellus interdixit Nempe Caesarum ego vultus non minus singulari quadam admiratione aereis numis inspiciendo delectari soleo. . . . " M. Baxandall, "A Dialogue on Art from the Court of Leonello d'Este: Angelo Decembrio's 'De Politia Litteraria' Pars LXVIII," *Journal of the Warburg and Courtauld Institutes* 26 (1963): 324–25.

8. Hill, *A Corpus*, nos. 23–32; " . . . nummos te ad decem millia aeneos vetustorum principum Romanorum more cudi curavisse, quibus altera in parte ad capitis tui imaginem tuum sit nomen inscriptum. . . . " Letter from Flavio Biondo to Leonello d'Este, Rome, February 1, 1446, published in *Scritte inedite e rari di Flavio Biondo*, ed. B. Nogara (Rome, 1927), 159.

9. Hill, *A Corpus*, no. 32. See now also *Da Pisanello alla Nascita dei Musei Capitolini. L'Antico a Roma alla vigilia del Rinascimento. Catalogo della mostra* (Rome, 1988), cat. no. 32; *Arte in Lombardia tra Gotico e Rinascimento. Catalogo della Mostra* (Milan, 1988), 260–61.

10. See *Fiore di Virtù*, ed. G. Bottari (Rome, 1740), 105; F. McCullough, *Medieval Latin and French Bestiaries* (Chapel Hill, N.C., 1962), 137–40.

11. See P. Meller, "Physiognomical Theory in Heroic Portraits," *Acts of the 20th International Congress on the History of Art* (Princeton, N.J., 1963), 53–69.

12. For other profile portraits of Leonello, see J. Woods-Marsden, "Ritratto al naturale: Questions of Realism and Idealism in Early Renaissance Portraits," *Art Journal* 46 (1987): 209–16.

13. J. Pope-Hennessy, *Italian Renaissance Sculpture* (London-New York, 1963), 46.

14. See the important articles by I. Lavin, "On the Sources and Meaning of the Renaissance Portrait Bust," *Art Quarterly* 33 (1970): 207–26; *idem*, "On Illusion and Allusion in Italian Sixteenth-century Portrait Busts," *Proceedings of the American Philosophical Society* 119 (1975): 353–62.

15. A. Heiss, *Les Médailleurs de la Renaissance. I. Vittore Pisanello* (Paris, 1881), 19.

16. For Alfonso, see the article by R. Moscati in *Dizionario Biografico degli Italiani* (hereafter *DBI*), vol. 2 (Rome, 1960), 323–31; E. Pontieri, *Alfonso il Magnanimo re di Napoli 1435–1458* (Naples, 1975); and A. F. C. Ryder, *The Kingdom of Naples under Alfonso the Magnanimous* (Oxford, 1976).

17. "Numismata illustrium imperatorum, sed Caesaris ante alios, per universam Italiam summo studio conquisita in eburnea arcula a rege pene dixerim religiosissime osservabantur. . . . " A. Beccadelli, *De dictis et factis Alphonsi regis Aragonum Libri Quatuor Commentarium in eosdem Aeneae Sylvii* (Basel, 1538), II, 12; pp. 39, 277. "E in tanto amò il nome di Cesare, che le medaglie e le monete antiche, ove la sua effigie era scolpita, per tutta Italia faceva ricercare, e quelle come cosa sacra e religiosa in una ornata cassetta tenea. . . . " P. Collenuccio, *Compendio de le Istorie del Regno di Napoli*, ed. A. Saviotti (Bari, 1929), 292 (a useful compilation of the sources which was written at the end of the fifteenth century and dedicated to Ercole I d'Este). For Panormita, see the article by G. Resta in *DBI*, vol. 7 (Rome, 1965), 400–06, s.v. Beccadelli; A. F. C. Ryder, "Antonio Beccadelli: A Humanist in Government," *Cultural Aspects of the Italian Renaissance*, ed. C. H. Clough (Manchester, 1976), 123–40. On the Quattrocento study of ancient numismatics, see R. Weiss, *The Renaissance Rediscovery of Classical Antiquity* (London, 1969), ch. 12.

18. Vespasiano da Bisticci, "La vita di Re Alfonso di Napoli" in *Le Vite*, ed. A. Greco, 2 vols (Florence, 1976), I, 107. For triumphs, see, among others, R. Brilliant, *Gesture and Rank in Roman Art* (New Haven, 1963), 177; A. Pinelli, "Festi e trionfi: continuità e metamorfosi di un tema," in *Memoria dell'antico nell'arte italiana*, II, ed. S. Settis (Turin, 1985), 281–350, esp. 321–35. Biondo's *Roma Triumphans* was written 1457–1459.

19. L. B. Alberti, *L'Architettura, De Re Aedificatoria*, ed. G. Orlandi and P. Portoghesi (Milan, 1966), bk. 8, ch. 6, 716–25; G. L. Hersey, *The Aragonese Arch at Naples 1443–75* (New Haven, Conn., and London, 1973), 31.

20. A poem by Cantalicio reads in part: "The royal triumphal gate tells of the deeds of the first Alfonso like that in Rome which witnesses Septimius's victories or as the worthy Flavian [i.e., Arch of Titus] shows forth." G. B. Cantalicio, *Gonsalviae*, in *Raccolta di tutti i più rinomati scrittori dell'istoria generale del regno di Napoli*, 6, ed. G. Gravier (Naples, 1769–72), 66–67, translated in Hersey, *The Aragonese Arch*, 1. For the Arch, see also C. von Fabriczy, "Der Triumphbogen Alfonsos I am Castel Nuovo zu Neapel," *Jahrbuch der königlichen Preussischen Kunstsammlungen* 20 (1899): 3–30, and 125–58; E. R. Driscoll, "Alfonso of Aragon as a Patron of Art: Some Reflections on the Decoration and Design of the Triumphal Arch of Castel Nuovo in Naples," *Essays in Memory of Karl Lehmann* (Locust Valley, N.Y., 1964), 87–96; L. H. Heydenreich and W. Lotz, *Architecture in Italy 1400–1600* (Harmondsworth, Middlesex, 1974), 124–25; H. W. Kruft and M. Malmanger, "Der Triumphbogen Alfonsos in Neapel: Das Monument und seine politische Bedeutung," *Acta ad Archaeologiam et Artium Historiam Pertinentia* 6 (1975): 213–305.

21. " . . . et lu dictu homo che stava di sopra era tutto armato et tenia un sceptro in manu et havia una girlanda dj lauro sopra la testa per arme et stava soto forma di Cesaro et como fu dinanti lu dictu Signore li disse le parolj sequente: Eccelsu Re e Cesare novellu . . . Alfonso Re di pace. . . . " Letter by a Sicilian observer, May 20, 1443, as transcribed in Kruft and Malmanger, "Die Triumphbogen," 290–92.

22. " . . . per . . . contemplare quel che doveva essere quando triumphava un victorioso imperatore." Letter from Isabella d'Este to Elisabetta Gonzaga, July 7, 1507, published in A. Luzio, "Isabella d'Este e la Corte Sforzesca," *Archivio storico lombardo* 28 (1901): 159.

23. U. Frittelli, *Giannantonio de' Pandoni detto il Porcellio* (Florence, 1960), 84–92. I have been unable to consult V. Nociti, *Il trionfo . . . cantato da Porcellio* (Bassano, 1895).

24. "Il est à la Table Ronde une place qui cette fois encore restera vide. C'est celle où aucun nom n'est inscrit, celle que l'enchanteur Merlin, le mysterieux conseiller d'Artus, a reservée jadis au Heros qui doit achever

les aventures du Graal. Quiconque, jusqu'à ce jour, osa s'asseoir là fut aussitôt massacré ou blessé affreusement par des mains invisibles. Pour cela on appelle cette place le Siège Perilleux. Puis [le vieillard] mène [le chevalier] droit au Siège Perilleux, en declarent très haut, afin que tous l'entendent: 'Sire, prenez cette place, c'est la vôtre.' Le chevalier s'assit avec tranquillité dans la chaire où plus d'un preux avait trouvé la mort ou quelque affreuse blessure. . . . Quand les compagnons de la Table Ronde virent le chevalier siéger en la place dont les meilleurs d'entre eux n'osaient approcher, ils s'en émerveillerent longuement. 'Quel est donc celui-ci, disaient-ils, qui vient vers nous paré de jeunesse et de beauté, et qui accomplit aisément l'impossible?' " *La Queste du Saint Graal translatée des manuscrits du XIII siècle*, ed. A. Pauphilet (Paris, 1923), 6–7, 15–16. For the standard text in Old French, see *The Vulgate Version of the Arthurian Romances*, VI, ed. H. O. Sommer (Washington, D.C., 1908–16), 5–11. In Malory's version Merlin says " . . . in the Siege Perilous there shall no man sit therein but one, and if there be any so hardy to do it he shall be destroyed and he that shall sit there shall have no fellow . . . " Sir Thomas Malory, *Le Morte d'Arthur*, ed. A. W. Pollard (New York, 1955), bk. 3, ch. 4.

25. " . . . sobre lo qual entremés eren les IIII virtuts e lo siti perillós que lo dit senyor fa per sa divisa o empresa. E la vna de les ditas virtuts ab alta veu significà e parlà al dit senyor que la dita empresa del dit siti perillós per la benaventurada conquesta havie son obtente, com algun altre Rey, príncep ne senyor no ere stat digne de seure sobre aquell siti, sinó lo dit senyor qui hauie supeditat e obtengut lo dit Reyme. . . . " Letter from Antonio Vinyes to the Conselleres of Barcelona, February 28, 1443, published in R. Filangieri di Candida, "Rassegna critica delle fonti per la storia di Castel Nuovo," *Archivio storico per le provincie napoletane* N. S. 24 (1938): 330–32, doc. 1; Hersey, *The Aragonese Arch*, 63, doc. 1.

26. See G. J. de Osma, *La Divisas del Rey en los pavimentos de 'obra de Manises' del castillo de Nápoles (anos 1446–1458). Textos y Documentos Valencianos. III* (Madrid, 1909), 77–86; L. Volpicella, "Le imprese nella numismatica aragonese di Napoli," *Supplemento a Le Monete del Reaume delle Due Sicilie*, ed. M. Cagiati (Naples, 1911–15), 2 (1912): 19–27, esp. 23; Hersey, *The Aragonese Arch*, pp. 15. 47. For a discussion of Arthurian works of art in early Renaissance Italy, see Woods-Marsden, *The Gonzaga of Mantua*, ch. 2.

27. For a discussion of chivalric versus classical iconography, see Woods-Marsden, *The Gonzaga of Mantua*, ch. 5. See Alfonso's recommendations to his captains to keep romances and books of chivalric exploits in military camps, in order to inflame the souls of the soldiers, cited in B. Croce, "La corte spagnuola di Alfonso d'Aragona a Napoli," *Atti dell'Accademia Pontaniana* 24, 4 (1894): 4 n. 5.

28. Cicero, *Epistolae ad Familiares*, Paris, Bibliothèque Nationale, MS. Lat. 8533, f. 80. See T. De Marinis, *La biblioteca napoletana dei re d'Aragona*, I (Milan, 1945-52), 45. The Siege Perilous is also recorded in 1455 painted on a banner (C. Minieri-Riccio, "Alcuni fatti di Alfonso I di Aragona dal 15 Aprile 1437 al 31 di Maggio 1458," *Archivio storico per le provincie napoletane* 6 [1881], 432); in 1456 painted on organ shutters (Filangieri di Candida, "Rassegna critica," 295); and in 1458 as a device on the *giornee* of pages and courtiers (G. Filangieri, "Nuovi documenti intorno la famiglia, le case e le vicende di Lucrezia d'Alagno," *Archivio storico per le provincie napoletane* 11 [1886]: 123).

29. Written June 13, 1443. Nogara, *Scritte di Flavio Biondo*, 147-53.

30. J. H. Bentley, *Politics and Culture in Renaissance Naples* (Princeton, N.J., 1987), 47 and passim. See also T. De Marinis, *La biblioteca*, I, ch. 1; E. I. Rao, "Alfonso of Aragon and the Italian Humanists," *Esperienze Letterarie* 4 (1979): 43-58; and E. Cochrane, *Historians and Historiography in the Italian Renaissance* (Chicago, 1981), 147.

31. See n. 3 above.

32. Hill, *A Corpus*, no. 41; Hersey, *The Aragonese Arch*, 28; Aeneas Sylvius Piccolomini, *De Europa* in *Opera quae extant omnia* (Basel, 1571), 470, " . . . corpore gracili, vultu pallido, sed aspectu laeto, naso aquilo et illustribus oculis, crine nigro et jam albicanti ad aures usque protenso, statura mediocri." Collenuccio, *Compendio de le Istorie*, 287, "Fu di statura mediocre, di corpo asciutto e leggiadro di volto, più presso al color pallido che bruno, di occhi lustranti e lieto aspetto; il naso ebbe alquanto rilevato in mezzo e alquanto aquilino, si come a li re, secondo la opinione de' persiani, pare che convenga, li capelli aveva negri per natura e portavali corti si, che l'orecchie non passavano."

33. Hill, *A Corpus*, nos. 34, 36.

34. Louvre, Cabinet des Dessins, Inv. 2307; M. Fossi Todorow, *I Disegni del Pisanello e della sua cerchia* (Florence, 1966), cat. no. 160.

35. The device was mentioned by Panormita: "Librum & eum quidem apertum pro insigni gestavit, quod bonarum artium cognitionem maxime rebus convenire intelligeret. . . . " Beccadelli, *De dictis et factis Alphonsi*, II, 14. See also De Osma, *La Divisas del Rey*, 76. The inscription on the book VIR SAPI/ENS/ DOM/INA/BITV/R AS/TRIS appears only on later casts.

36. "Molti restarono sospesi e dubij del significato . . . dissero chi gli portò il libro denotando, che la perfettione dell' intelletto humano constà nella cognitione delle scienze e dell'arti liberali, delle quali sua Maestà fu molto studiosa," P. Giovio, *Dialogo dell'imprese militari ed amorose* (Rome, 1557), 21; "per denotare che la cognizione de le lettere massimamente a li principi conveniva, per insegna portava un libro aperto," Collenuccio, *Compendio de le Istorie*, 291; "Alfonso, per favorita impresa hebbe un libro

aperto, senza motto, per significare l'ufficio del Re ch'è di sapere," G. C. Capaccio, *Delle Imprese* (Napoli, 1592) c. 40v.

37. "Caij Caesaris commentarios in omni expeditione secum tulit, nullum omnino intermittens diem, quin illos accuratissime lectitaret . . . " Beccadelli, *De dictis et factis Alphonsi*, II, 13 (see also II, 15, 16; III, 1; and IV, 34); Collenuccio, *Compendio de le Istorie*, 29, "in ogni sua spedizione e viaggio sempre con se portava Tito Livio e li *Commentari* di Iulio Cesare, li quali mai appena lascio dì che non li leggesse"; Aeneas Sylvius Piccolomini, *Epistolarum* in *Opera quae extant omnia*, epist. 105, addressed to the Duke of Tyrol, 602. See also De Marinis, *La biblioteca*, I, ch. 1; L. Piles Ros, "Una nota sobre el amore del Alfonso V hacia los libros," *Revista de bibliografia nacional* 7 (1946): 384–87, for the 1426 decree prohibiting the export of books from Valencia.

38. " . . . respondit, ex libris se arma, et armorum iura didicisse," Beccadelli, *De dictis et factis Alphonsi*, IV, 19.

39. Ripa shows *Autorità* or *Podestà* with open books on one side and arms on the other (C. Ripa, *Iconologia*, ed. C. Orlandi, [Perugia, 1764–67], I, 191.), just as the reverse of Pisanello's medal for Francesco Sforza shows sword and book on either side of a horse head (Hill, *A Corpus*, no. 23).

40. See C. M. Rosenberg, "The Double Portrait of Federico and Guidobaldo da Montefeltro: Power, Wisdom and Dynasty," in *Federico di Montefeltro. Lo Stato. Le Arti. La Cultura*, ed. G. Cerboni Baiardi, G. Chittolini, and P. Floriani, II (Rome, 1986), 213–22.

41. "Eos ubi honore commodisque prosequere, divinas exoriri artes et ad te instar apum advolare cernemus; ii te canent et scriptis illustrabunt suis et sic illustrabunt, ut cum omni posteritate adaequeris et buccinante calamo nulla regio, nulla de te conticescat aetas: quod nullas per imagines aut statuas fieri posse sperandum est, vel quia sine litteris mutae sunt vel quia per orbem terrarum huc atque illuc facile transferri nequeant." Letter from Guarino da Verona to King Alfonso, Ferrara, July, 1447, published in *Epistolario di Guarino Veronese*, ed. Sabbadini (Venice, 1915–19), letter 805, 492; M. Baxandall, *Giotto and the Orators* (Oxford, 1972), 90.

42. "Più altre [medaglie] erano state trovate ma così corrose che non si discernavano, se non a fatica, le lettere e le immagini." Letter from Antonio Ivano to Lorenzo de' Medici, March 14, 1473. Archivio di Stato, Florence, M.A.P., filza xxx, c. 141, cited by C. Braggio, "Antonio Ivano umanista del secolo XV," *Giornale Ligustico* 12 (1885): 362.

43. See n. 33 above.

44. J. P. C. Kent, *Roman Coins* (London and New York, 1978), cat. no. 150 (dating c. 25 A.D.). Augustus died August 19, 14 A.D., and was deified on September 17th.

45. S. R. F. Price, *Ritual and Power: The Roman Imperial Cult in Asia Minor* (Cambridge, 1984), 75; L. R. Taylor, *The Divinity of the Roman Emperor* (Middletown, Conn., 1931); S. Weinstock, *Divus Julius* (Oxford, 1971).

46. "Nam deum honor principi non ante habetur, quam agere inter homines desierit." Tacitus, *The Annals*, trans. J. Jackson (Cambridge, Mass, 1937), bk. 15, ch. 74, 335. The temple was vetoed on the grounds that it could have been interpreted as an omen of, or aspiration for, Nero's death.

47. "Egli era l'uomo più prosuntuoso, non voleva ammetter nessuno al proprio livello come compagno. La sua arroganza, il suo orgoglio erano tali, che si teneva degno non solo di essere onorato tra gli uomini, ma anche adorato tra gli dei; pensava che persino gli alberi e le mura dovessero curvarsi innanzi a lui per fargli onore. Con lui non si poteva stabilire nessuna comunanza di vita, nessuna amicizia." Quoted in E. Gothein, *Il Rinascimento nell' Italia meridionale*, trans. T. Persico (Florence, 1915), 198–99; Ryder, *The Kingdom of Naples*, 28–29 (in each case without giving a source).

48. C. Foucard, "Proposta fatta dalla Corte Estense ad Alfonso I Re di Napoli (1445)," *Archivio storico per le provincie napoletane* 4 (1879): 738.

49. G. F. Hill, *Pisanello* (London, 1905), 198; *Fiore di Virtù* (Venice, 1477), ch. 14, c. 24ᵛ. "De la Liberalita. Esempio. Puose aseminare e apropriare la virtu de la liberalita a Laquilla la qualle e lo piu liberale oselo che sia nel mondo per che la non poreva mai haver tanta fame che la non lassasse sempre la mita de quello che la manza a i altri oselli che se trovano da presso quando la manza e per cio chiare volte se vede volare: per che molti oselli non se puol pasere per se quando la vede volare li vano drieto per cibarsi e nutrirsi del suo cibo che li rimane." Cardinal Francesco Gonzaga also used the term *liberalitas* on his medal by Sperandio. Hill, *A Corpus*, no. 390.

50. Kent, *Roman Coins*, cat. no. 125.

51. E. Kantorowicz, *Frederick the Second (1194–1250)* (London, 1957), 225–26, and passim; Weiss, *The Renaissance Rediscovery*, 12; E. Panofsky, *Renaissance and Renascences in Western Art* (Stockholm, 1965), 65–66. For Frederick II's *augustales*, see H. Nussbaum, "Fürstenporträte auf italienischen Münzen des Quattrocento," *Zeitschrift für Numismatik* 35 (1925): 145–92, pl. 12. See now also the suggestive article by J. Meredith, "The Revival of the Augustan Age in the Court Art of Emperor Frederick II," in *Artistic Strategy and the Rhetoric of Power. Political Uses of Art from Antiquity to the Present*, ed. D. Castriota (Carbondale, Ill., 1986), 39–56, esp. 42.

52. "Alessandro affermava che è comportamento regale quello di donare spesso e molto." G. G. Pontano, *I Trattati delle Virtù sociali*, trans. and ed. F. Tateo (Rome, 1965), ch. 31, 46 and 198; F. Gilbert, "The

Humanist Concept of the Prince and *The Prince* of Machiavelli," *Journal of Modern History* 11 (1939): 463.

53. Vespasiano da Bisticci, "La vita di Alfonso," 91. Panormita also stressed Alfonso's generosity towards scholars (Beccadelli, *De dictis et factis Alphonsi*, II, 61; III, 11, IV, 18). See also P. Cortese, *De Hominibus Doctis Dialogus*, trans. and ed. M. T. Graziosi (Rome, 1973), 41.

54. Pontano, *I Trattati*, ch. 24, pp. 40 and 193.

55. " . . . nuj intendemo la Maystà V. essere de sua natura liberalissima, et intanto che quella mai non se retrova havere pure una minima moniciunzella di dinari, e intanto uxa liberalita, che epsa ad uno suo caxo et bixogno non poria mettere le mane, alchune volte, suxo 1000 ducati. . . . " Foucard, "Proposta," 711.

56. "La liberalità, usato in modo che tu sia tenuto, ti offende . . . [perché] è necessario non lasciare indrieto alcuna qualità di suntuosità; talmente che, sempre, uno principe così fatto consumerà in simili opere tutte le sua facultà; e sarà necessitato alla fine . . . gravare e' populi estraordinariamente ed essere fiscale e fare tutte quelle cose che si possono fare per avere danari." Machiavelli, *Il Principe*, ch. 16, trans. G. Bull (Harmondsworth, Middlesex, 1981), 92.

57. "Noi sappiamo che Alfonso . . . a forza di grandissime spese, con ogni genere di sperpero si ridusse a tal punto, che non era più in grado di dar soddisfazione ai creditori, tanti erano i debiti accumulati. Alla fine fallì e, preso dallo sgomento e dall'ira, spogliò gran parte degli amministratori del fisco di quasi tutti i loro beni, col pretesto di multarli." Pontano, *I Trattati delle Virtù*, 19, 174.

58. J. N. Hillgarth, *The Spanish Kingdoms, 1250–1515*, II (Oxford, 1976-78), 245–66.

59. M. Grant, *Roman Imperial Money* (London, 1954), pl. xx, 4. See also *Liberalitas* reverse on medal for Raffaello Riario attributed to Adriano Fiorentino, and dated after 1483 (Hill, *A Corpus*, no. 333), where a very large female personification seated to the right gives money to a very small man standing at left.

60. See Brilliant, *Gesture and Rank*, 170–73, pl. 4.21. For a complete listing of imperial Roman *liberalitas* from Julius Caesar to Valentinian II, see G. Barbieri, "liberalitas," in E. de Ruggero, *Dizionario Epigrafico di Antichità Romane*, 4 (Rome, 1958), 838–74.

61. Ryder, *The Kingdom of Naples*, 29–32, 48, and 368; B. Croce, *Storia del Regno di Napoli* (Bari, 1925), 55 ff., and 89 ff.

62. Foucard, "Proposta," 714. For a highly idealized view of Alfonso, see W. Valentiner, "A portrait bust of King Alphonso I of Naples," *Art Quarterly* 1 (1938), 65 (" . . . he was to become the ruler who could make his subjects happy . . . ").

63. See n. 8 above.

64. For Cristoforo, see U. Rossi, "Cristoforo Geremia," *Archivo storico dell'arte* 1 (1888): 404–11; J. de Foville, "Un médailleur du XVe siècle: Cristoforo Geremia," *Revue de l'art ancien et moderne* 30 (1911): 435–50; and the article by L. Pirzio Biroli Stefanelli, in *DBI*, vol. 31 (Rome, 1985), 85–86.

65. See the inventory of Paul II's collection of coins in E. Müntz, *Les arts à la cour des Papes pendant le XVe et XVIe siècle*, Partie 2, Paul II 1464–71, *Bibliothèques des Ecoles Françaises d'Athènes et de Rome*, fasc. 9 (1879): 265–79.

66. Letter from Cristoforo di Geremia to Lodovico Gonzaga, April 1, 1468, published in Rossi, "Cristoforo Geremia," 409. He would later (1468) restore the equestrian statue of Marcus Aurelius in front of the Lateran (*Da Pisanello . . . Musei Capitolini*, cat. no. 82).

67. L. Pratilli, "Felice Feliciano alla luce dei suoi codici," *Atti del Reale Istituto Veneto di Scienze Lettere ed Arti* 99, part 2 (1939–40): 75. The dedication of that dated 1465 reads "Felix Felicianus Veronensis ad commendationem famosissimi sculptoris christophoris Hyeremie," and the poem reads in part "Quanto chel buon Christophol Hyeremia/Examina distingue una figura/Con lalto ingegno di sua fantasia/Ne fu mai intanto precio la sculptura/Ne anchor per ladvenir credo che sia/Chi meglio di lui siegui la natura." Antonio Averlino detto il Filarete, *Trattato di Architettura*, ed. A. M. Finoli and L. Grassi (Milan, 1972), 172, 259, and 391.

68. Hill, *A Corpus*, no. 754. See now also *Da Pisanello . . . Musei Capitolini*, cat. no. 20. This medal is sometimes dated after Alfonso's death but the remarkable realism of the portrait, which must have been based on personal observation, argues for a date within the king's lifetime.

69. K. Fittschen and P. Zanker, *Katalog der römischen Porträts in den Capitolischen Museen und der anderen kommunalen Sammlungen der Stadt Rom*, III (Mainz, 1985), no. 46. See also nos. 30, 35, 52, 68, 80, 92, and 113.

70. See n. 14 above.

71. "Sola Hispania romae atque Italiae imperatores ac reges dare solita est. At quales imperatores aut quales reges. Traianum, Adrianum, Theodosium, Archadium, Honorium, Theodosium alterum. Postremo Alphonsum virtutum omnium vivam imaginem, qui cum superioribus ijs nullo laudationis genere inferior extet . . . longe superior est atque celebrior." Beccadelli, *De dictis et factis Alphonsi*, IV, Proemium, 105, echoed by Pius II on p. 239.

72. E. Bernich, "La sala del trionfo in Castelnuovo," *Napoli nobilissima* 13 (1904): 165–68.

73. J. Pope-Hennesy, *Cellini* (New York, 1985), 215–17.

74. For bibliography, see A. Allison, "four new busts by Antico," *Mitteilungen der Kunsthistorischen Institutes in Florenz* 20 (1976): 213–24. The

bust of Julius Caesar in the Metropolitan Museum, attributed to the work-shop of Antonio Rossellino, may be a late Quattrocento example of this type. See R. Krautheimer and T. Krautheimer-Hess, *Lorenzo Ghiberti* (Princeton, N.J., 1970), II, fig. 108.

75. Other similar busts on Quattrocento medals are of Federico da Montefeltro by Clemente da Urbino, 1468, where the cuirass is an exact copy of that worn by Alfonso in Cristoforo's medal (Hill, *A Corpus*, no. 304); and Lodovico Gonzaga by Melioli, 1475 (ibid., no. 194).

76. C. A. Willemsen, *Kaiser Friedrichs II. Triumphator zu Capua* (Wiesbaden, 1955); C. Frugoni, "L'Antichità: dai *Mirabilia* alla propaganda politica," *Memoria dell'antico nell'arte italiana*, II, ed. S. Settis (Turin, 1985), 5–72, esp. 24. The pose could also have been taken from a medal design by Pisanello showing Alfonso enthroned frontally (Louvre, Cabinet des Dessins, Inv. 2318v; Fossi Todorow, *I Disegni del Pisanello*, cat. no. 74v.) For the statue of Frederick II at Capua, see Meredith, "The Revival of the Augustan Age," 47.

77. For cuirassed statues, see C. C. Vermeule, "Hellenistic and Roman cuirassed busts," *Berytus* 13 (1959): 3–82; 15 (1964): 95–110; 16 (1966): 49–59; 23 (1974): 5–26; K. Stemmer, *Untersuchungen zur Typologie, Chronologie und Ikonografie der Panzerstatuen* (Berlin, 1978), pl. 27.

78. Museo Civico Filangieri, *Un secolo di Grande Arte nella monetazione di Napoli 1442–1556* (Naples, 1973), 59, cat nos. 29, 30. See also sculpture by Benedetto da Maiano, believed to represent the coronation of Ferrante at Barletta in 1459 (Florence, Bargello, Inv. 8). The inscription on Ferrante's coin CORONATVS LEGITIME CERTAVIT, "having been crowned he strove legitimately," is a reminder that Alfonso was the first king of Naples and Sicily not to be officially crowned (Ryder, *The Kingdom of Naples*, 38).

79. E. H. Kantorowicz, "Oriens Augusti—Lever du Roi," *Dumbarton Oaks Papers* 17 (1963): 119–77; J. M. C. Toynbee, "Ruler-Apotheosis in Ancient Rome," *Numismatic Chronicle* ser. 6, vol. 7 (1947): 126–49; Meredith, "The Revival of the Augustan Age," 50.

80. C. Daremberg and E. Saglio, *Dictionnaire des Antiquitiés greques et romaines*, I, 2 (Paris, 1887), 1535.

81. Louvre, Cabinet des Dessins, Inv. 2266 (Fossi Todorow, *I Disegni del Pisanello*, cat. no. 218 v.) See the important discussion of this and similar drawings in A. Schmitt, "Zur Wiederbelebung der Antike im Trecento," *Mitteilungen der Kunsthistorischen Institutes in Florenz* 18 (1974): 167–218.

82. Hill, *A Corpus*, no. 81. The inscription on the obverse reads DIVI AC INCLITI GALEAZ SFORCIE VICECO PAPIE COMITIS.

83. J. Pope-Hennesey, assisted by R. Lightbown, *Italian Sculpture in the Victoria and Albert Museum*, I (London, 1964), cat. no. 300, as Nea-politan, c. 1470–80. In my view, the work was probably made in Alfonso's

lifetime. It has not previously been noted that the king's features are closely based on Pisanello's portraits, even to the pronounced vein in his neck, although added lines around the eyes, nose, and mouth make him seem older.

84. For Panormita's presentation of Alfonso as the modern equivalent of Augustus, see B. C. Bowen, "Roman Jokes and the Renaissance Prince, 1455–1528," *Illinois Classical Studies* 9, 2 (1984): 137–48.

85. For Sigismondo Malatesta's distribution of his medals, see J. Woods-Marsden, "How Quattrocento Princes Used Art: Sigismondo Pandolfo Malatesta of Rimini and *Cose Militari,*" *Renaissance Studies* 3 (1989): 387–414.

86. Hill, *A Corpus*, nos. 907, 908, 909, and 910 (between 1465 and 1469); 915 and 916 (after 1478); *idem, Medals of the Renaissance*, revised and enlarged by G. Pollard (London, 1976), 72. But see, however, A. Brown, "The humanist portrait of Cosimo de' Medici, pater patriae," *Journal of the Warburg and Courtauld Institutes* 24 (1961): 186–221.

87. H. Baron, *The Crisis of the Early Renaissance*, I (Princeton, N.J., 1955), 55.

88. See F. Gundolf, *The Mantle of Caesar*, trans. J. W. Hartmann (London, 1928), ch. 3.

89. L. Martines, *Power and Imagination* (New York, 1979), 270–71, 286.

90. H. Baron, *The Crisis*, 44–55; R. Witt, "The 'De Tyranno' and Coluccio Salutati's view of politics and Roman history," *Nuova rivista storica* 53 (1969): 434–74; J. W. Oppel, "Peace versus Liberty in the Quattrocento: Poggio, Guarino and the Scipio-Casear Controversy," *Journal of Medieval and Renaissance Studies* 11 (1974): 221–65; Gilbert, "The Humanist Concept," 456 ff.; V. Brown, "Gaius Julius Caesar," in *Catalogus Translationum et Commentariorum. Medieval and Renaissance Latin Translations and Commentaries*, III, ed. F. E. Cranz and P. O. Kristeller (Washington, D. C., 1976), 87–139.

91. A strong statement to this effect is made by E. Pontieri, "Alfonso V nella politica italiana del suo tempo," *Estudios sobre Alfonso el Magnanimo* (Barcelona, 1960), 274 ff., and 299 ff. The inscription on the Arch reads "Alphonsus Rex Hispanicus Siculus Italicus Pius Clemens Invictus."

92. K. W. Forster, "Metaphors of Rule: Political Ideology and History in the Portraits of Cosimo I de' Medici," *Mitteilungen der Kunsthistorischen Institutes in Florenz* 15 (1970): 65–104.

93. See J. Woods-Marsden, "Pictorial Style and Ideology: Pisanello's Arthurian Cycle in Mantua," *Arte lombarda* 80–82 (1987): 132–39.

94. " . . . he recebido . . . los presentes de los quales no solamente haueys contentado e dado deleyte a los sesos corporales mas aun a los spirituales. . . . " B. Croce, "Una lettera di Alfonso d'Aragona," *Napoli*

nobilissima 1 (1892): 126–27. See also his more conventional statement of delight in works of art in bronze and marble in a letter to Doge Francesco Foscari, May 26, 1450, in Hersey, *The Aragonese Arch*, 66, doc. 7.

95. Letter to Giovanni Ricinati, published in L. Mehus, *Kyriaci Antonitani Itinerarum* (Florence, 1742), 54–55; C. Mitchell, "Archaeology and Romance in Renaissance Italy," in *Italian Renaissance Studies: A Tribute to the late Cecelia M. Ady*, ed. E. F. Jacob (London, 1960), 470.

96. See the conclusions reached by A. Grafton and L. Jardine (*From Humanism to the Humanities* [Cambridge, Mass., 1986], 57) that "humanist learning provided the male equivalent of needlepoint or musical skill; it provided the fictional identity of rank and worth on which the precarious edifice of the fifteenth-century Italian city state's power structure depended."

Triumph and Mourning in North Italian Magi Art

RICHARD C. TREXLER

FOR SOME TIME I have been studying the political and social relevance of the Christian story of the Magi or wise men.[1] Called the Three Kings since the sixth century, these men are said to have followed a star to Bethlehem, there worshipped King Jesus, and then returned home to spread Christianity among the gentiles. The Magi story is relevant because it describes an idea and a type of legitimating behavior both in past times, when people have evoked it in art, festive life, oral tradition, or literature, and in the present, whenever scholars still call such historical activities to our attention as I do now. For to be taken seriously, any movement must first and last be recognized by outside savants or princes who come inside. Thus did the Magi legitimize Jesus at Bethlehem, in the traditional Christian telling.

In my view, this Magi theme belongs to a select group of Christian stories whose essences powerfully relate art to life processes at a fundamental narrative-structural level, and isolating such themes must be a priority of cultural historians who hope to relate their "objects" to broad social and political realities. I call such life-pictures 'iconographs'. Like certain other stories in Christian history such as the Marriage of Jesus' parents and St. Francis of Assisi's Renunciation of his Father and Property,[2] the Journey and Adoration of the Magi continually lend themselves first to the *pictorial* reproduction of contemporary discourses about the structure and activity of the body *social* — this iconograph talks, after all, about differences, mediated by the gifts of the Magi, between rich and

poor, urban and rural, old and young, exotic and quotidian, and so on.

But second, still today that same story of the Magi in legions of school plays, parades, and even adult processions continues to lend itself to the mirroring or reproduction in *festive* behavior of *political* activities in Christian nations. This story, in short, not only has left pictures about past social structures and relations, but, politics being process, it still allows any given political process to be acted out in a recognized and legitimate process (procession) — the Journey of the Magi — thus making politics.

The present essay is an attempt to understand the story of the Magi as one type of journey some say individuals all make: from life to afterlife. According to André Grabar, few recognize that "the Adoration of the Magi was the sign of the Incarnation-Redemption. [It] is the oldest image-sign for . . . collective and individual salvation, and this explains its frequent appearance in funerary art from the beginning."[3] In what follows we shall see polities send their men of power on the journey into death, so that both can triumph over it.

For almost a century, historians of early Christianity have known that the pictures of the Adoration of the Magi, who were first represented in the catacombs that were used for Christian burial, derive from the picture of the ancient Roman triumph, with its mandatory prisoners prostrate at the feet of the *imperator*.[4] Only in the last decade, however, and especially since an article by Johannes Decker in 1982, has it become clear that these oldest representations of the Magi stem not from the second or third century when Christianity was a cult, as was previously thought, but that they are from the age of Constantine and thus were done under the aegis of majoritarian, imperial Christianity.[5]

When, therefore, as an example, one sees the Magi in the catacomb of SS. Pietro and Marcello look up in the sky and find not a star but the first letter or letters, the chi-rho, of "Christ,"[6] it becomes clear that the historical stimulus for the story's immediate and subsequent popularity was almost certainly the stellar story of that first Christian emperor. For Constantine, too, saw Christ's name. Eusebius' and Lactantius' story of Constantine at the Milvian bridge seeing a Christic sign in the sky with some variant of a notation like "In this sign conquer" was one means by which to legitimate Christian

political actions; making the fourth-century emperor into that for which the biblical Magi had actually been searching was still more powerful.

With this insight, much of the magian art from Justinian's San Vitale through Charlemagne to the famous illuminations of the Ottonians receiving reverence falls into a meaningful pattern.[7] The Spanish and Portuguese would still be finding or playing the Magi as emblems of imperial Christianity when they conquered the new world in the sixteenth century.[8]

Thus, from its beginnings, the theme of the Magi, from their reading of fate in the stars through their appearance in Herod's court to their majestic return to their homelands was the iconograph par excellence for acting out secular triumph in all of Christian art. Beside it, the story of Christ's so-called "triumphant" entry into Jerusalem on Palm Sunday was a conceit of limited use in Christian behavior. The subjects of this story were Jews, whom few besides hired clergy wanted to play. The story of the gentilic Magi, on the other hand, lent itself to processional representation by the laity not only in pictures but in festivals: it allowed a powerful man to act politically legitimately, no matter whether he played the infant Jesus adored — as did earlier kings and even baroque popes — or one of the Three Kings as was more customary, or even if he humbly played what I shall call a "Fourth Magus," a figure almost as old as the pictorial tradition of the Magi itself.[9]

It is in this latter guise that we often find powerful Christians showing themselves triumphing over death, a theme generally neglected in the literature on the Magi and the particular subject of the present essay. A 1354 Piedmontese fresco over a grave serves as a particularly striking example of that link (Fig. 1). At the top Jesus is shown in majesty among the evangelists. Then, in the register below, the Magi, including a fourth magus, adore Jesus. Below the Magi are the Three Living and the Three Dead, and below them, finally, comes an image of the dead patron stretched out on his grave.[10]

In the work at hand, several monuments of Italian Magi art, beginning with the tomb of a mid-Trecento doge, will be the objects of attention, the aim being to work out the relation of the Magi to the theme of triumph over death. It ends with the mid-Quattrocento

frescoes of Benozzo Gozzoli in the chapel of the Medici-Riccardi Palace in Florence.[11]

THE TOMB OF DOGE GIOVANNI DOLFIN

The imposing anonymous tomb of the Venetian doge Giovanni Dolfin (1256–1361) is, along with the contemporaneous Piedmontese frescoes mentioned above, the first monument in late medieval Italian art I know to link the Magi unambiguously with the death of a powerful man (Fig. 2).[12] It was originally in the choir of the great state basilica of SS. Giovanni e Paolo, open to the view and reverence of all. Its iconography is symmetrical. In the central panel a statue of Jesus is shown being unveiled by two angels. On its left kneels a woman, presumably the *dogaressa*, and next to her is a field showing the death or Dormition of Mary. This female side of the monument obviously wants to save the *dogaressa* by linking her to the Assumed Mary. On Jesus' right kneels a man, certainly the doge, and behind him is a field showing the Journey and Adoration of the Magi.

How specifically does this male field think to save the doge by associating him with the Magi? The answer lies in the representation. Four men approach the mother and child, who are seated under what for all intents and purposes is the baldachin of a triumphal car or wagon. In addition to the three kings is one servant — a version of the "fourth magus" — who holds the crown for the oldest, kneeling, sovereign. Increasing one's honor by close association with real kings was a tried and true theme in Italian republican representations as well as in the magian representative tradition in general.[13] This figure probably represents the doge; being the only non-monarch, there can be little doubt that this servant is at least associated with him. In his own humble way, Dolfin states that in life — like the Magi, the archetypical gift-givers of Christian tradition — he too showered gifts on poor Jesus, that is, on the church and poor for whom the babe stands. As in many similar scenes in earlier European art, the doge Dolfin claimed a right to heaven on the basis of the gifts he, and the republic for which he stood, had made to the ruler of heaven.

THE BURIAL CHAPEL OF
BALDASSARE DEGLI UBRIACHI

The "capella de' tre magi," as it was named by its donor, is located off the cloister of Santa Maria Novella in Florence. It was built in the 1360s and 1370s by the Florentine messer Baldassare di Simone degli Ubriachi who, incidentally, was also active in Venice as early as 1369, when the Dolfin tomb was newly in place. Ubriachi was an important art impresario and perhaps an artist who spent a lifetime associating with and producing art for princes. Perhaps the first of these was the German emperor Charles IV, who in the same year, 1369, made Baldassare a Count Palatine. It may be at that point that messer Baldassare decided to vaunt his status by building his personal burial chapel in the Florentine Dominican complex.[14]

Gert Kreytenberg has claimed that messer Baldassare was actually the grandson of another Baldassare degli Ubriachi,[15] and it was this so-called "Baldassare the Elder" who built the chapel in the 1330s. I have responded that this older Baldassare never existed; Kreytenberg merely misread an eighteenth-century Italian document.[16] In fact, our messer Baldassare, the first in the family with that Christian name, built his chapel after 1365 and before 1378. It had come to include a marvelous lintel facing on the Chiostro Grande that shows the magus Baldassare commending the kneeling Baldassare degli Ubriachi to Mary and the Child (Fig. 3). Here is another type of "fourth magus." Now the orant figure of the type in the central field of the Dolfin tomb is integrated into the space of the Magi.

Hugo Kehrer recognized long ago that any picture of an orant patron being presented to Mary and the Child is a type of Magi Adoration, and one often employed in funerary contexts. Elsewhere in the same volume, he also documented what I am calling the "fourth magus" in Magi representations, some (unrecommended) person who follows or accompanies the gift-bearing trio, often with a present of his or her own.[17] Kehrer failed, however, to bring the recommended orant and the fourth magus together so as to reveal that central tributary or caritative or exchange message of such magi: the patron has gifted God and the church in life, and thus deserves paradise. As we shall presently see, Baldassare degli Ubriachi was not finished with paying honor to his homonymous magi patrons.

THE BOVI CHAPEL IN PADUA

In 1397, one Pietro, of the originally Veronese family of the Bovi, commissioned Jacopo da Verona to fresco the walls of his burial chapel in the one-time parochial church of San Michele, Padua. The patron was either Pietro di Bonaventura de' Bovi, an official of the Paduan mint, or, more probably, Pietro di Bartolomeo de' Bovi, who also may have worked for the same mint.[18] The artist seems to have been a friend or pupil of the Paduan painter Altichiero and his Bolognese associate Jacopo Avanzi, active in Padua, and may indeed earlier have contributed to an important Altichiero Adoration frescoed in the oratory of San Giorgio in 1384. In any case, an important Journey and Adoration of the Magi was the result of Jacopo's labor in the Bovi chapel (Fig. 4).[19]

Three things strike the viewer of this Adoration. First and most unusual at this point in the tradition, the three Magi are all dressed in basically the same clothes. The uniformity is almost certainly liturgical in nature, the three kings actually being three cathedral canons, chaplains, or schoolmen, that is, members of the ceremonial clergy. Given the fame of the Paduan Epiphany theater, in which clerics usually played the kings, I believe that this painting in part reproduces a Magi play.[20]

This hypothesis is the more attractive because neither the crèche nor the magi figures but certain non-biblical individuals are the center of attention: two august lay figures and their six retainers dominate the middle of the painting. It should be pointed out that it was not unusual in contemporary Italy for important politicians to make up the retinue of the Magi in public processions.[21]

A third remarkable fact is that while the older magus kneels before the infant, the second and third kings direct their attention away from Jesus and to these august lay figures. The middle king looks at the first such figure and points out the Star *to him*, while the third king actually turns away from Jesus to look at the younger august figure and hold his hand. Without any doubt, these "fourth and fifth magi," so to speak, dominate the painting. It remains to be seen, however, if their message — that terrestrial charity should be reciprocated with heaven — is as simple as in the previous works.

That depends on who these two men are. The possibility that they are members of the Bovi family itself cannot, of course, be

excluded; it was noted long ago that there are figures of cattle (*bovi* or *bue*) on the sleeve of the older man on the left. If that is so, the Bovi would stand to the Magi as did Baldassare Ubriachi: a patron of art recommending himself through the Magi. But for over a century, scholars have commonly identified the two lay figures with two generations of the ruling Carrara family of Padua, primarily because the cattle, and the motto *memor* on a sleeve, together formed the device of Francesco il Vecchio, who died a prisoner of the Visconti in 1392, shortly before the chapel was founded. By extension, the younger is said to be his son Francesco Novello, who ruled Padua from 1390 until 1405, that is during the time the painting was being done.[22]

If this reading is correct, two important results follow. First, dynastic rulers and their polities recommended themselves in the context of other people's burial chapels. Second, inversely, chapel owners recommended themselves to and for heaven and to viewers by vaunting their association with powerful men and rulers. The historian wanting to reconstruct the "frame" of such a work should imagine this in quotidian behavioral terms: just as signores customarily honored selected city inhabitants by going in procession to visit some activity put on by them or their group (including perhaps a Magi play!), so the lords in turn, journeying to the beyond, have the chapel patrons as retinue.

The particular association between the Bovi and Carraresi is not hard to speculate upon. As has been noted, one and perhaps both known Pietros de' Bovi were mint officials. Now, not only are these Bovi not the only minters we shall see associating themselves with the Magi, but there was a fundamental reason in the story of the Magi itself for them to do so. Minters furnished gold coinage, the premier medium of exchange in society, and at its deepest roots, the story of the Magi tells about how social groups — including those in heaven with those on earth — circulate things and values. Whether we imagine the Bovi or Carraresi as the "fourth magus," therefore, the sociopolitical relevance of this iconograph to the theme of the triumph over death should now be evident.

THE CERTOSA TRIPTYCH, PAVIA

Reenter, Baldassare degli Ubriachi. From concern for his own chapel in Florence, Baldassare came about 1396 to the task of creating, or supervising the creation of, the altarpiece for the Certosa of Pavia. Elena Merlini has recently laid out the iconographic program of this marvelous work (Fig. 5): the Life of the Virgin on the left wing of the triptych, that of Jesus on the right extension, and, in the middle, most unusual in its amplitude, a field of twenty-six scenes, which is the focus of Merlini's and our attention. Merlini observes that the top fourteen sections of this field deal with the Old Testament story and legends surrounding the prophet Balaam, who was believed in the Middle Ages to have prophesied the star of the Magi. The bottom twelve sections show the Magi proper.[23]

Though unable to add new documentation, Merlini does an excellent job of summarizing and assessing existing data and views regarding the political background and content of this work. First, she addresses the question of patronage. The abbey of the Certosa, founded in 1396, was in debt to an agent of Baldassare Ubriachi in 1400, and sometime thereafter, before 1409, paid Baldassare for this work. Merlini rightly dismisses both the eighteenth-century story that the altarpiece was a gift of the French king to Gian Galeazzo Visconti, and also the old idea that the abbey itself had commissioned the altarpiece.[24]

Merlini confirms the by-now standard view that the patron of the monastery itself, Gian Galeazzo Visconti, *who wanted to be buried there*, was the work's real commissioner. As Charles Rosenberg has noted, building Certosas was a standard activity of great European nobles at the time.[25] Merlini's view is especially persuasive because the Visconti had an established relation to the Magi cult, because that cult in turn was one of the central cults of the Ambrogian city of Milan, and perhaps, especially because of the close association between Baldassare Ubriachi and the Visconti.[26]

When, then, was the work done? The general opinion is that it was finished around 1396, at the time that the Certosa itself was built, probably to sit on the main altar. A date at this juncture proves irresistible when one considers events of the time in relation to likely motivations for its construction. Merlini reviews the previous notions: because of the profusion of fleurs-de-lis around the

base of the work, Sant'Ambrogio believed that it was done in 1394, the year of a supposed treaty between Visconti and the French.[27] And another scholar has suggested that its commissioning had a domestic motivation, Gian Galeazzo's wife Caterina having ordered it as an ex voto after a difficult birth.[28]

But, in my view, the strongest hypothesis remains that the work was commissioned to commemorate the coronation of Gian Galeazzo Visconti as the first Duke of Milan by an agent of the Holy Roman Emperor. Indeed, this ducal investment can be viewed as the historical essence of the iconography of the work's central panel. *Mi spiego.*

As precisely recorded in a contemporary miniature (Fig. 6), Gian Galeazzo Visconti was made a duke, and thus Milan a duchy, in a grand pomp that was held in the Lombard metropole on September 5, 1395, in the presence of many dignitaries.[29] However, an earlier event deserves as much attention. In traditional Europe, the date that was commemorated relevant to such an event was often the date the news reached a city that such an event was to take place.[30]

The news that Milan and Gian Galeazzo were to receive this honor actually arrived in Milan about January 2, 1395. On that day, Gian Galeazzo ordered that the German imperial eagle be quartered into his Viscontean arms.[31] This date is the point: it could mean that it was on the vigil of Epiphany or on the "feast of the kings" itself (January 6), as that day was usually called, that the news was first celebrated by the Milanese, most probably by separate German and Visconti banners being flown together and by some new Viscontean flags (with the imperial quarter) being displayed. Since, according to tradition, a Magi pageant was performed annually in Milan on these dates, and since in similar pageants it was customary to unfurl various contemporary flags while accompanying the Magi to Jerusalem and Bethlehem,[32] it is easy to imagine that the Magi festival of January 1395, celebrated the impending coronation of the first duke of Milan, in part by flying these mixed flags.

Thus, the enormous attention given to the Magi in the Ubriachi altarpiece may not just show the traditional Visconti and Milanese devotion to the kings. It may also directly refer to a particular Feast of the Magi on which a momentous event in Visconti history tran-

spired. Not only does this thought concur with the common European understanding of the Adoration of the Magi as a coronation (did not in truth the Magi essentially crown the new King of the Jews by their legitimating visit?),[33] there is a further, previously unnoticed but striking piece of evidence precisely to this effect in the triptych itself.

Merlini notes that in the segment of the triptych which she numbers "B-I-11," there is a Viscontean viper (*biscione*) painted in gold on the shield of one of the soldiers. She then notes elsewhere that an imperial eagle is visible once on a shield and again on a flag of what turns out to be the very same scene (Fig. 7)![34] Putting two and two together, I surmise that the flags of the Empire and of the Visconti are together here to commemorate the Feast of the Magi, 1395, when the two flags first flew together. The altarpiece recalls Epiphany, 1395, as well, of course, as September 5, the day of Visconti's investment.

Once the significance of this one segment is understood, we may explain the general iconography of the central panel of the altarpiece as related to the same historical event. That iconography, as Merlini well states, is passing strange, for the story of Balaam is told in such unusual detail as to take up more space than do the Magi![35] Why would the prophet receive more attention than what is prophesied?

We shall see that the answer lies in the very segment — B-I-11 — we have been studying. It is as follows: Balaam is to be thought of as prophesying the coronation of Gian Galeazzo, and then blessing Visconti's arms along with those of the Empire! Now to the subject matter of the segment, which is about Balaam and not the Magi. In it, soldiers bear the arms of the Empire and of the Visconti. Merlini labels this Old Testament scene: "Balaam receives divine inspiration and blesses the people of Israel." Given what we have already found, we can now ask if the Milanese are not the people of Israel. Let me pursue this hypothesis after retelling the story of Balaam.

The story is that Balak, king of Moab, feared the Israelites, who were being led out of Egypt by Moses. Wanting to destroy the Jews, he employed the famous magician Balaam to curse his enemy. Constrained by God, Balaam instead delivered oracles foretelling the future greatness of Israel and the rise of King David.[36] Worse,

Balaam blessed the Jews (that is, their army) instead of cursing them. Our segment shows Balaam blessing the united arms of the Germans and the Milanese. It is fair to conclude, I think, that here the Old Testament was being made to say that imperial Milan, led by the Davidic Duke Gian Galeazzo, was a chosen people, destined for greatness now that its leader, and the city itself, had achieved princely status. Nor was this the first time that Gian Galeazzo was associated with David. Indeed, it was propagandized at the time that Gian Galeazzo Visconti wanted (like David) to become King of Italy![37]

Thus, I would suggest that the great altarpiece of the Certosa features Balaam because the greatness of the Visconti and Milan — as once that of Constantine — are being prophesied at the same time as the Magi.

In this work, earthly triumph stands supreme. To see that Visconti's resurrection into a friendly eternity was also in play, we have, in turn, only to fill in what is missing, and remember, as Gian Galeazzo's testament insists we do, that the prince's body was to lie near this great story of Balaam and the Magi, conceivably even at the cross of the church immediately before it.[38] The people would mourn, yet see and know that their ruler would live forever. They would recall the fact, indeed, whenever they were a part of a festive procession of the Ambrogian Magi, whenever, that is, they practiced legitimated politics. Gian Galeazzo is not a fourth magus. Instead he is a king himself, comparable to David and in the succession of Balaam, who foresaw David, the Star, Jesus, the Magi, and now, Visconti himself in paradise.

THE BOLOGNINI CHAPEL

The frescoes of the Bolognese painter Giovanni da Modena in the burial chapel of the Bolognini family in the basilica of San Petronio, Bologna, were done around 1410.[39] Certainly one of the most extensive cycles of Magi representations in all of Christian art, this "Chapel of the Magi," as it was named, has recently been the object of an excellent dissertation by Ilka Kloten.[40] Among much else, Kloten asked what the relations were between the patrons and paintings in this chapel and comparable work elsewhere in Italy,

just as Merlini had asked about her Pavian work.[41] I hope to show that a stark theme of triumph in the Bolognini chapel continued the pattern of Magi funeral monuments that we have already reviewed.

Let us begin by sketching the chapel's whole picture program, for the eight frescoed scenes showing the Magi, those great legitimators of King Jesus, command only the right wall of a chapel crammed with frescoes.[42] To the left of the entrance, opposite the Magi, the wall is divided into three zones. At top is the coronation of Mary, in the middle zone sits the heavenly court, and at bottom is hell. Thus, a theme of coronation is found on the left and right walls: here of Mary, there of King Jesus. The linkage was not fortuitous: these two surfaces were the only ones whose pictorial contents the patron prescribed in his testament of February 10, 1408.[43]

Yet, a motif similar to coronation is again represented on the wall facing the chapel entrance (Fig. 8). At the top one sees the figure of a pope who, as Kloten has convincingly argued, actually plays two different pontiffs, worshipped, be it noted, by three patrons, in Kloten's view probably members of the Bolognini family. As Pope Celestine I, the figure turns toward our right and invests with a ring St. Petronius, the first bishop of Bologna. The rest of the pictures below this register consist, in fact, of scenes from the life of Petronius, the most prominent being the bishop's first triumphant entry into, or *possesso* of, Bologna.

But the other identity of this pontifical figure is not unimportant. He is the contemporary Pope John XXIII, otherwise known as Baldassare Cossa, for one sees on our left beneath the seated prelate a contemporary bishop who bears a scroll seeming to announce that this pontiff had "elected" him.[44] Cardinal legate of Bologna since August 1403, Cossa had long been the effective ruler of Bologna before being elected pope *in Bologna* by the Pisan obedience on May 17, 1410 — well after Bolognini wrote his testament, but a year before his death. Baldassare Cossa was deposed by the Council of Constance in May 1414.[45]

The fourth painted surface is difficult to see, but truly important. From the chapel altar, which not only reproduces the theme of the Magi but, through statues of SS. Andrew and Batholomew directly commemorates the death of Bartolomeo and his only begotten son, turn toward the chapel entrance. Look up from the gravestone of Bartolomeo to the inside surface of the entry arch. There,

Christ flanked by angels announces his judgment. A half figure in a mandorla, he opens his arms wide and beckons to himself the resurrected dead, who climb from their sarcophagi up the steep incline. Kloten links this scene of resurrection to the altar beneath:

> Christ shows his wounds to those who are not yet judged and [thus] announces their salvation. . . . He lets himself be recognized by the resurrected. Bartolomeo Bolognini, who rests at the feet [of Jesus], will also belong to [this group] on the last day. The hope of salvation is what is important, not judgment. The theme of resurrection is explained in the context of the grave.[46]

Thus, elegantly, Kloten sees the heavenly apotheosis of the Bolognini as the central pious desideratum in this chapel, yet did not grasp the position of the Magi in the salvation strategy, although the whole chapel is dedicated to them. While documenting the important view that the Bolognini family probably had a devotion to the Magi before this chapel was painted, she missed the programmatic idea that not just Jesus, but the Magi were one of Bolognini's tickets to heaven.[47] We, however, are prepared to see that Bartolomeo Bolognini was but another influential Italian who, proud of what he had given to Christ and the church, placed himself in the retinue of the Magi in one way or another so as to pass through the heavenly gates, as the Magi had passed the gates of Jerusalem on their way to the King of the Jews.[48] All beg for salvation with gifts.

If the logic of the Magi as Bolognini's journeymen is evident, we must still ask what it was that Bartolomeo gifted the Judge, and the faithful who visited his chapel, as surety for his right to heaven. As we shall see, the answer is as it was for the Bovi of Padua: the patron's relation to his superiors and to their triumphs in time. And what a time of schisms for the church and triumphs for the communes! Yet, though Kloten's work argues that other paintings in the Bolognini chapel propagandized against the Great Schism, she neglected to say that the Magi are about union, and about triumph.[49]

The notion of union over diversity in Magi art almost goes without saying. Since Augustine of Hippo, the story of the Magi

coming not just from "the east," but from "all parts of the world," has lent itself to ecumenical ideology, as the whole "exotic" character of the iconograph in festival and art, for instance in Gozzoli's Journey of the Magi in the Medici chapel in Florence, pervasively demonstrates.[50] In the Magi story, pluralities become a unity and schisms are terminated, and in no historical moment more than one with three popes could a plea for unity through a representation of the Magi have been more apposite.[51] Even today Christian teachers and parents have their children perform the play of the Magi to teach them pluralism . . . under one God, of course.[52]

We have already established that the theme of triumph had been central to the image's meaning from its inception in the catacombs. Its role in the Bolognini chapel begins, certainly, with the pictures themselves. The Journey of the Magi is shown as so many triumphal processions in three different frescoes: the departures from the East and from Jerusalem, and the march to Bethlehem (Fig. 9). The enthroned pope opposite the entrance, Jesus crowning Mary on the left wall, the majestic Jesus on the inside entry arch, and St. Petronius entering Bologna beneath a palio like a conquering hero, all these scenes are triumphs.

From the beginning, I have maintained that during these ages certain Christian images were vehicles for political and social discourse, and the Magi story was one of a limited number of such images offering a privileged way to study art in politics. Its significance is that, as an iconograph, it evoked and shaped the processual structures of Italian polities. Thus, from the triumphal character of the paintings, we turn to the question of magian activity in real Bolognese time.

First comes the question of the quality of the powerful persons Bartolomeo Bolognini's chapel vaunts, and of the patron's relations to them. St. Petronius presents no problem. He is the patron saint of the city of Bologna, whom all good citizens revered as they did any Infant or pope. Baldassare Cossa, appointed cardinal-legate or ersatz-pope in Bologna in 1403, long before he became pope in the same city, presents a more interesting object of devotion. Not only was he named after one of the Magi; so was his brother Gaspare, an important papal representative in Bologna in these years.[53] This was certainly not the only reason Bartolomeo chose the Magi for his

chapel, but he could hardly have been oblivious to the fact that the theme flattered the prelate.

Bartolomeo's links to both the city of his birth and to these magian prelates were many. The very first civil office Bolognini filled of which we are informed links him to the Bovi of Padua: Bartolomeo was supervisor of the Bolognese city mint.[54] I can do no more here than state, not demonstrate, that gold in the form of (often specific) *coins* was a standard gift of the Magi in the commercial centers where so many paintings and festivals of the Magi were produced.

Second, beginning in the 1390s or slightly earlier, Bartolomeo Bolognini served Bologna and later the cardinal as ambassador.[55] Need it be pointed out that the three kings were precisely on a diplomatic mission, first to Herod and then to King Jesus? In the late Middle Ages diplomatic missions might indeed be commemorated through a painting of the Magi.[56]

Third, Bartolomeo was made a knight not once but three times: by the city, by a Bentivoglio, and by Cossa.[57] The vaunting of the knightly status of especially the youngest magus in many Adorations hardly needs mentioning, and on another occasion I hope to show that the investment of a knight, like the coronation of a king, was one memorable occasion for Magi paintings. Such knightly investments, incidentally, were commonly bestowed on the so-called "youth ambassador" of some Italian communes during or on the conclusion of his first mission.[58]

With all of these honors, it is no surprise that messer Bartolomeo Bolognini not only had the title of privy counsellor to Cossa, but was indeed an important political and financial arrow in the quiver of the authorities, one of the richest and most influential citizens of Bologna.[59] There can, therefore, be little doubt that Bolognini was also prominent in the seemingly endless festive triumphs that distinguished life in Bologna in these years, events which we will presently summarize.

But first, it should be emphasized that the Bolognini and the pope filling magian roles in life does not prove that the eight Magi frescoes in the Bolognini chapel consciously quoted those past roles. Nor will showing that Bologna was all but overwhelmed by formal triumphal events in these years allow us to think that any particular

one of them was commemorated in the art of the Bolognini chapel, any more than any particular festive drama of the Magi performed in the streets and squares of Bologna in these years, if there were such, would likely have been *the* event explaining the unmistakable theatricality of some of the frescoes.[60] I cannot demonstrate that the Magi painted in San Petronio memorialized a specific event. I can describe a civic experience of festive triumph in these years that, the Magi story being about the triumph of civil order, the inhabitants had to recall again in these frescoes.

I shall distinguish those events occurring before Bolognini's testament of February 1408 — in that testament he stipulated that the chapel was to be painted with and dedicated to the Magi[61] — from events after his testament up until Bartolomeo's death on July 2, 1411, that could still have affected the patron's understanding of the meaning of his chapel.[62] Then I will list certain events from that death up until late 1414 when, according to Kloten, the painting was finished.[63]

Before the Testament

A. September 3, 1403. Bologna having reentered the Papal States, Baldassare celebrates his first triumphal entry as legate or ersatz-pope into Bologna. Presumably Bolognini was among the major citizens said to have honored Cossa on this occasion. "The salvation of Bologna" in one chronicler's words, this triumph was extensively described.[64] Cossa being essentially a Bolognese *condottiere*, in subsequent years many triumphs followed, each celebrating some victory for Bologna.

B. August 1407. Baldassare Cossa reenters Bologna in triumph after military victories at Forlì. Three days of celebration followed in which Bolognini may be assumed to have joined.[65] In May of the following year, just three months after Bartolomeo Bolognini wrote his testament dedicating his chapel to the three kings, the recipient of that triumph, Baldassare Cossa invested Bartolomeo as a knight and named him one of his privy counsellors.[66]

At this time, Cossa emerged as the ecumenical leader par excellence. On June 29, 1408, he broke away from the Roman pope

Gregory XII and with thirteen friendly cardinals began to plot a
general council *causa tollendi sismam.*[67] What was in the headlines
almost at the moment that Bolognini wrote his testament? The
notion that (like some infant Jesus gathering around him multilin-
gual Magi) Cossa would unify the church.

Between Testament and Death

A. January 12, 1410. The pope elected by Cossa's Council
of Pisa, Alexander V, the former archbishop of Milan, entered
Bologna in great triumph as the guest of the legate and church
chancellor, Baldassare Cossa. The sources spare no effort to detail
the event. The *anziani* of the city rode out in the festive wagon or
carozzo to meet the pope. In three days of feasting, the apostolic
twelve citizens carried the baldachin over the pope much as, in the
Bolognini chapel, earlier Bolognese are shown carrying a baldachin
over St. Petronius, first bishop of the city, and holding the reins of
his horse. "The greatest happiness I believe Bologna has ever had,"
said one chronicler.[68] In the coming weeks, Bologna revelled as one
Italian prince after another sent ambassadors to the city to recog-
nize the new pope, and thus honor papal Bologna.
 B. May 26, 1410. Pope Alexander having died in Bologna,
Cossa is elected pope there by the cardinals, and on this day crowned
in the very basilica of San Petronio. All this was in the midst of
marvelous celebrations, for it is not often that a city other than
Rome hosts the death, election, and coronation of a pope! One
source exclaims, "Never had such dignity been seen in Bologna!"[69]
The same source says that after the coronation "gran triunfi" of
clothes and flags marched through the city.[70] Certainly, Bartolomeo
Bolognini, confidant of Cossa, must have shown off his status in
these days, perhaps precisely the time the Magi were being painted
onto the wall of his chapel. For, as we have seen, in June, Bolognini
hosted King Louis d'Anjou in his home.[71]
 A year later, on July 2, 1411, Bartolomeo died in Bologna.
His frescoes of the Magi had been envisioned and executed at
a marvelous conjuncture of Bolognese and Bolognini honor and
triumph.

From Death to the Finished Chapel

A. April 27, 1412. Bartolomeo's grandson and heir Girolamo d'Andrea Bolognini presents the first chaplain of the family chapel to the episcopal vicar, the Benedictine Giovanni di Michele, abbot of St. Procolo.[72] Thus, at this date, the decoration of the chapel of the Magi must have been largely complete.

B. November 6, 1412. This same prelate, now bishop of Bologna, enters the city for his triumphal *possesso*. One of those who held the reins of the bishop's horse on that day was Marchionne (that is, Melchior), son of Giovanni Bolognini, a brother of the deceased Bartolomeo.[73] Given this link of the Bolognini to the new bishop, Kloten may be right that Giovanni di Michele was indeed the bishop who in the fresco of the Bolognini chapel seems to say he was "elected" by Pope John XXIII.[74]

C. November 11, 1413. Pope John approaches Bologna for still another triumphal entry. He is the guest of Giovanni Bolognini, Bartolomeo's brother and his testamental executor.[75] Thus, the papal link to the Bolognini family remaining in place, it made sense for the family chapel to describe the new bishop's election by that pope. By the time the Cossa pope left Bologna for the last time, on October 1, 1414, going to the Council of Constance which imprisoned and deposed him, the painting of the Bolognini chapel was finished.

Visitors to the chapel knelt before the altar and gravestone, beneath which presumably lay the remains of Bartolomeo and his son Andrea. On the facing wall, they saw how Bartolomeo had triumphed in life by serving the great city of Bologna and its pope in a period of incredible pageantry and civic vanity. Glancing, then, at the wall to their right and then to their left, they saw not only scenes of Christian convention, but the journey of the Bolognini souls. Their salvation was implored on one wall by the biblical wise men in reciprocation for the gifts Bartolomeo had bestowed on their church and city, the options of a blissful or damned eternity shown starkly on the other. Behind and above the orant, mercifully, Jesus promised Bolognini resurrection. A comforting decorum of individual and group history is matched by a sure and honorable future, dead history linked to merely promised future by the procession or

journey of gift-givers through time, and across the barrier of death. What better encouragement for that viewer to himself march out and take his place in politics!

ON THE ROAD TO THE NEW SACRISTY

The previous pages have established that the strong association of the Magi with funereal themes in early Christian art continued in Renaissance Italy. In concluding, let me dwell once more on two notions central to the task of discovering the political content in this artistic image.

The first is the notion of political space, if I may employ a new figure to repeat my leading theme. I have claimed a peculiar relevance for the Magi as a political iconograph because their story lends itself both to parades and to the discourse on politics as legitimated through process or activity. In late medieval Italy, Magi dramas were used as story frames for the demonstration of political structures and processes. That notion has been brought to the fore especially through our review of processional life in Bologna as background to the Bolognini chapel.

Another way of expressing this idea of space is that through Magi pictures, one imagined oneself, as a political animal, in the midst of the train of the Magi. In a subsequent article, I will be able to trace that notion of the Journey and Adoration of the Magi within political space beginning in the two Ravennate monuments of Sant'Apollinare Nuovo and San Vitale,[76] continuing into the chapel of the Medici-Riccardi Palace where Benozzo Gozzoli placed a viewer in the midst of the circumambulating Magi, to the New Sacristy, where the viewer is once more in their midst.[77] And I will be able to extend that notion of magian space into the famous Holy Mountains of the sixteenth century where, as at Varallo, visitors once wandered through the space of the Magi in Journey on their visiting that station.[78] Thus, the earlier reconstruction of the magian character of the New Sacristy will be confirmed by an insistence on people's processional participation in the political life and space of the Magi.

Finally, we return once more to the notion of political triumph which informed the several monuments of late medieval Italian pol-

iticians we have reviewed. The Magi emerged as a subject of art at the time of Constantine, we recall. His heavenly sign, or a variant, was in fact the Star of Bethlehem seen by the Magi. The link between magian iconography and secular triumph, I said, has been patent from the beginning.

Nothing changed on this score, as a feature of the Gozzoli paintings a millennium later shows. It is now generally agreed that a complex emblem (Fig. 10) on the ceiling of the Medici-Riccardi chapel, having as its core the Bernardine JHS with protruding sun rays, stands for the Star of Bethlehem.[79] Forming the circular border around these typical rays is what passes for a laurel (= Lorenzo?) wreath of triumph. It is as if to say that not just Jesus and his church, but the Medici, or at least the Kings beneath, conquer. Then, completing the figure, at four corners outside the wreath are diamond rings, the device of Piero di Cosimo, the chapel's patron.

Thus a millennium and more after the chi-rho — not a star — that was seen by the Apollonian Constantine had led the Magi to Christ, so now, in humble Florence, the initialed sun stands again for the Star of Bethlehem, describing the laureled triumph of a more modern ruler. Those great predecessors, the Emperors Constantine and Justinian, recognized that myrrh, the medicine used to preserve the dead, was borne not just by the three Marys to the tomb of Jesus, but also by the three Magi to the cave where he was born.

This much of a conceit the intellectuals in the Medici circle must certainly have communicated to their patrons: the Magi kept the dead from being forgotten. In the great magian space of the New Sacristy, beneath another Bethlehemic star "in whose sign [one] conquers," the Medici family would memorialize, apotheosize, the sons and nephews of two popes, who had so often marched in magian ranks to worship the infant pontiff.

NOTES

1. R. Trexler, "The Magi Enter Florence. The Ubriachi of Florence and Venice," in R. Trexler, *Church and Community, 1200–1600. Studies in the History of Florence and New Spain* (Rome, 1987), 75–167; R. Trexler and Mary E. Lewis, "Two Captains and Three Kings. New Light on the

Medici Chapel," in ibid., 169–244; R. Trexler, "La vie ludique dans la Nouvelle Espagne. L'empereur et ses trois rois," in ibid., 493–510; R. Trexler, *Public Life in Renaissance Florence* (New York, 1980), passim. I would like to thank Ilka Kloten and Debra Pincus for their help, and my former collaborator Lewis for her inspiration.

2. On Mary and Joseph's Marriage, see C. Klapisch-Zuber, *Women, Family and Ritual in Renaissance Italy* (Chicago, 1985), esp. chs. 9 and 12; and on St. Francis, see R. Trexler, *Naked Before the Father: The Renunciation of Francis of Assisi* (New York, 1989), esp. part 3.

3. Grabar continues, "It is the iconographic sign that indicates the principal argument in favor of the salvation of each believer: the fact of the Saviour's Incarnation and his work on earth." A. Grabar, *Christian Iconography A Study of Its Origins* (Princeton, N.J., 1968), 11. Note that Grabar does not link the Magi directly to Jesus', but to the general resurrection.

4. The two fundamental works on the origins are F. Cumont, "L'Adoration des mages et l'art triomphal de Rome," *Memorie della pontifica accademia romana di archeologia* 3 (1922–23): 81–105 and plates; A. Grabar, *L'Empereur dans l'art byzantin. Recherches sur l'art officiel de l'empire d'Orient* (Paris, 1936); see further C. Ihm, *Die Programme der Christlichen Apsismalerei vom Vierten Jahrhundert bis zum Mitte des Achten Jahrhunderts* (Wiesbaden, 1960), 51–55. The standard overview of the cultural history of the Magi is by H. Kehrer, *Die heiligen Drei Könige in Literatur und Kunst*, 2 vols. (Leipzig, 1908–9). More recently, see H. Hofmann, *Die Heiligen Drei Könige. Zur Heiligenverehrung im kirchlichen, gesellschaftlichen und politischen Leben des Mittelalters* (Bonn, 1975). Also important is *The Image of the Black in Western Art*, vol. II, *From the Early Christian Era to the "Age of Discovery"* (New York, 1979), pt. 1, J. Devisse, "From the Demonic Threat to the Incarnation of Sainthood," and pt. 2, J. Devisse and M. Mollat, "Africans in the Christian Ordinance of the World (Fourteenth to the Sixteenth Century).

5. J. Decker, "Die Huldigung der Magier in der Kunst der Spätantike," in *Die Heiligen Drei Könige — Darstellung und Verehrung. Katalog zur Ausstellung des Wallraf-Richartz-Museums in der Josef-Haubrich-Kunsthalle Köln, 1. Dezember 1982 bis 30. Januar 1983* (Cologne, 1982), 20–32.

6. Reproduced in G. Wilpert, *Ein Cyclus Christologischer Gemälde aus der Katakombe der heiligen Petrus und Marcellinus* (Freiburg in Breisgau, 1891).

7. R. Deshman has made an important advance in comprehending the political significance of the Magi in the early Middle Ages in his "Christus rex et magi reges: Kingship and Christology in Ottonian and Anglo-Saxon Art," *Frühmittelalterliche Studien* 10 (1976): 367–405. I will present complete evidence for the link of Constantine to the Magi in subsequent work.

8. See the link between the Magi theme and triumph and exploration in Devisse and Mollat, *Image of the Black*, pt. 2, passim; also Trexler, "Vie ludique."

9. Several early Christian sarcophagi, for instance, show the "fourth Magus" (G. Wilpert, *I sarcofagi cristiani antichi* [Rome, 1929–30], *tavole* 177,3; 185,3; and 222,1) " . . . as if [he] too wants to approach [the child] to adore him," ibid., II, 285. The literary theme of the "Fourth Magus" is at least as old as Goethe's "Epiphanias." See, *Goethes Werke*, ed. E. Trunz (Hamburg, 1948), I, 112–113. Among many works so titled, see, recently, Michel Tournier's novel, *Gaspar, Melchior et Balthazar* (Paris, 1980), translated into English as *The Four Wise Men* (New York, 1984).

10. A. Brizio, *La pittura in Piemonte. Dall'età romanica al cinquecento* (Turin, 1942), 158–59. Described by I. Kloten, *Wandmalerei im Grossen Kirchenschisma. Die Cappella Bolognini in San Petronio zu Bologna* (Heidelberg, 1986), 115. The fresco is in S. Maria in Vezzolano (Piedmont). The patron was a lord of Castelnuovo. Kehrer mentions the funerary link of the Magi in *Heiligen Drei Könige*, II, 221–22. D. Davisson developed the idea in "The Advent of the Magi: A Study of the Transformations in Religious Images in Italian Art 1260–1425" (Ph.D. diss., Johns Hopkins University, 1971), 227, 384–85. There is a series of late thirteenth- and fourteenth-century tombs with representations of the Magi in the old cathedral of Salamanca. See A. Rodriguez G. De Ceballos, *Las cathedrales de Salamanca* (Madrid, 1979), 17 and 22–25.

11. Gozzoli's work is one that Michelangelo knew intimately. Mary Lewis and I argued some years ago ("Two Captains and Three Kings") that Michelangelo's New Sacristy in the church of San Lorenzo in Florence was a Magi funeral monument. One motive I have in studying earlier works at this juncture is, I admit, to prepare to resubmit that argument about the New Sacristy, this time with a better understanding and contextualization of the Magi in death.

12. W. Wolters, *La scultura veneziana gotica (1300–1400)*, 2 vols. (Venice, 1976), I, 193. I am grateful to Debra Pincus for bringing this tomb to my attention.

13. E. Muir, *Civic Ritual in Renaissance Venice* (Princeton, N.J., 1981); and Trexler, *Public Life*.

14. All the data relevant to the chapel and its patron, including his testament, is in my biography of Ubriachi, see Trexler, *Church and Community*, 82–94, 149–160.

15. G. Kreytenberg, "Das 'Capitulum studium' im Konvent von Santa Maria Novella," *Mitteilungen des kunsthistorischen Institutes in Florenz* 23 (1979): 237.

16. R. Trexler, "The Ubriachi at Santa Maria Novella," *Mitteilungen des kunsthistorischen Institutes in Florenz* 32 (1988): 519–21. Unfortunately, two other scholars have credited Kreytenberg; E. Merlini, "Il trittico eburneo della Certosa di Pavia: iconografia e committenza," *Arte cristiana* 73 (1985): 369–84; 74 (1986): 139–54; and Kloten, *Wandmalerei*, 113, 219.

17. Kehrer, *Heiligen Drei Könige*, II, 221–22, 143. Thus, more is involved than Elizabeth of Schönau's (d. 1164) prayer, "Pro me aurum, thus et mirram offerte deo," cited in F. Büttner, *Imitatio Pietatis. Motive christlichen Ikonographie als Modelle zur Verähnlichung* (Berlin, 1983), 19.

18. Davisson, "Advent," 220; and, A. Medin, "I ritratti autentici di Francesco il Vecchio e di Francesco Novello da Carrara ultimi principi di Padova," *Bollettino museo civico di Padova* 11 (1908): 100–04.

19. See, recently, F. D'Arcais, "Jacopo da Verona e la decorazione della cappella Bovi in S. Michele a Padova," *Arte Veneta* 27 (1973): 9–24, esp. 10. Kloten, *Wandmalerei*, 115, compares the Bovi chapel painting to the frescoes commissioned by (the mint official!) Bartolomeo Bolognini in Bologna which are studied below.

20. For the dramatic tradition, see *Uffici drammatici padovani*, ed. G. Vecchi (Florence, 1954).

21. Rather than to play a king, see Trexler, *Public life*, 423.

22. See Medin, "Ritratti autentici"; and, D'Arcais, "Jacopo da Verona."

23. Merlini, "Trittico," 371–75; and, Trexler, *Church and Community*, 118–22.

24. Merlini, "Trittico," 141–42.

25. C. Rosenberg, "Per il bene di . . . nostra ciptà: Borso d'Este and the Certosa of Ferrara," *Renaissance Quarterly* 29 (1976): 332–34.

26. Merlini, "Trittico," 141–44.

27. Cited in Merlini, "Trittico," 151 n. 51. The treaty never happened. D. M. Bueno de Mesquita, *Giangaleazzo Visconti Duke of Milan* (Cambridge, 1941), 157–58.

28. Merlini, "Trittico," 142.

29. Trexler, *Church and Community*, 120. The primary sources for this ceremony are the Chronicon Bergomense, in the new edition of *Rerum Italicarum Scriptores* (hereafter *RIS*), XVI, pt. 2, p. 61; a contemporary letter by Gregorio Azanello to Andreolo Arisi, in the old *RIS* (hereafter *RIS* old ed.), XVI, 821–26; and, the description in Bernardino Corio, *Storia di Milano*, vol. 2 (Turin, 1978), 929–33. An imperial official bestowed the ducal beret and cloak.

30. Trexler, *Public Life*, 279–90.

31. Trexler, *Church and Community*, 169–70, n. 156. See, Merlini, "Trittico," 143, for the quartering of the French lily in the Visconti arms. The source for the imperial news is in the Pavian document of January 2,

1395, summarized by C. Santoro, *I registri dell'ufficio di provvisione del ufficio dei sindaci sotto la dominazione viscontea*, I (Milan, 1940), 44, no. 223: "Il signore di Milano scrive ai nobili uomini il podestà, il referendario, il vicario e i XII di Provvisione di Milano, di far depingere la sua arma inquartata coll'arma imperiale." See also, Bueno de Mesquita, *Giangaleazzo Visconti*, 173. With reference to "Registro civico, f. 136 a tergo," G. Giulini, however, says that it was on January *4* that the order came out, *Memorie spettanti alla storia, al governo e alla descrizione della città e campagna di Milano ne' secoli bassi*, vol. 5 (Milan, 1856), 794.

32. A glance at any collection of Magi paintings shows that flags were often a feature of the festive Journey of the Magi. I must admit that Galvano Fiamma's description of the Milanese Magi festival of 1336, with its statement that the celebration was held each year thereafter, is accepted at one's peril; in fact, I have still to find a description of any other Magi festival held in Milan during the late Middle Ages. For Galvano, see Hofmann, *Heiligen Drei Könige*, 154–55.

33. On the Magi and coronations, see Hofmann, *Heiligen Drei Könige*, 141ff. The most striking visual confirmation of this doctrinal association are illuminations on facing pages of a Madrid manuscript of Gratian's *Distinctions* recently brought to my attention by Debra Pincus: on the left, divine Majesty oversees two angels crowning a pope and a king, who in turn invest their subjects; on the right is an Adoration of the Magi. They are now reproduced in R. Trexler, "Die Träume der Heiligen Drei König," in *Iconographie der Träume im Mittelalter*, ed. A. Paravicini-Bagliani and G. Stabile (Stuttgart, 1989).

34. "Trittico," 143. The contemporary miniature by Anovelo da Imbonate (Fig. 6) also shows at least two distinct coats-of-arms: the Visconti viper, and one with an azure base covered with gold fleurs-de-lis. Giulini speculates that the latter is the banner of Gian Galeazzo as Count of Virtù, *Memorie*, V, 797.

35. "Trittico," 369–70, 373.

36. R. Brown, *The Birth of the Messiah* (Garden City, N.J., 1977), 194.

37. King David prophecied Gian Galeazzo in Psalm 1 of the Visconti Hours (pre-1395). Throughout this work's illuminations, the association between the two princes is insistent. See *The Visconti Hours*, ed. M. Meiss (New York, 1972), BR 3, 128, and for the Balaam miniature where, within a border made up of a Visconti device, the prophet blesses Israel, see ibid., LF 126v–127v. For Gian Galeazzo as "the Messiah who has arrived" for Italy, see H. Baron, *The Crisis of the Early Italian Renaissance* (Princeton, N.J., 1966), 37. For Milan as a second Rome and its archbishop as a second pope, see Bonvesin da la Riva, *De magnalibus Mediolani*.

Le meraviglie di Milano, ed. Maria Corti (Milan, 1974), 15. Note that an army is being blessed in the picture. This is just what would be expected at the investment of a duke, and what transpired at the coronation of Gian Galeazzo, as we see in the miniature by Anovelo da Imbonate, which also has a characteristic stockade of military prisoners. Coronations in feudal practice were associated with battles and victories, as were knightings imagined to follow upon a victory.

38. Merlini, "Trittico," 154, no. 75 (testament of August 23, 1397). He was in fact not buried there.

39. Plans for the chapel matured in 1400, as can be reconstructed from the curious fact that the inscription in Bartolomeo's "and his heirs' " gravestone tells us the month and year (May 1400) that stone was carved. It transpires that Bartolomeo's only son Andrea died in the same May 1400, as we know from the latter's gravestone in the Bolognese Servite church. Thus, the history of the Bolognini chapel—where Bartolomeo's gravestone was in place when he wrote his testament in 1408—began on the occasion of his only son's death (cf. Kloten, *Wandmalerei*, 51 and 181).

40. Kloten, *Wandmalerei*, esp. 183; "Et in sponda dicte capelle versus sero pingi debeat historia trium magium . . . et . . . sacrari debeat sub nomine trium magium"; from Bolognini's testament, in L. Frati, "La cappella Bolognini nella Basilica di San Petronio a Bologna," *L'Arte* 13 (1910): 215.

41. Kloten makes a notable circumstantial case that the silk merchant Bolognini and the banker-art impresario Baldassare Ubriachi may have known each other at Pavia or at Florence (Kloten, *Wandmalerei*, 115 and 118; and Merlini, "Trittico," 144–46). Since Ubriachi did diplomatic duty for Gian Galeazzo Visconti, it is worthwhile adding that Bolognini had diplomatic contacts with Visconti as well (A. Pini, "Bolognini, Bartolomeo," *Dizionario biografico degli Italiani* [hereafter *DBI*], vol. 11 [Rome, 1969], 332). Further, Bolognini had dual citizenship and thus a residence in Florence (Frati, "Cappella," 214).

42. The best illustrations of the chapel are in *La Basilica di San Petronio in Bologna*, 2 vols. (Bologna, 1983–84), the chapter by C. Volpe, "La pittura gotica. Da Lippo di Dalmasio a Giovanni da Modena," I, 213–94.

43. Kloten, *Wandmalerei*, 183. Bartolomeo Bolognini died on July 2, 1411; Pini, "Bolognini, Bartolomeo."

44. For the reading of this difficult text, see Kloten, *Wandmalerei*, 39–40.

45. On Cossa, see A. Esch, "Das Papsttum unter der Herrschaft der Neapolitaner. Die führenden Gruppe Neapolitaner Familien an der Kurie

während des Schismas 1378–1415," in *Festschrift für Hermann Heimpel*, vol. 2 (Göttingen, 1972), 757–800.

46. Kloten, *Wandmalerei*, 94–95, 5. I cannot find a reproduction of this scene. Note that the New Sacristy in Florence is dedicated to Jesus' resurrection, and that Lewis and I built our argument on the notion of the magian Medici journeying to eternal resurrection; "Two Captains."

47. Kloten, *Wandmalerei*, 96–98.

48. See Domenico Ghirlandaio's Sassetti Adoration, which shows the Magi passing under a triumphal arch on their way to the crib.

49. The author does indicate in passing that Baldassare Cossa wanted to play the unifier, and that he was a force behind the calling of the Council of Pisa in 1409 which aimed at ending the Great Schism (Kloten, *Wandmalerei*, 78 and 144).

50. On Augustine's calculated notion that the Magi came from "all over the world," see Kehrer, *Heiligen Drei Könige*, I, 34. On Gozzoli's work, see A. Beyer, "Der Zug der Magier" (diss. Frankfurt am Main, 1985), kindly shown to me by the author; and the same author's "De significatione cometae. Guglielmo De Becchis Traktat 'De Cometa' (1456) und sein Einfluss auf die bildische Kometenikonogaphie in Florenz," in *Die Kunst und das Studium der Natur vom 14. zum 16 Jahrhundert*, ed. W. Prinz and A. Beyer (Weinheim, 1987), 181–91.

51. The Magi were unity symbols as well at the Councils of Constance and Florence. I will describe this notion in detail in coming work.

52. As recently as 1958, in Endicott, New York, rectors did this as part of the holiday season, each king played by children of different ancestry from the ethnic populations of this area. I owe this information to M. E. Semple, whose children were involved in such plays. Today, each Epiphany in New York City, the school children of ethnic Puerto Ricans perform a Journey of the Magi through the streets of Spanish Harlem. Led by three adult Magi, many trios of children dress as the Magi, emphasizing this pluralism.

53. Gaspare is mentioned as administrator for Baldassare in Bologna by M. de Griffonibus, *Memoriale Historicum*, in *RIS*, XVIII, pt. 2 (hereafter Griffoni), 96, 158; also in the *Corpus Chronicorum Bononiensium*, XVIII, pt. 1, vol. 3 (hereafter *Corpus*), 520; further, see C. Carbonetti, "Cossa, Gaspare," *DBI*, vol. 30 (Rome, 1984), 87–88. There is as yet no direct evidence that the brothers, as distinct from their father Giovanni, showed any avocation to the Kings or politically used them. That cannot be proven from their siblings' names: Marino and Petrillo (Esch, "Papsttum," 758).

54. Pini, "Bolognini, Bartolomeo," 332.

55. In 1389 a communal secretary treated Bolognini with the deference that might become an ambassador (Pini, "Bolognini, Bartolomeo").

He was a city ambassador in 1401 (Kloten, *Wandmalerei*, 13), and legatine one to the pope in Rome in 1405 (Griffoni, 95, and *Corpus*, 514).

56. As I maintain did Botticelli's Uffizi "Adoration" record an embassy to the pope of Lorenzo de' Medici, *Public Life*, 439.

57. On March 14, 1401, G. Bentivoglio on seizing power in Bologna made Bartolomeo a knight with twenty others (*RIS*, 18, pt. 1, 473; and 18, pt. 2, 90). In 1408, Cossa made him a papal counsellor and knighted him (Griffoni, 96). In June 1410, King Louis d'Anjou knighted him again (Griffoni, 98; *Corpus*, 536; and Kloten, *Wandmalerei*, 15).

58. The young king in Gentile da Fabriano's Strozzi altarpiece is a striking example of such a knight. For a youth of the "honor class," his first diplomatic mission was an important rite of passage. On the youth ambassador, who I believe is sometimes the model for the young king in Adorations, see Trexler, *Public Life*, 292.

59. His wealth was a local legend, but so was his influence. On February 8, 1404, he was appointed to guard Gabione Gozzadino for the legate (Esch, "Papsttum," 761–62). In early 1405, at a government meeting called by the legate to meet the challenge of a marauding local count, Bolognini volunteered, essentially in concert with Cossa, to finance a unit of soldiers until victory over the count was achieved; *Corpus*, 511–12. He was a papal counsellor in 1408; above, n. 57.

60. Especially the one of Herod talking with his intellectuals while the Magi await an audience with him. For vestiges of Magi theater in Bologna, see Kloten, *Wandmalerei*, 111–13, and esp. 218, n. 40. On the link in Florence between such festival and art, see R. Hatfield, "The Compagnia de' Magi," *Journal of the Warburg and Courtauld Institutes* 33 (1970): 107–61.

61. See above, n. 40.

62. See above, n. 43.

63. Kloten, *Wandmalerei*, 26–27.

64. Griffoni, x, 92–93; and *Corpus*, 501–03.

65. *Corpus*, 523–24.

66. Griffoni, 96.

67. *Corpus*, 526 (June 26–29). The Latin phrase is used when Cossa goes to Cesena on February 25, 1409, to meet with Pope Gregory; Griffoni, 97.

68. Griffoni, 97; and *Corpus*, 532–33.

69. *Corpus*, 534.

70. Ibid. See also Griffoni, 98.

71. See above, n. 57.

72. F. Filippini, "Gli affreschi della cappella Bolognini in San Petronio," *Bollettino d'arte* 10 (1916): 193; and Frati, "Cappella Bolognini," 215.

73. The deceased Bartolomeo himself had a brother named Melchior. Obviously the family was not bereft of magian namesakes. For the brother, see Kloten, *Wandmalerei*, 97; for Marchione, see Griffoni, 100; *Corpus*, 543; and Kloten, *Wandmalerei*, 43, for a Bolognese writer identifying Marchione with Melchior. It may be significant that in Florence the customary honor of holding a bishop's horse during the *possesso* belonged to the Strozzi, a family, as is known from the Strozzi altarpiece, associated with the Magi cult (Trexler, *Public Life*, 273).

74. Kloten, *Wandmalerei*, 40–43.

75. Griffoni, 101; *Corpus*, 546–47; and Frati, "Cappella," 215.

76. In the mosaic on the left side of the choir of San Vitale, Justinian bears a gift (now we can understand the significance of the chi-rho on the shield of one of Justinian's soldiers: it was a sign the Magi, as well as Justinian's ancestor Constantine, had seen in the sky). Opposite Justinian is the gifting figure of Theodora (meaning "God's Gift"), with the three Magi on the empress's hem bearing their gifts.

To see the magian space in San Vitale, as can be done with the help of O. von Simson's brilliant *Sacred Fortress: Byzantine Art and Statecraft in Ravenna* (Princeton, N.J., 1987), recall the procession on the great southern wall of the church of Sant'Apollinare Nuovo where the virgins of the church bear their gifts behind the Magi like so many fourth, fifth, sixth, etc., magi. Beneath, the faithful once actually brought their gifts to the altar.

Now, ask if in San Vitale, Justinian and Theodora did not, like the servants of the Magi, bear gifts behind invisible Magi to Jesus (not Mary) in the apse mosaic, just as in the triumphal arch of S. Maria Maggiore in Rome, visible Magi had waited on an enthroned Jesus (but not Mary).

77. Mary Lewis and I argue that the three Magi in Michelangelo's monument were Cosimo di Giovanni, buried at the cross of San Lorenzo, and Lorenzo and Giuliano di Piero, buried in the *sepultura in testa* of the New Sacristy, beneath the statues of Mother and Child and Cosmas and Damian. The two captains of Michelangelo were servants of these Magi, bearing gold and frankincense (the doctors [*medici*] Cosmas and Damian bore the myrrh). Visitors thus stand in the space of the retinue of the Magi; "Two Captains."

78. I owe this information to Eugenio Battisti. On the *sacro monte*, see *Il sacro monte di Varallo*, ed. M. Bernardi (Turin, 1960), and the thoughtful characterization of its spaces by P. De Vecchi, "Annotazioni sul Calvario del sacro monte di Varallo," in *Fra rinascimento, manierismo e realtà*, ed. P. Marani (Florence, 1984), esp. 111: "non la 'cappella dei Magi,' ma il corteo dei Magi, che i pellegrini risalivano nel loro viaggio. . . . "

79. Beyer, "De significatione," 182. Beyer did not know this "destarring" of the Star of Bethlehem had precedents. Bernardino called his monogram (which can as easily be read triumphantly as IHS ["in this sign (conquer)"] as it can be YHS ["Jesus"]) a "sun" (I. Origo, *The World of San Bernardino* [New York, 1962], 118). Before Bernardino, the visionary Bridget of Sweden in a miniature watches the infant lying in the manger on a (magian) sun or star (*Medieval and Renaissance Miniatures from the National Gallery of Art*, ed. G. Vikan [Washington, D.C., 1975], xiii, 58–60). On Jesus in Medicean tradition as the *lux vera* that *in tenebris lucet*, see Trexler and Lewis in *Church and Community*, 213. The Johannine words "lux vera" may also be shown on the breast of a rider behind the oldest king in Gozzoli's "Journey of the Magi."

A Tale of Two Cities: Verona and Padua in the Late Middle Ages

JOSEPH R. BERRIGAN

FOR MORE THAN two generations, beginning toward the middle of the thirteenth century, Verona intermittently threatened Padua with domination. Two despots appeared in Verona and aspired to add Padua to their possessions; in the end they both succeeded. The story of Paduan liberty is a short and sad tale but one that deserves telling. In the aftermath of Ezzelino's fall Rolandino would compose his judicious treatment of the rise and collapse of Veronese conquest in his *Chronicles of the Trevisan March*. As danger again impended from Verona in the second decade of the thirteenth century, Albertino Mussato refashioned Rolandino's story into the first tragedy since antiquity, the *Ecerinis*. This Paduan response to Veronese despotism will be the theme of this essay but we should first look at the impact of this tyranny upon Verona itself.[1]

The Verona of Can Grande della Scala could be a hospitable place; tyrants can afford to be generous to guests, as Can Grande was to Dante. His courteous reception of the Florentine exile has done much to soften the edges of his harsh reputation, but it cannot obscure the reality of his tyranny. We can glimpse the true nature of his rule in the way men turned to history under him. There were two practicing historians in Verona and they both chose subjects far removed from current events and della Scala interests.

Benzo d'Alessandria[2] was close to Can Grande. A native of Lombardy, he had come to Verona and served as the despot's chancellor. He devoted his spare time to the compilation of his *Chronicon*, now in the Ambrosiana. The manuscript we possess ranges from biblical history through geography to Greek mythology and history.

Of particular interest is the way in which he takes the two epics of Statius and translates them into contemporary Latin. He also retells the story of Troy on the basis of Dictys and Dares. He is about as far from the Adige as he can get, and my suggestion is that this is a conscious choice on his part, a withdrawal from the contemporary scene to the safety of a far distant past.

The one hundred forty-fourth chapter of his Book XIV deals with Verona: foundation by the Gauls, texts from Justinus, Sicard of Cremona, Godfrey of Viterbo, Livy, Lucan, Paul the Lombard, and Papias. The closest he gets to Can Grande is the wall that the Veronese had built with material from their arena near the gate to Mantua.[3]

The last book of the *Chronicon* we possess, the twenty-fourth, allows Benzo to retreat as far as anyone could wish from contemporary history, to the heights of Olympus, for in it he deals with the memorable deeds and sayings of Greek gods and heroes. In his prologue he explains his purpose, a purpose somewhat odd since he deals with the likes of Jupiter and Hercules, as well as Plato and Aristotle.

> In truth we should never despise reading about the deeds and words of such men; rather we should engage in such reading with enthusiasm. . . . We as Christians endowed with the gift of faith should particularly choose their lives as a model for our character and as a guide for our behavior. Although they were not privileged to live in the glorious age of salvation and remained in only the shadow of truth, still they struggled so valiantly for perishable glory and, in their ignorance of that life to which our faith aspires with hope, they so fervently abstained from earthly concerns that they acquired wisdom and glory and even possessed knowledge of divine matters.[4]

The one surviving manuscript of the *Chronicon* is more than matched by the three codices containing the *Historia Imperialis* of Giovanni Mansionario, a canon of the Veronese cathedral.[5] There is a manuscript, codex 204, still in Verona, in the capitular library so vital to the researches of Benzo. There are two in Rome: one in the Vatican, Chigi I VII 259, and another in the Valicelliana, D 13. A critical edition of this work is still needed.

The theme of Giovanni's history is a splendid one, the same one that would so attract Petrarch and other later humanists: Roman history. He breaks off his story with the successor of Charlemagne, Louis the Pious. Like his contemporaries and their predecessors, he sees no break in the line of Roman emperors, whether in 476 or 800. For Giovanni, as for Dante, Henry VII is as much the Emperor of Rome as Justinian or Theodosius or Tiberius had been. This incomplete state of the *Historia* should be a warning to all those who try to deal with it.

As a classical and medieval historian, Giovanni was able to avoid contemporary Verona as properly as Benzo, although the camouflage of the twelve labors of Hercules provided no ample shelter for him. Even Benzo, on occasion, let the mask slip and referred to the current situation[6] or something he had seen or heard, e.g., the tomb of Henry VII in Pisa, or the remark of an old man on Acqui, that it is an "aurea concha scorpionibus plena."[7] In the one instance I am aware of, Giovanni not only refers to a contemporary event but dates it to November 23, 1316, with the first bell of Matins ringing in Verona. What he tells us is certainly astonishing: a demon appeared to him and asked for his soul. An intense prayer to the Virgin rescued him from the peril of a demonic assault; fully awake, he turned to the *Historia* and summarized the story of Theophilus.[8]

With the devil assailing him at night and Can Grande glowering in the daylight, Giovanni was well advised to turn to Roman history for both study and delight. But even as he involved himself in the details of the story, he would on occasion be unable to refrain from an outburst of clerical wrath, especially at the lay spoliation of church property.

> So many Christians of our own time should indeed blush; they are Christians only in name, in deed they are pagans. Of them the apostle says, They confess God with their words but they reject virtue; and again, They confess God with their words but by their deeds they deny him. . . . But our fellow Christians, in time of peace, ravage the goods of churches; not only do they pay no attention to the practice of their Christian faith, they even become more brutal than the Jews — a plight even worse than not practicing their faith. They buy and sell

Christ; they deride, beat and scourge Him; they spit on Him, cover His eyes and thrust on His head a crown of thorns.[9]

And what prompted this tirade, worthy of the clergy speaking of Pepin or Henry VIII, was the exemplary behavior of Alaric, the King of Visigoths. I am sure that many of you may be remembering the eighteenth canto of the *Purgatorio* and the excoriation of Can Grande's father by the fleet-footed abbot of San Zeno.

I would like to preface my comments on the Paduan response to Veronese tyranny with two quotations, one from the *Commedia*, the other from the *Civilization of the Renaissance in Italy*. Towards the end of the twelfth canto of the *Inferno* the centaur Nessus points out some of the tyrants boiling in their dire river of blood:

> E quella fronte ch'ha il pel cosi nero
> È Azzolino. . . . [10]

Five and a half centuries later Jacob Burckhardt also cites the Veronese despot. "At the side of the centralizing Emperor appeared a usurper of the most peculiar kind; his vicar and his son-in-law, Ezzelino da Romano. . . . Here for the first time the attempt was openly made to found a throne by wholesale murder and endless barbarities, by the adoption, in short, of any means with a view to nothing but the end pursued. None of his successors, not even Cesare Borgia, rivalled the colossal guilt of Ezzelino."[11]

Ezzelino da Romano was recognized as a tyrant in his own age or he would not have been plunged up to his eyes in boiling blood, and he was a phenomenon, a marvel, a *stupor mundi*, at least to those in his own neighborhood. He was something unheard of, the stuff of nightmares, an evil prodigy. In his impact upon Padua, her citizens, her leadership and literature, his uniqueness provoked response from the restored commune of Antenor, as they liked to think of themselves — a history of 1262 and a tragedy of 1315. Rolandino and Mussato not only offer us two powerful portrayals of the evil of tyranny, especially the sort that flourished in Verona, but Mussato would base his drama upon the well-known and very popular *Chronicles of the Trevisan March*; thus his Ezzelino is like Shakespeare's Richard III, a historical figure already familiar to the dramatist's audience, thanks to Thomas More's *Life of Richard III*. Or we may think of Aeschylus serving up slices of Homer in his tragedies.

Both Rolandino and Mussato were Paduans and public men. They both began life in that most public office of late medieval Italy; they were notaries. They became something quite different, men of letters. Rolandino became a professor of rhetoric at the University of Padua, as well as a historian, while Mussato became a poet and tragedian, as well as a historian. Thanks to his poetry we know much more about Mussato's life than we do about Rolandino's.

We must depend upon his own words in his *Chronicles* to learn anything about him. His father was a notary and kept a running account of important events in the Paduan vicinity. Rolandino inherited both the profession and the avocation. Furthermore, he was a student of that master of the *ars dictaminis*, Boncompagno. Crucially, this versatile Bolognese master had experimented with history in his Siege of Ancona and had shown that a *dettatore* could be a historian.

During the years of Ezzelino's dominance in Padua, Rolandino was a public figure, serving the state and keeping his own records. With the collapse of the despotism, citizens of the restored commune turned to him as the natural and trustworthy recording secretary: he was to provide a truthful version of the events they had all lived through and it was to be an instructive tale. He was to teach by the example of Ezzelino what they had learned by experience: tyrants are to be avoided and liberty prized beyond all earthly possessions. They left nothing to chance. In a preface to Rolandino's work, they declare:

> They can clearly see that the cruelty of tyrants is terrible in the cities over which they rule. Likewise they can see the deeds of the worst form of government, how they extend their impious hands not only against the laity, but also lay waste church property, imprison the clergy, tear down towers and palaces, dissipate wealth, orphan the poor and the young, widow women, and destroy everyone and everything.[12]

In his prologue, Rolandino insists that the only reason he had agreed to undertake this onerous task was the insistence of some men of religion, who would chide him if he were to shirk his responsibility. He is quite conscious of his own inadequacy and of the enormity of the undertaking. Placing his confidence in God, he recalls the assistance God had granted an ass to chide Balaam. He

insists that he shall be brief and leaves it to others, his succes-
sors, to "smooth out what I have dislodged and broken up with
my mattock."[13]

He is really too humble about the character of his achieve-
ment. It is a masterpiece of the historical art. He has shaped the
events of the first sixty years of the thirteenth century into a cohe-
sive, instructive, artistic whole. He has indeed followed the example
of Boncompagno in his use of *dictamen* in the writing of history, but
he displays a marvelous mastery of disposition, transition, and pro-
gression, which has to be the fruit of long hours spent in the study
of the Roman poets, especially Virgil. The arrangement Rolandino
has imposed upon his material, the twelve harmonious books that
comprise its composite unity, recall the *Aeneid* in their artistry.

The horror of tyranny, along with the necessity of liberty, is
central to the work, but Rolandino finds ample room for other sub-
jects. One reason for this is the wide range of his interests; he does
not limit himself to Padua alone. The whole March of Treviso is his
stage; occasionally, he includes events from beyond this compass.
The amplitude of this presentation allows him to have the people of
Padua play the major role. They are the Aeneas of this history and
their virtues are his theme. I wish I could find a single adjective like
"pious" to qualify Rolandino's Paduans, but I shall to settle for three
characteristics: unity, endurance, and Catholicism.

Basic to his purpose is the presentation of Paduans as united
and single-minded in their resistance to tyranny. There were to be
no collaborators, quislings, or scalawags mentioned. We find this
sense, after all, in the commune's endorsement of Rolandino's work:
"it tells the truth and does not slander anyone from Padua."[14] For
they had all suffered; Rolandino intentionally draws a veil over
those who must necessarily have cooperated with Ezzelino. Thus, if
no one worked with the tyrant, everyone suffered. And they suf-
fered as Catholics. The theme of "Catholic Padua" is strong through-
out the work. Inevitably, the enemy of such a devout, single-minded,
long-suffering city assumes diabolical characteristics. So dreadful
had he been during his life that Rolandino wonders whether Ezzelino
may not now, after his death, be ruling or terrifying the very devils
of hell.[15]

Fine as Rolandino's work is, it is limited. Its intended audience
is the people of Padua, especially those who will assume a role of

government in the commune. The language is not simply Latin; it is the special Latin of the *ars dictaminis*. The subject is local or provincial, limited essentially to the events of the Trevisan March. The lessons on liberty and tyranny, then, are local in origin, language, and intended impact. I feel that Rolandino almost makes the jump to a more transcendent theme by associating Padua with Rome, as Bruni would do with Florence. He does link Padua and Rome in the first chapter of his twelfth book, but it is essentially their sufferings which unite them and lead Rolandino to speculate, "Cannot . . . Padua now be called a second Rome?"

I think that the answer to this question would be closer to the affirmative if it were asked more than a generation later, during the maturity of Albertino Mussato, around 1315. In his prologue Rolandino had wished that there were a Lucan or a Virgil to record the events he had to relate. Padua never had the good fortune to discover such an epic poet, but in Mussato she got her Seneca. The Paduan would be the first to write a tragedy since antiquity, and he did so during the lifetime of Dante.

There are three essential elements which constitute the background of the *Ecerinis*. First, there is the educational role of Rolandino's work in schooling more than a generation of Paduan leaders in the lessons of tyranny and liberty. Second, men like Lovato and Mussato had turned to classical Latin poetry for relaxation. They had mastered relatively obscure genres, including tragedy. We have some Mussato's preliminary studies of Seneca's tragedies and their meters. We now know that the text these Paduans were using derived from the *Etruscus*, now in the Biblioteca Laurenziana, but discovered by Lovato in the abbey of Pomposa. Third, once again danger loomed over Padua from the direction of Verona, this time in the person and intentions of Can Grande della Scala.

To awaken his fellow citizens to this peril, Mussato turned to the familiar pages of Rolandino's work and from them crafted a tragedy. Immediately obvious is the great difference in the situations of these two authors. Rolandino had been asked to write his history, Mussato undertook his tragedy on his own. Rolandino wrote in peace and leisure, Mussato in the hectic anticipation of tyrannical usurpation. Only a few years later Benzo d'Alessandria would say of Padua:

Today this city, although once it was most powerful and famous both in wealth and resources, in the pursuit of liberal studies and the size of its population, among the cities of Italy, has suffered from the plague of sedition and the damage inflicted upon it by Can Grande, the ruler of Verona and Vicenza, and mourns its previous happiness in the light of its present circumstances.[16]

Most important, Rolandino was fundamentally concerned with presenting a truthful account of the past, especially that part of the past involving Ezzelino; Mussato was primarily concerned with the future, with what he believed would be the inevitable assault upon the liberties of Padua by another despot of Verona. He was not so much interested in historical accuracy as he was in the effect he would have upon audience. He intended his drama to be a firebell in the night, an alarm signal that would startle everyone to his senses.

In line with this intention, Mussato radically alters the character of Ezzelino. Rolandino had been scrupulously fair in his depiction of the da Romano family, including Ezzelino. The only time he falters is his speculation about Ezzelino's role in the afterworld. Mussato exercises no such restraint. His familiarity with the drama of Seneca doubtless inspired him to compose the opening scene of his drama. Both the *Agamemnon* and the *Thyestes* open with grisly monologues delivered by ghosts from Hades, Thyestes in the first, Tantalus in the second. Ezzelino and his mother hold center-stage as the *Ecerinis* begins. He is no ghost, but there is the smell of sulphur and hell-fire about him. His mother manages to terrify the audience with her proclamation of his diabolical conception; his sire had been none other than Satan. Given the basic Christianity of fourteenth-century Padua, a city familiar with the *disciplinati* and the dramatic presentation of the Passion, we may be sure that they would have made the intended inference: Ezzelino was the Antichrist, the most fearful of eschatological figures. But Mussato was obviously interested in the carry-over effect, in what this assertion said about Ezzelino's contemporary incarnation, Can Grande della Scala.

The Catholic Church was the supernatural enemy of the Antichrist and Rolandino had taught and his readers believed that they,

the citizens of Padua, were essentially Catholic and hence, the primary target of the wiles and wickedness of their satanic foe. The *Ecerinis*, then, should be seen as an eschatological drama between the forces of evil, represented by Ezzelino, and the forces of good, represented by the people of Padua.

Mussato underscores this character of the *Ecerinis* in several ways. First, there are Ezzelino's repeated proclamations of his malignity.

> I swear
> By the black and murky pools of Styx I have
> Denied Christ. I have always hated Him.
> I loathe the hostile name of the Cross . . . [17]

> Mine the use
> Of bloody swords. As single judge I shall end
> All suits; my trusty hand will tremble at
> No crime. Assist me, O Satan. Give your son a
> chance.[18]

These awful lines are from the first act.

Act III, scene one, is a conspiratorial meeting of Ezzelino and his brother Alberic. Ezzelino concludes their conversation with words.

> Away
> With trust; may piety never color our deeds.[19]

Mussato's second means of emphasizing Ezzolino's malevolence is his interview with Friar Luke in Act III, scene three. The friar presents an eloquent version of the traditional, harmonious order of the universe. God providentially guides the entire world and wills that men reflect this tranquility in their private and public lives.

> If you but think, you'll see how order prevails.
> The earth, the sea, the sky, and all the elements
> Are kept in certain bounds by definite laws.
> What withers in winter, thrives in summertime.
> The earth produces her fruits in various seasons.
> The sea is troubled by dreadful storms, but once
> The wind dies down, it suffers ships to sail.
> You see the heavens moved in their orbits,

The hinge eternal supports the poles
And keeps them stable, the stars pursue their wandering
Courses, subject to determined law.
But who's the mighty mover that directs all this?
Almighty God is their exalted mover.
With fair scales He fairly arranges these works of His.
Justice is this sacred order called
And just the God that willed its maintenance
By all the mortal men He would create.[20]

As Antichrist, Ezzelino rejects the friar's arguments and perversely identifies himself with God's plans.

To cities He gave tyrants, who with swords
Unsheathed could wallow in the blood they shed
Without order and without end.[21]

He identifies himself with such antiheroes as Nebuchadnezzar, the Pharaoh, Saul, Philip of Macedon, and Nero. This speech is the high point of Ezzelino's insolence and is the last straw for the already overloaded back of the providence championed by the friar. The very next scene brings the reversal — Padua has fallen to his enemies.

But the most effective instrument employed by Mussato in contrasting Ezzelino and Padua is the chorus of Paduan citizens, who do not always act as their ancient counterparts would have, but who do represent the other side of the struggle between good and evil. They embody the themes we have already seen in Rolandino's work: unity, endurance, and Catholicism. I would particularly cite the choral ode that concludes the fourth act with paean to the return of peace.

Together we should offer thanks
To the giver of such joys,
You youths, you aged, you timid maids,
Worthy thanks.
From lofty Olympus mercy came
To put an end to evil deeds;
The awful tyrant's wrath is dead and
Peace returns.
Together let us all enjoy this peace

And every exile be recalled in safety;
Let every man return to his own home
Blessed with peace.
Now, suppliants, curb your passions
And purge your guilt with frequent blows.
May your prayers be answered by God
Virgin-born.[22]

The final ode concludes the play with its triumphant assertion of
the divine order.

The rule of justice lasts forever.
Be confident, you just men,
Nor does the rule collapse, should Fate
At times exalt a rogue. Each man
Receives the merit due his deeds.
A harsh judge, a calm judge,
Conscious of fair judgment, rewards
The just, condemns the evil.
This stable order never ends.
Virtue soars to heavenly joys,
Sin descends to nether darkness.
So while you may, take our advice
And learn this stable law.[23]

Mussato, then, succeeded in shaping the story of Ezzelino into
a transcendental lesson. He did so by employing the form of Senecan
tragedy but the morality he inculcated is the light and dark, the
black and white variety embodied in the Christ-Antichrist conflict.
We are all too familiar with its latter-day, secularized form, that of
the Evil Empire. He may have been right, but Can Grande della
Scala won out anyway.

NOTES

1. I should note that I am consciously writing this in the tradition of
Benedetto Croce (*History as the Story of Liberty* [New York, 1955]) and Hans
Baron (*Crisis of the Early Italian Renaissance* [Princeton, N.J., 1966]). Like
them I find despotism revolting and deadening. Nor is this just an aca-
demic pose. I am a native Louisianian, who grew up in the shadow of Earl

Long. Then, too, at Georgia I have known academic forms of this same political aberration.

2. My first work with Benzo was an edition of sections of the fourteenth book of the *Chronicon*, "Benzo d'Alessandria and the Cities of Northern Italy," *Studies in Medieval and Renaissance History* 4 (1967): 127-92. My most recent essays have been "Benzo as a Historian," *Manuscripta* 27 (1983): 108-119; and 29 (1985): 12-23.

3. Berrigan, "Benzo d'Alessandria and the Cities," 177-79.

4. "Revera autem legere acta et dicta talium virorum nequaquam vilipendo debet haberi sed multo pocius affectu talis leccio amplectenda . . . Precipue autem nobis qui Christiane fidei sumus sortiti gratiam, debet talium vita nostris actibus ac moribus esse magistra. Ipsi quippe quamquam non meruissent gloriosum gerere tempus et in veritatis tenebris residentes, tamen pro caduca gloria tantum laborare videbantur et vite illius ignari ad quam nostra fides sperando aspirat, tanto studii fervore se ab terrenis quibuslibet abdicabant ut et sapienciam et gloriam nasciscerentur et celestium eciam cognicionem haberent." Milan, Biblioteca Ambrosiana, MS B24inf., *Chronicon*, f. 256.

5. See J. Berrigan, "Riccobaldo and Giovanni Mansionario as Historian, *Manuscripta* 30 (1986): 215-23.

6. See n. 16 below.

7. Berrigan, "Benzo d'Alessandria and the Cities," 189.

8. Biblioteca Apostolica Vaticana, Vatican, Chigi I VII 259, ff. 153ᵛ-154.

9. "Erubescere igitur deberent multi Christiani nostri temporis qui nomine quidem Christiani sunt, opere vero pagani, de quibus ait apostolus, habentes speciem pietatis, virtutem autem abnegantes; item, Deum verbis confitentur, factis autem negant. . . . Nostri autem tempore pacis ecclesiarum bona dirripiunt, sacerdotes et eorum monita derident, et non solum cultum Christiane fidei vilipendunt sed, quod deterius, Iudeis serviores effecti. Christum vendunt et emunt, derident, verberant et flagellant, conspuunt, velant faciem, arundinem et spineam coronam adiciunt." MS. Chigi I VII 259, ff. 106ᵛ-107.

10. Dante, *Inferno*, canto 12, ll. 109-10.

11. J. Burckhardt, *Civilization of the Renaissance in Italy* (New York, 1954), 6.

12. Rolandino, *Chronicles of the Trevisan March*, trans. J. Berrigan (Lawrence, Kansas, 1980), 1.

" . . . potest manifeste videre, quia horribilis est crudelitas tyrannorum in civitatibus, quibus presunt. Item quid pessima operentur dominia, quia manus impias extendunt non solum ad seculares, set et loca ecclesiastica dissipant, carcerant religiosos, turres et pallacia dirruunt, devorant divicias,

pauperes orphanant et pupillos, viduant mulieres, res omnes destruunt et personas." *Rolandini Patavini Cronica Marchie Trivixane*, ed. A. Bonardi, *RIS*, VIII, pt. 1 (Città di Castello, 1905), 5.

13. Rolandino, *Chronicles*, 3–4.

" . . . ut aliquis post me veniens culture sue aratro debeat adequare, quod movi meo crosso fossorio et abrupi." *Rolandini Patavini*, 7.

14. Rolandino, *Chronicles*, 1.

" . . . veritatem dicendo, nullam infamando vel accusando personam de Padua." *Rolandini Patavini*, 5.

15. Rolandino, *Chronicles*, 179.

16. Berrigan, "Benzo d'Alessandria and the Cities," 180.

"Hodie autem civitas ista, licet olim potentissima et famosissima tum opibus et divitiis ac liberalium artium studiis quam innumeris populis fuerit inter urbes Ytalie, tandem peste seditionis strageque illata a Cane Grande Verone et Vincentie dominatore subsequentibus, pristinam gemit felicitatem consideratione presentium."

17. A. Mussato, *The Ecerinis*, trans. J. Berrigan (Munich, 1975), 24–25.

> Paludis atrae lividam testor Stigem,
> Christum negavi semper exosum michi
> Odique semper nomen inimicum Crucis.

18. Ibid., 26–27.

> Ensis cruenti detur officium michi;
> Ipse executor finiam lites merus:
> Nullis tremescet sceleribus fidens manus.
> Annue, Sathane, et filium talem proba.

19. Ibid., 52–53.

> Absit fides
> Pietasque nostris actibus semper procul.

20. Ibid., 56–59.

> Servare seriem cuncta, si pensas, vides.
> Terra mare caelum et illa, quae substant eis,
> Gerunt statutas legibus certis vices.
> Quae pallet hieme, tempore aestatis viret,
> Certasque certis mensibus fruges alit
> Tellus. Procellis aestuat vastis mare,
> Turbine remisso quod patitur ultro rates.
> Caelum intueris orbibus motum suis;
> Stabiles perennis sustinet cardo polos;
> Disposita sidera peragunt cursus vagos

Sub lege certa. Sed quis haec praepotens movet?
Excelsus horum motor omnipotens Deus:
Hic aequus aequa lance dispensat sua,
Quae fecit, opera: dictus hic ordo sacer
Iustitia. Iustus hanc coli voluit Deus
A se creatis hominibus mortalibus.

21. Ibid., 62–63.

Dedit et tyrannos urbibus, licuit quibus
Sine ordine, sine fine, strictis ensibus
Saevire largo sanguine in gentes vage.

22. Ibid., 82–85.

Vota solvamus pariter datori
Digna tantorum, iuvenes, bonorum;
Vos senes, vos et trepidae puellae,
Solvite vota.
Venite a summo pietas Olympo,
Quae malis finem posuit patratis;
Occidit saevi rabies tyranni
Paxque revixit.
Pace nunc omnes pariter fruamur,
Omnis et tutus revocetur exul,
Ad lares possit proprios reverti
Pace potitus.
Supplices renes feriant habenis,
Ictibus crebris domitent reatus.
Annuit votis Deus, ut petitis,
Virgine natus.

23. Ibid., 96–99.

Haec perpetuo durat in aevo
Regula iuris. Fidite, iusti:
Nec, si quando forsitan ullum
Quemquam nocuum sors extollat,
Regula fallit. Consors operum
Meritum sequitur quisque suorum.
Stat iudicii conscius aequi
Iudex rigidus, iudex placidus;
Donat iustos, damnat iniquos.
Haud hic stabilis desinit ordo:
Petit illecebras virtus superas,
Crimen tenebras expetit imas.

The French Connection: Thoughts about French Patrons and Italian Art, c. 1250–1300*

JULIAN GARDNER

IN THIS DISCUSSION of artistic patronage in Rome and central Italy in the latter half of the Duecento, the patrons considered will be, largely, but not exclusively French ecclesiastics. It must constantly be borne in mind that a full-fledged French monarchy had been established in southern Italy after 1265, and that its first ruler, Charles I d'Anjou, the younger brother of Saint Louis IX of France, spent considerable periods of time in Rome and Tuscany.[1] Charles was on a number of occasions Senator of Rome, and even during his absences from the city his agents there exerted a powerful influence. An exasperated French pope, Clement IV, had to write a stern letter to Charles protesting against the occupation of the papal palace at the Lateran by the Angevin household.[2] French lay patronage of Italian art will occupy a later section of this essay, but essentially I shall be talking about French churchmen in Italy.

The Italian language makes a distinction between *patrocinio* (political patronage) and *mecenatismo* (artistic patronage), a differentiation which is largely lost in English.[3] Charles d'Anjou practiced both, the former more heavy-handedly and frequently. The main characters on whom I shall concentrate, however, are the French popes — Urban IV (1261–1264), Clement IV (1265–1268), Innocent V (1276), and Martin IV (1281–1285) — and a group of French cardinals, mainly appointed by them. The papacy was thus in French hands for approximately a decade, with the longest continuous period falling in the 1260s and leading up to the installation and first years

of the Angevin kingdom in the south of the peninsula. Before we begin to pose questions concerning artistic taste and the possible role of these French churchmen in the development of artistic fashions in central Italy, we must attempt to establish the parameters within which such patronage of the arts might operate.

In the case of popes and cardinals age was an important factor — with few exceptions such as the thirty-six-year-old Innocent III (1198–1216), men came to the papacy relatively late in life, and none of the French pontificates was lengthy, certainly not in comparison with those of Innocent III at the beginning of the century, or Boniface VIII (1294–1303) at its end. Pierre de Tarentaise, the Savoyard Dominican who became Pope Innocent V, had a pontificate of just over five months. Age often militated against major architectural projects, although this did not prevent the building activities of both Urban IV and Clement IV, even if it meant that their projects remained to be completed by others.[4] Furthermore, the French popes generally did not live in Rome: the climate and xenophobic Roman mob saw to that.[5] Nonetheless, it was a medieval truism that *Ubi papa, ibi Roma*, and Roman craftsmen worked under the papal aegis at Orvieto, Viterbo, Perugia, and elsewhere.

Connected with this consideration is the problem raised by tomb sculpture. While it may well be correct to point to the magnificent tomb of Clement IV, originally in the choir of the Dominican church of Santa Maria in Gradi at Viterbo, as an important index of the importation of the monumental effigial tomb into Italy, it is unproven that this tomb expressed Clement's taste — an eloquent gesture, so to speak, of posthumous patronage (Fig. 1).[6] To establish tastes we must survey such meager evidence as we have about attitudes to art during the period. Such attitudes must also have been colored by the religious profession of the men concerned — Clement IV was notably ascetic — and by past experience — both he and Martin IV had formerly been members of the French royal council.[7] We shall subsequently consider to what extent their attitudes differed from those of the French sovereigns who patronized Italian art. In Italy too, partly by reason of the fact that Urban, Clement, and Martin were members of the secular clergy, their patronage has the town as its focus. Innocent V, a Dominican and former provincial of his order's Roman province, ironically provided by his death an opportunity for Charles d'Anjou memorably

to express his personal stylistic preferences.[8] Here too, as I have elsewhere shown, it is possible to discriminate between Charles's taste in Italy and his taste in Provence.[9] The tombs of the Angevins in Aix were very different from those in southern Italy. Among secular patrons there additionally did not exist the distinction between court and administration which is so marked a feature of the medieval and Renaissance papacy. Finally, there is perhaps too often an assumption made that there is something which can be termed a "court style."[10] As we shall see, a plurality of styles can be found, and it is the reasons for this plurality which are revealing. Some of these differences will emerge more clearly as we come to consider specific cases.

Clement IV, most unusually for a pope, had been a married man with children. A provincial jurist from Saint-Gilles and a man celebrated for his probity, he moved from the service of Raymonde VII, Comte de Toulouse to that of Alphonse de Poitiers, and from thence into the royal service. With the death of his wife, he entered a religious life, and by 1256 he is designated *clericus* in the documents.[11] Barely a year later he was chosen unanimously by the chapter of Le Puy as their bishop. In 1259 he was elevated to the archbishopric of Narbonne. Narbonne is of importance in French architectural history as an example of the transference of high gothic style, a product of the Ile de France, southwards (Fig. 2).[12] Guy Foucois' rise continued inexorably and, in 1261, he became cardinal bishop of Sabina and embroiled in a futile legation to England intended to end the revolt of Simon de Montfort and the English barons, an imbroglio which was later to have a shocking coda in Viterbo.[13] The new cardinal was certainly in central Italy at the time of his election as Pope Clement IV in February 1265, for, although absent from the conclave in Perugia, he reached the city within a few days.[14]

In his new role he signally favored his native town of Saint-Gilles, and his former archbishopric of Narbonne. The great abbey at Saint-Gilles received a large number of privileges and gifts. But Narbonne provides the clearest indication of the pope's aesthetic attitudes. When he dispatched a foundation stone specially blessed and inset with a gold cross to Narbonne for the great new cathedral under construction there, he wrote of the new cathedral in the following terms " . . . mira sumptuosa pulcherrima et decora. . . . et

in faciendo imitare ecclesias nobiles et magnifice operatus et opera ecclesiarum que in regno Francie construuntur."[15] This preference for a metropolitan gothic style may also be perceived in Clement's own seal matrix as archbishop of Narbonne (Fig. 3).[16] Significantly, too, he sent a new silver seal matrix to his favored abbey at Saint-Gilles while he was pope.[17] We have evidence of his interest in visions, and he wrote a vernacular poem on the Seven Joys of the Virgin.[18] But, the essential point for the present inquiry is the pope's decision to promote the gothic architectural style of the Ile-de-France in southern France.

At Viterbo, where Clement IV established himself, significant additions were made to the papal palace, where tracery of a new style is used for the imposing papal loggia. Whereas it seems unlikely that Clement was directly responsible for the rebuilding of the palace, it was the presence of French popes in Viterbo which stimulated the building of the new palace (Fig. 4).[19] From a stylistic point of view it is the papal tomb which breaks important new ground. I do not want to rehearse here the problems of the relationship of this tomb to the Shrine of Edward the Confessor in Westminster Abbey, but I do want to examine the tomb as a result of French patronage in Italy and as a dynamic of stylistic change.[20] Yet, it is not quite such a simple matter, however, as it might at first sight appear.

Earlier I referred to the separation between administration and court which characterized the medieval papacy. There were, nevertheless, situations when the two came closer together, and one such was when the papal throne itself was vacant. In periods of *sede vacante* the papal *camerarius* assumed a more influential position.[21] As is well known, the conclave following Clement's death in November 1268 provoked one of the longest and bitterest confrontations of the entire middle ages. The podestà of Viterbo Corrado di Alviano and the Capitano del Popolo Raniero Gatti, having already ineffectually barricaded the Sacred College within the *salone* of the papal palace, just before Pentecost 1269 took the drastic step of removing the roof to expedite the choice of a new pontiff.[22] The stratagem provoked the wry comment of the English cardinal John of Toledo, who had prudently remained outside the conclave, that it would allow the Holy Spirit to reach the assembled cardinals more easily.[23] Meanwhile, Clement's tomb was still the subject of furious dispute between

the Dominicans of Santa Maria in Gradi, where Clement had elected burial, and the canons of San Lorenzo who had shanghaied both his tomb and his corpse. Eventually the Dominicans prevailed. The documentation of the dispute yields the precious information that it was the papal *camerarius* Pierre de Montbrun who was effectively responsible for the dead pontiff's monument.[24] Thus, if the tomb reflects anyone's taste it is that of Pierre de Montbrun. What then do we know about his taste?

As both executor and *camerarius* Pierre de Montbrun was again responsible for the tomb of Cardinal Enrico da Susa, the celebrated canonist better known as Hostiensis, which was also once in the Dominican church at Viterbo but is unfortunately not preserved.[25] In 1272 Pierre was chosen as archbishop of Narbonne, Clement IV's former see. At Narbonne, the former papal chamberlain was also commemorated in an ostentatious monument in the cathedral within the Chapelle de Saint-Pierre, for whose construction he was himself responsible.[26] The tomb design is recorded in a drawing made for Roger de Gaignières (Fig. 5). It makes at the very least an interesting comparison with that of Clement IV at Viterbo. It is considerably more up-to-date with its pleurants, angels supporting the head-cushion, and lion at the feet of the effigy.[27] Here again, however, one must be careful not to indulge in what I earlier termed the posthumous patronage fallacy, with the dead man being responsible for the style of his own tomb. Nonetheless, in the case of Pierre de Montbrun, we can form some view of his taste. A prime document for this is the jewel-like oratory which he erected in the episcopal palace at Narbonne.[28] Regrettably, the paintings in the oratory are now shadows of their former magnificence, but enough survives to testify to a sophisticated and up-to-date taste. The tiny cross-vaulted chapel opens off the great upper hall of the palace. Its depth is one and a quarter meters, its width half a meter more (Fig. 6). On the altar wall the scene of the Annunciation is divided by a lancet window, an arrangement later current in Italy, most memorably at San Leonardo al Lago.[29] The keystone bears Montbrun's coat of arms oriented so as to face the spectator as he enters the oratory. The *basamento* is decorated with fictive drapery, a motif which can be found in both contemporary painting and sculpture in France, and the ceiling has a pattern of gold stars set against a blue background.[30] On the left wall, when entering, the main picture

field is of the Crucifixion, with a censing angel in the lunette above, while the main field opposite shows Ecclesia and Synagogue with a second censing angel above. Enough is preserved on the exterior wall of the chapel to indicate that it was also elaborately painted. The iconography of the individual scenes is evidently French, but the decorative organization of the painted oratory has its artistic roots in Italy. It is only five years later in date than the paintings commissioned by Nicholas III at the Sancta Sanctorum, which, however, Montbrun is unlikely to have seen, and the apse of the Upper Church at Assisi.[31] A more striking, and certainly more relevant comparison is the Crucifixion executed in Santa Prassede in Rome, the titular church of Cardinal Ancher Pantaléon, and almost certainly painted during his cardinalate (Fig. 7).[32]

Pierre de Montbrun's oratory at Narbonne suggests a sophisticated taste, as indeed does the patronage of Charles d'Anjou at Aix-en-Provence. It is wholly understandable, therefore, that the tomb of the French pope Clement IV for whose erection Pierre may be held responsible was the first surviving effigial tomb in central Italy. It may be that, given his building activity at the cathedral, archbishop de Montbrun was responsible for his own tomb, as well — a famous Italian example of this procedure was that of Boniface VIII in his private chapel in Old Saint Peter's.[33] More significant analogies, however, can probably be derived from the behavior of Charles d'Anjou in providing a tomb for his protégé Innocent V.[34] For Innocent V, Charles directed his vicar in Rome Hugues de Besançon to provide an appropriate tomb.[35] What more can we deduce from this episode?

Porphyry tombs for popes seem to have last been used from Innocent II (*nomen est omen?*), and more recently Honorius III (1216–1227) had occupied a *concha porphiretica* in Santa Maria Maggiore.[36] The reuse of such a material, with its powerful imperial resonances, was more significant than the reuse of marble sarcophagi. A strigillated sarcophagus had indeed been used, although in a somewhat reticent manner, even for the tomb of Clement IV.[37] Charles recognized that such porphyry vessels were uncommon and difficult to obtain — although ironically enough his supplanter and successor in Sicily, Pere III d'Aragon, obtained one for his Cistercian foundation of Santes Creus in Catalonia — and so he proposed an alternative in the event of failure. If Hugues de Besançon was

unable to obtain a suitable porphyry container he was to provide a
tomb imitating that of Amicie de Courtenary, the recently deceased
wife of Robert d'Artois, who had been buried a few years previ-
ously with much pomp in Old Saint Peter's.[38] Unfortunately, we do
not know which solution was employed. Nevertheless, it is clear
that when in Rome, Charles d'Anjou's first preference was for a
"Roman" tomb. Outside Rome a more overtly French taste appears
to have been more acceptable. We know too little, alas, of the tomb
of Martin IV, another councillor of the king of France, but once
again, we can perhaps glean some indication of his personal stylistic
preferences.[39]

Honorius IV, the successor of Martin IV, made arrangements
for the transfer of a silver statuette of Saint Cecilia garnished with
precious stones to Martin's former titular church at Rome.[40] Silver
statuettes of saints from thirteenth-century France have very seldom
survived, but there is enough contemporary material preserved to
provide some inkling of the style of Martin IV's donation. It should,
perhaps, be reiterated here that there is no substantial evidence
from the cardinals' wills and inventories, which do survive in sur-
prising quantity, that Frenchmen were the first to bring ivories or,
indeed, other northern gothic artifacts into Italy.[41] The earliest evi-
dence, in fact, of northern gothic objects in the south comes from
inventories and gifts of Italian prelates: the inventory of Cardinal
Ottaviano degli Ubaldini, which records his "argentum quod fuit
laboratum Parisius;" Pope Nicholas III, who left an ivory image to
Santa Maria in Trastevere; Goffredo of Alatri, who also owned an
ivory Virgin at his death in 1287; and the inventory of Benivenga
Bentivenghi (f. 1290) indicates that he too collected northern arti-
facts.[42] Thirteenth-century Christendom was a continuum and the
gifts of northern European sovereigns of manuscripts, such as that
purchased by Hostiensis in Paris, were the normal events of an
international ecclesiastical career.[43] A letter of the bishop of Hereford
Thomas Cantelupe is a grovelling apology for not being able to sup-
ply the aged and influential Roman cardinal Matteo Rosso Orsini
promptly with an altarfrontal and *superfrontale* of *opus anglicanum*.[44]
Matteo Rosso Orsini was perhaps unusual in that he travelled abroad
relatively little, but the Franciscan cardinal Bonaventura, in con-
trast, spent more time in the period between 1236 and 1257 in Paris
than he did in Italy, and, during his generalate of the Order

(1257–1274), the Maestro di San Francesco decorated the Lower Church at Assisi.[45] John Pecham, the notably austere Franciscan archbishop of Canterbury, was pursuing the executors of his predecessor as primate, Robert Kilwardby, for a Bible costing over 100 marks, the property of the archdiocese, which Kilwardby had taken to Italy.[46] It seems probable, however, that Kilwardby had died intestate and that the Bible had been sold.[47] Thus, sufficient evidence exists to indicate that the flow of foreign bibelots and manuscripts into central Italy was a phenomenon divorced from nationality, and it is to other aspects of the problem which we must now turn.

One more generally applicable index of taste, where one may compare the taste of Italian and ultramontane cardinals, as briefly suggested earlier, is in their seal matrices. Seals were jealously guarded, destroyed at their owner's death, and in general appear to reflect personal taste.[48] Here, one may point to the matrix of Cardinal Ottobuono Fieschi and its evident analogies with contemporary English seals, for example those of Robert Stichil or Merton Priory.[49] The letters of Ottobuono indicate that he enjoyed his travels through the English countryside as papal legate; and his will demonstrates his respect for Henry III and reverence for English saints such as Thomas à Becket. It has recently been suggested, on the testimony of the newly discovered Ampleforth leaf of the Oscott Psalter, that Ottobuono was, in fact, the ecclesiastic who commissioned that splendid manuscript (Fig. 8).[50] Even if one feels, as I do, that the case for the Oscott Psalter is unproven, such close similarities exist between Ottobuono's seal matrix and those cited above as to make it certain that it is an English design. But his seal is an exception, and in general it may once again be said that the seals of French cardinals are no more gothic than those of Italians or others.

Where then is any impact to be seen? I believe, first of all, that we should approach the problem from another angle. Urban IV, the first pope with whom we are concerned, may serve as an example. As Jacques Pantaléon, the future pope had been archdeacon of Liège and legate in Poland prior to his appointment in April 1255 as patriarch of Jerusalem.[51] In 1249 he is alleged to have sent his sister, a religious at the nunnery of Montreuil-en-Thiérache, the copy of the Veronica which is now preserved in the cathedral of Laon.[52] The stylistic characteristics of the copy may indicate that he

acquired it during his legation in Eastern Europe. As pope, he was later to collaborate with an aristocratic Roman lady in the building of Sant'Urbano ai Pantani, and a comparison between this church and his more celebrated commission of Saint-Urbain at Troyes is instructive.[53]

Saint-Urbain, begun in 1262 on the site of the house where the pope had been born, is one of the most structurally audacious of French churches (Fig. 9). Although still incomplete at Urban's death in 1264, the building nevertheless progressed at great speed, supported by the pope on the most generous financial scale.[54] The skeletal structure, with its remarkable stained glass windows, was, despite commando-style raids stage-managed by an aggrieved local nunnery, substantially advanced by the time of Urban's death. There can be little doubt that it represents the kind of church the pope wished for as his monument in his native Troyes. This slender, supremely elegant building provides an extraordinary contrast to the church for which he was contemporaneously responsible in Rome, Sant'Urbano ai Pantani. This nunnery, near the Roman Forum, was a single aisled church without a transept and with a flat east end. The roof was supported on heavy diaphragm arches. Its round-topped windows were small, and the exterior walls of the nave of tufa faced with brick, unarticulated. The contrast with Saint-Urbain could hardly be more marked (Fig. 10).[55] Unfortunately, the church of Sant'Urbano was demolished in 1933 to make way for Mussolini's Via dei Fori Imperiali, and the only record of its existence are a few summary plans and photographs taken at the time of its destruction.[56] Some impression of what the church may have looked like can be gained from the surviving late thirteenth-century church built by the Caetani within their Rocca beside the mausoleum of Cecilia Metella, San Nicola Capo di Bove.[57] The difference between Urban's two churches is stark and the distinction can usefully be followed into the next generation.

Ancher Pantaléon, the nephew of Urban IV, projected into high ecclesiastical office, as were so many often unsuitable but well-connected young men, became cardinal priest of Santa Prassede in 1261. Vastly affluent, he undertook the completion of Saint-Urbain at Troyes.[58] He negotiated important donations of roofing timbers and building stone for the transept from Charles d'Anjou, who himself had special reasons for gratitude towards the dead pope. Ancher

himself made the church generous gifts of plate and vestments. A financial crisis gripped the church after his death in 1286, but before that Ancher had been responsible for one of the most astonishing of the surviving elements of the decoration of Saint-Urbain, the superb piscina in the choir (Fig. 11).[59] In its elaborate sculptural program Urban and Ancher are shown presenting models of the church to Christ, models sufficiently detailed to provide important evidence for the progress of the building. The diaphanous construction of the piscina, and the anecdotal nature of much of its sculpture have been seriously neglected. The upper level with its tiny armed figures resolutely defending the battlements represents the precocious symbolic use of a later popular motif. The idea of the church as fortress and the symbolic use of military detailing in ecclesiastical architecture is a fertile field which awaits adequate investigation.[60] Perhaps coincidentally, military detail was to be exploited, more or less contemporaneously, on a monumental scale in the apsidal architecture of Narbonne cathedral.

It is also instructive to compare the work at Troyes with enterprises which Ancher promoted in Italy. Unlike his uncle, Ancher resided for a number of years in Rome. As the laudatory inscription now set above the cardinal's splendid tomb in his titulus, Santa Prassede, records, Ancher was comparably open-handed to this Roman church as he had been to Saint-Urbain. Very probably, Ancher re-roofed Santa Prassede, a ninth-century church imitating Old Saint Peter's in plan. The diaphragm arches used there are not dissimilar from those utilized earlier at Sant'Urbano ai Pantani.[61] The painted Crucifixion on a nave pier near to the right transept mentioned earlier, may also be dated to his cardinalate. Ancher's tomb, no longer in its original location in the church, is a magnificent, if neglected example of contemporary tomb sculpture in Rome. Its form with the effigy on an arcaded bier swathed in an elaborately draped pall decorated with fleurs-de-lys was to prove extremely influential. While again we must guard against taking the tomb as evidence of Ancher's own person taste — there is absolutely no evidence to suggest that it was executed during his lifetime — it is not out of keeping with what we know of his piscina at Troyes.[62] But we may perhaps suggest that one of his French executors, perhaps that other canon of Laon, Félix de Troyes, took a hand in the commis-

sion.[63] Also, Ancher's seal matrix is of notable quality and shows an advanced figure style in its design.[64]

Urban IV and Ancher, the first generation so to speak of the French papacy, had relatively little impact on Italian architecture. Charles d'Anjou in the south, with his meticulous repetitions of the Royaumont architectural style, was quite different. Innocent V, despite being ceremonially escorted to Rome for his coronation by Charles, was pontiff too briefly to undertake any significant patronage projects, although, at the assiduous Ancher's solicitation, he did issue several indulgences for Saint-Urbain at Troyes.[65] Martin IV was an entirely different matter. A former keeper of the Great Seal of France and, in the words of a contemporary chronicler, wholly devoted to the interests of his countrymen, Martin was, nevertheless, an ardent support of the Franciscan order. He wished himself to be buried at Assisi, a desire, which if carried out, would have represented the second French papal tomb in a modern mendicant church.[66] Recently, there have been suggestions that it was during his pontificate that the nave painting in the Upper Church at Assisi was initiated, but the evidence for this supposition is exiguous.[67] A more tangible record of Martin's building activity is provided by his work on the papal palace at Orvieto.[68]

Painting and manuscript illumination occupied a different time scale. Perhaps the most suggestive, indeed puzzling example is the work of Pietro Cavallini in Santa Cecilia in Trastevere. During the period in which the painting program in Santa Cecilia was being planned and executed the titular cardinal was a Frenchman, Jean Cholet, a man of considerable personal wealth if his will is any guide. Born at Nointel (Oise), and a contemporary of Martin V as canon of Rouen, he had been titular of Santa Cecilia since 1281, in succession to Martin himself. Cholet's will was drawn up at Montier-la-Celle in 1289, shortly before his death in Rome in August 1292.[69] This will deals almost certainly only with his transalpine property, if the example of the nearly contemporary French Dominican cardinal Hugues Aycelin is a reliable guide to current practice. Cholet's specifically Italian testament is lost.[70] Cholet had founded a chapel dedicated to Santa Cecilia at Beauvais, presumably after the 1272 rebuilding of the choir vaults which had collapsed in 1247, and had donated a window with an inscription. All this is now lost, but the

window may very well have been comparable to that given by Cardinal Nicholas de Nonancourt to his home cathedral of Évreux.[71] It has recently become clear through the researches of the late Robert Branner, that Cholet commissioned a number of fine manuscripts in Paris. One of these, a missal now in the Seminario Arcivescovile at Padua, has a colophon identifying the cardinal as patron. The stylistic position of this manuscript within the group plausibly linked by Branner to Cholet, indicates a dating for the whole group to after 1281, that is, considerably later than they are commonly dated by students of French manuscript illumination.[72] Like Martin before him, Cholet commissioned an image of Santa Cecilia in the chapel of Saint Leonard in the cathedral at Beauvais. Furthermore, in his will he made generous provision for a chantry chapel in the great abbey of Saint-Lucien at Beauvais.[73] The elaborate canopy of his tomb was recorded by Gaignières. Cholet was thus demonstrably an active patron of sculpture and stained glass. Can one observe any impact of the French cardinal in Cavallini's frescoes in his Roman titulus?

Our knowledge of the painted decorations in Santa Cecilia has been substantially increased by the recent restoration campaign.[74] Above the baroque ceiling a number of additional standing figures have been recovered adding to those long known. These monumental figures set within gothic niches constitute a striking novelty in Roman painting: standing figures inside churches are a fashion which develops in French churches after the example of Saint-Louis' Sainte-Chapelle (Fig. 12).[75] The framing of figures in gothic niches is without major precedent in Rome, and, indeed, its only significant Italian forerunner is to be found in the right transept of the Upper Church at Assisi, where a non-Italian painter is now generally agreed to have been active.[76] The other aspect of the program requiring comment is the iconography of the Last Judgement on the reverse facade. Here Christ prominently displays his wound, while also without precedent in Italy, the enthroned apostles prominently hold their attributes.[77] This iconographic convention was well-established in French gothic sculpture, and may be seen at Chartres and Amiens.[78] Other northern elements appear in Cavallini's Last Judgement, and significantly the enthroned apostles in Giotto's Arena Last Judgement, which owes much to Roman precedents,

have no attributes. In general, the frescoed program of Santa Cecilia is consistent with the promptings of a French patron.

Whereas the emphasis thus far has been on Italian art as patronized by Frenchmen in Italy some other connections deserve a concluding comment. The tomb of Isabelle d'Aragon at Cosenza is one of the most striking examples of an imported work by a Parisian sculptor (Fig. 13).[79] In 1271, the king's young consort had drowned while courageously attempting to ford a river in flood and was buried in the Duomo at Cosenza. The Cosenza monument is an entrail tomb, and a comparison between the monument in Calabria and the deposit tomb at Saint-Denis is very illuminating. The convention of erecting an entrail tomb at the place of death, and deposit tomb for the bones appears to have been extensively developed, particularly by the French royal family.[80] The tomb at Saint-Denis is made of marble and qualitatively far finer. Yet, it is also more conventional in design. But, the monument for the wife of a reigning sovereign, albeit in a foreign kingdom, merited special treatment. The tomb at Cosenza is a state monument abroad. It is close in date to the lost monument of Amicie de Courtenay in the Vatican, and there may have been other French royal tombs in Italy.[81] From surviving monuments in Italy, however, there seems little evidence of its influence in Italian sepulchral sculpture, and even in France it appears strangely uninfluential as a tomb design, although a number of statues of the Virgin close to it in date betray notable similarities of pose and drapery style.[82]

A second example. It is increasingly clear that with the death of Boniface VIII and during the brief pontificate of Benedict XI, the possibility of the papacy abandoning Rome was openly canvassed. With the reluctant departure of the Curia northwards after the election of Bérard de Goth as Clement V, Rome's precocious "renaissance" withered, and the artists departed.[83] The atrophy was to last for a century and a half. It has recently been established that the papal mosaicist Filippo Rusuti and his workshop quit Rome for France even before the travailed conclave at Perugia of 1304.[84] Roman artists also painted at Béziers in a chapel commissioned by Cardinal Bérenger Frédol l'Ancien. There, in the Chapelle de la Trinité established by Frédol in 1307, a workshop steeped in the style of Pietro Cavallini struggled,

as had earlier painters at San Francesco at Assisi, to adapt to the constricted, architecturally articulated spaces of a northern gothic church (Fig. 14).[85]

Rusuti departed even earlier, however. So early in fact, that it raises the possibility that his departure was associated with the disgrace of the Colonna family and their departure for France, since he had been deeply associated with the Colonna and their decorative program at Santa Maria Maggiore (Fig. 15). Rusuti with his associates Nicolaus and son Johannes worked for the French crown at Paris and Poitiers.[86] The continuity of payments to this Roman workshop in the royal accounts make it very unlikely that Rusuti returned to Italy. If a major Roman mosaicist was in the French royal service during the first two decades of the fourteenth century can one detect any influence on Parisian painting? It may be that the leading miniaturist of the *Bible Historiale* made for Jean de Papeleu had some contact with Roman painters in France (Fig. 16), and the related paintshop which worked on the *Vie de Saint-Denis* shows an interest in perspectival recession which may well indicate a similar influence.[87]

In any event, the diaspora of Italian artists after the departure of the papacy saw Italian painters working for French patrons in France itself. It is this which perhaps shows the extent of changes in attitudes and aesthetic sensibilities. In the third-quarter of the thirteenth century French ecclesiastical patrons in Italy, financially constrained by the pitiless struggle against the Hohenstaufen, had relatively little impact on Italian style. Rome is, however, notoriously voracious of the art of the late Middle Ages. French patrons, in the main, were content to accept different styles in Italy and in France. In the last quarter of the century the enduring presence of French patrons in Italy conditioned their taste and this familiarity had the effect of opening up Italian art, albeit tentatively, to northern gothic influence in both iconography and, to a more limited extent, in style. This intervention in Italian artistic patronage, however, had the consequence of French patrons re-exporting Italian art with the transference of the papacy northwards. The Angevin monarchy in Naples quickly employed Cavallini, as the Capetians employed Rusuti. The Italianisms of Jean Pucelle and the success of Simone Martini and Matteo Giovanetti at Avignon are in part the result.

NOTES

*A first draft of this paper greatly benefited from the careful reading of Professor John Larner, to whom I am most grateful.

1. E. G. Léonard, *Les Angevines de Naples* (Paris, 1954); and P. Herde, *Karl I. von Anjou* (Stuttgart, 1979). For Charles I's relations with Tuscany, see A. S. Terlizzi, *Codice Diplomatico di Carlo d'Angiò con la Toscano* (Florence, 1914). A full itinerary is printed in P. Durrieu, *Les Archives Angevines de Naples. Bibliothèque des Écoles Francaises d'Athènes et de Rome*, XLVI, LI (Paris, 1886-87), II, 163-213.

2. E. Martène and U. Durand, *Thesaurus Novus Anecdotorum*, II (Paris, 1717), col. 141.

3. G. Ianziti, "Patronage and the Production of History," in F. W. Kent and P. Simon, eds., *Patronage, Art and Society in Renaissance Italy* (Oxford, 1987), 300.

4. For the papal palace at Viterbo, see G. Radke, "The Papal Palace at Viterbo" (Ph.D. diss., New York University, 1980).

5. R. Brentano, "Violence, Disorder and Order in Thirteenth-Century Rome," in L. Martines, ed., *Violence and Civil Disorder in Italian Cities 1200-1500* (Berkley, 1972): 308-30.

6. For the tomb of Clement IV, see now G. B. Ladner, *Die Papstbildnisse des Altertums und des Mittelalters*, II, *Monumenti di Antichità Cristiana. II ser. IV* (Città del Vaticano, 1941-1984), 143 ff. J. Gardner, "Arnolfo di Cambio and Roman Tomb Design," *Burlington Magazine* 115 (1973): 424. I. Herklotz, *'Sepulcra' e 'Monumenta' del Medioevo* (Rome, 1985), 164.

7. The most up-to-date biographical sketch of Clement IV is Y. Dossat, "Gui Foucois, enquêteur-reformateur, archévêque et pape (Clément IV)," *Les Évêques, les Clercs et le Roi. Cahiers de Fanjeaux.* 7 (Toulouse, 1972), 25-37.

8. J. Gardner, "The Tomb of Cardinal Annibaldi by Arnolfo di Cambio," *Burlington Magazine* 114 (1972): 141.

9. J. Gardner, "A Princess among Prelates: A Fourteenth-century Neapolitan Tomb and its Northern Connexions," *Römisches Jahrbuch für Kunstgeschichte* 23 (1988): 50.

10. R. Branner, *St. Louis and the Court Style* (London, 1965), esp. ch. V, launched this concept on an enduring career. In fact, it is rather the plurality of styles at court which should be emphasized. See recently, C. Bruzelius, *The Thirteenth-century Church of Saint-Denis* (New Haven, 1985), esp. 165 ff.

11. Dossat, "Gui Foucois," 29 ff. and 36.

12. J. Bony, *French Gothic Architecture of the Twelfth and Thirteenth Centuries* (Berkeley, 1983), 435 ff. L. Sigal, "Contribution à l'histoire de la

cathédrale Saint-Just de Narbonne," *Bulletin de la Commission Archéologique de Narbonne* 15 (1921): 11–153; and Dossat, "Gui Foucois," 39.

13. M. Powicke, "Guy de Montfort (1265–1271)," *Transactions of the Royal Historical Society* 4th ser., 18 (1935): 1–23.

14. Dossat, "Gui Foucois," 43.

15. A. Erlande-Brandenburg, *"Compte-rendu* of M. Durliat, 'La signification de la cathédrale de Narbonne et sa place dans l'architecture gothique', *Narbonne. Architecture et Histoire.* II. *Narbonne au Moyen-Age* (Montpellier, 1973), 209–15," *Bulletin Monumentale* 131 (1973): 374–75. Professor Vivian Paul has recently reminded me that this text survives only in a fourteenth-century redaction. However, there appears to be no reason to doubt that it is a copy of a genuine document of the thirteenth century.

16. Paris, Archives Nationales 6239 (Impression of 1260). See M. Douet de l'Arcq, *Archives de l'Empire. Inventaires et Documents. Collection des Sceaux.* Première partie. II (Paris, 1867).

17. For this episode, see C. Nicolas, *Un Pape Saint-Gillois. Clément IV dans l'Église* (Nimes, 1910), 185.

18. Dossat, "Guy Foucois," 45. H. Suchier, *Denkmäler Provenzalischer Literatur und Sprache* (Halle, 1883), 271–83.

19. Radke, "The Papal Palace," 147.

20. Most recently, see J. Gardner, "The Cosmati at Westminster: some Anglo-Italian reflections," (forthcoming); and, for a different interpretation, P. C. Claussen, *Magistri Doctissimi Romani* (Stuttgart, 1987), 174 ff.

21. C. Pinzi, *Storia della città di Viterbo*, I (Rome, 1887), 273; N. Kamp, "Una fonte poco nota sul conclave del 1268–1271: i protocolli del notaio Basso della Camera Apostolica," *Atti del Convegno di Studio. VII Centenario del I Conclave (1268–1271)* (Viterbo, 1975), 167; E. Petrucci, "Il problema della vacanza papale e la costituzione 'ubi periculum' di Gregorio X," ibid., 86.

22. L. Gatto, "Il conclave di Viterbo nella storia delle elezioni pontificie del '200," *Atti del Convegno di Studio. VII Centenario del I Conclave (1268–1271)* (Viterbo, 1975), 49ff.; and Radke, "The Papal Palace," 239.

23. B. Guidonis, *Vita Gregorii X*, in L. A. Muratori, ed., *Rerum Italicarum Scriptores*, III (Milan, 1723–38), col. 597, "Domino Johannes Cardinalis tempore quo Cardinales inclusi pro electione pontificis tenebantur, dicebat ludendo ceteris cardinalibus discooperiamus hanc domum, quia Spiritus Sanctus non potest per tot coopercula pertransire."

24. Herklotz, *'Sepulcra' e 'Monumenta'* 164; and E. T. Ripoll and A. Brémond, *Bullarium Ordinis Fratrum Praedicatorum*, VIII (Rome, 1729–40), 45–46, " . . . quoddam marmoreum sepulchrum . . . fabricari fecerat. . . . " See also n. 6 above.

25. A. Paravicini Bagliani, *I testamenti dei Cardinali del Duecento. Miscellanea della Società Romana di Storia Patria*, XXV (Rome, 1980), 138.

26. Sigal, "Contribution," 79.

27. L. Serbat, "Monuments Réligieux Cathédrale," *Congrés Archéologique. LXXIIe. Session. Carcassone et Perpignan* (Paris, 1906), 79–91; J. Adhémar and J. Dordor, "Les tombeaux de la Collection Gaignières. Dessins d'Archéologie du XVIIe. Siècle," *Gazette des Beaux Arts* 106 (1974): 1–192, n. 403. There are surviving tombs of similar type in the cathedral of Rodez.

28. R. Mésuret, *Les peintures murales du Sud Ouest de la France du XIe. au XVIe. Siècle* (Paris, 1967), 192–94; E. Castelnuovo, *Un pittore italiano alla corte di Avignone* (Turin, 1962), 15; and Y. Carbonelle-Lamothe, "Récherches sur la construction du Palais Neuf des Archévêque de Narbonne," in *Narbonne* (cit. n. 15 above), 217–35.

29. E. Borsook, "The frescoes at San Leonardo al Lago," *Burlington Magazine* 98 (1956): 351–58.

30. Montbrun's arms are "De gueules à un mont d'azur surmonté d'un créquier de sinopie à sept branches bordé et componé d'azur." Mésuret, *Les peintures murales*, 192; and, V. Perret, "Les fresques de l'oratoire de l'église haute de la Madeleine a Narbonne," *Bulletin de la Commission Archéologique de Narbonne* 33.2 (1953–55): 146–56.

31. J. Gardner, "Nicholas III's Oratory of the Sancta Sanctorum and its Decoration," *Burlington Magazine* 115 (1973): 283–94; J. Wollesen, "Eine 'Vor-Cavallineske' Mosaikdekoration in Sancta Sanctorum," *Römisches Jahrbuch für Kunstgeschichte* 18 (1979): 11–34; and *idem*, "Die Fresken in Sancta Sanctorum," *Römisches Jahrbuch für Kunstgeschichte* 19 (1982): 37–83.

32. I plan to discuss this painting more fully elsewhere.

33. G. Poggi, "Arnolfo di Cambio e il sacello di Boniface VIII," *Rivista d'arte* 3 (1905): 187–98; Gardner, "Arnolfo di Cambio and Roman Tomb Design," 428 ff.; and M. Maccarrone, "Il sepolcro di Bonifacio VIII nella Basilica Vaticana," in *Roma Anno 1300. Atti della IV Settimana di Studi di Storia dell'Arte Medievale dell'Università di Roma 'La Sapienza'. 19–24 Maggio 1980* (Rome, 1983), 757.

34. M. H. Laurent, *Le Bienheureux Innocent V (Pierre de Tartentaise) et son temps. Studi e testi* 129 (Città del Vaticano, 1957); and Gardner, "The Tomb of Cardinal Annibaldi," 141.

35. "Quia sanctissimus pater et dominus noster dom. Innocencius papa V aput Urbem, ubi habemus regimen, fuit viam universe carnis ingressus et intelleximus quod aliquis se non intromictit de faciendo tumulo pro eodem, volumus et tibi presentimus mandamus quatinus per Urbem inquiras et inquiri facias diligenter si aliquia conca profidis [!] vel alicuis

alterius pulcri lapidis prout ille que sunt in Sancto Iohanne Laterani, poterit inveniri, quam si invenimus, emas de pecunie curie nostre que est etc. et in ea corpus dicti summi pontificis reponi facias diligenter in ecclesia Sancti Iohannis predicti in aliquo loco eminenti. Et si conca predicta non poterit inveniri, volumus quod de predicta pecunia curie nostre fieri facias sepulturam consimilem illi comitisse Attrebatensis et etiam si fieri pulcriorem, in qua corpus eiusdem summi pontificis sollemniter reponatur. Datum etc."

36. J. Deér, *The Dynastic Porphyry Tombs of the Norman Period in Sicily*. Dumbarton Oaks Studies 5 (Cambridge, Mass., 1959): 146 ff.; and Herklotz, *'Sepulcra' e 'Monumenta'*, 97.

37. Ladner, *Die Papastbildnisse*, 145; Gardner, "Arnolfo di Cambio," 424. For the porphyry vessel obtained for the tomb in Santes Creus, see G. Lo Bue de Lemos, "Le tombe di Pietro III d'Aragona e di Ruggiero di Lauria," *Archivio storico sciliano* ser. III, 7 (1955): 279–86; and B. C. Rosenman, "The Royal Tombs in the Monastery of Santes Creus" (Ph.D. diss., University of Minnesota, 1984).

38. Gardner, "Arnolfo di Cambio," 427; and Gardner, "A Princess among Prelates," 50.

39. Martin had wished to be buried at San Francesco, Assisi, but, dying in Perugia, his remains were obstinately retained by the Perugians despite the efforts of Honorius IV to have the wishes of the deceased pontiff respected. For this episode, see M. Prou, ed., *Les Registres de Honorius IV. Bibliothèque des Écoles Françaises d'Athènes et de Rome*, ser. 2, 7 (Paris, 1898 f.), no. 270; and n. 66 below.

40. Prou, ed., *Registres de Honorius IV*, no. 65 (17 June 1285). See, recently, S. Romano, "Alcuni fatti e qualche ipotesi su S. Cecilia in Trastevere," *Arte Medievale* II, 1 (1988): 117. I am not persuaded that it was a papal commission.

41. D. Lüdke, *Die Statuetten der gotischen Goldschmiede*, II (Munich, 1983), 526 ff., n. 173.

42. Ubaldini's inventory is published by G. Levi, "Il cardinale Ottaviano degli Ubaldini secondo il suo carteggio ed altri documenti," *Archivio della Reale Società Romana di Storia Patria* 14 (1891): 297 ff., and no. XXIV. For the ivory given by Nicholas III to Santa Maria in Trastevere, see P. Egidi, *Necrologi e libri affini della provincia romana. Fonti per la Storia d'Italia*, I, 44 (Rome, 1908), 97. M. Prou, "Inventaire des meubles du Cardinal Geoffroi d'Alatri," *Mélanges de l'École Française d'Athènes et de Rome* 5 (1885): 401 n. 271. A. Tenneroni, "Inventario di sacri arredi appartenuti ai Cardinali Bentivenga e Matteo Bentivenga d'Acquasparta," *Archivio storico italiano* 5, 2 (1888): 262.

43. Paravicini Bagliani, *I Testamenti*, 135 n. 10: "Bibliam quam emi Parisius sine glossis et sine postillis illuminatam auro et azuro in uno volumine ordini Predicatorum lego."

44. R. G. Griffiths and W. W. Capes, *Registrum Thome de Cantilupo Episcopi Herefordensis*. *Canterbury and York Society*, II (London, 1907), 223 ff., 7 October 1270: " . . . nec moleste feratis si placet, si dicta ornamenta tardius ad vos venerint quam exprimat littera memorata, quia licet fecerim operatices eorum ut accelerarent in operando quam plurium excitari, vix tamen secundo die Octobris eadem ornamenta poterant extrahi de manibus earundem completa."

45. J. F. Quinn, "Chronology of St. Bonaventura (1217–1257)," *Franciscan Studies* 32 (1972): 168–86; and J. G. Bougerol, "Saint Bonaventura et le roi Saint Louis," in *S. Bonaventura, 1274–1974*, II (Grottaferrata, 1973), 469–93. For the date of the Lower Church frescoes, see B. Brenk, "Das Datum der Franzlegende der Unterkirche zu Assisi," in *Roma Anno 1300*, 229–37. See also J. Cannon, "Dating the Frescoes by the Maestro di San Francesco at Assisi," *Burlington Magazine* 124 (1982): 65–69.

46. E. Sommer-Seckendorff, *Studies in the Life of Robert Kilwardby, O.P.* Istitutum Historisum FF. Praedicatorum Romae as S. Sabinae. Dissertationes Historicae. Fasc. VIII (Rome, 1937), 123.

47. Paravicini Bagliani, *I Testamenti*, 33 n. 2.

48. J. Gardner, "Some Cardinals' Seals of the Thirteenth Century," *Journal of the Warburg and Courtauld Institutes* 38 (1975): 72–95.

49. J. Gardner, "Some Cardinals' Seals," 77 and fig. 10b. For the seals of Bishop Stichil and of Merton Priory, see Royal Academy of Arts, London, *The Age of Chivalry* (London, 1987), 317, no. 278 and 319, no. 283.

50. D. Turner, "Two Rediscovered Miniatures of the Oscott Psalter," *British Museum Quarterly* 34 (1969): 10–19; and N. Morgan, *Early Gothic Manuscripts 1250–1285*, II (London, 1987), 136 ff., cat. no. 151a.

51. W. Sievert, "Das Vorleben des Papstes Urban IV," *Römisches Quartalschrift* X (1896): 451–505, and XII (1898): 127–61.

52. A. Grabar, *La Sainte Face de Laon* (Prague, 1930), passim. Important reservations concerning the authenticity of the letter appear in Sievert, "Das Vorleben," 127 ff. O. Demus, *Byzantine Art and the West* (London, 1970), 206, regards the icon as Bulgaro-Byzantine and dates it to the late twelfth century.

53. C. Ceschi, "S. Urbano ai Pantani," *Capitolium* 9 (1933): 280–91; and J. Gardner, "Patterns of Papal Patronage *circa* 1260–*circa* 1300," in *The Role of the Papacy: Ideals and Reality*, Pontifical Institute of Medieval Studies (Toronto, forthcoming).

54. F. Salet, "Saint-Urbain de Troyes," *Congrès Archéologique de France. 113e. session* (Troyes, 1955), 96–112; and M. T. Davies, "On the Threshold of the Flamboyant: the Second Campaign of Construction of Saint-Urbain de Troyes," *Speculum* 59 (1984): 848 ff. For the depredations of the nuns from Notre-Dame aux Nonnains, see C. Lalore, "Documents sur l'abbaye de Notre-Dame aux Nonnains de Troyes," *Mémoires de la Société Académique de l'agriculture des sciences et belles-lettres du Départment de l'Aube* 38 (1874): 121, and Davies, "On the Threshold," 851.

55. Ceschi, "S. Urbano ai Pantani," remains the only substantial published analysis of this structure.

56. Photographs of an eighteenth-century ground plan are preserved in the Archivio Communale di Roma.

57. See most recently M. Righetti Tosti-Croce, "Un ipotesi per Roma angioina: la cappella di S. Nicola nel castello di Capo di Bove," in *Roma Anno 1300*, 497, whose re-dating I find unpersuasive.

58. C. Bruzelius, "The second campaign at Saint-Urbain at Troyes," *Speculum* 62 (1987): 636. For Ancher's other French patronage, see H. Millet, *Les chanoines du chapitre cathédral de Laon, 1272–1412*, Collection de l'École Française de Rome, 56 (Rome, 1982), 448–49.

59. Salet, "Saint-Urbain de Troyes," 105, suggested a date of 1265. A. Didron, "Une piscine du Moyen-Age," *Annales Archéologiques* 7 (1847): 36–40.

60. C. H. Coulson, "Hierarchism in Conventual Crenelation," *Medieval Archaeology* 26 (1982): 69–100, is an important introduction to the topic. I owe my knowledge of this article to the kindness of my Warwick colleague Richard Morris.

61. R. Krautheimer, *Corpus Basilicarum Christianarum Romae*, III (Città del Vaticano, 1937–77), 245.

62. For Ancher's tomb, see Gardner, "Arnolfo di Cambio," 432. I intend to discuss Ancher's artistic patronage more fully in a forthcoming book. See also n. 58 above.

63. Millet, *Les chanoines*, 94.

64. A cast of his seal, dated 1270, is in the Archives Nationale, Paris. See Douet d'Arcq, *Archives de l'Empire*, no. 6139.

65. Bruzelius, "The Second Campaign," 638.

66. F. Bernini, ed., Salimbene de Adam, *Cronica*, II, ed. F. Bernini (Bari, 1942), 289 ff. "Martinus IIII . . . ultimum diem clausit, et Assisii in Ecclesiam Francisci sepulturam eligit, quia totaliter erat intimus amicus Ordinus Fratrum Minorum."

67. A. Monferini, "L'Apocalisse di Cimabue," *Commentari* 18 (1966): 25–55; and P. Scarpellini, ed., *Ludovico da Pietralunga, La Basilica di San Francesco d'Assisi* (Treviso, 1982), 393 ff.

68. R. Bonelli, "Il Palazzo Papale di Orvieto," *Atti del II Convegno Nazionale dell'Architettura* (Assisi, 1937), 211-20; D. Valentino, "Il restauro del Palazzo Papale di Orvieto," *Bollettino d'arte* 60 (1975): 209; and Radke, "The Papal Palace," 292.

69. Paravicini Bagliani, *I Testamenti*, 250 ff. For Cholet, see E. Müller, "Le cardinal Jean Cholet," *Mémoires de la Société Académique de l'Oise* 11 (1880): 790-835.

70. Paravicini Bagliani, *I Testamenti*, 51 n. 1.

71. See M. Baudoit, "Les verrières de la cathédrale d'Évreux; cinq siècles d'histoire," *Nouvelles de l'Eure* 27 (1966): 29 and fig. on p. 26.

72. A. Barzon, "Codici Miniati," in *Biblioteca Capitolare della cattedrale di Padova* (Padua, 1950), 13-14. R. Branner, *Manuscript Illumination in Paris during the Reign of Saint Louis* (Berkeley, 1977), 130 ff. and fig. 391. The explicit on folio 310v reads: "Explicit missale dni Iohis dicti cholet. Dns conservet eum. Amen."

73. Paravicini Bagliani, *I Testamenti*, 251; and Müller, "Le cardinal Jean Cholet," 815.

74. See, most recently, AA.VV. *Restauri agli affreschi del Cavallini a Roma. Quaderni di Palazzo Venezia*, 4 (Rome, 1987), 9-44; and A. M. Romanini, "Il restauro di S. Cecilia a Roma e la storia della pittura architettonica in étà gotica," in *Tre Interventi di Restauro* (Rome, 1981), 75-78.

75. W. Sauerländer, "Die Sainte-Chapelle du Palais Ludwigs des Heiligen," *Jahrbuch der Bayerischen Akademie der Wissenschaften* (1977): 1-24; and *idem, Gotische Skulptur in Frankreich 1140-1270* (Munich, 1970), 152.

76. The hypothesis was first given substantial form by C. Volpe, "La formazione di Giotto nella cultura di Assisi," in G. Palumbo, ed., *Giotto e I Giotteschi in Assisi* (Rome, 1969): 23 ff. H. Belting, *Die Oberkirche von San Francesco in Assisi* (Berlin, 1977), 192 ff. See Scarpellini, *Ludovico da Pietrlaunga*, 374 ff., for a valuable synthesis. For a recent discussion of the problem, see V. Pace, "Presenz oltremontane ad Assisi: realtà e mito," in *Roma Anno 1300*, 239-51.

77. R. Offner, *A Corpus of Florentine Painting*, section III, vol. V (New York, 1947), 251-59; and R. Feldhusen, *Ikonologische Studien zu Michelangelos Jüngstem Gericht* (Bad Liebenzell, 1978), 42 ff.

78. Sauerländer, *Gotische Skulptur*, figs. 107, 110-11 (Chartres) and 161-62 (Amiens).

79. Gardner, "A Princess among Prelates," 47 ff.; and A. Erlande-Brandenburg, *Le Roi est Mort. Bibliothèque de la Société Française d'Archéologie*, 7 (Geneva, 1975), 169 ff.

80. Gardner, "A Princess among Prelates," 47 ff.

81. Ibid., 49.

82. R. Suckale, *Studien zu Stilbildung und Stilwandel der Madonnenstatuen der Ile-de-France zwischen 1230 und 1300* (Munich, 1971), 159 ff. (Saint-Omer), 164 ff. (Précy-sur-Oise), figs. 18 and 20, and p. 162.

83. J. Gardner, "The Stefaneschi Altarpiece: a Reconsideration," *Journal of the Warburg and Courtauld Institutes* 37 (1974): 102; and, most recently, *idem*, "Bizuti, Rusuti, Nicolaus and Johannes: Some Neglected Documents Concerning Roman Artists in France," *Burlington Magazine* 130 (1988): 381–83. G. Holmes, *Florence, Rome and the Origins of the Renaissance* (Oxford, 1986).

84. Gardner, "Bizuti, Rusuti," 382.

85. M. Meiss, "Fresques italiennes, cavallinesques et autres à Béziers," *Gazette des Beaux-Arts* 79 (1937): 275–86; and L. Bellosi, *La Pecora di Giotto* (Turin, 1985), 123 and p. 143 n. 57. Belting, *Die Oberkirche von San Francesco*, 32, makes the important point about adaptation at Assisi.

86. P. Favreau, "Le palais de Poitiers au Moyen-Age: étude historique," *Bulletin de la Société des Antiquaires de l'Ouest* 4e. ser. 11 (1971): 35–85; and Gardner, "Bizuti, Rusuti," 382.

87. C. Lacaze, *The 'Vie de St. Denis' Manuscript, Paris, Bibliothèque Nationale, Ms. fr. 2090–2092* (New York, 1979), 140 ff., 181 ff., and esp. 202; J. D. Udovitch, "The Papeleu Master: a Parisan Illuminator of the Early Fourteenth Century" (Ph.D. diss, New York University, 1979); and J. Diamond, "Manufacture and Market in Parisian Book Illumination around 1300," in *Europäische Kunst um 1300. Akten des XXV Internationalen Kongresses für Kunstgeschichte*, Wien, 4–10 September, 1983, IV, 101–110.

Insignia of Power: The Use of Heraldic and Paraheraldic Devices by Italian Princes, c. 1350–c. 1500

D'A. J. D. Boulton

HERALDRY, THE ART and "mistery" of the medieval herald, has long been neglected by most serious students of medieval history, whether their interests have been political, social, or artistic. Indeed, since the beginning of the critical study of heraldry about a century ago, the number of medievalists who have devoted much of their energy to the subject has remained very small even in Europe, and understandably smaller in North America. Nevertheless, in the last twenty years or so, the post-war revival of interest in the medieval nobilities of most parts of medieval and Renaissance Europe has contributed to a similar (though considerably less marked) revival of interest in medieval and Renaissance heraldry, led until recently by the French historian Michel Pastoureau.[1]

For a variety of historical reasons, scholarly interest in the rural nobility of Italy in this period has only recently been reawakened,[2] and partially because of this delay, contemporary heraldic usages in that region have received even less critical and systematic work than those of most other regions of Europe.[3] This neglect has inevitably limited our understanding of important aspects of the complex relationship between art and politics in Italy in the three centuries in question, for the princes, *signori*, and barons of Italy were no less likely than their peers in other parts of Latin Christendom to employ insignia of both an heraldic and what I shall call a "paraheraldic" nature to represent graphically such important political concepts as territorial lordship, political adherence,

and dynastic affiliations both agnatic and uterine. Furthermore, while thus functioning as political insignia — especially on the field of battle, in the tournament, and in the other forms of court festival that grew out of the tournament in the fourteenth and fifteenth centuries — heraldic and paraheraldic emblems constituted a recognized genre of artistic expression, often practiced even in its primary environments (shields, banners, and other flags) by leading artists. In fact, the years between 1250 and 1500 are generally regarded by modern heraldists as the classical period of heraldry as an art form, as well as the period that saw the adoption and continued use of heraldic devices — hitherto largely restricted to the battlefield, tournament ground, and seal — as standard elements of decoration in both gothic and Renaissance art in all of its manifestations, major and minor. Despite the well-known peculiarities of Italian society in this period, and the apparent failure of heralds there to assume the role of a secular priesthood of chivalry,[4] the cognizances which the heralds elsewhere came to regulate were no less prominent in the art produced in the Italian peninsula, and many of the finest examples of late medieval and Renaissance heraldic sculpture and ceramic work are to be found there even today.[5]

Three distinct forms of heraldic and paraheraldic cognizance must be distinguished. The oldest and only strictly heraldic ensign was that called the "arms" in English and either *arma/arme* or *stemma* in medieval Italian.[6] True heraldic arms consisted of a design conventionally represented covering the whole surface of a shield or rectangular flag, and composed of fixed, often geometrical elements drawn from a relatively limited conventional repertory (essentially that of Romanesque decoration), depicted in a formalized fashion in two or three fixed contrasting colors (including either gold or silver), in a fixed arrangement, and generally in a fixed number. Arms were usually quite arbitrary in composition and their elements rarely represented anything more arcane than their owner's surname, but they occasionally alluded to the arms of their owner's lord, and in Italy they often included upper bands or "chiefs" of the arms of Anjou or the Empire, indicative of adherence to the Guelph and Ghibelline parties respectively.

Such ensigns had first been adopted as stable cognizances by princes in the middle third of the twelfth century, had come into general use among the knightly class (primarily for use in tourna-

ments) by about 1220, and had come to be thoroughly systematized by the heralds (originally tournament officials) by about 1250. Both old arms adopted before 1220 and new ones created according to the same conventions continued to be used by princes, barons, and lesser nobles throughout our period in every possible environment, alone as well as in combination with other types of ensign. They remained the primary symbol of their dynastic identity, political authority, and noble status, and were commonly conceived of as an almost totemic embodiment of the honor of both the lineage and the individual. In countries where the dynastic type of lineage had become the norm in the nobility, cadets of noble houses had been compelled to distinguish their arms from those of the head of their house through the addition of some sort of mark or "brisure," but in countries like Italy where the nobility was organized into consorterial lineages that ignored the principles of primogeniture and seniority, such differentiating was both less common and less systematic.

At some time in the first third of the fourteenth century the shield of arms (both real and pictorial) seems to have been joined in Italy as in France and England by a second type of cognizance: the helm bearing at its apex a "crest" (*cimiero* in Italian). The crest was a three-dimensional figure of wood, leather, and fabric, sometimes (like the Plantagenet lion statant and the Visconti demi-viper vorant a child) alluding to the arms, but often (like the dog's head between wings of the della Scala, whose arms were a ladder) alluding to something completely different. Indeed, crests were on the whole more fanciful in form and less stable in use than arms, and furthermore — in conformity with the growing taste for naturalism in art — less formalized in both depiction and color. It has been argued that their adoption was fueled at least in part by a widespread desire for a more personal ensign than arms, which had come to be too closely associated with patrilineages and territories.[7] From about 1350 to about 1500 pictorial shields of arms and crested helms were commonly represented together in Italy as in most of transalpine Europe in most of the various environments in which the arms had earlier been displayed, arranged in a sort of trophy that has come to be called in English an "armorial achievement" and in modern Italian a *stemma*.[8]

Finally, at some point in the second half of the fourteenth century, the arms and crests of princes in England, France, and Italy

were joined by the third major type of ensign, the badge or device. This took the form of an object, beast, or plant—typically alone, but sometimes in a set of two or three bound together in some way. Badges were even less restricted in form and color than crests, and they were much more likely than either arms or crests to have some sort of symbolic or allusive significance, usually esoteric. Very often, especially after 1400, this significance was partially explained by a word or phrase (in both Italian and modern English called a *motto*) set on or next to the badge, often on a scroll. The ensigns thus formed were actually worn on clothing or armor in the form of a jewel or a bit of embroidery, and although their form might be similar to that of a crest or of a "charge" on a shield of arms (and despite the fact that they were sometimes actually displayed on a shield like arms), they were normally displayed pictorially—for purposes of decoration, identification, or propaganda—without any sort of frame or support. These ensigns, though commonly associated pictorially with arms and crests, were never fully integrated into either the armorial achievement or the "mistery" of the herald, and they are thus best described as "paraheraldic."[9]

The broad outlines of the history of the heraldic ensigns just described, the arms and crest, have been established for some time now, but the history of the paraheraldic ensigns—what has been called by Michel Pastoureau *l'emblématique parahéraldique*, and what I shall call more simply "paraheraldry"—remains largely to be written. In the past three decades or so literary and cultural historians, stimulated by the pioneering work of Mario Praz,[10] Arthur Henkel, and Albrecht Schöne,[11] have devoted considerable energy to the study of emblems and devices of the Renaissance and Baroque periods, but it would appear that to date no scholar has attempted more than a cursory general examination of the devices of the late gothic period from which both of the former types of figure were unquestionably derived.[12] Since the later emblems used throughout Europe were all of Italian inspiration, the question of the origin of the use of their paraheraldic antecedents in Italy is of particular interest. I shall accordingly devote what remains of this brief essay to this subject. I shall first suggest a conceptual framework and terminology for the discussion of paraheraldic ensigns,[13] and then attempt to establish when, how, and why the principal forms of ensign came to be employed by Italian princes in the fourteenth century.

For my discussion of the individual elements of paraheraldry, I shall adopt a terminology based upon that suggested by Michel Pastoureau[14] — one of the few scholars who has approached the subject in anything like a systematic way — and integrated both with the terminology developed by the students of the more elaborate *emblemata* for the sixteenth through eighteenth centuries[15] and with the one I have myself developed for the classification of real and pseudo-orders of knighthood.[16] Following Pastoureau, I shall employ the contemporary English word "badge"[17] to designate a simple paraheraldic figure without a motto, and the term "device" (derived from the contemporary French term *devise* and corresponding to the contemporary Italian term *divisa*) to mean a simple emblematic composition including both a badge and a motto.[18] I shall not use the modern Italian word *impresa* (adopted in the sixteenth century to designate the new, allegorical type of composition called in English an "emblem,"[19] and loosely applied since that time to both badges and devices), since that term and its equivalents (French *enprinse/emprise*, and so forth) were primarily reserved in our period for a particular type of badge or device, symbolic (as the name suggests) of participation in a chivalrous "enterprise."[20] I shall apply the adjective "paraheraldic" only to badges and devices that were adopted in addition to, rather than instead of, heraldic arms, and could be (and commonly were) displayed in some sort of association with arms. This restriction will eliminate from consideration numerous superficially similar ensigns used in all periods, including those adopted in Italy after about 1250 by such corporate bodies as the *Società d'Armi* of Bologna.[21] Devices of the latter sort may be described as either "non-heraldic" or (when like the Bolognese ensigns they have some of the characteristics of heraldic devices) "quasi-heraldic."

Any attempt to establish precisely when the custom of adopting paraheraldic devices began must similarly confront the fact that, unlike heraldic arms after 1250, such devices were not characterized by exclusiveness, stability, or even a single pattern of use. In the fourteenth and fifteenth centuries a man who employed a single shield of arms and a single crest — the first normally and the latter commonly inherited from his father — might make use of several distinct badges or devices at the same time, some inherited and some adopted. While he might keep some of these for life or even pass them on to his descendants, he might abandon others after a

brief period, and adopt yet others according to his whim. It is thus imperative to divide the paraheraldic devices into distinct classes, and to consider the history of each of these classes separately (though not in isolation) from the others. Since there were no rules governing the form that either badges or devices could take, the *principal* classes of any taxonomy, at least, will have to be based on the intended longevity and/or function of the devices they comprise. I propose a system of classes in which a primary division is made between badges and devices that were intended to be ephemeral — to be used only for a brief, and often definite period of time — and those that were intended to be stable — employed, that is, for a relatively extended period of time, typically indefinite.

The class of *ephemeral badges and devices* may then be divided into five subclasses: (1) one made up of what are best termed *occasional devices*, which were adopted for use only for a particular occasion such as a tournament, solemn entry, or other similar court festival, and were then disregarded completely; (2) one made up of what may be called *periodic devices*, which were adopted for use during a certain fixed period, such as a year, and replaced by a new device when that period had elapsed; (3) one of what may be called *votive devices* or *emprises*, which as we have noted were borne in token of a vow to accomplish some chivalrous enterprise, and were discarded when the vow was fulfilled; (4) one of *amorous devices*, borne by a single individual as a mark of his or her love (often for one dead); (5) and finally one of what are perhaps best termed *propagandistic devices*, which were intended to announce or counter some significant position or claim, especially during a military or political campaign, and discarded when the situation had ended.

The general class of *stable badges and devices* may similarly be divided into five subclasses: (1) one of *corporate devices*, borne collectively and individually by the members of a non-monarchical corporate body such as a confraternity or religious order; (2) one of *personal devices*, borne like heraldic arms only by one individual at a time, as a mark of his identity or personality, and not distributed to others; (3) one of *livery devices*, adopted by a prince or lord and distributed (often along with a uniform of one or several fixed colors) to members of his household, his retinue, and his affinity as a sign of their service and adherence to him; (4) one of what may be called *ordinal devices*, associated with membership in a formally con-

stituted monarchical order of knighthood maintained by a prince, and used to confer honor upon the prince's servants, adherents, and allies, as well as to proclaim their attachment to him; and (5) one of *pseudo-ordinal devices*, which, though distributed for much the same purposes as those of the ordinal type, and actually designated by the term "order" or some equivalent term, were in reality only a more honorable version of the livery device.

Since the turn of the present century, various more or less informed conjectures have been proposed by scholars concerning the time (and place) of the introduction of the practice of adopting paraheraldic devices of some or all of these types. All of the scholars in question have placed the inception of the practice in the fourteenth century, but they have disagreed about the particular part of the century.[22] I cannot claim to have the final answer to these questions, but my own research suggests that the adoption of devices began in England and proceeded in several distinct stages: that ephemeral devices were adopted first, in the two decades between 1330 and 1350, and that the use of stable devices developed from this earlier practice in two stages during the four decades following 1346. So far as I have been able to discover, true paraheraldic devices were first employed in the 1330s, when Edward III of England is recorded as having displayed both badges and mottoes of the classic type in tournaments held in his court.[23] These devices (of obscure but probably allusive significance) were not only displayed on various forms of hangings, along with arms and various other decorative motifs, but seem to have been worn (on some occasions at least) by all of the members of the royal team in the tournament.

The association of the earliest devices with tournaments was not unexpected, for this form of mock-war had been converted over the previous century into a relatively harmless and highly decorative festival of chivalry, at which the prince who staged it could appear as a patron of the nobility and of its traditional customs and values.[24] Furthermore, the heralds themselves were essentially tournament officials, and the use of both arms and crest by ordinary knights developed out of the needs of the tournament rather than the battlefield. Edward III of England, who assumed control of his kingdom in 1329, was himself an enthusiast for chivalry in the Arthurian tradition, and staged at least fifty tournaments between that date and 1350—considerably more than any other contempo-

rary prince.[25] It is thus far from surprising that the use of paraheraldic devices first developed at tournaments held in his court in that period.

Similar devices may well have been employed in the same period in tournaments staged in northern France and adjacent areas of the Low Countries, whose nobilities had a close relationship with the English court, but the research on this region remains to be done. In Italy the use of paraheraldic devices before 1350 is not only unattested but unlikely, for according to recent research the tournament proper (the *torneamento* as distinct from the *bagordo*) seems to have been introduced there only in 1328, when Can Grande I della Scala held one in Verona, and between that date and 1366 only two further tournaments are recorded: one more in Verona in 1334, staged by Can Grande's successor Alberto II; and one in Mantua in 1340, held by the first Gonzaga *signor*, Luigi I.[26]

Down to 1346 all of the devices known to have been employed by Edward III seem to have been purely occasional, and were probably soon forgotten.[27] The first stable paraheraldic device certainly used in England, and the first such device to have any real political significance, was in fact the mysterious blue garter bearing the famous motto *Hony soit ke mal y pense*, which seems to have been adopted by Edward in 1346 both as a propagandistic device for his upcoming campaign in France, and as the ordinal device of the chivalrous order he had proclaimed as a revival of the Round Table in 1344, and actually established as the Order of St. George *alias* the Garter in 1349.[28] This was actually the second monarchical order of knighthood to be founded in Western Christendom — a type of order distinguished by the permanent attachment of its presidential office to the crown of its princely founder — but the one earlier order (that of the Band of Castile, founded in 1330) had been given a cognizance of a very different type: a simple stripe of contrasting color applied diagonally across the front and back of the tunic of its members.[29] So far as I have been able to determine, the English garter was the earliest stable device of any paraheraldic type to be adopted anywhere, and it was certainly the primary model for the devices of similar monarchical or princely confraternal orders founded by the Kings of France,[30] mainland Sicily, Germany and Bohemia,[31] and Cyprus,[32] in the years between 1347 and 1359.

The device of the second of these orders, formally designated the Company of the Holy Spirit of Right Desire but informally known from its device as the Company or Order of the Knot, was thus in all likelihood the first stable paraheraldic device adopted by a prince in Italy. The order in question was proclaimed in Naples on the day of the coronation of King Loysi or Lodovico "di Taranto," second consort of Queen Giovanna I, in 1353, and its statues (probably composed by the Florentine Nicola Acciaiuoli, Loysi's chief minister) were based directly on those of the French order founded by Jehan II in the previous year. The badge of this superficially romantic monarchical order was a love-knot (symbolic of the indissoluble bonds of fraternity) that could be untied and retied to indicate the achievement of the order's ostensible goal of "right desire" (one of several specified feats of arms followed by a journey to the Holy Sepulchre), and it was accompanied by a French motto (*Se Dieu plaist*) that was to be altered (to *Il a pleu a Dieu*) when the knot was finally retied and augmented with the rays of the Holy Spirit. This ingenious device—partially inspired by the prizes awarded to successful competititors in tournaments—thus appealed at once to the chivalrous ideals of knightly brotherhood and equality and to the current vogues for chivalrous enterprises and pious pilgrimages, while evoking both the traditions of the Round Table and the inspiration of the Holy Spirit. It may also have evoked the conventions of courtly love, for at a tournament staged by Edward III in 1342 the love-knot had served as a prominent element of the decorative scheme,[33] and another Franco-Italian prince was soon to adopt a love-knot as his badge, as we shall see.

Despite its resemblance to the later votive devices or emprises, however, Loysi's knot resembled the other ordinal devices created by princes in this period in being primarily a kind of livery-badge, the sign of membership in an organization created to promote loyalty and service to the king, who served as its perpetual and hereditary president. Those who wore the device—knights drawn at least in part from the leading families of the *Regno* and possibly from those of central and northern Italy as well—were almost certainly seen by their contemporaries as members of a sort of royal party or faction in the state. As such the Company of the Knot was in important respects similar to the local and regional confraternities

that had been founded in northern Italy during the middle third of the previous century to combat heresy and Ghibellinism, and had functioned as corporate embodiments of the Guelfic party.[34]

Although these confraternities had all fallen on hard times by 1300, they may well have served as a model for the first princely (though not strictly monarchical) order of knighthood, the Fraternal Society of St. George, established in 1325 or 1326 by King Károly I of Hungary[35] — for Károly, christened Carlo Roberto, was the great-grandson of the first Angevin King of Sicily, and had been born and raised in Italy in close association with the Guelfic cause. The Fraternal Society of St. George in its turn probably served as a model for a political confraternity dedicated to and named after St. Catherine, which was founded by Károly's nephew the Dauphin Humbert of Viennois at some time in 1330s,[36] and that society probably inspired the first of two political confraternities founded by Humbert's neighbor Count Amé VI of Savoy.

This brings us back to Italy again, for Amé or Amadeo was also the Duke of Aosta and "Marquis in Italy," and as such was deeply involved in the political life of northern Italy. In fact his first society — called the Company of the Black Swan — was founded on the occasion of the marriage in September 1350 of his sister Blanche to Galeazzo Visconti, future Lord of Milan, and the latter was among the founding members. The device from which this society took its name — a black swan with red beak and legs — was displayed on a white shield. It was thus of a quasi- rather than paraheraldic form, and may have been inspired by the rather similar ensigns adopted in the previous century by such north-Italian confraternities as the Bolognese *Società d'Armi*, which often took the form of a beast of some sort, and were commonly displayed both with and without a shield.

The Savoyard state, straddling the Alps as it did, seems to have been the principal conduit into Lombardy for the chivalrous culture cultivated in the royal courts of England and France in this period, and especially during the long reign of Amé VI — who was known from the green livery he first distributed at the tournament held to celebrate his *adoubement* in 1352 as the "Green Count." Amé seems to have had regular contact with the court of Edward III, and in 1355 he strengthened his ties to the French court by marrying Bonne, sister of Duke Louis II of Bourbon and sister-in-law of the

Dauphin and future King of France Charles V. Not surprisingly, Amé — who was perhaps the first prince in Christendom to adopt a stable color for his livery — seems to have been the first prince in northern Italy to found an order of knighthood on the new, neo-Arthurian model: the Order of the Collar, probably created in Avignon in January 1364.[38] During the course of its history between 1364 and 1500, this order — which still exists today under the name of the *Annunziata* — included among its fifteen companions some of the leading princes of Burgundy and Italy as well as many of the leading barons of the Savoyard state.

In form Amé's order was a sort of cross between the Order of the Garter and his own earlier Company of the Black Swan, and thus had an Italian as well as an English component, but its insignia were entirely of the new English type. As the order's name would suggest, its device was a zoniform collar, probably inspired by the English garter, from which hung a circlet of three love-knots, identical in form (and probably in significance) to the knot which had served as the device of the Neapolitan royal order until its collapse on the death of its founder in 1361. The collar itself was sometimes ensigned with individual love-knots, and with the comital motto *fert*, of obscure significance. The latter was apparently adopted at about the same time as the knot, but it was never exclusively associated with it. What is of most interest in the present context is that, while the collar proper had been invented for the order and always represented membership in it, the love-knot seems to have been adopted by Amé at some time before the order was founded, and used as stable personal badge.[39] Certainly it continued to be employed in this way after the foundation of the order. The love-knot of Savoy thus constituted one of the earliest known stable paraheraldic badges not symbolic of membership in an organized order, as well as the first preexisting badge to be incorporated into the insignia of an order to indicate its founder's proprietary interest.[40]

I say "one of the earliest known stable badges", because it is not clear how long before his foundation of the order Amé had adopted the love-knot as a badge, and various other princes are known to have adopted stable non-ordinal badges and mottos in or shortly after the year 1360. These princes included three of the sons of Edward III of England — Edward "the Black Prince" of Wales,

Lionel Duke of Clarence, and John Duke of Lancaster — all of whom employed at least one stable device by 1368 at the latest, and two of whom certainly did so by 1363.[41] Across the Channel, Jehan Duke of Berry and Auvergne, younger brother of the new king Charles V, had adopted a bear for use as a badge by 1365, and on his great seal of 1370 the bear is accompanied by a swan, its constant companion for the next five decades.[42] Another French prince, Duke Louis II of Bourbon (the brother-in-law of Count Amé of Savoy), is known to have adopted a stable device very similar to the English garter — a belt bearing the motto *Esperance* — immediately after returning from captivity in England in October 1366, and shortly thereafter, on the first day of 1367, is known to have founded a knightly order with an entirely different device, a golden shield bearing the motto *allen* (dialect for *allons*).[43]

The evidence that I have so far discovered thus points to the seventh decade of the fourteenth century as the period in which the custom of adopting stable badges and devices not associated with orders began, and points once again to the royal court of England as the place in which the custom began. There is also every reason to suppose that the custom was inspired by the association of essentially similar devices with the orders of knighthood founded by kings (and especially Edward of England himself) in the immediately preceding decade, and that the earliest stable devices adopted by subordinate princes were seen as being inferior equivalents to the devices of orders, suitable to the lesser station of their creators.

Unlike the practice of adopting heraldic arms two centuries earlier, the use of stable badges and devices spread very unevenly in Western Christendom in the decades following 1360. It cannot be surprising that in England, where the practice seems to have begun, it spread very rapidly indeed, not only in the princely but in the baronial stratum of the nobility, so that by the beginning of the fifteenth century almost every lord of any consequence (including from 1390 the king himself) seems to have marked both his property and his retainers with one or several stable paraheraldic badges or devices. In France the use of stable badges and devices seems to have remained the prerogative of princes for a longer period, and came to be systematized to a unique degree in the royal court. Recent research has shown that on the accession in 1380 of the

young king Charles VI, under the tutelage of his uncles the Dukes of Anjou, Berry, and Burgundy, a truly revolutionary system of symbolism was introduced in the court, under which all members of the *compaignie du roy* from the king and the princes of the blood royal down to the humblest servants were constantly dressed in livery costumes of particular sets of colors (such as red-white-black) and bearing particular badges and mottoes. Through most of his forty-two year reign Charles VI and his counsellors decided at some point in every year what colors and devices would be worn by the court during the following year, and had hundreds of vestments in those colors and bearing those devices—their material, cut, and decoration varying according to the rank of the recipient—distributed to the courtiers. In this system, ephemeral badges and mottoes used only for a year or two were commonly intertwined with stable ones—like the broom-plant and the winged white stag—that were used throughout the reign and even beyond it.[44]

In Italy the use of stable devices on the Anglo-French model was adopted by some princes, at least, in the 1360s and 1370s, but there orders of knighthood were founded outside the Savoyard dominions only by kings or princes with a pretension to royal rank. Since there were only two independent kingdoms in greater Italy—mainland and island Sicily—orders and ordinal devices were associated exclusively with the princes of the Houses of Barcelona, Capet d'Anjou, and (from 1381) Capet de Valois-Anjou, who occupied or attempted to occupy their thrones. New monarchical orders were founded by the heads of the first two of these dynasties in the first decade or so of this period: at some time between 1371 and 1379, Pere "the Ceremonious" of Aragon, who on the death of his cousin Federigo III in 1377 had claimed the reversion of the Kingdom of island Sicily, created an order for his dominions, dedicated to and named after St. George, the patron of Aragon,[45] and in 1381 Carlo III "di Durazzo" founded the first successor to the defunct Company of the Knot, the Order of the Ship, immediately after seizing the throne of mainland Sicily from his cousin Giovanna I.[46]

The latter society was by far the most elaborate lay order founded anywhere in this period, and bore the closest resemblance to an organized party dedicated to the service of its royal president. Its statutes were based in part on those of the Knot, but may have

owed even more to the (unknown) current version of the statutes of the Hungarian Society of St. George—and thus to the Guelfic confraternities of the thirteenth century—since Carlo had been raised in the court of his cousin Lajos (or Louis) "the Great" of Hungary. The basic badge of the new order—a ship in a patch of sea denuded of ropes, sails, oars, anchors, and flags—could be augmented with any and all of those articles, in various positions and colors, to indicate the accomplishment of feats of arms in the king's service. The known members of the order were mostly members of the upper baronage of the *Regno*, but the statutes not only make provision for the admission of foreign princes—by which the princes of northern Italy were almost certainly intended—but also for the admission by the latter of knights of their own lands. Given the great ambitions of Carlo "di Durazzo," who saw himself as the heir to the hegemony within Italy as a whole that had been enjoyed a century earlier by the first king of his line, it is not unlikely that he hoped to use his order to create a political affinity stretching into every part of the peninsula. Had he not been assassinated shortly after his successful seizure of the throne of Hungary in 1386, he might well have succeeded, at least for a time; instead, the order he founded simply collapsed, and its badge ceased to be worn.

Carlo's widow Margherita, who assumed the regency of the kingdom before being driven out by Duke Louis II of Anjou (head of the Valois line of claimants), immediately adopted a new device—an *argata*, which seems to have meant "spool" or "capstan."[47] Whether this device was symbolic of membership in a true order is unclear, since by 1380 the word "order" and its equivalents were beginning to be used in the sense of "stable livery badge," and outside of England they were as likely to be employed as any other term to designate the new type of ensign.[48] This practice, if often confusing, is also highly suggestive, for it implies that devices of this sort were closely linked in the minds of contemporaries to the notions of political adhesion and service that membership in a true order entailed. In an Italian context, they would have served a function similar to that served by the devices of the Guelfic confraternities in the previous century.

If Queen Margherita's capstan was not the badge of a true order, but only a livery-badge comparable to those in common use by 1386 in both England and France, it might well have been the

oldest of its type to be used in southern Italy. Otherwise that honor probably belongs to the white patriarchal cross adopted as a badge at some time before 1380 by her husband's rival Duke Louis I of Anjou,[49] and maintained by his son Duke Louis II, who from 1386 to 1399 was the effective king of much of mainland Sicily. I have so far found no evidence for the employment of any device in the court of Naples, either ordinal or livery, between 1399, when Margherita's son Ladislao was finally reestablished, and the death of his sister and successor Giovanna II in 1435, but Alfonso "the Magnanimous" of Aragon introduced his own devices of both types when he finally entered Naples as a conqueror in 1443, and these were maintained and elaborated by his successors.[50] His son and successor in Naples, Ferrante I, founded his own monarchical order, that of the Ermine, in 1465,[51] and its insignia were proudly displayed, along with those of the Garter, by his ally Federigo da Montefeltro, first Duke of Urbino, in a famous portrait[52] and in a manuscript of the *Divina Commedia*.[53]

In the fifteenth century most of the rulers of the new *signorie* of central and northern Italy made use of paraheraldic devices,[54] but the chronology of their adoption remains to be established. There is reason to think that one or more of these princes began to employ at least one stable badge in the period between about 1366 — when the first of a new series of sixteen tournaments and jousts staged by the lords of Mantua, Milan, Ferrara, and Padua was held — and about 1385.[55]

Among the first of the Lombard *signori* to take up the new custom — and quite possibly *the* first — was Galeazzo II Visconti, who from 1354 to 1378 shared the lordship of Milan with his brother Bernabó (who may have been made a knight of the Neapolitan order of the Knot at some time between 1352 and 1362) and from 1359 maintained his own brilliant court in Pavia.[56] Galeazzo is, in any case, a likely candidate for the role of initiator, for among the *signori* of Lombardy he had the closest ties to the courts of France and England, as well as to that of Savoy. In 1350, as we have already noted, Galeazzo had joined the Company of the Black Swan and married the sister of its founder, the Green Count. In 1361 the first son born to this marriage, Gian Galeazzo, was married through the mediation of the same count to Isabelle, daughter of King Jehan II and sister of the future King Charles V. A few

years later, in June 1368, Galeazzo's daughter Violante was married
to Lionel "of Antwerp," Duke of Clarence, the second son of Edward
III of England, in a famous ceremony attended by Petrarch him-
self.[57] After five of the eighteen courses of the enormous banquet
that followed the wedding proper, Galeazzo is said to have distrib-
uted buttons or other objects bearing his own arms and those of his
new son-in-law, but no mention is made in the accounts of the
badge attributed to him by later historians and certainly used by his
son Gian Galeazzo after his death: the *divisa dell'acqua e de fuoco*,
which consisted of a ragged staff set diagonally, burning at its lower
end and supporting at its upper end two pails of water suspended
from the same rope.[58] Precisely when he adopted this badge is
unclear, but it is likely that he was inspired to do so by the badges
he saw on the liveries worn by the retainers of the Duke of
Clarence, who was one of the first English princes to employ a
stable badge.

The evidence I have found for Galeazzo II's use of a stable
badge is thin, but fortunately there is a wealth of evidence for the
use of at least one further stable device by his son Gian Galeazzo,
who was Count of Vertus in Champagne from the time of his mar-
riage in 1361, co-Lord of Milan from the death of his father in
1378, sole lord from 1385 (when he ousted his uncle Bernabo), and
first Duke of Milan from 1395 to his death in 1402. Gian Galeazzo
is unlikely to have made use of any badge before the wedding of his
sister to Lionel of Clarence in 1368, when he was only sixteen, and
would have had relatively little use for one before 1371, when at
twenty-one he began to take an active part in public affairs. His
favorite device as Duke of Milan was a turtledove set against a sun
and bearing a scroll with the motto *A bon droit* which was the subject
of a poem — the *Canzone morale fatta per la divisa del conte di Virtù* —
composed by the Visconti court poet Francesco Vannozzo.[59] This
device had certainly been adopted before Gian Galeazzo's elevation
to ducal status in 1395, as it appears along with other devices in the
famous books of hours still preserved in two parts in the Biblioteca
nazionale of Florence, in which he is still styled "count."[60] In fact, it
was probably adopted between 1368 and 1374, for the poet Petrarch
(who lived in Milan from 1353 to 1361, attended Violante's wed-
ding in 1368, and died in 1374) claimed to have suggested the
device to Gian Galeazzo.[61]

In the book of hours, the three elements of that device appear in a great variety of settings, both together and separately, and they are associated with both the arms and the two crests of the Visconti. In the first part of the manuscript, illuminated by Giovanni dei Grassi for Gian Galeazzo himself, the dove-and-sun device is the only one thus represented,[62] but in the second part, illuminated at some time between 1412 and 1433 by Belbello da Pavia for Gian Galeazzo's son and successor Filippo Maria, it is occasionally replaced either with the fire-and-water device of Galeazzo II[63] or with two other stable badges, used both separately and in combination: a *nodo* or knot in the form of a white cloth twisted tightly at the center and tied into a circle; and an open crown enfiling an upright frond of palm paired with a frond of laurel.[64] This and a fifteenth-century book of the arms and devices of the various members of the Visconti and Sforza families[65] seem to indicate that Filippo Maria himself adopted the latter devices, but preserved his father's stable device, just as his father had preserved the fire-and-water device of his own father.

Eventually, the heirs of Galeazzo Visconti would adopt at least twenty-two distinct devices — more than any other dynasty either in Italy or elsewhere in Europe[66] — and would employ them in every possible environment. Evidence such as a banner[67] showing six different Visconti badges and devices repeated in panels in the bordure around the arms of Visconti impaling those of Pavia, and a Milanese sarcophagus of c. 1420,[68] on which the devices of the dove-and-sun and the sun alone are prominently carved in the company of the badges the Cypriot pseudo-order of the Sword, the Castilian pseudo-order of the Band, the English royal livery-collar of "SS," and several other badges,[69] indicates clearly that some, at least, of the stable devices used by the Visconti rulers of Milan were employed not merely to identify and decorate their owner's property, but as livery and pseudo-ordinal devices indicative of the political adherence of those who wore them. They were thus a prime example of art in the service of politics.

NOTES

1. Among the studies by Pastoureau himself may be cited his *Traité d'héraldique* (Paris, 1979), *L'Hermine et le Sinople: Etudes d'Héraldique Médiévale*

(Paris, 1982), and *Figures et Couleurs* (Paris, 1986). Other important scholarly works on heraldry published recently include D. L. Galbreath, *Papal Heraldry* (London, 1972); O. Neubecker, *Heraldry: Sources, Symbols, and Meaning* (Maidenhead, 1976), trans. into French by R. Harmignies as *Le grand livre de l'héraldique* (Brussels, 1977); and D. L. Galbreath and Léon Jéquier, *Manuel du Blason* (Lausanne, 1977).

2. In Italy, as elsewhere in Europe, there has been lately a revival of interest in the medieval nobility, and a debate is now in progress about the extent to which Italy was 'defeudalized' or 'refeudalized.' There are still very few general accounts of the nobility of later medieval Italy, but one of the most useful is in John Larner, *Italy in the Age of Dante and Petrarch 1216–1380* (London and New York, 1980), 83–105. Therein (p. 104) he cites in addition three studies by Gina Fasoli: "Feudo e castello" in the Einaudi, *Storia d'Italia*, V. pt. 1 (Turin, 1972–6); *Monumenti di storia e storiografia feudale italiana* (Bologna, 1957); and "Signoria feudale ed autonomie locali" in *Studi ezzeliniani* (Rome, 1963). On the nobility of the Regno, see R. Moschati, "Ricerche e documenti sulla feudalità napoletana nel periodo angioino," *Archivio storico per le provincie napoletane* 59 (1934).

3. For a long time the most important scholarly account of heraldry in Italy was the article "Araldica" by Cesare Manaresi in the *Enciclopedia italiana*, III (Milan, 1929), 924–47, but several works, of unequal value, have appeared recently, including H. Zug Tucci in the Einaudi, *Storia d'Italia*, vol. X; G. C. Bascapè, *Insegne e simboli: araldica pubblica e privata medievale e moderna* (Rome, 1983); and S. Nero, *Emblemi, stemmi e bandiere delle società d'armi bolognesi* (Florence, 1978). A great deal of basic research still needs to be done before the study of Italian heraldry reaches even the point at which the study of French, German, and British heraldry now stands.

4. On this, see the comments by Professor Larner in this volume. On the rarity of *stemmari* or rolls of arms in Italy before the sixteenth century, see Manaresi, "Araldica," 945.

5. Numerous examples of heraldic sculpture of very high quality are to be found in the courtyards of the Palazzo del Podestà and Museo Nazionale in Florence. See Manaresi, "Araldica," figs. 26 and 30, and tav. CCIV for examples of these.

6. The latter term, which in Greek designated a crown of olive branches of the sort used by the Romans to adorn ancestral images, came to be used in Classical Latin to designate first a genealogical tree, and then the cartouches in which the names of ancestors were displayed. From the latter usage the Italians took the idea of using the word *stemma* to designate the devices painted on shields and displayed on seals, but the term never came into use outside of Italy.

7. M. Pastoureau, "Aux origines de l'emblème: La crise de l'héraldique européene aux XVe et XVIe siècles," in *Emblèmes et devise au temps de la Renaissance* (Paris, 1981); reprinted in *idem, L'Hermine et le Sinople*, 327–33.

8. The terms "arms" and "coat of arms" are often loosely used in English even by heraldists to describe this trophy, but as these terms are more properly applied to the design depicted on the shield, the term "achievement" is to be preferred. The later history of the Italian term *stemma* appears to have been similar to that of the English terms, but I know of no technical word in Italian for the achievement as distinct from the arms.

9. The French version of this adjective was employed in this sense by M. Pastoureau, *Traité*, 205, and "Aux origines d'emblème." He may not have coined the term, but I have not found it in any earlier works.

10. *Studies in Seventeenth-Century Imagery* (London, 1939–45, 2d ed. 1964–74).

11. *Emblemata: Handbuch zur Sinnbildkunst des XVI. und XVII. Jahrhunderts* (Stuttgart, 1967).

12. The most extensive general study is probably that in J. Evans, *Pattern: A Study of Ornament in Western Europe from 1180 to 1900*, I (Oxford, 1931, repr. 1976), 94–113. See also Mrs. B. Palliser, *Historic Devices, Badges, and War-Cries* (London, 1870; repr. Detroit, 1971); A. C. Fox-Davies, *Heraldic Badges* (London, 1907); H. S. London, *Royal Beast* (London, 1958); and C. Beaune, "Costume et pouvoir en France à la fin du Moyen Age: Les Devises royales vers 1400," *Revue des sciences humaines* 183 (1981): 125–46.

13. Unlike heraldry *stricto sensu*, which by 1250 had already acquired a rather elaborate technical vocabulary as well as set of rules governing the possible arrangements of colors and figures, paraheraldry never acquired either rules or a set of terms to describe it, and it has therefore proven necessary to invent one.

14. "Aux origines de l'emblème," 333 n. 15.

15. See especially D. S. Russell, *The Emblem and Device in France* (Lexington, Ky., 1985), 15–24.

16. *The Knights of the Crown: The Monarchical Orders of Knighthood in Later Medieval Europe, 1325–1520* (Woodbridge and New York, 1987), xvi–xxi.

17. According to the *OED*, it is first attested in a work of about 1350 (*St. Alexander*). *Bage* seems to have had a limited use in Middle French, but Godefroy gives only one citation, from 1465. In Middle Latin it gave rise to the word *bagia/bagea*, but the use of this word seems to have been restricted, like its original, to England.

18. In French the word *devise* — an old word with a wide variety of

meanings including division, difference, description, and identifying mark of any sort, heraldic or otherwise—was the usual name for the ensigns of this new type both before and after 1500, but it was used equally of what I have termed the badge, the motto, and the device as a whole. Pastoureau ("Aux origines de l'emblème," 333 n. 16) has pointed out that the term *devise* in French long continued to be ambiguous, since in the period 1500–1800 it still meant both figure and motto, and in the nineteenth century came to be restricted to the motto alone, leaving no term for the composition involving both. In English the term "device" could similarly be applied to badge, motto, and the combination thereof until recently, and the term "badge" has meant either the figure alone or (especially when referring to the insignia of knightly orders) the figure and motto together. Both the French *devise* and its Italian equivalent *devisa* were also applied in the fifteenth century to the colors or sets of colors associated with the livery-uniforms distributed by princes beginning in the later fourteenth century, and closely associated in their evolution and function with the ensigns often embroidered on them. In modern Italian *devisa* still means "uniform," but in French it had lost this sense completely by 1611, and in English it has long been represented by the word "liveries" or the phrase "livery colors."

19. The Greek word *emblema* and its various fifteenth-century derivatives—*emblème*, "emblem," and so forth—have been restricted by modern students to more complex allegorical (and often scenic) compositions accompanied by an epigram, of the type apparently invented by Leonardo da Vinci just after 1500 (probably on the basis of the medallic form of device invented by Pisanello in 1438), and from the 1540s commonly published and explained in "emblem books." In contrast to the device, which was characteristic of the period before 1500 and continued to be employed in France and England down to about 1650, the emblem was characteristic of, as well as peculiar to, the period between 1500 and about 1750, especially in Italy, where it completely superceded the older *divisa* during the course of the sixteenth century. Perhaps for that reason the emblem acquired there the highly misleading name of *impresa*—misleading, because it had nothing in common either in form or in function with the medieval devices originally so called.

20. I have not yet been able to determine precisely when the term *impresa* began to be used of devices not symbolic of a chivalric enterprise. By 1474 it had come into use in Italy as a term for the device of a monarchical order of knighthood—the device of the Order of the Ermine is referred to as the *enpresa de lo Armellino* in a letter of Galeatto Carrafa composed on October 3 of that year. See Boulton, *Knights of the Crown*, 404.

21. See S. Nero, *Emblemi, stemmi e bandiere della società d'armi bolognesi,* 41ff.

22. In 1916, for example, the French archaeologist Camille Enlart (Manuel d'archéologie française, III [Paris, 1916], 404) declared that the vogue for *devises et emblèmes* was at its height between c. 1350 and c. 1450, while in articles published in the *Reallexikon zur deutschen Kunstgeschichte* in 1954 and 1959, Eberhard Schenk zu Schweinsberg and W. S. Heckscher and Wirth tentatively situated the origin of the practice in the "Burgundian courts" in the last third of the same century, and in 1982, Michel Pastoureau placed it in the middle third of the century. In a book on the emblem and device in France published in 1985 (D. Russell, *The Emblem and Device in France* [Lexington, Ky., 1985], 23–24) Daniel Russell cited the first two of these conjectures—none of which is supported by much in the way of research—as equally authoritative.

23. On the use of devices by Edward III, see J. Vale, *Edward III and Chivalry: Chivalric Society and Its Contest 1270–1350* (Woodbridge, Conn., 1982), 57–75. The earliest reference to such a device is in an account of 3 Edward III [i.e. January 25, 1329–January 24, 1330]; "20 'hernes' cum angelis auris et litteris argentis pro Rege" (ibid., 161 n. 16). But the earliest mention of a specific motto seems to be in the account for a tournament held in February 1342 (ibid., 64).

24. On the tournament in medieval Europe, see especially *Das ritterliche Turnier im Mittelalter. Beiträge zu einer vergleichenden Formen- und Verhaltensgeschichte,* ed. J. Fleckstein (Göttingen, 1985), and J. R. V. Barker, *The Tournament in England 1100–1400* (Woodbridge, 1986).

25. Vale, *Edward III,* 172–74.

26. See Thomas Zsabó, "Das Turnier in Italien," in *Das ritterliche Turnier im Mittelalter,* 344–70, esp. 347 and 365. Zsabó makes a sharp distinction among several types of *hastiludium* on the basis of the terms used. According to his research, the term *torneamentum* first appears in any source in 1158, but only appears in an Italian source in 1328, while the term *bagordo* appears continuously from 1208, and the term *giostra* appears in an isolated document of 1212 and then again only around 1300.

27. One such device, a white swan with the accompanying motto "Hay, Hay, the Wythe Swan, by Godes soule I am thy man," which probably alluded to the legend of the Swan Knight, was apparently used by Edward at Christmas festivities in both 1347 and 1348, just before the definitive establishment of the Order of the Garter. It has been suggested that Edward contemplated adopting this device as that of his order, but this seems to me unlikely in the light of the fact that the adoption of the garter itself is now dated to 1346. On this and the use of the swan as a

badge by various European princes after 1350, see A. R. Wagner, *The Swan Badge and the Swan Knight* (Oxford, 1959).

28. See Boulton, *Knights of the Crown*, 152–61.

29. Ibid., 86–91.

30. The *Compaignie ou Societé de Nostre Dame de la Noble Maison*, commonly known as the *Ordre de l'Estoille* or "Order of the Star," established by King Jehan II in October 1352. See Boulton, *Knights of the Crown*, 167–210.

31. The *Gesellschaft in der Fürspang* or "Society of the Buckle," founded by Karl IV, Emperor and King of Bohemia, in 1355. See Boulton, *Knights of the Crown*, 241.

32. The Order of the Sword, founded by Pierre, titular Count of Tripoli, in 1347, and reestablished when he became King of Cyprus in 1359. See Boulton, *Knights of the Crown*, 241–48.

33. Vale, *Edward III*, 64.

34. See N. J. Houseley, "Politics and Heretics in Italy: Anti-Heretical Crusades, Orders, and Confraternities, 1200–1500," *Journal of Ecclesiastical History* 33 (1982): 193–208.

35. See Boulton, *Knights of the Crown*, 27–45.

36. Ibid., 27–45.

37. See E. Cox, *The Green Count of Savoy* (Princeton, N.J., 1967), 259–361.

38. See Boulton, *Knights of the Crown*, 248–70.

39. The principal evidence for this appears to be the statement in the account of January 1364 mentioning the purchase of the first fifteen collars *ad divisam domini*. See L. Cibrario, *Statuts et Ordonnances du très-noble Ordre de l'Annociade* (Turin, 1940), xv.

40. Similarly, the comital motto *fert* seems to have been the earliest stable motto not formally associated with a knightly order.

41. The earliest of these devices was the ostrich feather adopted by the Black Prince, and was first attested on the seal he had made shortly after his elevation to the dignity of Prince of Aquitaine in 1360. His brother John later adopted a similar ostrich feather as a badge (as did many other members of his house), but the earliest badge he is known to have used, the falcon and fetterlock, first appears on the seal he had made for himself in 1363. Their brother Lionel displayed a lion and an eagle as supporters on a seal cut for him in c. 1362–8, and may have adopted in addition the black bull displayed by his heirs. See J. H. and R. V. Pinches, *The Royal Heraldry of England* (London, 1974); and London, *Royal Beasts*, 25–27.

42. See M. Meiss, *French Painting in the Time of Jean de Berry: The Late*

XIV Century and the Patronage of the Duke, 2d ed., Text vol. (New York, 1969), 95–97.

43. See Boulton, *Knights of the Crown,* 271–74.

44. See C. Beaune, "Costume et pouvoir en France à la fin de Moyen Age: Les Devise royales vers 1400," *Revue des sciences humaines* 183 (1981): 125–46.

45. See Boulton, *Knights of the Crown,* 279–88.

46. Ibid., 289–324.

47. Ibid., 294.

48. Ibid., 478.

49. Evans, *Pattern,* 106.

50. In 1416 Alfonso had succeeded his father Ferran of Aragon as the president of the monarchical Order of the Stole and Jar, founded by the latter monarch in 1403, and in 1443 Alfonso introduced this into Naples along with several badges of his own invention.

51. On this order, see Boulton, *Knights of the Crown,* 402–26.

52. Published in J. J. [Viscount] Norwich, *The Italians: History, Art, and the Genius of a People* (New York, 1983), 109.

53. Rome, Biblioteca Apostolica Vaticana, MS. Urb.Lat. 365, of which folio 1 and 97, displaying the devices of both orders in different combinations, are published in J. J. G. Alexander, *Italian Renaissance Illuminations* (New York, 1977), pls. 23 and 25.

54. See, for example, Evans, *Pattern,* I, 113 (on the Medici devices), and Mario Praz, "Gonzaga Devices," in *Splendours of the Gonzaga,* ed. D. Chambers and J. Martineau (London, 1981), 65–72.

55. Zsabó, "Das Turnier in Italien," 344–70. It is not clear that there was any causal relationship between the revival of the tournament and the adoption of badges, but there might well have been.

56. For this and what follows, see especially, D. M. Bueno de Mesquita, *Gian Galeazzo Visconti, Duke of Milan. A Study in the Political Career of an Italian Despot* (Cambridge, 1941), and *Storia di Milano,* ed. G. Martini, V, *La Signoria dei Visconti* (Milan, 1955).

57. On this feast see *Annales Mediolanenses, Rerum italicarum scriptores* (hereafter *RIS*), xvi, cols. 738–40; Giovanni de' Musi, *Chronicon Placentium, RIS,* cols. 509–11; A. S. Cook, "The Last Months of Chaucer's Earliest Patron," *Transactions of the Connecticut Academy of Arts and Sciences* (1916): 1–44. I am grateful for these references to John Larner, who himself describes the banquet in some detail in *Italy in the Age of Dante,* 211–13.

58. *Storia di Milano,* v, 891, citing G. Giulini, *Memorie spettanti alla storia, al governo e alla descrizione della città e della campagna di Milano nei secoli bassi,* V (1st ed., Milan, 1760; 2d ed., 1854), 597.

59. *Storia di Milano*, V, 892, citing Novati, *Il Petrarca*, 73–81.

60. Florence, Biblioteca Nazionale, MS Banco Rari 397 and MS Landau-Finlay 22; published by P. Toesca, *L'Uffiziolo Visconteo Landau-Finlay donato alla città di Firenze* (Florence, 1951); and by M. Meiss and E. W. Kirsch, *The Visconti Hours* (New York, 1972).

61. *Storia di Milano*, V, 891. The device is described in the letter as "turturem cum brevi notula *a bon droit* radiantis solis in medio."

62. The device or one of its parts occurs at least once on many of the illuminated pages of the first part of the manuscript, Banco Rari 397. The sun is often depicted alone, replacing the arms of the Visconti on a blue shield under the second Visconti crest on fol. 23, opposite a normal Visconti achievement, alternating with the two versions of the Visconti achievement in the quatrefoils set in the corners of fol. 48, etc.

63. Borne by two pink sejant lions wearing created helms in Landau-Finlay, fol. 41.

64. These occur in combination both with one another and with the dove-and-sun device on Landau-Finlay, fol. 85ᵛ, which depicts the latter device surrounded by the knot surmounted by the crown encircling the two fronds, the whole set on a blue shield set in the upper right corner of the page opposite a similar shield bearing the dove-and-sun device alone, and alternating with shields of the arms of Visconti in the other corners of the page.

65. Milan, Biblioteca Trivulziana, cod. 1390, f. 2, published in *Storia di Milano*, VI, 164; see also pp. 33 and 193.

66. See E. Pellegrin, *La bibliothèque des Visconti et des Sforza* (Paris, 1955), 490–92; and L. Beltrami, *Il Castello di Milano* (Milan, 1894), 715–25.

67. Published in Neubecker, *Le grand livre d'héraldique*, 130.

68. The Sarcofago della Corse, now in the Museo di Sant'Ambrogio, Milan. Published in *Storia di Milano*, VI, 733.

69. Eight distinct badges or devices are displayed on nine war-shields, arranged in a horizontal series on the folds of a wide scroll. The first and eighth display a mantled head bearing a crest in the form of a sphinx statant (possibly the crest of the occupant of the tomb); the second bears a moor's head issuant of an open crown from whose base issue rays (an unknown device); the third, a plain zoniform collar supporting an annulus surrounding a swan (with SS on the belt, the livery-collar of King Henry V of England); the fourth, the Visconti sun (often displayed alone); the fifth, a double-headed eagle displayed and crowned on both heads (possibly the arms of the Holy Roman Empire, and indicating some service to the Emperor); the sixth, the Visconti device of the dove-and-sun; the seventh, a simple heraldic bend (probably the device of the Castilian royal pseudo-order of the Band, which was worn in the form of a gold stripe

arranged sashwise across the chest and back of a red coat); the ninth a naked sword pointed upward and enfiled with a scroll in the shape of an S that should have borne the motto *Pour loyaute maintenir* (the device of the Cypriot royal pseudo-order of the Sword). The Kings of England, Castile, and Cyprus conferred their collars or pseudo-orders on many foreign noblemen who either visited their court or served them in some way. For an early Italian example (1408/11), see I. Toesca, "Lancaster and Gonzaga: The Collar of SS at Mantua," in *Splendours of the Gonzaga*, 1-2.

Commentary on Gardner and Boulton

JOHN LARNER

THESE TWO ESSAYS reflect two different ways in which art in our period served politics. Julian Gardner has considered those buildings, tombs, statues, mosaics, even seals, with which French popes and cardinals, together with the government of Charles of Anjou, sought visibly to woo and intimidate their subjects, to project that quintessentially political message: "submit!" Jonathan Boulton has looked at images whose immediate impact is of a different type, those that say: "I am your friend, your ally, or your man."

Gardner's essay deals with an art which is difficult to recapture, one which has often to be dug out, almost archaeologically, from such things as photographs or drawings of lost works or presumed analogies between what survives and what has been irrevocably lost. In this digging I thought his essay demonstrated immense skill. I shall leave it to those with specialized knowledge to consider specialized points such as the very original Narbonne material, which he has presented. Also, I will leave to others the question of his emphasis upon the "gothic" as opposed to George Holmes's recent stress upon the "Roman" elements in Roman art of the time.[1]

What I shall consider is another, more intimate, political exchange, that found in the relations between patrons and artists. Gardner's thesis is that in the third quarter of the thirteenth century French patrons had little effect upon Italian art; in the last quarter they exercised influence upon its iconography, even its style; and, as a result, in the fourteenth century, Italian art itself came more easily to be accepted in France. What lies at the heart of this essay is the role of the patron in these cultural leaps and assimilations. I will begin with an analogy, not of course a strict one because it

comes from something with different dynamics, that of the influence
of French languages and literatures.

French literature enjoyed a predominant place in the penin-
sula, at least up to the 1280s. The three most powerful Italian poets
before that time wrote not in Italian but in Provençal and it was
Provençal which was the natural language of poetry in the North
Italian courts. In prose, too, many works like the *Book of Marco Polo*
or Martin da Canal's chronicle of Venice were written by Italians in
the *langue d'oeil*, in northern French. Again, in central and northern
Italy one sees the rise of that curious hybrid language, Franco-
Italian, a basically northern French speech which is interpenetrated
by Italian words and locutions. The old Carolingian epics were
being rewritten in Franco-Italian right up to the second quarter of
the fifteenth century. One finds them in luxurious court manu-
scripts and, more surprisingly, one learns of them being sung in
this language by the *cantastorie*, the singers in the marketplace.

How shall we explain this? It was certainly not because of
patrons in Italy who were French. The patrons of the Provençal
literature were Italian nobles, the men and women of the courts of
Treviso, Ferrara, Mantua, Ravenna, and so on. It was not at all
connected with Angevin sympathies. Most of the surviving Italian
political poetry in Provençal is pro-imperial, anti-French. What
brought about this phenomenon was simply the attraction of French
language and literature, the glittering prestige which they enjoyed
all over Europe.

In light of this, let us return to art. Gardner has told us that
it was not French patrons who originally brought northern art to
Italy; it was Italian cardinals, on the evidence of their wills, who
were collecting French ivories and manuscripts, *opus Anglicanum* and
gothic statuettes. It was simply that Italians found them desirable.
In thirteenth-century Europe, it seems to me, there was a vast
broadening of aesthetic sensibility, a new pluralism. It was partly
the result of the foundation of the mendicant orders, societies whose
members were itinerant, posted all over Europe. It was partly a
result of the legations and travels of the upper clergy and the increase
in numbers of pilgrims. Perhaps, too, it came with the expansion of
international trade.

As a result, taste was less conditioned by where one happened
to be born. We have had an interesting example of this: the future

Urban IV who sent off to his sister in France a copy of the *Veronica*, which, the indications are, he had obtained in Eastern Europe. Given this, I wonder how much importance should be attached to the nationality, or rather, the provenance, of the patron who commissioned a work of art. Think of Tuscany, of Nicola and Giovanni Pisano. Were the French influences in their work due to the presence of French patrons? It was once argued in the past that they are found in the Siena pulpit because one of the supervisors of the work was a Cistercian and so closely attuned to the art of the Cistercian heartland. Is that it? Or is it just that there was something immensely attractive about gothic art and that Italian painters, sculptors, and architects are able now to set about their own reinvention of this style? Or again: at what remove does one have to think of Greek patrons to explain the Byzantine influence on Duccio in Siena? Though, obviously, the provenance of patrons is something to take into account, how far should it be taken into account? As Gardner has pointed out the "French" architecture of the *Sancta Sanctorum* was owed to that archetypally Roman pope, Nicholas III.

This leads one to a wider thought about the position of the patron. We have been brought up with a picture of the Middle Ages in which the patron dictates the work of the mere *artifex* or artisan who is simply his instrument. Of course this has strong elements of truth in it. But can it be overstressed? Is it possible, for instance, to discriminate between Charles of Anjou's taste in Italy and in Provence? Unless, as with the Cosenza tomb, the French patron took along his favored sculptor, his taste must to a large extent have been dependent on what artists and craftsmen were available to him in Italy and Provence. It seemed to me in a way that Charles's letter on the tomb of Innocent V emphasized how distant the patron's role must often have been. He would like a tomb of porphyry, or if not that, something utterly different, a tomb like that of the Countess of Artois. I suppose it is too much to think that this is like saying, "I want a picture. I'll have a Picasso, or that failing, I'll have a Grandma Moses." But it suggests a certain resignation to the idea that, ultimately, he will have to take what is available. Or again, if Ottobuono Fieschi had his seal made by an Englishman, does this mean anything else but that he needed a seal, he was in England at that time, and so at the mercy of an English seal-maker?

Obviously when the Rusati workshop moved to Paris the patron must have exercised a dominant influence in that migration. But how important a role does the Frenchness of a patron play at Rome in the last quarter of the century? In the politics of patronage even the humble *artista* had his own position of power. That is just one of the many interesting conclusions that I have derived from Gardner's learned and richly textured essay.

I now turn to the contribution of Jonathan Boulton. Its particular value, it seems to me, lies in sensitizing us to an original issue. It will now be difficult for us to come across, in the future, a badge or device in a literary or visual source without stopping to examine it. Here is a new aspect of Italian chivalry together with something of the prehistory of the Renaissance emblem.

Boulton has written of the revival of interest in the medieval European nobility. It is in Italy certainly where the revival has had the sharpest influence. As a result, Italian historians discuss whether there was a "refeudalization" of Italian society in the Renaissance or indeed whether medieval Italy was ever "defeudalized." (The jargon is unattractive but the debate is of great importance.) From this, too, a new attention is being given to Italian chivalric culture. It is interesting, for instance, that Hannelore Zug Tucci's work on Italian heraldry should have appeared in the series of that radically inclined and *marxisant* Einaudi, *Storia d'Italia*.[2] Here, Boulton is in the vanguard.

We start with a distinction between the heraldic and the "paraheraldic": arms and crests which are recognized by the heralds; badges and devices which stand outside that recognition. This definition prompts questions about the character of Italian heraldry. Looking at what I would call "Italian" Italy — setting aside peripheral areas, like Savoy, or peripheral people, like those members of the second house of Anjou who sought to establish themselves in the Neapolitan kingdom, considering simply the communes and *signorie* of central and northern Italy — I would like to ask what relation heraldry here bears to heraldry across the Alps. In the communes, of course, there were heralds. In Richard Trexler's famous book on *Public Life*, for example, the Herald of Florence is constantly in evidence. But what status did heralds enjoy in regard to arms? What I haven't found — of course, I haven't been looking for them — are, for

instance, Rolls of Arms or that position of the Herald as secular priest of chivalry which existed in the northern world. In the fourteenth century an Italian wrote a very influential book on heraldry. This was the *De insigniis et armis* of Bartolo da Sassoferrato.[3] It was not written by a herald, but by a jurist, and a jurist commentating on the *Digest*. And Bartolo is immensely relaxed on any chivalric aspect of the subject. Every man has as much right to a coat of arms as he has to a name. It is more honorable if you are granted arms by some great lord, but if you are so unfortunate as not to know any, then make them up yourself! He treats of arms just as, in the same work, he treats of personal notarial signs or commercial marks. What Bartolo says here was later taken over by some other non-Italians, but I think it significant that it was an Italian who said these things first.

Take again the *Trecentonovelle*, written in the 1390s by Franco Sacchetti. There are several stories in them about coats of arms. One of them had a particularly long life because over 150 years later, Vasari was to copy it out, with some changes, as an appendix to his life of Giotto. It tells of a "new man" who goes along to Giotto's workshop and asks him "as if he were of the *Reali di Francia* to paint his arms on a shield." And Giotto, recognizing what sort of man this is, instead of painting a normal coat of arms, covers the shield with a mess of daggers, swords, gorgets, armlets, and so on: "these are your arms."[4] Obviously what we have here is a typical snobbish joke of the period against the *gente nuova*—these people, says Sacchetti, who come from the Foundling Hospital and who are now flashing their money around. Still, how did people like the Visconti, the Gonzaga, and the della Scala—the della Scala are particularly interesting because we know they started off as *popolani*—how did they acquire their first arms? Presumably by doing exactly the same thing. And so what I wonder is this: if heraldry is what the heralds took cognisance of, was not all heraldry in the communes and *signorie* what Boulton calls "paraheraldry?" Or is it to be understood as—another term he used, though without defining it—"quasi-heraldry?" But I will return to definitions later.

The next offering of this essay is a taxonomy of ephemeral and stable devices. Within this, what Boulton has concentrated on are, above all, personal and ordinal devices. Thinking of these in terms

of the Renaissance emblem to come I wondered whether it might be useful to make another distinction which seems to me quite striking, between devices whose messages are, like those of heraldry, at least in Italy, overt, which are designed to convey information, and those which, and this is much closer to the Renaissance emblem, are recondite and whose meaning is only clear to the initiate. To understand the devices of the Garter or the Knot you have to be versed in the *arcana*. And even Boulton cannot tell us what the motto of the Order of the Collar is supposed to mean. These, I take it, are rather different from what he calls propagandistic or livery devices.

The last aspect of this essay I would like to consider is the chronology for the emergence of these badges and devices. Boulton argues that the earliest devices must be associated with tournaments. I am not clear why this should be so, why they should not emerge with the *corti*, the *magnae curiae*, the great Italian chivalric assemblies, which loom so large in the chronicles of the thirteenth and fourteenth centuries, with dubbing ceremonies, or with marriage celebrations.[5] Boulton goes on to claim that the true tournament, the tournament as decorative festival, did not appear in Italy before 1328. He bases this on a recent article by Thomas Szabó. I have not had the opportunity to read this, but I presume that some highly specialized definition of "tournament" must lie behind his argument, for I can think of several, what I would call, decorative tournaments which go back much earlier.[6] Further, it seems to me untrue that there were no tournaments in Italy between 1340 and 1366. There is a remarkable letter of Petrarch in which he describes the horror he has experienced in seeing a knight killed in a royal tournament held at Naples on Saint Andrew's day, 1343.[7]

If there is a possibility, and of course it is no more than that, of pushing back just one of these devices to the thirteenth century, can we do it for any of the others? Boulton told us that the Italian noble orders formed to fight heresy in the thirteenth century may have served as a model for some orders of the fourteenth. Certainly one of these, the most notorious among them, the *Cavalieri Gaudenti* had an ordinal badge: a cross with two stars.[8] One thinks too of the party-emblems of the Guelfs and the Ghibellines, such as the Marzocco, the Guelf lion, with the motto "Libertas" beneath it. When did that device first emerge? While this essay has made a

very plausible case for the English origins of the *recondite* device in Italy, I am not convinced that one needs to look outside Italy for the device itself.

I end by returning to the question of definition. The members of the papal army which invaded Frederick II's kingdom in 1229 wore "the sign of the keys." This was before formalized heraldry existed and the keys, curiously enough, were not formally incorporated into papal heraldry until the fifteenth century. So what shall we call this badge? If it was too early to be called "heraldic," it cannot be called "paraheraldic." Shall we call it "preheraldic?" Or perhaps "quasi-heraldic?" Or shall we, carrying on the good fight against neologisms, simply call it "a badge?"

NOTES

1. G. Holmes, *Florence, Rome, and the Origins of the Renaissance* (Oxford, 1986).

2. H. Zug Tucci, "Un linguaggio feudale: l'araldica" in *Storia d'Italia, Annali* I, *Dal feudalismo al captialismo*, (Turin, 1978), 811–73.

3. Bartolo da Sassoferrato, *Tractatus de insigniis et armis*, ed. F. Hauptmann (Bonn, 1883).

4. F. Sacchetti, *Le novelle*, I (Milan, 1804), 203–05 (*Novella* lxiii).

5. See J. Larner, "Italian chivalric culture in the age of Dante," *Renaissance Studies*, II, no. 2 (1988): 387–414.

6. Debra Pincus noted that Martin da Canal describes a most elaborate tournament held in 1253 in Saint Mark's Square to celebrate the election of the Doge Ranieri Zeno. Further, Canal tells of a parody of the idea of a chivalric tournament which was put on by members of the Venetian guilds (Martin da Canal, *Les estoires de Venise*, ed. A. Limentani [Florence, 1972], 128–30 [1253 tournament], 298–300 [burlesque], and see, too, 218–22 [1272 tournament].

7. F. Petrarca, *Le familiari*, ed. V. Rossi, II (Florence, 1934), 20–1 (V, 6). For the date, see p. 15 (V,5).

8. A. de Stefano, "Le origini dei Frati Gaudenti," *Archivium Romanicum*, X (1926): 314, n. 4, citing Giovanni Villani, *Chronica*, VII, 12.

The Campidoglio as the Locus of *Renovatio Imperii* in Renaissance Rome

CHARLES L. STINGER

IN RENAISSANCE ROME, the popes, determined to assert their authority in the church and in the world, looked to the visual arts as potent means for proclaiming spiritual and temporal aspirations. The confluence of various intellectual and cultural tendencies, involving humanism especially, encouraged this regard for architecture, sculpture, and painting as powerful forms for conveying ideological content. Ambitious papal projects, undertaken in the Vatican and elsewhere in the city, were meant to manifest Rome's rebirth as a capital, sacred both to Christianity and to Western civilization.

The Campidoglio in particular became a focal point for such urbanistic development. Venerated as a symbol of the imperial idea, the Capitoline Hill mythically embodied renewed Rome's imperial vocation. In the later fifteenth century the popes continually embellished the hill with antique sculpture — artworks intended to remind viewers of ancient Rome's glorious past and to evoke celebration and praise of the city's transcendent destiny. By the early sixteenth century the Capitoline had also become the setting for an annual ceremony honoring the city's foundation. These trends reached a climax in 1513 in a lavish pageantry staged on the Capitoline in an elaborate theater created expressly for the occasion. The ceremony had as its specific purpose the granting of Roman citizenship to the brother and nephew of the newly elected pope, Leo X. But, more important, it afforded an opportunity to stage a spectacle honoring the city's historical mission and its restored status as *caput mundi*. The 1513 *festa* enlisted the intellectual and artistic energies of much of Leonine Rome. It involved close collaboration between its human-

ists and artists, and also between municipal officials and the papal
court. As such, it serves as an apt subject for considering the rela-
tions between art and politics in Renaissance Rome and for inves-
tigating the ideological aspirations of the Renaissance papacy.

Before examining more closely the Campidoglio and the *festa*
of 1513, it is essential to grasp certain distinctive features of Renais-
sance Roman culture. One countenance among the many that Rome
presented to its Renaissance beholders was as a city of monumental
ruins. Ancient temples, theaters, aqueducts, and triumphal arches
dotted the cityscape as haunting reminders of the Eternal City's
former glory. Beginning in the middle decades of the fifteenth cen-
tury, the humanists dedicated considerable effort to identifying, com-
prehending, and interpreting these tangible remains of the city's
classical past. This approach to antiquity in Roman humanism was
less historical than archaeological. That is, the starting point for
inquiry into the past tended frequently to be the monument or arti-
fact itself, rather than texts. Moreover, the intellectual tasks the
humanists set themselves involved not investigation of political or
cultural processes nor attempts to explain Rome's rise and decline.
Instead, the monument, not in its present dilapidated state, half-
buried beneath medieval accretions and subjected to the indignities
of time and fortune, but rather as restored in the mind's eye to its
original splendor, was seen as standing for the timeless superiority
of Rome's achievement. Repeatedly the humanists described ancient
Rome as the mirror and exemplar of all that was truly civilized, the
reflection of a triumphant world civilization whose benefits, as Flavio
Biondo put it, "seemed rather the work of gods than of men."[1]

The monuments, sculpture, and other antiquities of the city
thus served as talismans, and in ways not unlike the pilgrim vener-
ation accorded to the tombs of the apostles and martyrs, they were
regarded with wonder, awe, and stupefaction as the living embodi-
ments of Rome's ancient glory. This emotive response bears striking
similarity to the intellectual intent of epideictic rhetoric, the classi-
cal genre of praise and blame that became the expected mode for
the orations delivered to the papal court.[2] Epideictic rhetoric, by its
very nature, was strongly visual in content. The orator intended his
audience to see, gaze upon, and admire what he described. More-
over, epideictic orations typically included as a stylistic device

ekphrasis, that is, an extended visual description, often of buildings or a work of art.

The earliest instance of an epideictic work from Renaissance Rome is Manuel Chrysoloras's *Laudatio Urbis Romae et Constantinopolis*, an extended comparison of the two capitals written in Greek shortly after this leading Byzantine intellectual visited the Eternal City in 1411 and translated into Latin some thirty years later.[3] Chrysoloras seems to have known, and used as a source for some of his ideas, the "Roman Oration" of Aelius Aristides, a work composed in Greek in the mid-second century A.D. Aristides was an influential figure within the Hellenistic rhetorical tradition known as the "Second Sophistic," and his oration in praise of Rome exemplifies the characteristics of epideictic rhetoric. Like Aristides, Chrysoloras lavishes praise upon the splendor, magnificence, power, dignity, and beauty of the ancient imperial capital. While all now lies in ruin, the very ruins themselves suggest the magnitude of Roman achievement. What especially impressed him were the triumphal arches. Testaments to triumphant Rome's conquests of barbarian forces, they had a particular relevance to his own times when Byzantine civilization found itself so threatened by the Ottoman menace. Describing the sculptural reliefs of battles, captives, sacrifices, and altars on the arches, Chrysoloras exclaims in admiration that

> . . . one can see all this in these figures as if really alive, and know what each is through the inscriptions there. So that it is possible to see clearly what arms and what costume people used in ancient times, what insignia magistrates had, how an army was arrayed, a battle fought, a city besieged, or a camp laid out; what ornaments and garments people used, whether on campaign or at home or in the temples or the council-chamber or the market-place, on land or sea, wayfaring or sailing in ships, laboring, exercising or watching games, at festivals or in workshops. . . . Herodotus and some other writers of history are thought to have done something of great value when they describe these things; but in these sculptures one can see all that existed in those days . . . so that it is a complete and accurate history — or rather not a history so much as

an exhibition, so to speak, and manifestation of everything that existed anywhere at that time.[4]

What Chrysoloras has done is to make us see through hearing, the purpose of ekphrasis. Moreover, for him, it is monumental public sculpture, enduring intact since antiquity, that presented the most direct means to appropriate the historical reality of ancient Roman civilization.

Chrysoloras's and Aristides' orations provided material for visualizing ancient Rome and for praising it, and the influence of their works can be traced in the writings of Roman humanists throughout the fifteenth century and in the early sixteenth.[5] At the same time another important characteristic of epideictic rhetoric as practiced by humanist orators in Rome emerged. This was the tendency to stress the similarities between the art of words and the art of painting.[6] Humanist preachers at the papal court described sacred deeds as if they were acts of artistic creation. Thus, Tommaso Inghirami, a humanist who played a principal role in the Capitoline festivities of 1513, delivered a sermon for All Saints' Day 1497, in which he depicts God creating the cosmos as if he were constructing a magnificent temple, decorating it with all levels of existence from the supercelestial to the earthly so that all who gaze upon it might admire its beauty and wonder at its magnitude.[7] More startling yet is the description of the Sermon on the Mount in Hieronymus Scoptius's oration for All Saints' Day dating from the pontificate of Sixtus IV. Scoptius describes Christ as an expert in the art of painting, who in his Sermon on the Mount "paints" all the individual elements that lead the way to beatitude, and who restores, as if with a new portrait, our sin-soiled souls to the true form of their original beauty.[8]

If the creative power of God's speech and redemptive authority of Christ's word could be likened to the procedures of the visual arts, so, too, as in a reverse image, art and architecture could be understood as means for conveying theological ideas and for inculcating ideological content. That is, the arts could be made to express words. In Giannozzo Manetti's account of Pope Nicholas V's deathbed address to the assembled cardinals the pope asserts just that. Extraordinary sights, he argues, arouse the devotion of the faithful,

and great buildings "as perpetual monuments and nearly eternal testimonies, almost as if made by God," serve to corroborate and confirm the church's authority. To the beholders of these admirable structures, whether in the present or times to come, sacred doctrine is continuously proclaimed, and the populace's devotion to the Roman Church and to the Apostolic See is thereby conserved, augmented, and made steadfast.[9]

The cultural imperatives of Roman humanist thought and the ambitions of the Renaissance popes thus joined in ascribing particular value and potency to architectural and artistic works. Nicholas V, in fact, was the first of the great builder popes of the Renaissance, and he established the basic agenda for the rebuilding of Rome over the next century. While the various regions of Rome all drew some attention, the urbanistic rebirth of Rome, following Nicholas's initial impetus, focused on two centers of power. In the Vatican, at the tomb of the Prince of Apostles, arose a new temple-palace complex. Built on what Giles of Viterbo regarded as the pivot of the entire cosmos, it embodied Rome's transcendent destiny as the "holy Latin Jerusalem." Prefigured by what Solomon constructed, the new sacred capital altogether surpassed it, just as the Roman Church as the true Mt. Zion fulfilled all that had been foreshadowed in the "synagogue."[10]

While Roman imperial themes marked much of what was created in the Vatican, particularly under Pope Julius II, the Capitoline Hill, second of the two most potent centers of mythic power in the Eternal City, was more directly connected to ancient Rome's *imperium*. Here had arisen the temple of Jupiter Optimus Maximus. Here had been kept the Sybilline Books that contained the destiny of the Roman people. Here the ancient Roman triumphs reached their goal and climax. The Campidoglio thus symbolized and manifested the imperial idea of Rome.[11]

In the campaign for the urbanistic renewal of Rome as world capital, the Campidoglio inevitably drew papal attention. But its restoration as an urban symbol of *renovatio* meant confronting existing traditions with differing views of the hill's historical meaning and contemporary import. The medieval Palazzo del Senatore (Fig. 1), built on the ruins of the ancient Roman *tabularium*, the archives building, served as the seat of municipal government. Here the

Commune's councilors and officials met, here the notarial cartularies recording civic life were preserved, and here verdicts in criminal cases were handed down before an ancient sculpture of a lion tearing a horse, a grim reminder of stern communal justice.[12] Here, too, Cola di Rienzo had harangued Roman throngs with his dreams of restoring the Roman Republic, and here he had proclaimed himself tribune.[13]

The medieval Campidoglio was thus associated with the municipal liberties of Rome's citizens. The Renaissance popes were determined to exert papal control over municipal life, and it was hardly in their interests to encourage veneration for the Campidoglio as the expression of civic liberty. In effect, by transforming the Capitoline into a scenographic expression of the myth of imperial *renovatio*, they eroded its role as the active center of civic life and as the site of actual political power.

Pope Sixtus IV's transfer of various antique bronzes to the Capitoline in 1471 contributed to this end.[14] The bronzes, including the Roman she-wolf (the *lupa*), and an enormous arm holding a globe (popularly known as the *Palla Sansonis*, Samson's ball, and regarded as a symbol of Rome's world domination), had stood for centuries before the Lateran, the cathedral church of Rome and the principal papal residence during the Middle Ages. Sixtus represented their transfer to the Capitoline as a restitution to the Roman people of monuments testifying to their former preeminence and ancient valor.[15] Not just objects of antiquarian interest nor expressions of classical artistic achievement, these bronzes visually embodied the potency of Rome's imperial myth, particularly the she-wolf, associated with the legends of Romulus and Remus and the history of Rome's founding. Moreover, the bronzes were not exhibited as museum objects. Several, including the arm with the globe, were prominently displayed in the portico of the Palazzo dei Conservatori (Fig. 2) that Nicholas V had constructed two decades earlier. Moreover, Sixtus IV explicitly ordered and provided funds for the placement of the she-wolf at the center of the building's facade over the principal entrance, in full view of all who passed there (Fig. 3).[16] Half a decade later, in 1477, Sixtus ordered that the open air market held at the Campidoglio be transferred to Piazza Navona, a measure that fur-

ther isolated the Capitoline from mundane activities and reinforced its ceremonial function.[17]

Later Renaissance popes added to the collection of imperial statuary on the Capitoline. In 1486 Innocent VIII provided for placement there of the head and limbs of a colossal marble statue of the Emperor Constantine that had been excavated near the Basilica of Maxentius in the Roman forum.[18] In 1515 Leo X ordered the display there of three ancient marble reliefs of Marcus Aurelius, taken from a destroyed triumphal arch. These showed the emperor on the battlefield, in a triumphal chariot, and performing a sacrifice to Jupiter before the Capitoline temple. The new inscription identified the emperor as *triumphator Romanorum imperator*.[19] The equestrian statue of Marcus Aurelius, however, despite the proposal of the Conservatori in 1498 that it, too, be moved to the Campidoglio, remained at the Lateran until the pontificate of Paul III. Then, of course, it became the focal point for Michelangelo's totally redesigned Piazza del Campidoglio.[20]

As the Campidoglio gradually acquired these tangible testimonies to its imperial glory, it became the setting for celebrating the revived Palilia (or *Parilia*), the ancient Roman festival commemorating the city's "birthday." The impetus for renewing the Palilia originated with Pomponio Leto and his fellow members of the Roman Academy, on whom the antiquities of classical Rome and the lore of the ancient city exerted a particular fascination. Initially the revived Palilia, first held in 1483 at Leto's home on the Quirinal, on April 20 (one day earlier than the ancient Roman holiday) consisted of an oration in praise of Rome, delivered that first year by Paolo Marsi, a member of Leto's humanist sodality, followed by a banquet for the members.[21] By 1501, when the papal Master of Ceremonies Johannes Burchard describes the event, its celebration had become considerably more elaborate. The site of the festival was now the Campidoglio, members of the Papal Curia attended as did foreign diplomats and Rome's municipal officials, the papal choir sang Mass in S. Maria in Aracoeli, and there also, following Mass, an oration in praise of Rome was delivered. The banquet took place in the courtyard of the Palazzo dei Conservatori, and there to conclude the *festa* a Latin comedy was performed. In fact, preparations for the play forced the postponement of the Palilia to May 2 that year.

A large throng came to view the proceedings. Burchard complained that no places had been reserved for the dignitaries and that the disorderly crowd prevented anyone from having a good view of the performance.[22]

Increasing emphasis on the historical mystique of the Capitoline and the increasingly elaborate ceremonial this occasioned provide the context for considering the Capitoline festivities of September 13–14, 1513. The specific purpose of this event was to grant Roman citizenship to Giuliano and Lorenzo de' Medici, the brother and nephew of the newly elected pope, Leo X. But honoring the pope's nearest male relatives merely presented an opportunity to express more fundamental political and ideological aims. For Leo the festival was meant to underscore the dynastic interests of the Medici family, rulers now of both Florence and Rome, and to celebrate the global Christian *imperium* that Rome ruled as its sacred capital. For Rome's municipal officials, who organized the celebration and secured its financing, granting Roman citizenship to the Medici meant an opportunity to affirm the dignity of the city's civic traditions, to acknowledge gratitude to a pontiff whose initial policies seemed more conciliatory to municipal sensibilities than those of his predecessor, Pope Julius II, and to encourage the pope to regard with favor further restoration of municipal autonomy.[23]

By tradition, granting Roman citizenship took place on the Campidoglio, and Rome's municipal officials decided that the solemnities should take place as part of the celebrations of the Palilia as well, even though this would occur out of season. Among those urging that the event should be accorded the greatest possible splendor was Marc'Antonio Altieri (1450–1532), who was named to the organizing committee and who, along with Paolo Palliolo of Fano, a jurist in service to the communal government on the Campidoglio, provides us with the most extensive account of the occasion. Altieri belonged to Rome's urban nobility or civic patriciate, which had seen its position in Rome's public life sharply eroded in the Renaissance period. Not only had the city's municipal autonomy decreased with the enlargement of papal administration over the city, but the popes had employed ever larger numbers of non-Romans to staff the curial bureaucracy, excluding members of Rome's urban nobility. Altieri's *Li nuptiali*, a treatise on wedding ceremonies composed during the pontificate of Julius II, laments these developments and

argues that only by respecting their own traditions, particularly the ritual and ceremony of patrician marriage, can the urban nobility recover its class solidarity and hope to avoid yet further isolation from political influence.[24]

Altieri sought the origins of nuptial ritual in Rome's classical past, an intellectual orientation inspired by Pomponio Leto and the Roman Academy in whose activities he had participated in his youth. A second major figure involved in preparation of the Capitoline festivities, who was similarly inspired by the antiquarian studies of the Roman Academy, was Tommaso 'Fedra' Inghirami (1470–1516). The successor to Leto as holder of the chair of rhetoric at the Sapienza, Rome's university, he had been involved from his youth in the revival of classical theater in Rome. Indeed, he had gained his nickname from acting the role of Phaedra in the production of Seneca's tragedy *Hippolytus* that was staged in 1486 by members of the Roman Academy under the sponsorship of Cardinal Raffaele Riario. Inghirami, a native of Volterra, worked his way up within the Roman Curia, becoming papal librarian and eventually secretary to the Fifth Lateran Council. A leading humanist of early sixteenth-century Rome, he delivered orations on important ceremonial occasions, including the funeral eulogy for Julius II, and also helped design pageantry for both Julius and Leo.[25] Inghirami was entrusted with preparing the overall iconographic program for the festival and with staging the play, Plautus's *Poenulus*, that concluded the celebration.

The ceremonies themselves unfolded in a large wooden theater, built expressly for the occasion on the Capitoline Hill. The design was probably the work of the famed architect Giuliano da Sangallo, though the actual work of construction was entrusted to the lesser-known builder Pietro Rosselli.[26] Nearly square in plan (Fig. 4) its basic function was to provide sufficient tiered seating for all the participants and dignitaries. To make room for it, various older walls and buildings including some houses had to be destroyed (Fig. 5). While lacking the semicircular shape of the classical Roman theater, the structure's architecture nonetheless evoked the grandeur and magnificence of ancient buildings. Gilded, fluted columns and a classical frieze framed the entrance, which Altieri described as taking the form of a triumphal arch, and over this appeared the inscription OPTIMO PRINCIPI SPQR (Fig. 6). Intercolumnar spaces on

either side of the entrance were filled with monumental paintings in chiaroscuro meant to imitate classical reliefs. Inghirami, our sources state, "invented" the *istorie* of these and the paintings in the interior of the theater. The execution of the paintings was entrusted, it seems, to various artists, but with the exception of the scene of Tarpeia, which Vasari credits to Baldassare Peruzzi, none is known to us and no paintings survive. Our written sources allow us, however, to know their placement and subject matter. The facade paintings, whose figures were more than life-sized, depicted various events from Rome's foundation and earliest history, all related to the Capitoline. The four scenes, beginning at the right, showed *Saturn Greeted by Janus on His Arrival in Latium, The Surrender of the Tarpeian Rock to the Sabines, Romulus Bringing Spoils to Jupiter,* and *The Dedication of the Temple of Jupiter.* In the attic story above, on the right was the Florentine Marzocco with the *palla* of the Medici flanked by the River Arno, while on the left was the Roman she-wolf suckling Romulus and Remus flanked by the River Tiber. Overall the splendor of the entrance facade struck one witness as like the ancient palaces the emperors had built with great art and at inestimable expense, whose ruins still stupefied observers.[27]

On top of columns just inside the entrance to the theater were placed the ancient bronze she-wolf, the symbol of Rome, and the gigantic bronze hand and ball, now interpreted as the Medici *palla* (Fig. 7). These announced a chief allegorical theme of the festivities, the linked destinies of Rome and the Medici. A gigantic blue and white striped cloth served as a roof, like the awnings once stretched to provide shading at the Colosseum, and from this hung numerous torches to provide night lighting. On the walls above the stage, opposite the entrance and above the rising tiers of seats on the other three sides, were more paintings (Fig. 8), each, like the sculptural decoration of the triumphal arches Chrysoloras had admired, provided with an explanatory Latin inscription. These set forth incidents from ancient history that demonstrated the bonds linking Etruscans and Romans. The first scene showed Aeneas landing with his Trojans at the Tiber and meeting the Etruscans from whom he received aid in founding the Empire, as the inscription stated: AENEAS HETRUSCORUM ARMIS FUNDMENTA IMPERII IACIT. Another depicted the Second Triumvirate's founding of Florence as a colony of Rome. Several scenes referred to ancient religious mat-

ters. Two presented Romans learning from Etruscan priests the
proper forms of sacrifice, how to interpret omens, and other rituals,
meant as praise for the new high-priest from Tuscany, Leo X.
Another illustrated the sacred images of Rome's gods being taken
for safekeeping in Etruria to avoid the plundering of the Gauls. Yet
another showed the goddess Juno being brought to Rome from
Etruscan Veii. Still other scenes revealed Etruscans instructing young
Romans in the liberal arts, introducing theater and stagecraft to
Rome, and providing various symbols of public office. The overall
meaning of the paintings, according to Palliolo, was to demonstrate
that the friendship of Romans and Tuscans, renewed in the present,
had the most ancient origins, and that the Romans had derived
from the Etruscans not only various customs, forms of literature,
much of its citizen body, and even the insignia of Empire, but
also the rituals of augury and sacrifice, its priests, and its deities
themselves.[28]

The festivities began with the ceremonial arrival of Giuliano
de' Medici (Lorenzo had stayed behind in Florence, and Pope Leo
for reasons of protocol did not attend). First came the celebration of
a solemn Mass inside the theater. The Latin oration praising Rome
and the Medici followed. Then Roman officials conferred the actual
grant of citizenship on Giuliano, the moment signaled to the crowds
by the blare of trumpets and the blasts of artillery. After this came
a lavish banquet consisting of more than twenty courses that lasted
some six hours. The scent of perfumes, the sounds of music, and
the antics of buffoons enlivened the festivities, as did the noisy
throng of onlookers crowded onto the balconies of the Palazzo dei
Conservatori, peering though the windows of the theater, and pok-
ing through cracks in its wooden sides. The food itself, described in
minute detail by observers, consisted not only of rare and expensive
ingredients but also the various fowl and meat dishes were pre-
sented as if they were living animals dressed in feathers and skins,
in imitation of ancient Roman culinary practice. Other dishes were
sculpted in the form of *palle* and the Capitoline *lupa*. As course fol-
lowed course, the principal guests at the head table had long since
had their fill and even those occupying the more distant seats became
satiated, so that at length there began to fly through the air all the
capretti, cunigli, caponi, fasiani, and other foods that no one could eat.
So ended the banquet whose sumptuousness was in no way inferior

we are told to the feasts Cleopatra presented to Marc Antony. Like other famous ancient banquets, the actual food mattered less than its Lucullan lavishness as a political display of wealth and power. Now, after a short pause, followed the series of allegorical *rappresentazioni*. These took the form of a succession of triumphal *carri*, like those of the Festa di Agone of Rome's Carnival, passing across the stage. As each stopped at center stage the various allegorical or mythological personages, elaborately costumed, engaged in dramatic action, and in dance and in Latin prose, verse, and song celebrated Rome and the Medici. Camillo Porzio, young scion of an influential Roman family and a leader of the Roman Academy, was the organizer of this spectacle though other Roman humanists were enlisted to prepare the allegorical subject matter for the individual sections and to compose the Latin texts. First on stage came Roma herself, dressed in splendid golden garb and wearing a golden crown, who prayed that all divine blessings be bestowed on Pope Leo "unconquered conqueror" and on her citizens. Then came a pastoral eclogue, written by the humanist Blosio Palladio. This consisted of two peasants who had come to Rome to complain to the civic magistrates about their misfortunes, but approaching the Campidoglio they became aware of the festivities. Discovering the reason of such joyousness, they set aside their woes and proceeded to sing rustic verses honoring Giuliano and Leo. This peasant interlude possesses a certain irony since guards, armed with maces, were stationed at the entrance to the theater to prevent any artisan or "vile plebian" from coming in and allowing entry only to those whose appearance they judged worthy to view such a spectacle.[29]

The peasants were followed by the first piece of elaborate stagecraft. There appeared on stage a large mountain, the Mons Tarpeius itself, with a citadel at its summit. On reaching the middle of the proscenium, cannons were fired, the mountain opened and the ancient Deus Capitolinus came forth, supporting on his right shoulder the temple of Capitoline Jove, against his chest the refuge of Romulus, and in his hand a tree branch. Marvelling at the festive crowd before him, then realizing the reasons for such joyous celebration, he divested himself of his hoary beard and unkempt hair, emerging as a handsome youth, rejuvenated, just as the Campidoglio itself, adorned with its theater, had been renewed. Speaking Latin verse, the rejuvenated god expressed amazement at the pomp of the tri-

umphal splendor. What god had come? Never in antiquity had
Saturn's citadels been so honored, nor could any ancient triumphal
procession equal it. For so long this citadel of the Roman people
had lain deserted, deprived of glory. Now at last was fulfilled Jove's
decree that the fates would bring forth from the highest heaven as
the Capitoline's benign benefactor that supernal issue, the Medici,
to whom Rome would erect resplendent statues, under whose pon-
tificate the toga-clad people will regain its Empire, and the Capitoline
rise up again. In antiquity, under the Consuls and the Caesars, to
whose might the world had yielded, the Capitoline had preserved
the *fasci* and other insignia of Roman power and had witnessed dis-
tant, barbarian peoples made subject to Roman rule. Now it is for
Giuliano, spurred on by the same "pious glory" to take up the
Romans as his comrades and to defend Rome's citizens.

> In you is my hope, and in Leo X, whom Rome, now pre-
> served, calls Father and the radiance of the whole world; the
> Senate and the People applaud you and Roman prayers vie
> with plebian favor. Live felicitously, and if these last words of
> our mouth move you my Rome through you will reassume the
> curule chairs; Italians, sovereign, will return to their stan-
> dards; and the ancient Campus Martius will renew its rights
> of suffrage. Thus, as true physicians [Medici] your name will
> mount to the stars and the fame of your race will be celebrated
> eternally.[30]

With the departure of the Mons Tarpeius, there entered another
triumphal *carro* conveying Roma, Justice, and Fortitude, who cele-
brated the election of Leo X as the return of an age of justice and
concord. Night was now falling and torches were brought in to illu-
minate the stage. The next tableau consisted of two lions drawing
an ancient chariot on which was seated Cybele and before her a
large *palla*, in the form of a globe. At the blast of artillery, no less
terrible, we are told, than if Jove himself let loose a lightning bolt
over the theater, the globe burst open revealing Roma as a beautiful
young girl, while at the same time there were tossed to the crowd
commemorative coins incised with the head of Giuliano on one side
and on the other an image of Roma. Coming forth from the globe,
youthful Roma praised the new light that had come into the world,
the luminous sun, the great Leo that had forced the shadows to

retreat. And now Florence entered, bewailing the loss of the Medici to Rome, but Cybele replied that they should make of the two cities one people to live forever in concord. So ended the first day's spectacle.

The festival resumed the following day, at vespers, with the final and most elaborate of the *rappresentazioni*, designed by Evangelista Maddaleni Capodiferro. Also from an ancient Roman family and a disciple of Pomponio Leto, he would, a year later at Leo X's behest, take up the first chair of Roman history at the Capitoline.[31] Four white horses, as specified for a Roman triumphal quadriga drew forward a *carro* in the front of which stood a pelican with open wings, feeding its young with its own blood and bearing the inscription: ROMA OMNIBUS UNA EST. On its neck it bore a yoke, one of Leo's devices, while on its right appeared the she-wolf with Romulus and Remus and on its left the celestial Bear, a reference to the Roman baronial family the Orsini (Clarice Orsini was Leo's and Giuliano's mother). Clarice herself appeared in the middle of the float, underneath a laurel tree, associated with Leo's father, Lorenzo, and from the tree hung golden *palle*, gilded yokes, and diamond rings, all Medicean symbols. At Clarice's sides were the Arno and the Tiber in the guise of ancient river-god statues. The poetic texts mingled a stronger religious note within the mythological allusions and references to Roman history. Clarice emphasized again the Etruscan origins of ancient Roman rites and ritual, "by which to know the will of the gods and placate their wrath," and compared her role in giving birth to Leo to that of Latona, mother of Apollo, for both had brought forth a sun to the world. Father Tiber prophesied that under the guidance of Christ Leo would return Italy to eternal peace, submit Europe's kings to his commands, bring war again to infidel Asia to cleanse it of its evils and vane superstitions, and baptize Africa's people. The nymphs of the Tiber enjoined Leo and the Roman people to mutual love, while the nymphs of the Arno urged Romans to revere and love Leo more than they had the good emperors Titus or Trajan.

To conclude the festivities Plautus's comedy was performed, in Latin and in classical costumes, under Inghirami's direction. Several days later all the dramatic elements of the *festa* were performed again in the Vatican palace so that Leo X could view for himself the spectacle.

In considering the Capitoline festivities, several fundamental features stand out. First, the splendor of the theater itself, its classicizing decorations, and the pomp of the festivities that unfolded within it comprised an essential embodiment of the *Roma rinata* that the *festa* celebrated. That is, the event itself formed part of the restoration of the Campidoglio as the locus of Roman dignity, power, and glory.

Second, the subject matter of the theater's paintings and of the dramatic *rappresentazioni* set forth ideological claims clearly imperialist and papalist in nature. The pervasive evocation of the ancient Roman gods, in particular, was meant to be interpreted in this way. The repeated allusions to Leo as Apollo echoed panegyric themes enunciated from the beginnings of Leo's pontificate, particularly as the fulfillment of the Golden Age prophesied in Virgil's Fourth Eclogue.[32] Janus and Saturn, too, shown in the first painting on the facade, were the Golden Age deities of Rome, a Golden Age first renewed under Augustus, according to Virgil,[33] and now renewed again under Leo X.[34] To stress the links between ancient Latium and Etruria formed an apt topos of praise for Leo X, the first Florentine pope, but the Etruscan Janus embodied another mythical dimension of Rome's past. In the primeval history of Rome put forth in the *Antiquities* of Annio da Viterbo, a work published in 1498 which enjoyed great authority in the early sixteenth century despite the dubious authenticity of some of Annio's sources, Janus, the inventor of viticulture is identified with Noah the biblical creator of wine. Even more significantly, after the Flood, according to Annio, Noah-Janus had settled in Etruria and there had established the first urban civilization, a mighty kingdom governed with such justice that it formed the source for subsequent Golden Age legends.[35] That Janus was Noah meant further, according to Giles of Viterbo who enthusiastically embraced Annio's ideas, that the Etruscans, like the ancient Hebrews, were possessors of divinely revealed truth, and it is for this reason that a golden life of faith, concord, and peace flourished in ancient Etruria under Janus. Regarded as the founder of the Etruscan religion, his cult was associated with the Janiculum, named after him and situated on the west bank of the Tiber that it was believed had formed the boundary between ancient Etruria and Latium. To Etruria, therefore, belonged the Vatican, destined to be the tomb of Peter, and the

sacred capital of the church. Etruscan history thus foreshadowed the establishment of the church, a linkage Giles saw further confirmed in the fact that both Janus and St. Peter were keybearers.[36]

These ideas found an enduring representation in the fresco decorations for the *salone* of the Villa Lante on the Janiculum, a villa constructed by Leo's datary, Baldassare Turini. One of the principal ceiling scenes of the *salone*, painted by Polidoro da Caravaggio, shows Janus, key in hand, greeting Saturn at the bank of the Tiber.[37]

Saturn, in turn, was directly linked to the Capitoline, for here in ancient Roman tradition he had settled and here, too, on the Clivus Capitolinus, the winding path that linked the Forum Romanum to the Capitol, had arisen the Temple of Saturn, the impressive ruins of which still remain. The mythical origins of Rome thus were interpreted in Leonine Rome as retrospectively prophetic of Rome's sacred renewal under the new Etruscan priest, Leo X. In this view, too, the heroic achievements of Aeneas, Romulus, and the Roman Republic represented the unfolding of the divinely guided destiny of Rome as the center of global Christianity.[38]

The Jupiter elements of the Capitoline *festa*, too, echoed the frequent comparisons drawn between Leo and Jove by contemporaries.[39] The most striking manifestation of this is the statue of the pope commissioned by Rome's civic officials about the year 1515 for the *aula magna* or main meeting room in the Palazzo dei Conservatori on the Capitoline. In 1521 the Conservatori planned a public celebration for the installation of the completed statue, again to be held in connection with the Palilia, whose celebration had been allowed to lapse. Postponed, the festival never took place, as Leo died in December of that year. There survives Blosio Palladio's lengthy Latin speech on Roman history intended for the occasion, in which, like other humanists of early sixteenth-century Rome, he saw an essential continuity between the Roman Empire and the *imperium* of the Roman Church. This Christian empire, though, *quanto magis* (that is, by how much more), had now surpassed its predecessor in extent with the carrying of Christianity to the New World and the Indies. At the end of the oration Palladio invokes the Virgin Mary, not, however, as the humble mother of humanity's Redeemer or the grief-stricken witness to her Son's crucifixion. Instead, she, as the Capitoline Virgin (doubtless a reference to the legend of the Ara

Coeli and the church of S. Maria in Aracoeli on the Capitoline) has succeeded Jupiter in presiding over the hills of Rome and as protector of the city and Capitol. The Virgin Mary has replaced the pagan Jupiter, but her religious role is the same.[40]

Responding more directly to the statue of Leo is a long hexameter Latin poem by an otherwise unknown poet, C. Silvanus Germanicus. Like Palladio's oration, imperialist in form and content, the poem imitates the style and specific passages of Statius's *Silva* (1.1) written in the first century A.D. in honor of an equestrian statue of the Emperor Domitian. In his poem Silvanus compares the statue of Leo, sculpted by the Bolognese Domenico Amio, to Phidias's famed statue of Zeus for the temple at Olympia. Further, it was appropriate to erect a statue of Leo on the Capitol, he claims, for from here Jupiter once ruled the city and the world. He urges us to behold great Leo, seated in his ivory chair, giving law to heaven, earth, and hell, and assisting the Creator of the world with his authority. So awesome is this image that the hall is hardly big enough, we are told, for the god it has received.[41]

Third—turning to the political implications for the municipality of Rome—physically dominating the meetings of Rome's civic officials and as a sacred presence joining the ancient marble and bronze totems of Rome's imperial majesty on the Capitoline, the Jove-like statue of Leo only further confirmed the limited role the popes allotted to civic government. Any pretense to an autonomous voice disappeared as Rome's civic officials found themselves restricted to ingratiating themselves before the real authority in the city. The *festa* of 1513 which demonstrated Altieri's high expectations was quickly followed by disillusionment in his hopes for Leo and the further marginalization of Rome's civic patriciate.[42]

In actuality, too, despite the triumphalist elements of the *festa*, the emphasis on the eternal fame of the Medici, and the restored Golden Age of peace and concord, the political ambitions of the Medicean pontificate so optimistically celebrated on the Campidoglio proved all too ephemeral. Giuliano died in 1516, and Leo's costly war of Urbino, undertaken to make that Duchy an enduring entity of Medicean dynasticism in central Italy, proved fruitless when Lorenzo de' Medici died three years later. The Ottomans advanced, despite Leo's efforts to promote a crusade, while the Reformation movement gained headway in Germany.[43]

Yet, in the end, the Capitoline festivities endure as a remark-
able expression of Roman High Renaissance culture. Roman — and
Etruscan — myth, history, and religion as interpreted by Rome's
humanists provided the origins and foundations for the civilizing
mission of the Roman *imperium* to which the *Ecclesia Romana* and the
papacy were heir. The meaning they saw in Rome's past and in its
destiny was also presented in characteristic ways, namely through
potent visual images. The paintings Inghirami conceived for the
theater, like the visual descriptions in his orations, were intended to
evoke feelings of wonder, awe, and praise, the purpose of epideictic
rhetoric. Like the antique statuary assembled on the Campidoglio,
these paintings and the dramatically visual festivities that took place
in their presence manifested to their beholders the greatness of
Rome, the centrality of the Eternal City to humanity's loftiest dreams
and aspirations, and the renewal of the empire whose global reach
surpassed even that achieved in antiquity.

NOTES

1. " . . . quod quidem maximum humani generis beneficium dei
potius quam hominum opus fuisse videtur." *Roma triumphans* in Flavio
Biondo, *Opera omnia* (Basel, 1531), 2.

2. J. W. O'Malley, *Praise and Blame in Renaissance Rome: Rhetoric, Doc-
trine, and Reform in the Sacred Orators of the Papal Court, c. 1450-1521*, Duke
Monographs in Medieval and Renaissance Studies, 3 (Durham, N.C.,
1979), esp. ch. 2.

3. H. Homeyer, "Zur *Synkrisis* des Manuel Chrysoloras, einem
Vergleich zwischen Rom und Konstantinopel: Ein Beitrag zum italienischen
Frühhumanismus," *Klio* 62 (1980): 525-34. The Latin translation, by
Francesco Aleardo da Verona, appears in Biblioteca Apostolica Vaticana
[BAV], MS. Reg.lat. 807, fols. 24ᵛ-59.

4. M. Baxandall, *Giotto and the Orators: Humanist Observers of Painting in
Italy and the Discovery of Pictorial Composition, 1350-1450* (Oxford, 1971), 81.
For further discussion of Chrysoloras's work and its sources, see C. L.
Stinger, *The Renaissance in Rome* (Bloomington, Ind., 1985), 73-74.

5. Note especially Domenico de' Domenichi's "Oratio in laudem civitatis
et civilitatis Romanae," delivered on the Capitoline Hill in June 1476 as
part of the ceremonies by which this Venetian humanist and curialist was
made a Roman citizen. The text of the oration appears in BAV, MS.

Ottob.lat. 1035 fols. 83–87ᵛ. For a discussion of this and other humanist
works in praise of Rome, see Stinger, *Renaissance in Rome*, 241–46.

 6. O'Malley, *Praise and Blame*, 63–65.

 7. Ibid., 132–33.

 8. Ibid., 65.

 9. C. W. Westfall, *In This Most Perfect Paradise: Alberti, Nicholas V, and
the Invention of Conscious Urban Planning in Rome, 1447–55* (University Park,
Penn., 1974), 33. For recent discussion of Manetti's *Vita Nicolai V*, see M.
Miglio, *Storiografia pontificia del Quattrocento* (Bologna, 1975), 98–111, and L.
Onofrio, "Sacralità, immaginazione e proposte politiche: La *Vita* di Niccolò
V di Giannozzo Manetti," *Humanistica Lovaniensia* 28 (1979): 27–77.

 10. Stinger, *Renaissance in Rome*, 222–26, and 264–81. For Giles's
views, see J. W. O'Malley, S.J., *Giles of Viterbo on Church and Reform: A
Study in Renaissance Thought*. Studies in Medieval and Reformation Thought,
5 (Leiden, 1968), 124–25; and *idem*, "Giles of Viterbo: A Reformer's Thought
on Renaissance Rome," *Renaissance Quarterly* 20 (1967): 1–11.

 11. For an overview of the historical significance of the Capitoline
Hill, see F. Saxl, "The Capitol during the Renaissance — A Symbol of
the Imperial Idea," in *Lectures* (London, 1957): 200–14. See also H.
Siebenhüner, *Das Kapitol in Rom: Idee und Gestalt* (Munich, 1954).

 12. M. Miglio, "Il leone e la lupa: dal simbolo al pasticcio alla
francese," *Studi romani* 30 (1982): 178.

 13. Saxl, "Capitol," 202–03; P. Bondanella, *The Eternal City: Roman
Images in the Modern World* (Chapel Hill, N.C., 1987), 31–35.

 14. I am convinced by Miglio, "Il leone e la lupa," 178–79, who
stresses that Sixtus's actions had clear political ramifications for Roman
municipal traditions.

 15. The inscription placed on the Capitoline on December 15, 1471,
reads:

SIXTUS IIII. PONT. MAX. OB IMMENSAM BENIGNITATEM AENEAS INSIGNES
STATUAS PRISCAE EXCELLENTIAE VIRTUTISQUE MONUMENTUM ROMANO
POPULO UNDE EXORTAE FUERE RESTITUENDAS CONDONANDASQUE
CENSUIT . . . ANNO SALUTIS NOSTRAE MCCCCLXXI.XVIII KAL.IANUAR.

 16. Miglio, "Il leone e la lupa," 179; note also E. Lee, *Sixtus IV and
Men of Letters*, Temi e Testi, 26 (Rome, 1978), 148–50. For Nicholas V's
projects undertaken on the Capitoline, see Westfall, *In this Most Perfect
Paradise*, 92–100.

 17. Miglio, "Il leone e la lupa," 179; in moving the market Sixtus
may have acceded to municipal officials' requests: see Lee, *Sixtus IV*, 126.

 18. Siebenhüner, *Das Kapitol*, 46.

 19. Saxl, "Capitol," 209.

20. Siebenhünder, *Das Kapitol*, 54. For Paul III's intentions, see T. Buddensieg, "Zum Statuenprogramm in Kapitolsplan Pauls III," *Zeitschrift für Kunstgeschichte* 32 (1969): 177–228.

21. Jacopo Gherardi da Volterra, *Il diario romano*, ed. E. Carusi, *Rerum Italicarum Scriptores* (hereafter *RIS*), 2d ed., vol. 23, pt. 3 (Città di Castello, 1904), 117.

22. Johannes Burchardus, *Liber notarum*, ed. E. Celani, *RIS*, 2d. ed., vol. 32, pt. 1 (Città di Castello, 1906), 278–80.

23. The fullest account of the 1513 *festa* is F. Cruciani, *Il teatro del Campidoglio e le feste romane del 1513, con la ricostruzione architettonica del teatro di Arnaldo Bruschi*. Archivio del teatro italiano, 2 (Milan, 1968), which includes texts of the most complete contemporary accounts, Cruciani's extensive historical introduction, and Arnaldo Bruschi's reconstruction of the theater's design and appearance. For the motives that led to the festival, see pp. xxxiv–xxxv. An annotated bibliography of sources for the festival and of scholarly studies about it appears in B. Mitchell, *Italian Civic Pageantry in the High Renaissance: A Descriptive Bibliography of Triumphal Entries and Selected Other Festivals for State Occasions*, Biblioteca di bibliografia italiana, 89 (Florence, 1979), 119–24. Note also Mitchell's discussion of the event in his *Rome in the High Renaissance: The Age of Leo X* (Norman, Okla., 1973), 61–74, and *idem*, "The S.P.Q.R. in Two Roman Festivals of the Early and Mid-Cinquecento," *Sixteenth Century Journal* 9, 4 (1978): 95–102. The Capitoline festivities of 1513 have most recently been considered by J. Cox-Rearick, *Dynasty and Destiny in Medici Art: Pontormo, Leo X, and the Two Cosimos* (Princeton, N.J., 1984), 98–100; and by B. Davidson, *Raphael's Bible: A Study of the Vatican Logge* (University Park, Penn., 1985), 22–23.

24. C. Klapisch-Zuber, "An Ethnology of Marriage in the Age of Humanism," in *Women, Family, and Ritual in Renaissance Italy*, trans. L. C. Cochrane (Chicago, 1985), 247–60 (originally published as "Une ethnologie du mariage au temps de l'Humanisme," *Annales, E.S.C.* 36 [1981]: 1016–27); S. Kolsky, "Culture and Politics in Renaissance Rome: Marco Antonio Altieri's Roman Weddings," *Renaissance Quarterly* 40 (1987): 49–90.

25. For Inghirami's career, see F. Cruciani, "Il Teatro dei Ciceroniani: Tommaso 'Fedra' Inghirami," *Forum Italicum* 14 (1980): 356–77; and J. F. D'Amico, *Renaissance Humanism in Papal Rome: Humanists and Churchmen on the Eve of the Reformation* (Baltimore, 1983), 36 and 134. His various orations are discussed by J. M. McManamon, S.J., "The Ideal Renaissance Pope: Funeral Oratory from the Papal Court," *Archivum historiae pontificiae* 14 (1976): 14–15, and 30–32; and by O'Malley, *Praise and Blame*, 64–65, 114, and 132–33.

26. A. Bruschi, "Il teatro capitolino del 1513," *Bollettino del Centro Internazionale di Studi di Architettura Andrea Palladio* 16 (1974): 189–218.

27. Palliolo, "Narratione," in Cruciani, *Teatro del Campidoglio*, 26–27.

28. Ibid., 32–33.

29. Ibid., 51.

30. [I]n vobis spes una mihi decimoque Leone,
 quem mundi commune iubar, quem Roma parentem
 iam servata vocat; populus plauditque Senatus,
 votaque plebeio certant Romana favore.
 Vivite felices, si vos tamen ultima nostri
 verba movent oris, per vos mea Roma curules
 ducat, et Ausoniae redeant ad signes secures.
 Martis et antiquus renovet suffragia Campus.
 Sic Medicos vero, surget sic nomen ad astra,
 et vestri generis semper celebrata per annos
 fama erit aeternos. . . .

(Palliolo, "Descriptio," in Cruciani, *Teatro del Campidoglio*, 85)

31. Miglio, "Il leone e la lupa," 179; Cruciani, *Teatro del Campidoglio*, xlvi, n. 7.

32. Stinger, *Renaissance in Rome*, 56 and 298; Davidson, *Raphael's Bible*, 21 and 23–24; Cox-Rearick, *Dynasty and Destiny*, 28, 140–42, 184–86, and 197–98.

33. *Aeneid*, VI, 791–94; see also VIII, 314–27 where Saturn, fleeing Jupiter, is described as creating the first Golden Age in Latium.

34. Lorenzo de' Medici's *broncone* pageant for Carnival 1513 in Florence, just before Leo's election as pope, associated the restored Medicean regime there with the return of the Golden Age, and included *carro* of the first golden age when Saturn and Janus reigned: Cox-Rearick, *Dynasty and Destiny*, 26–27. Golden Age imagery thus had a specifically Medicean dynastic context, first propagated during the regime of Leo's father, Lorenzo 'il Magnifico'. But Golden Age themes as imagery of praise were set forth in Rome as early as the pontificate of Nicholas V and particularly flourished under Leo's predecessor, Julius II: Stinger, *Renaissance in Rome*, 297–98; note also J. W. O'Malley "The Discovery of America and Reform Thought at the Papal Court in the Early Cinquecento," in *First Images of America: The Impact of the New World on the Old*, ed. F. Chiappelli, I (Berkeley, 1976), 191.

35. I. D. Rowland, "Render Unto Caesar the Things Which are Caesar's: Humanism and the Arts in the Patronage of Agostino Chigi," *Renaissance Quarterly* 39 (1986): 673–730, esp. 716–20.

36. O'Malley, *Giles*, 30–31 and 123–24.

37. D. R. Coffin, *The Villa in the Life of Renaissance Rome* (Princeton, N.J., 1979), 262–325; A. Marabottini, *Polidoro da Caravaggio* (Rome, 1969), 63–81.

38. Cox-Rearick, *Dynasty and Destiny*, 31–32, suggests an association of Leo with Aeneas in the vignette of Aeneas, Anchises, and Ascanius fleeing Troy, which appears in the left foreground of Raphael's *Fire in the Borgo*, painted in the Stanza dell'Incendio during Leo's pontificate.

39. Davidson, *Raphael's Bible*, 20; note also Stinger, *Renaissance in Rome*, 79–80, for a poem of Zaccaria Ferreri addressed to the newly elected Leo X that situates Rome, overjoyed at the pope's election, in the sphere of Jupiter.

40. D'Amico, *Renaissance Humanism in Papal Rome*, 134–37.

41. H. H. Brummer and T. Janson, "Art, Literature and Politics: An Episode in the Roman Renaissance," *Konsthistorisk Tidskrift* 45 (1976): 79–93.

42. Kolsky, "Culture and Politics in Renaissance Rome," 68–69.

43. Stinger, *Renaissance in Rome*, 30.

Republicanism and Tyranny in Signorelli's *Rule of the Antichrist* *

JONATHAN B. RIESS

LUCA SIGNORELLI'S MURAL representing the *Rule of the Antichrist* (Fig. 1) is the keystone in the artist's definitive cycle of eschatological representations, dated 1499 to 1504, in the Cappella Nuova of Orvieto Cathedral (Fig. 2). The broad artistic and historical importance of this unique, monumental portrayal of the life of the Antichrist, and of this most ambitious portrayal of the Last Things in Renaissance art, has long been recognized.[1] However, the actual nature and extent of Signorelli's novel political refashioning of established iconographic formulae have not been understood. The Orvieto *Antichrist* is not an impassive exercise in a shared cultural tradition. It is a bitter commentary on contemporary tribulations, here characterized as a phase in the corrupt and calamitous history of human governance. Unexpectedly, perhaps, the Orvieto mural represents one of the most original expressions of political intention in Renaissance art and comes to encapsulate the divided nature of a late fifteenth-century Roman humanistic culture — divided in the sense that it is eager to embrace the political philosophy of the past, but just as unambiguous in asserting its reservations concerning that same philosophy.[2]

The purpose of this essay is to offer a new interpretation of the Signorelli mural based on an examination of those varied forces that shaped the work.

The Revelation of Saint John, the biblical wellspring for knowledge and understanding of the Antichrist, is of all the scriptures the most openly contemptuous of the world and of worldly success, and so the most ardent in its anticipation of the final destruction and

157

judgment.[3] Signorelli's portrayal of Apocalypse is singular in its confrontation with and realization of this fundamental aspect of the text. His interpretation derives from a distinct confluence of Roman and local influences, and from his increasingly charged penitential Christianity as he came to conceive the masterwork of his career.[4] André Chastel's widely accepted thesis, first advanced in 1952, that the Orvieto *Antichrist* was intended as a condemnation of Savonarola must be rejected. This reduction of the mural to something that verges on mere poster art misses the larger political and ecclesiastical significance of the work.[5]

The originality of Signorelli's ruminations on political history and on their particular manifestations in the special circumstances of his own age are perhaps most immediately foreshadowed in his *Court of Pan*, painted about ten years earlier. Like *Pan*, the *Antichrist* molds classical references and analogues into lessons for the present.[6] But unlike the mythological painting, Signorelli's consideration of the future of the world, fired by the history of the Antichrist, suggests that a militant Christianity offers a solution to present trials.

There are many ways of accounting for the artist's new approach, for his involvement in the politics of religion; the most obvious among these explanations is also possibly the most important: Signorelli's move from Medicean Florence to papal Orvieto.[7]

Pius II arrived in Orvieto in 1460 and remarked, on the occasion, how the cathedral, "which is inferior to no church in Italy," stands at the center of a ruined neighborhood. "Age has destroyed much," he wrote, "civil strife has burned and ravaged more."[8] On this same theme of decline, a civic official stated to the pope that "Our city, which once envied none in Tuscany, is now pitied by all men."[9] A respite from the melancholy consideration of these difficulties comes with the pope's reflections on the importance of the celebration of the Feast of the Corpus Christi in Orvieto.[10]

The decaying civic world delineated by Pius still well characterizes the city around 1500, the time of Signorelli's *Antichrist*. Violent discord continued to beset the city. Papal involvement in the political life appears to have become even more dominant as Alexander VI made Orvieto a center of his political and territorial ambitions in central Italy.[11] The famous cult of the blood-stained corporal of the Miracle of Bolsena remained pivotal to the religious

culture and one other ongoing source of papal association with the city.[12] Signorelli's history of the end of time was itself inevitably linked to the promotion of church power, to anxiety about the contemporary disorder, and to the Feast of the Corpus Christi.[13]

Before examining the political ramifications of the fresco of the *Rule of the Antichrist* it is necessary to establish, however superficially, the lineaments of the overall artistic program. Misinterpretation of the mural has resulted in part from the isolation of the scene from the larger cycle, as well as from an inadequate understanding of the general character and premises of Signorelli's exegesis of Apocalypse.[14]

Signorelli's grandiose scheme is divided into four sections that correspond to the four spheres of medieval and Renaissance eschatology: first is the *Rule of the Antichrist* to the left as one enters the chapel; second, *The End of the World*, which is pictured above the entry arch; third is *The Resurrection*, directly opposite the *Antichrist* on the right wall; and fourth, the *Last Judgment*, described in the three large murals at the altar end of the chapel and in the quadripartite vaults, much of which were painted by Fra Angelico about a half century before Signorelli began work in the chapel. Thus, while the vaults reflect Fra Angelico's design, the decoration of the walls — so the documents make clear beyond any doubt — was planned in 1499 and 1500.[15]

The progression of events could not be clearer or more dramatic. The history of the future opens with the appearance of God's great enemy at the end of time, the Antichrist. Following the defeat of the evil one, pictured in the upper left of the mural, the viewer is thrust into the right half of *The End of the World* — more precisely, a depiction of other "signs" of the approach of the cataclysm — and is brought next to the universal destruction represented in the left half of the scene. The onlooker is then led precipitously into *The Resurrection*, and so the way is prepared for the return of Christ described in the second region of wall murals and in the vaults.

The drama of the end is given sacramental meaning in the grouping of frescoes above and to the sides of the altar. The depictions of *The Blessed Ascending to Paradise* and of Christ as Judge and *Salvator Mundi*, and the statue of the *Assumption of Mary* and the Crucifixion originally displayed on the altar in this chapel dedicated to the Assumption — these embellishments connect the *Last Judgment*

with the celebration of the eschatological sacrament of the Eucharist
and so with the attainment of eternal life. Christ represents, in
common with his meaning in comparable decorative assemblages of
the time, man's victory over death, a doctrine liturgically expressed
in the Mass celebrated at the altar. Signorelli's history of the end
is thus related to the great events in the history of salvation, a rec-
ord that concludes with the triumph of the faithful proclaimed in
the vaults.[16]

The place of the *Rule of the Antichrist* within the overall eucha-
ristic meaning of the chapel can be very briefly summarized. The
advent of the Antichrist, so it was believed in the fifteenth century
and earlier, is a time of purgation of the earth, a time of testing that
precedes Christ's final act of judgment.[17] The prominent Domini-
can behind the preaching Antichrist points out the Sacred Way —
pace Chastel's belief that he be identified as a follower of the evil
one — as the attentive Cistercian directs our gaze to the true God in
the vaults.[18] (Among its manifold ramifications, the scene contrasts
good and evil preaching.) The belief, expressed by Aquinas and
others, that the celebration of the Mass, the foundation of the Chris-
tian life, is a protection against the challenge and temptation of the
Antichrist, opposes the early and ephemeral victory of the Anti-
christ with the final and eternal victory of the church.[19] An explicit
reference to the Eucharist in the border immediately below the
mural makes most clear the interplay between the Antichrist and
the Sacrament.[20]

A second large import of the chapel introduces an overt and
heretofore undeveloped political perspective to the history of the
end and to the Antichrist. Within the dense pattern of grotesque
ornamentations found in the basement section of walls are portraits
of six writers enframed by illustrations drawn from their writings.
The idea of Christian triumph proclaimed on the altar wall comes,
with these representations, to be cast as a victory over the political
life.[21] As important as these six writers are to the formation of
Christianity, and as engaged as several were in the reformation of
the political worlds in which they lived, they are faulted by Signorelli,
to paraphrase the neo-Augustinian sentiments of a leading Domin-
ican in 1501, because they sought temporal civic triumph and glory
and did not give themselves wholly to the pursuit of a transcendent
eternal triumph in the more courageous struggle against the devil.[22]

Beneath the *Antichrist* is a portrait I believe to be of Cicero — one of the grouping of six writers — accompanied by three illustrations drawn from the *Philippics* (Fig. 3).[23] We will see shortly how these representations amplify the story of the Antichrist, imbuing the evil one's tyranny with imperial Roman overtones. The political dimension is further enlarged through the presence of Lucan, with two scenes taken from the *Pharsalia*, beneath *The Resurrection*. The *zoccolo* below the scenes of the Christian afterworld in the region of the altar includes three pagan authors — Statius, Ovid, and Virgil — all of whom in one way or another anticipate the nature and composition of the Christian netherworld pictured above. And, finally, there is a portrait of Dante accompanied by illustrations of the first eleven cantos of the *Purgatorio*.[24]

The triumph of the faith and the rejection of the political life, as concerned solely with bodily rather than spiritual well-being, are themes developed more extensively in the *Antichrist* mural. The interaction between the preaching Antichrist and the Dominican who stands behind him, a relationship already alluded to, establishes the central meaning of the work as the opposition between the political and religious realms.

Before looking more closely at the development of this theme it is important to stress that the documents suggest that Signorelli enjoyed some measure of freedom in the painting of the large wall murals. Further, the Opera del Duomo, the body that oversaw Signorelli's work, was, as a result of the special significance of the cathedral and the papal cult of the Miracle of Bolsena, more directly under the sway of Rome before it was beholden to local ecclesiastical authority. Still less were the chapel decorations a reflection of the will of its patrons, the Monaldeschi family.[25]

The most noteworthy artistic anticipation of the meaning of the Orvieto Antichrist is not to be found in the vast field of Antichrist illustration, but rather in Signorelli's own murals representing Saint Benedict and Emperor Totila (Fig. 4), a part of the life of the saint that decorates the cloister at Monte Oliveto, works that were carried out immediately before the Cappella Nuova murals (1497–1498). (Beyond the conceptual parallels there are many specific compositional and figural affinities that point to a direct derivation of the *Antichrist* from the immediately preceding work.[26]) Benedict's success, at least for a time, in quelling the "savage cruelty"

of the leader of the Ostrogoths, as Gregory the Great described Totila in his life of the saint, is portrayed by Signorelli as, in its essence, the confrontation between the monastic and political worlds. The idea of victory of monastic principles and obligations over tyranny was adapted by Signorelli to his interpretation of the Antichrist.[27]

Most important to the formation of Signorelli's work at Orvieto was the writing of three theologians, none of whom has been connected previously with Signorelli's work. All were Dominicans, a point that speaks, among other matters, of the particular contemporary influence of the order both in Rome and in Orvieto.[28]

First among these theologians is Saint Vincent Ferrer, as revealed in his sermons on the Antichrist delivered in the first decade of the fifteenth century and widely available in print by 1500.[29] The mural as a consideration of unstable and hazardous contemporary conditions, with monastic devotion put forth as a palliative to these conditions, much in the manner of Signorelli's own Saint Benedict murals, owes much to Vincent's view of the Antichrist.

The importance of Vincent in Signorelli's concept of the Antichrist is most tangibly manifest in the fact that the aged Dominican behind the evil one may well be a portrait of the saint. This identification is based on comparison with several of the many works dedicated to Vincent following his canonization in 1455. Reproduced here, for example, is the central panel of what is possibly the first altarpiece devoted to him, a work attributed to Colantonio found in San Pietro Martire in Naples and dated 1459 (Fig. 5). The parallels with the Signorelli are, I believe, immediately apparent.[30] The fact that Signorelli's Vincent is seen patiently disputing questions raised by members of various Eastern churches relates to his unsurpassed reputation in the struggle against heresy and schism, and to the belief that division within the church is a chief barometer of an age ripe for the appearance of the Antichrist.[31] It is entirely fitting that the man who came to be officially designated, in the bull of canonization, as the "Angel of the Apocalypse" — the voice of the church for the pronouncement of the Second Coming of the true Messiah — should oppose the false Christ.[32] The gesture of the Cistercian who so ardently looks toward Vincent for guidance quotes directly the gesture associated with the iconography of Vincent, as we have seen him portrayed, for example, in the Naples altarpiece.

The second writer whose influence is evident in the mural is Saint Antoninus. His lengthy consideration of the Antichrist, in the *Summa* of 1454, is itself based on the sermons of Vincent, whom he calls the "greatest preacher" on the subject.[33] Antoninus develops the Augustinian notion of the Roman emperors as Antichrist types, a notion central to the connections Signorelli forges between the illustration of Cicero in the *zoccolo* and the Antichrist mural.[34]

The third significant theological source is the Dominican, Annius of Viterbo, the greatest authority on the Antichrist and the chief papal theologian at the time of Signorelli's work in Orvieto in his position as Master of the Sacred Palace. Annius's 1480 gloss on *Apocalypse* was reprinted several times during the 1490s.[35] While the interpretation is somewhat extreme, even eccentric, the text was nevertheless of possible formative impetus to Signorelli's conception of the active part played by the church, personified by several conspicuous friars, in the struggle against Christ's chief foe.[36]

The episodes illustrating the reign of the Antichrist are set on Mount Oliveto, with the city of Jerusalem in the background valley and the massive temple constructed by the Antichrist on the site formally occupied by the Temple of Solomon. This symbol of the pride of the Antichrist and his followers contrasts with Christ's holy temple of the spirit above.[37] The pagan, classicizing design of the structure is a first indication of Signorelli's exposition of the Antichrist's reign as a projection into the contemporary world of Roman tyranny.

The classical rostrum on which the Antichrist stands, rather than the wooden pulpit on which he was normally pictured, underscores the link with the idea of an imperial prototype to the Antichrist, a notion which will shortly be developed in some detail. The podium is decorated with a rearing horseman emblematic of the pride and avariciousness of the Antichrist's strivings, a symbol directly associated with this rule by Antoninus. He writes: "The rider of the horse is he who clings to the earth and is brought down from her because of love of the world. . . . "[38] The statement may well serve to locate Signorelli's own view about the nature of all temporal authority, its lust for the worldly, the profane.

The moment portrayed in the foreground was drawn from Vincent Ferrer, the first of the three theologians mentioned as having influenced Signorelli's *Antichrist*. In one of his sermons he describes

how the Antichrist will gather together the people of the world under the guise of promising them salvation and will preach, unlike the individual he claims is the false and deceitful God, that he, the Antichrist, is not interested in riches or in having the faithful give him their possessions, but would rather aid the poor by giving them gifts.[39] In Signorelli's scene, the Antichrist preaches before a varied crowd meant to suggest, in the spirit of Vincent, the universality of his threat and potential allure. A human devil prompts him, as one of his followers distributes to the poor treasures taken from the hoard at the base of the podium.[40] That the distributor of the gifts is a Jew who stands among poor, venal women — he may be so identified by his physiognomy and by the Stars of David on his purse — these details bring the scene closer to the letter of Vincent's sermons. Vincent, a militant anti-Semite, spoke often of how the Antichrist's first appeal was among Jews because of their expectation of riches, and he warned of how the Jewish usurer and his temptations presented a particular lure to poor women.[41]

The pile of bodies to the left, beside one of the Antichrist's henchmen in the act of strangling another victim, denotes the violent means employed by the Antichrist against those who resist his preaching and bribes. (The final strategy used to gain power, that of false miracles, is illustrated in the left and middle background.) Antoninus writes of how the bodies of the martyrs are left unburied in order to frighten the recalcitrant into submission.[42] That the martyrs are virtually all friars points generally to the church as leading and directing the resistance to the Antichrist. The unburied and martyred friars may also be related, more specifically, to the many references made by Vincent to the violation of the sanctity of the monastic life by the state. This profanation of monastic life, according to Vincent, is one of the chief signs of a propitious moment for the Antichrist and is a leading example of the evil and violent excesses committed by secular rulers.[43] For Vincent, the monk's denial of worldly power and delights is an exemplum of a spiritual course that all should follow, not only as the actual challenge of the progress of the Antichrist is countered, but also as a preparation for the Last Days. The avowal of poverty and humility, Vincent wrote in a treatise on the spiritual life, protects one against the Antichrist

who plays upon one's prideful tendency toward ambition and who represents temptation away from the faith.[44]

While friars are slaughtered or preach the word of the true Christ, various political leaders of Signorelli's day and of the past stand and listen to the false preachment of the Antichrist. These contemporary political leaders comprise, for the most part, the rear three rows of the crowd just left of center.[45] The unmistakable figure of Cesare Borgia to the far left, and of the tyrant Vitellozo Vitelli, third figure from the left, suggest that other figures in the grouping — several of whom can be tentatively identified — might well be rulers of the time.[46]

The contemporary political leaders are balanced by the crowd on the right, which includes rulers from the past. Among them is a Roman in imperial dress who stands close to the rostrum, and the figure to the far right who, I believe, may be identified as Alexander the Great.[47]

Traditionally, in the written lives of the Antichrist, rulers had been the subject of special interest; their conversion to the party of Christ's enemy was believed to precede and prepare the way for their subjects to join with the Antichrist.[48] (Vincent states, for example, that the lives of the "captains" and "princes" of the day are in particular danger as the Antichrist will try to tempt them first, knowing that if he succeeds, others will follow.[49])

Signorelli gives this aspect of the story new immediacy through the portrayal of contemporary and historical figures, rather than the stock characters traditionally found in Antichrist illustrations.[50] The world appears to hang in the balance; the rulers of the time seem distanced from the action, as if no final commitment in favor of or against the Antichrist had as yet been made by them.

Two well-dressed figures on the left, those closest to the Antichrist, are, curiously, barefooted, and stand like the others in the back rows of the crowd on steps that raise them above the group of more actively involved individuals. While space does not permit extensive elaboration of this matter, I believe that the barefooted figures are the leaders of the Cathedral Confraternity of Saints Mary and Martin. This confraternity had from the late 1200s to the early 1500s been charged with the staging of sacred plays in Orvieto, including at least one enactment of an Antichrist play in front of the

Duomo in 1508, distinguishing features of which include parallels with the mural.[51]

How may this putative staging of the Antichrist play in Orvieto relate to Signorelli's fresco? Perhaps the steps on which the rulers stand and the sense of aloofness about these figures can now be more fully explained in terms of theatrical representation. Placed upon the steps of what appears to be a kind of amphitheater, they witness not the actual preaching of the Antichrist, but a sacred enactment of his evil ranting. The manifest narrating, the Greek chorus function of the figures to the far left — Luca Signorelli and his predecessor in the Cappella Nuova, Fra Angelico — would thus complement perfectly this staged drama or mystery play of the Antichrist that they present to us the audience, the play-goers, inviting us through glance and gesture to complete a grouping of spectators around the enactment, to enter into this play within a play.[52] The prominence of Fra Angelico in his Dominican habit as one of the narrating figures, and wearing a cap (*zuchetto*) associated with venerable members of the order, is entirely appropriate in this scene in which the Dominican Saint Vincent leads the struggle against the Antichrist.[53]

The many-leveled fiction that Signorelli describes comes to represent Vincent's belief in a conditional Last Judgment. If the world reforms its ways, according to Vincent, the fearful beginnings of the eschatological future will be postponed.[54] A choice is thus presented to the political leadership of the time to follow the rule of the Antichrist, depicted in the staging of the story, or to follow the example of the Dominican behind the Antichrist, and so remain faithful to the true God and strong of heart and spirit in the period of testing and purgation ahead. The likelihood that the friar is Vincent gives a kind of historical validity to his supposed ability to bring together warring leaders.[55] It is in the spirit of Vincent, then, that Signorelli pleads that the "princes" and "captains" cast aside their political differences, unite and prepare themselves for the greater danger presented by the Antichrist.

The wisdom of Signorelli's political considerations is established and made acceptable by associating it with historic precedent. This is done by including earlier leaders among the figures in the crowd to the right, and also, more important, through the Ciceron-

ian scenes in the region of the *zoccolo* directly below the *Antichrist*. We must look more closely at one or two other details of the *Antichrist* mural, however, before the relationship with Cicero may be explored.

The depiction, already referred to, of a classical rostrum instead of a wooden pulpit—the Antichrist's rostrum pictured in the Velislav Bible (c. 1350, Fig. 6), is the one earlier example of which I am aware—and the unique, humanized devil who advises the Antichrist indicate,[56] I believe, reference to and parody of the most popular of Roman state ceremonies: the *Adlocutio*. The several ancient variants on the artistic expression of the *Adlocutio* center around the idea, as Richard Brilliant has expressed it, of "triumphal address and proclamation of power over a Roman audience." In its quintessential form on the coinage of Nero, of which an example is included here (Fig. 7), the emperor, with arm extended in a gesture of authority toward the individuals he addresses, is mounted on a platform above the audience in the company of the advising Praetorian Prefect or officer whose body and position mirror the emperor's yet, to cite Brilliant again, the Prefect "does not intrude on the Emperor's relation with his audience."[57] (Nero made the widest use of the motif and was himself the most frequently invoked imperial figure of the Antichrist during the Quattrocento.[58])

The relationship between the Antichrist and the humanized devil, and that between the Antichrist and the crowd, might well be described in these words, except, of course, the Antichrist may hardly be said to hold his audience in thrall. The treasures piled at the base of the rostrum, it would now seem, also allude to imperial ceremony and stand for the trophies emblematic of political and military triumph.[59] More specifically, the inclusion of plates, vases, and instruments associated with pagan rites suggests Antiochus's desecration and sacking of the temple—the "abomination of desolation" (Daniel 11:31). This action is described by Antoninus as a "metaphor for the destruction of the Church and the end of the world."[60] The rostrum in a parodic context such as this may also be likened to a pedestal, the Antichrist to a statue placed upon it. The Antichrist's association with idolatry, and with the erection of a statue of Antiochus in the temple, can also be included in Signorelli's broad condemnation of temporal authority.[61]

Another telling adaptation (or travesty) of imperial iconography is evident in the extraordinary way, noted earlier, in which the bribes of the Antichrist are distributed. The common manner of illustrating the episode is with the Antichrist himself handing out gifts, such as in the Vicenza life of the Antichrist of 1496. The combination of the preaching of the Antichrist and the Jewish gift-giver at Orvieto suggests the *Congiarum*. This ceremony, again one associated first with Nero's state liturgy, was the ritual gift-giving to the citizenry that followed a triumph and the imperial address commemorating it. Its true purpose, as distinguished from demonstrations of *Liberalitas*, was to secure popular acceptance. The typical scene, as portrayed during Nero's reign, shows the emperor on his platform directing the task of distribution either to an official who shared the platform with him, or more commonly, as in the example illustrated here, to one within the crowd (Fig. 8).[62]

I cannot refrain from noting, as evidence of the contemporary understanding of Roman political liturgy, that Flavio Biondo observes, in a passage which may relate somewhat ironically to the stereotypical Jewish usurer in the mural, that the gifts were a way of keeping the poor happy and "away from the clutches of usurers, who were deplored by Romans."[63] The interest, especially apparent in Orvieto during the second half of the fifteenth century in challenging the practice of usury through such means as the *Monte di Pietà*, suggests that the ironic implication of the scene may not have been lost to the audience of the time.[64]

Turning now to the reinforcement and amplification of the imperial links expressed in the grisaille murals below the Antichrist, I should point out that evidence close at hand may be found for Cicero as the subject of the portrait (Fig. 9). In 1503, Antonio degli Albèri, archdeacon of the cathedral and the leading humanist in the city, commissioned from a follower of Signorelli a grouping of portraits for his library, which adjoins the Cappella Nuova at the northwest corner of the Duomo.[65] A figure labeled "Cicero" in the Albèri ensemble corresponds to Signorelli's contemporary image (Fig. 10). What may be referred to as the Cicero portrait type in Orvieto appears to originate with the Cicero in Federigo da Montefeltro's *studiolo* and with a drawing of the writer ascribed to Uccello (Vienna, Albertina).[66]

Albèri's possession of a copy of the *Philippics* (IX.G.20, Biblioteca Comunale, Orvieto) speaks of a local interest in this comprehensive attack on Roman tyranny, which is the subject, I believe, of the illustrations that accompany the portrait.[67] These new identifications of the portrait, and of the enframing murals, make most explicit the political dimension of the *Antichrist*, and amplify as well the meaning of the fresco as a rumination on good and bad preaching.[68]

Signorelli leaves no doubt that the grisailles are intended to be linked to the *Antichrist* fresco: in the uppermost scene frenzied figures look up directly toward the figure of the Antichrist in gestures that suggest a Roman Acclamation and an outpouring of religious veneration (Fig. 11).[69] Cicero's concern that Antony will soon declare himself a god, and his censure of Antony for the part he played in the deification of Caesar, are dramatized in this mural.[70]

Foremost in Cicero's criticism are the many violations of legal procedure that have occurred under Antony, and which are held to reveal most clearly his despotic instincts. He writes of the tendency "to threaten against the innocent loyal citizens with punishment."[71] To the side of the portrait is a scene that encapsulates this aspect of Roman misrule: two, most probably wrongly accused, prisoners are brought before a ruler or judge who stands on a rostrum with an adviser (Fig. 12). The scene immediately suggests Signorelli's reformulation of the *Adlocutio* above, but it refers more pointedly to the episode in the right background of the *Antichrist* where the tyrant, once more atop his pagan rostrum, is seen ordering the death of two Christians, possibly Enoch and Elias.[72]

Consideration of the violent wellsprings of Antony's rule may be inferred in the presence of armed men at the legal proceeding. Cicero observes that Antony is "the only man since the foundation of Rome who has publicly kept armed men by his side."[73] The depiction is paralleled once more above as the Antichrist is represented in close proximity to one of his henchmen. Cicero writes also of how "most horrible of all" was the stationing of armed men at the Sanctuary of Concord and the plundering of its treasury by the avaricious ruler. The scriptural source for the presence of men in battle array within the precinct of the temple of the Antichrist was possibly reinforced by Signorelli's reading of the *Philippics*.[74] And the

analogy between Antony's consuming avarice and the rapacious Antichrist is also inescapable. The excesses of earthly rule from its beginnings to its eschatological conclusion are, Signorelli implies through these comparisons, completely consistent.[75]

Further, less ambiguous indication of the violent tenor of Antony's rule is found in the depiction of a murder in the lowermost grisaille (Fig. 3). It is difficult to know which of the many bloody events described in the *Philippics* is represented. Violence is pervasive; Antony "threatens us all . . . with destruction, devastation, and the pains of torture." The murdered individual, one who gave his life in the struggle for liberty, becomes a figure for the Christian martyrs in the *Antichrist* fresco.[76]

Perhaps, too, the battle of kith against kin narrated by Cicero suggested to Signorelli a connection with the Italian dislocations around 1500. The scenes of civil war taken from Lucan's *Pharsalia*, and found in the lower border of the opposite wall, point in much the same way to the violent disorder of Rome as a foreshadowing of the days of the Antichrist (Fig. 13).[77] The record of the unsuccessful fight against Roman absolutism is elaborated in the neighboring depictions of Dante's Antepurgatory, presided over by Cato, who like Cicero and Lucan was another victim in the cause of liberty.[78] Taken together, these depictions of past tribulations stand for the end of Rome, as Cicero and Lucan themselves believed.[79] And the final collapse of the "monarchy" of Rome, according to Antoninus in his neo-Augustinian history of governance, was to be followed by the reign of the Antichrist.[80]

The defeat of tyranny, in Signorelli's dismal assessment of the political order, will come only in the Last Days. Although the artist casts his lot with Ciceronian republicanism, he appears to believe that a fundamental reorientation of the political life will not come to pass. Temporal authority is fated to follow in the path of Roman absolutism; only complete surrender to the authority of the Church, and to the monastic ideals and obligations represented by Vincent Ferrer and his fellow friars, offer hope to the world. For Vincent, as for Annius of Viterbo, the eschatological future is closely related to the idea of the triumph of the church and the pope, and of safety found within the church as the only hope within a world torn by conflict.[81] These, too, are the basic dimensions of Signorelli's mural.

It is possible that Signorelli, like Annius, believed that the rule of the Antichrist precedes the foundation of a millennial papal monarchy that arises before the Second Coming.[82] The prominence of Saint Vincent, thought around 1500 to have prophesied a Christian world rule,[83] in this sense might signify not only the imminent return of the true Christ, but also the immediate need for secular power to give way to the church as humankind prepares for the New Kingdom.

NOTES

*Much of the research for this paper was made possible by a National Endowment for the Humanities Independent Study and Research Fellowship (Rome, 1986–1987). My thanks to Professors Julian Gardner, David Parrish, Sabine Poeschel, Lucio Riccetti, and Chester L. Riess. This study is part of a book I am presently completing on the Cappella Nuova.

The fresco is generally titled the *Acts of the Antichrist*. I believe that the appellation employed here better reflects the meaning of the work.

1. See, most recently, my "Luca Signorelli's Frescoes in the Chapel of San Brizio as Reflections of their Time and Place," in *Renaissance Essays in Honor of Craig Hugh Smyth*, ed. E. Borsook et al., The Harvard Center for Renaissance Studies, 7, vol. 2 (Florence, 1985), 383–93, and "The Genesis of Signorelli's Cappella Nuova Frescoes," in *Essays in Commemoration of the 700th Anniversary of the Foundation of the Orvieto Duomo*, ed. Lucio Riccetti (Rome, forthcoming). The standard study of the documentary history of the chapel remains L. Fumi, *Il duomo di Orvieto e i suoi restauri* (Rome, 1891), 88ff. and 400ff.; and the basic interpretation of the *Antichrist*, one which I believe is seriously flawed, is A. Chastel, "L'Apocalypse de 1500: la fresque de la chapelle Saint-Brice à Orvieto," *Bibliothèque d'Humanisme et Renaissance* 14 (1952): 124–40; and *idem*, "L'Antéchrist à la Renaissance," *Cristianesimo e ragion di stato: l'umanesimo e il demonico nell'arte*, ed. E. Castelli (Rome, 1952), 177–86. Indicative of the continued support for Chastel's point of view, Stanley Meltzoff has recently argued at length in its behalf in *Botticelli, Signorelli and Savonarola: "Theological Poetica" and Painting from Boccaccio to Poliziano* (Florence, 1987), 287ff. I will discuss what I believe to be the problems with Meltzoff's analysis in another place.

2. On late Quattrocento Roman thought, see, most importantly, J. F. D'Amico, *Renaissance Humanism in Papal Rome: Humanists and Churchmen on the Eve of the Reformation* (Baltimore and London, 1983); and J. W. O'Malley, *Praise and Blame in Renaissance Rome: Rhetoric, Doctrine, and Reform*

in the Sacred Orators of the Papal Court, c. 1450-1521, Duke Monographs in Medieval and Renaissance Studies, 3 (Durham, 1979). An excellent overview of the situation may be found in C. L. Stinger, *The Renaissance in Rome* (Bloomington, Ind., 1985), 292-319.

3. For consideration of this aspect of the Revelation of Saint John, see, among many sources, R. Freyhan, "Joachim and the English Apocalypse," *Journal of the Warburg and Courtauld Institutes*, 18 (1955): 211-44. Note, too, the first modern introduction to the Antichrist, R. K. Emmerson, *Antichrist in the Middle Ages: A Study of Medieval Apocalypticism, Art, and Literature* (Seattle, 1981). For a general introduction to Medieval and Renaissance eschatological thought, M. Reeves, *The Influence of Prophecy in the Later Middle Ages: A Study of Joachimism* (Oxford, 1969), remains unsurpassed. For a critical summary of the more recent literature, see B. McGinn, "Awaiting an End: Research in Medieval Apocalypticism, 1974-1981," *Medievalia et Humanistica; Studies in Medieval and Renaissance Culture*, n.s. 11, ed. M. Clogan (Totowa, N.J., 1982), 263-91. There are at present no broad, scholarly examinations of apocalypticism in art, although such surveys as B. Toscano, *Il pensiero cristiano nell'arte*, 1 (Bergamo, 1960), 323-453, are useful.

4. On Signorelli's religious sympathies, see D. M. Manni, *Vita di Luca Signorelli* (1756), as reprinted in R. Vischer, *Luca Signorelli und die italienische Renaissance, eine Kunsthistorische Monographie* (Leipzig, 1876), 377-78. For Signorelli's later association with various religious groups, refer to C. Mancini, *La vita di Luca Signorelli* (Florence, 1903), 106-07, and 241-42.

5. Reservations about Chastel's interpretation have been raised by Riess, "Luca Signorelli's Frescoes," passim; R. de Maio, "Savonarola, Alessandro VI e il mito dell'Anticristo," *Rivista storica italiana* 82 (1970): 533-59; and Emmerson, *Antichrist*, 308 n. 58. In my earlier consideration of the mural I related the work more directly to the contemporary Turkish threat and crusading enthusiasm than I will do here, while Emmerson believes that the *Rule of the Antichrist* should be understood as a straightforward, largely traditional illustration of the life of Antichrist. On this latter possibility, see also Emmerson and R. B. Herzman, "Antichrist, Simon Magus, and Dante's *Inferno* XIX," *Traditio* 36 (1980): 380-98. Chastel has responded—unsuccessfully, I believe—to De Maio's criticisms in his *Fables, formes, figures*, 1 (Paris, 1978), 163-65.

6. For the *Court of Pan* as political allegory, see W. Welliver, "Signorelli's *Court of Pan*," *Art Quarterly* 24, no. 4 (1961): 334-45. For the astrological and Medicean dimensions to the work, note J. Cox-Rearick, *Dynasty and Destiny in Medici Art: Pontormo, Leo X, and the Two Cosimos* (Princeton, N.J., 1984), 83-86. Note also G. Kury, *The Early Works of Luca Signorelli: 1465-1490* (New York and London, 1974), 300, who suggests, correctly I believe, that

Signorelli had an important role in the formulation of both the *Pan* and the Cappella Nuova.

7. For Signorelli in Florence, in addition to the sources cited in note 6 above, see A. Chastel, *Art et humanisme à Florence au temps de Laurent le Magnifique* (Paris, 1959), 230–33. For the impact of the society and culture of Orvieto on Signorelli, see Riess, "Luca Signorelli's Frescoes," passim.

8. *The Commentaries of Pius II: Books IV and V*, ed. W. D. Gray and H. U. Faulkner, and trans. F. A. Gragg, Smith College Studies in History, 30 (1947), Bk. 4, 337.

9. Ibid.

10. Ibid., 338.

11. There is no modern, scholarly history of the city during the Renaissance. L. Fumi, *Alessandro e il Valentino in Orvieto* (Siena, 1877), is the most complete history of Orvieto during the reign of Alexander V (1492–1503). Consult also, for the late Quattrocento, Tommaso di Silvestro, *Diario (1482–1514)*, in L. Fumi, ed. *Ephemerides Urbevetanae, Rerum Italicarum Scriptores* 15, pt. 5.11 (Città di Castello, 1902–20).

12. The fundamental study of the early history of the miracle of Bolsena is A. Lazzarini, *Il Miracolo di Bolsena; testimonianze e documenti dei secoli XIII e XIV*, Temi e Testi, 1 (Vatican City, 1952). For papal interest in the cult in Orvieto during the fifteenth century, see L. Fumi, *Statuti e registri dell'Opera di S. Maria di Orvieto* (Rome, 1891), 96f.

13. The foundation of the cathedral commemorates the feast which, tradition held during the fifteenth century, had been composed by Aquinas while he was in Orvieto. A. Walz, *La presenza di San Tommaso a Orvieto e l'ufficiatura del Corpus Domini* (Turin, 1966).

14. The most complete elucidation of the iconography is Vischer, *Luca Signorelli*, 57f. and 285f. Vischer sees the chapel decorations as straightforward illustration of the Last Things with none of the eucharistic implications suggested here. Vischer's analysis is followed, for the most part, in the most thorough recent analysis: E. Carli, *Il Duomo di Orvieto* (Rome, 1965), 96ff.

15. The most detailed description of the scenes, one not without errors, remains L. Luzi, *Il Duomo di Orvieto* (Florence, 1866), 59ff. See also Carli, *Il Duomo*; L. Kanter, *Orvieto: Chapel of San Brizio — Luca Signorelli* (Florence, 1983). On the chronology of Fra Angelico's work in the chapel in 1447, carried out with the assistance of Benozzo Gozzoli, note C. Gilbert, "Fra Angelico's Fresco Cycles in Rome: Their Number and Date," *Zeitschrift für Kunstgeschichte* 38 (1975): 245ff; and J. Pope-Hennessy, *Fra Angelico*, 2d ed. (Ithaca and New York, 1974), 33–34, 213–15, 218, and 238. The decision by the Opera del Duomo to commission Signorelli to complete Fra Angelico's decorations in the vaults was made on April 5,

1499 (Fumi, *Il Duomo*, Document CLVI, 406), and the decision to have Signorelli enlarge the original scheme to cover the walls was made on April 27, 1500 (ibid., Document CLXI, 408–09). Concerning the fact that Fra Angelico's designs extended no further than the vaults and that there existed at the time no plans for the walls, see the document of November 25, 1499 (ibid., Document CLVIII, 408).

16. For the dedication of the chapel — construction began in 1408 and was completed in about 1444 — see G. della Valle, *Storia del Duomo di Orvieto* (Rome, 1781), 242ff.; Fumi, *Il Duomo*, 370ff.; and *idem, Statuti*, 21–22. In 1446 a statue of the *Assunta* was placed on the altar, and in 1490 an elaborate tabernacle incorporating the statue and a crucifix was constructed. All this was lost when the massive altar now in the chapel was constructed. (One other decorative allusion to the Assumption of Mary — a window representing the subject — was removed in 1472: P. Perali, *Orvieto: note storiche di topografia e d'arte delle origini al 1800* [Orvieto, 1919], 145.) On the eucharistic implications of comparable decorative assemblages around 1500, see Staale Sinding-Larsen, "Titian's *Triumph of the Faith* and the Medieval Tradition of the Glory of Christ," *Acta ad archaeologiam et artium historiam pertinentia* 6 (1975): 315ff. And on the theology of the Assumption and its relation to the grouping of subjects at Orvieto, refer to P. M. Roschini, O.S.M., *Il dogma dell'Assunzione*, Studi Mariani, 3 (Rome, 1950).

17. On this aspect of the meaning of the Antichrist, note Emmerson, *Antichrist*, 95.

18. Only L. Dussler has posited a similar interpretation, *Signorelli: Das Meisters Gemälde* (Stuttgart, 1927), xxxiv. Emmerson notes his assent to this idea (*Antichrist*, 309 n. 58). I have more to say about the grouping shortly. For Chastel's hypothesis, see "L'Apocalypse," 129.

19. Thomas Aquinas, *Summa Theologica*, II, trans. Fathers of the English Dominican Province (New York, 1947), III, q. 49, a. 2, p. 2289. A comparable pairing or contrast between the Antichrist and the Eucharist is found in Bosch's contemporary *Epiphany*. See L. Brand Philip, "The Prado *Epiphany* by Jerome Bosch," *Art Bulletin* 35 (1953): 267–93.

20. I refer to the grisaille scene of wine-making directly below the preaching Antichrist. Note, on this type of image, M. Vloberg, *L'Eucharistie dans l'art* (Grenoble and Paris, 1946), 23–25.

21. The relationship between the large wall murals and the border scenes has been interpreted most generally as an expression of anti-paganism. L. Fumi, *Il Duomo di Orvieto e il simbolismo cristiano* (Rome, 1896); and Chastel, *Art et humanisme*, 445–49. See, most recently on the border murals, R. M. San Juan, "The Function of Antique Ornament in Luca Signorelli's Fresco Decoration for the Chapel of San Brizio," *Canadian*

Art Review, Proceedings of the Symposium of the Roman Tradition in Wall Decorations, Palazzo Cardelli (Rome, 7–9 June 1984) 12, no. 2 (1985): 235–41.

22. Master Denis of Bologna, in a speech of nomination for Vincent Bandinelli's promotion as Master General of the Order, invoked this theme. R. P. Mortier, *Histoire des Maitres Généraux de l'Ordre des Frères Prêcheurs*, 5 (Paris, 1911), 71.

23. The figure is said to be Homer, and the three scenes to derive from the *Iliad*. See, most importantly, Luzi, *Il Duomo*, 169–79, for the standard interpretation of the murals of the *zoccolo*. The conventional Quattrocento image of Homer, unlike Signorelli's figure, is bearded (L. Cheles, *The Studiolo of Urbino: An Iconographic Investigation* (Wiesbaden, 1986), 17–19 and passim. Signorelli's figure, further, is obviously not blind. On the identification of the portrait as Cicero, see below.

24. For Lucan, see Luzi, *Il Duomo*, 193–94, and for Ovid (beneath *The Damned*, close to the altar wall), note Luzi, 186–90. More disagreement surrounds the other figures. The figure I have said is Statius — beneath *The Blessed*, close to the altar wall — is most often said to be Virgil (Luzi, 184–85). My suggestion is based in large part on the earliest surviving detailed description of the chapel: Girolamo C. Clementini, "Esatta descrizione del celebre Duomo o chiesa Cattedrale di Orvieto e facciata di essa," manuscript, unnumbered, Archivio dell'Opera del Duomo, Orvieto, 1702. The figure said here to depict Virgil — beneath *The Damned*, middle of the west wall — follows San Juan, among others ("The Function of Antique Ornament," 239–40). On the Dante — below *The Blessed*, middle of the east wall — see Luzi, 170–71.

25. On the expectation of an active involvement on the part of Signorelli in the formulation of the program, see Fumi, *Il Duomo*, Document CLX, 408 (April 23, 1500). On the relative importance of the cathedral authorities, and of those charged with the embellishment of the structure in particular, see Fumi, *Statuti e registri*, 98–99. And on the closeness of the cathedral with Rome, see V. Natalini, "Il capitolo del Duomo di Orvieto ed i suoi statuti inediti," *Rivista di Storia della chiesa in Italia* 9 (1951): 177–232.

26. Of the grouping of ten murals painted by Signorelli I refer to the scene of *Saint Benedict Recognizes and Welcomes Totila*. The most complete examination of the works in E. Carli, *L'abbazia di Monteoliveto* (Milan, 1962). The stylistic affinities with the Orvieto murals have been noted before: S. M. Cruttwell, *Luca Signorelli* (London, 1899), 58 and 63; and R. van Marle, *The Development of the Italian Schools of Painting*, 16 (The Hague, 1937), 45. The broad elements of the Antichrist are, to be sure, related to traditional patterns of illustration, as only Emmerson (*Antichrist*, p. 309 n.

58) has recognized. See Emmerson, pp. 108–45, for the most complete survey of medieval and early depictions of the life. The *Antichrist* is, I believe, dated early in Signorelli's activity in Orvieto, and thus immediately after the Monte Oliveto frescoes. Space does not allow a consideration of the matter, but one important bit of evidence is the early reflection of the *Antichrist* in Pinturicchio's firmly dated *Christ Among the Doctors* of 1501 (Spello, Santa Maria Maggiore, Baglione Chapel). For a later dating of the *Antichrist*, note C. Gilbert, "Signorelli and the Young Raphael," in *Raphael Before Rome*, ed. James Beck, Center for Advanced Study in the Visual Arts, Symposium Series, 5, National Gallery of Art (Washington, D.C., 1986), 111–12.

27. For Gregory's description of Totila, see *Dialogues*, II, 14, 15; III.11, 12, 13. Note F. Homer Dudden, *Gregory the Great: His Place in History and Thought*, 1 (New York and Bombay, 1905), 30f., for a discussion of Gregory's characterization of Totila. The fact that the Benedictines were, in the late fifteenth century, "a model of moral cleanliness" (L. von Pastor, *History of the Popes*, ed. and trans. F. I. Antrobus, 6 [St. Louis, 1898], 174), and that the chapter at Monte Oliveto enjoyed a particular importance in the reform movement (S. Hilpisch, *Geschichte des Benediktinischen Mönchtums* [Frieburg im Breisgau, 1929], 250, 252), suggest that the active role of the friars in the Antichrist might well have been inspired by what Signorelli came to be exposed to while at the monastery.

28. On the broad influence of the order, see J. A. Mirus, "The Dominican Order and the Defense of the Papacy" (Ph.D. diss., Princeton, 1973). For Orvieto, note M. Rossi Caponeri and L. Riccetti, *Chiese e covnenti degli ordini medicanti in Umbria nei secoli XIII e XIV. Inventario delle fonti archivistiche e repertorio delle informazioni documentarie. Archivi di Orvieto, Archivi dell'Umbria. Inventari e ricerche* (Perugia, 1986). None of the Dominican sources here noted has previously been associated with the Orvieto murals. The large literature on the subject cannot be rehearsed here, but for one alternative, more traditional treatment, note C. Gilbert's belief that the *Legenda aurea* was the most important source for Signorelli ("Bramante on the Road to Rome — with Some Leonardo Sketches in His Pocket," *Arte lombarda* 66, pt. 3 (1983): 5–14.

29. For the publishing history and texts of the major Antichrist sermons of Vincent, see F. S. Brettle, *San Vincente und sein literarischer Nachlass* (Münster, 1924), 14–17 and 173–95. For the cult of Vincent in Orvieto, see L. Fumi, *San Bernardino da Siena in Orvieto e in Porano* (Siena, 1888), 18. The date Fumi gives here for the establishment of a feast day in honor of Saints Vincent and Bernardino should be August 4, 1457, rather than August 24. See Archivio del Commune di Orvieto, Rif. ad. an. 1457, c. 321 and 322v. For Vincent's widespread popularity during the Quattrocento,

see H. D. Fages, *Histoire de Saint Vincent Ferrier*, 2 (Louvain and Paris, 1901), 413ff.

30. The altarpiece — whose date is based on circumstantial evidence — includes eleven scenes of the life of the saint (G. Kaftal, *Saints in Italian Art: Iconography of the Saints in Central and South Italian Schools of Painting* [Florence, 1965], 1134; and P. H. Jolly, "Jan van Eyck and Saint Jerome: A Study of Eyckian Influence on Colantonio and Antonello da Messina in Quattrocento Naples" [Ph.D. diss., University of Pennsylvania, 1976], 67, 82, 88–95, and 131ff.). The work was restored in 1960 (*Mostra di restauri*, Palazzo Reale [Naples, 1960], 47ff.) The saint is depicted at Naples in typical fashion, with his right hand raised, and holding a book in his left on which is written a text from Apocalypse 14:7 (*"Timete Deum"*). For a list of the early portraits, see H. D. Fages, *Notes et documents de l'histoire de Vincent Ferrier* (Louvain and Paris, 1905), 494ff. Note also Van Marle, *The Development . . .* , vol. 15, 358–63. The same large head, heavy-set features, somewhat swarthy complexion, lined face, white band of tonsured hair, and stout body are common to virtually all Quattrocento representations. On the first cult images in Spain — the type is close to the friar in the *Antichrist* — note Fages, *Histoire*, vol. 2, 387f.

31. The hairstyle and dress of the figures to the right of Vincent conform closely to the Eastern monks, friars, and deacons pictured in Filippo Duoanni, *La gerarchia ecclesiastica* (Rome, 1720), pls. 90, 92–93 (following p. 336). The long, curly hair of the figure closest to Vincent leaves little doubt that he is a Greek deacon. One of the major points of division between the Eastern and Western churches at the time related to the Last Judgment. In the context of Signorelli's depiction of the Last Things the dispute between Vincent and the Greek might well allude to these questions (P. de Roo, *Material for a History of Pope Alexander VI*, 3 [Bruges, 1924], 36ff.) For Vincent, the Schism, and heresy, see M-M. Gorce, *Saint Vincent Ferrier (1350–1419)* (Paris, 1924), 193ff.

32. On the canonization of Vincent, see H. D. Fages, *Procès de la canonisation de Saint Vincent Ferrier* (Louvain, 1904). In 1455 Calixtus III declared him beatified and in 1458 Pius II published the bull of canonization, the text of which may be found in Fages, *Histoire*, vol. 2, 335–43.

33. For Saint Antoninus's account of the life of the Antichrist, one which in fact includes several references to Vincent's authoritative preachment on the subject, see *Summa theologiae*, 3 (Verona, 1740), cols. 716–28. Note col. 724 for an allusion to Vincent.

34. On Augustine's interpretation of the Antichrist, one of the most influential throughout the Middle Ages and Renaissance, see *The City of God Against the Pagans*, trans. W. C. Greene, 6 (Cambridge and London,

1960), Bk. 20, chs. 19–23, pp. 366–401. For Antoninus on imperial Anti-
christ figures, see *Summa theologiae*, vol. 3, cols. 718 and 722.

35. For the Dominican friar Giovanni (c. 1432–1502), or Iohannes
Nannius, or Annius of Viterbo, as he often referred to himself, see *Ad
beatissum papam Sixtum et reges ac senatus christianos triumphis in Saracenos . . .*
(Genoa, 1480). On his life and the early publishing history of the text, see
R. Weiss, "Traccia per una biografia di Annio da Viterbo," *Italia medievale
ed umanistica* 5 (1962), 425–41; and *Annio di Viterbo, documenti e ricerche*, ed.
G. Bonucci Caporali (Rome, 1981). For the power of the Master of the
Sacred Palace, see V. M. Fontana, *Syllabus magistorum: Sacrii Palatii
Apostolici* (Rome, 1663).

36. For Annio the contemporary Antichrist is to be identified with
Islam (*Ad beatissum papam Sixtum*, fol. 9 and passim). The work is in fact a
tract conceived first to drum up support for a crusade. On the possible
connection of Signorelli's murals with the contemporary Turkish threat,
see Riess, "Luca Signorelli's Frescoes," passim. Annius's text is marked by
an extraordinarily militant stance; at one point, for example, he argues
that as the Turks kidnap and murder Christian children, so must the
Christians do the same to the Moslems (fol. 15v).

37. On the topography of Jerusalem and its representation in con-
temporary art — the conformity with Signorelli's setting is close — note in
particular, C. H. Krinsky, "Representations of the Temple of Jerusalem
before 1500," *Journal of the Warburg and Courtauld Institutes* 33 (1971): 1–19.
For Antoninus on the symbolism of the temple, note *Summa theologiae*, col.
718. See, for the idea of the Christian holy temple of the spirit and its
opposition to the Temple of Solomon, J. W. O'Malley, *Giles of Viterbo on
Church and Reform: A Study inRenaissance Thought*, Studies in Medieval and
Renaissance Thought, 5 (Leiden, 1968), 119–22.

38. *Summa theologiae*, cols. 725–26. For the use of the classical ros-
trum, see below.

39. For reference to, and summary of, the sermon, see Antoninus,
Summa theologiae, col. 724. Note also Vincent in Brettle, *San Vincente*, 181,
where he speaks more generally of "disputation" — or preaching — as one of
the four methods he will use to gain power (the others being miracles,
gifts, and torture): "he shall falsely and unfairly cite scripture, to which
the master [of theology, of laws] themselves will not be able to reply, since
the devil will trip up their tongue, their memory, their intelligence, and
their good sense, so that in the presence of the people they will appear as
if mute."

40. The scene, in particular its broad variety of types, corresponds
closely to the description of the Antichrist's rise to power in Vincent, *De
fine mundi* (Venice, 1527), fols. 114v–115. On the use of the promise of the

gift of riches to gain power, Vincent states, in part, that "when Lucifer shall come . . . all the treasuries of gold and silver, precious stones . . . will be opened for him by the demons [who will serve the Antichrist], and will be put before him. . . . And he will distribute to whomever is willing to adhere to him. . . . " (Vincent, in Brettle, *San Vincente*, 181).

41. On Vincent's anti-Semitism, and on the centrality of the conversion of the Jews and Vincent's sense of the Last Days, see M. M. Gorce, "Vincent Ferrier (Saint)," in *Dictionnaire de théologie catholique*, XV.2 (Paris, 1946), cols. 3033–3045. The physiognomy and dark complexion of the gift-giver in the mural are identical to the figure of Judas in Signorelli's *Communion of the Apostles* of 1512 (Cortona, Museo Diocesano). The type conforms closely to a prevalent stereotype in art of the later fifteenth century (B. Blumenkranz, *La Juif médiéval au miroir de l'art chrétien* [Paris, 1966], 36–37). On the conspicuously luxurious dress of the figure as a mark of the usurer, see C. Roth, *The History of the Jews in Italy* (Philadelphia, 1980), 211. Chastel, *L'Apocalypse*, 128, also identifies him as a usurer. For the reference in Vincent to Jews and women, see Brettle, *San Vincente*, 183. Vincent notes that Jews must "be distinct from Christians in their dress . . . for when they are not so marked, they mix with Christians, especially women, and do much harm." The pairing of the women with the avaricious Jew suggests interesting parallels with a common grouping in Northern European art (L. A. Silver, "*The Ill-Matched Pair* by Quentin Massys," *Studies in the History of Art*, National Gallery of Art, Washington, D.C., 6 [1974]: 105–23).

42. *Summa theologiae*, col. 725. The statement is made in the course of Antoninus's exegesis of Apocalypse 11 and 13.

43. It is Vincent, in Brettle, *San Vincente*, 182, who designates such rulers as "Antichrists." Vincent writes, in part, that "there is no state in the world that is not strong enough, if wicked men are not brought to justice in it. It will be destroyed, and monastic life will be the more destroyed, but so will any ecclesiastical regime." See also *De fine mundi*, fol. 115.

44. *Le Traité de la vie spirituelle*, in *L'Asceticisme dans l'ordre de S. Dominque*, I, ed. R. P. Matthie and J. Rousset (Paris, 1899), pt. 3, ch. 1, 103.

45. The belief that several of these figures are portraits of contemporary leaders goes back to Vasari, who notes that there are "numerous portraits of the friends of Luca," proceeds to innumerate five individuals, and concludes that there are "many others, whose names are not known" (*Le opere di Giorgio Vasari*, 3, ed. G. Milanesi [Florence, 1879], 690). Several indeed can be identified, while others can only be guessed at. Other figures appear to be stock types used by Signorelli (note similarities with the types that appear in his Sistine Chapel and Monte Oliveto frescoes). The

most interesting comment on Signorelli's portraits in the context of late Quattrocento practice is C. Gilbert, "Review of John Pope-Hennessy, *The Portrait in the Renaissance*," *Burlington Magazine* 110 (1968): 278–89.

46. For the portrait of Cesare, note, in particular, A. de Hevesy, "Portraits of the Borgias: Cesare," *Burlington Magazine* 61 (1932): 70–75; and for Vitellozo, note the closeness to Signorelli's own independent portrait of him (Florence, I Tatti-Berenson Foundation) and Paolo Giovio, *Elogia Virorum bellica virtute illustrium* (Basel, 1577), 185.

47. For the Alexander identification, see the close similarity with the Giovio portrait of Alexander (Giovio, *Elogia*, 7), and with the stucco portrait of Alexander in the Borgia apartments (1492–4) that Sabine Poeschel has recently brought to light ("*Alexander Magnus Maximus*: Neue Aspekte zur Ikonographie Alexander des Grossen im Quattrocento," *Römisches Jahrbuch für Kunstgeschichte*, forthcoming). It is not possible to argue alternative possibilities here, but it must be pointed out that the traditional identification of the bald figure to the right of the Antichrist as Pandolfo Petrucci (pictured looking back into the crowd), is clearly incorrect. See, for example, the Petrucci in Giovio, *Elogia*, 264. Only P. Perali has also doubted this identification in *Orvieto: Note storiche di topografia e d'arte dalle origini al 1800* (Orvieto, 1919), 148.

48. In conventional illustrated lives, scenes of the conversion of the rulers generally preceded the other strategies employed by the Antichrist to gain power. See, for example, the most popular of illustrated lives of the Antichrist of the second half of the fifteenth century, *Der Enndkrist der Stadt-Bibliothek zu Frankfurt am Main*, ed. E. Kellner (Frankfurt am Main, 1891), pls. 12 ff., for a most extensive cycle of portrayals of the Antichrist converting rulers. Note Emmerson, *Antichrist*, 44–45, 94, 215, 231, and passim, for examination of this aspect of the rule of the Antichrist.

49. *De fine mundi*, fol. 115.

50. This is a primary distinction between Signorelli's representation and French, German, and Italian book illustrations and manuscript illuminations. For the important contemporary example, note *Antichristus* (Vincenza, 1496?, Biblioteca Apostolica Vaticana), a work of French origin in which the witnesses to the Antichrist in all the scenes are generalized types. This is true also of the illustration that is closest to Signorelli's representation: the woodcut by Michael Wolgemut of the Antichrist preaching in Hartmann Schedel, *Liber chronicarum* (Nuremberg, 1493), fol. XCV. See A. Wilson, *The Making of the Nuremberg Chronicle* (Amsterdam, 1976), pl. 10.

51. The text of the play, staged August 20, 1508, does not survive. A detailed summary of it is found in Tommaso di Silvestro, *Diario*, 372–74. The only reference to the play in the Signorelli literature is Perali, *Orvieto*,

143, who cites its performance as evidence of the strong local interest in the Antichrist. The only other considerations of the play, and the cycle of works of which it was a part — these later plays are also summarized by Tommaso — are two papers by Kathleen C. Falvey at the International Congress on Medieval Studies (Kalamazoo): "The Cathedral of Orvieto and the Confraternity Playbook" (1977), and "The Orvieto Creation Play and its Collection" (1982). Among the notable and heretofore unnoted similarities with the mural is the fact that a Dominican preacher, rather than Enoch and Elias, speaks out against the Antichrist. For the confraternity, see A. Tenneroni, "Sacre rappresentazione per la fraternite d'Orvieto nel Codice Vittorio Emmanuele 528," *Bollettino della Reale Deputazione di storia patria per l'Umbria* 5 (1916): 103ff.; and V. de Batholomaeis, *Laude drammatiche e rappresentazioni sacre*, I (Florence, 1943), 331 and 407. For the bare feet of the two figures as a possible indication of their membership in a lay confraternity of *disciplinati*, see W. A. Hinnesbusch, *The History of the Dominican Order*, I (New York, 1966), 146; and as a symbol of the penitential followers of Vincent Ferrer, another possible intention behind the figures, see Fages, *Histoire*, vol. 1, 159.

52. Gilbert, "Review of Pope-Hennessy," 284, has noted the sense of "disassociation" about the figures of the artists, and has suggested that they might be witnesses to an Antichrist tableau. There is some question as to the identification of the Dominican at Signorelli's side as Fra Angelico (P. Scarpellini, *Luca Signorelli* [Florence, 1964], 110). See my forthcoming "The Genesis of Signorelli's Cappella Nuova Murals," note 36, for consideration of this figure. The whole arrangement, or "staging," of the fresco corresponds closely to the arrangement of leaders, preaching Antichrist, and temple of the Antichrist in a famous earlier performance of an Antichrist play (J. Wright, *The Play of Antichrist*, Pontifical Institute of Medieval Studies [Toronto, 1967], 52ff.). Vischer, *Luca Signorelli*, 177ff., has noted the general importance of medieval mystery plays for Signorelli's conception.

53. My thanks to Father Boyle of the Vatican Library for identification of the cap that the figure wears. A bit of the friar's white undergarment may be seen at his feet and sleeve; he is indeed a Dominican, despite uncertainties expressed by Della Valle, *Storia del Duomo*, 213. It is possible, and not without significance in this scene concerned in part with the contrast between good and bad preaching, that while Signorelli's hands are clasped, the Dominican gestures in a manner associated with preaching and so is joined, in a sense, with the figure of Vincent in the middleground. For the meaning of the gesture, see W. Hood, "St. Dominic's Manners of Praying: Gestures in Fra Angelico's Frescoes at S. Marco," *Art Bulletin* 68 (1986): 200.

54. Fages, *Histoire*, vol. 1, 341. It was believed, in fact, that by Vincent's having set humanity on the right path in 1410 the Last Judgment had been postponed.

55. The text of the bull of canonization (1458) stresses this aspect of his ministry. See the text of the bull in Fages, *Histoire*, vol. 3, 335ff.

56. Prague, University Library, MS. XXIII.C.124, fol. 132 (facsimile edition: *Velislai Biblia Picta*, ed. K. Stejskal, Editio Cimelia Bohemica, 12 [Prague, 1970], vol. 2) See J. B. Russell, *Lucifer: The Devil in the Middle Ages* (Ithaca, N.Y., 1984), 209, for a comment on the grotesque manner in which the devil was most commonly characterized in art. Julian Gardner has suggested to me that the Antichrist appears like a puppet manipulated by Satan, a possibility that would accord well with the idea that the scene represents a staging of the Antichrist drama. See Russell, *Lucifer*, 327–29, for the devil's role on stage in the Middle Ages. The typical, bestial Satan who accompanies the Antichrist may be seen in the Velislav illustration noted above (Fig. 6).

57. The example included here is dated 66–68 A.D. See J. P. C. Kent, *Roman Coins* (New York, 1978), 285. For the comments of Richard Brilliant, see his *Gesture and Rank in Roman Art: The Use of Gesture to Denote Status in Roman Sculpture and Coinage*, Memoirs of the Connecticut Academy of Arts and Sciences, 14 (New Haven, Conn., 1963), 48 and 77. For the development of the *Adlocutio*, see P. G. Hamberg, *Studies in Roman Imperial Art, with Special Reference to the State Reliefs of the Second Century* (Uppsala, Stockholm, and Copenhagen, 1945), 135ff.; and for one important monument known to Renaissance artists that illustrated the theme, see P. P. Bober and R. Rubenstein, *Renaissance Artists and Antique Sculpture: A Handbook of Sources* (London and Oxford, 1986), 227–28.

58. A. Graf, *Roma nella memoria e nelle immaginazioni del Medio Evo* (Turin, 1923), 262–84.

59. Brilliant, *Gesture and Rank*, 40, 77, and 198.

60. Antoninus, *Summa theologiae*, col. 721. On Antiochus and the Antichrist, see Emmerson, *Antichrist*, passim; and for an important contemporary reference to Antiochus as an Antichrist type, see Schedel, *Liber chronicarum*, fol. lxxxxi verso. For identification of the types of vessels and instruments in the scene, refer to Bober and Rubenstein, *Renaissance Artists*, 225; and to A. Martindale, *The Triumph of Caesar by Andrea Mantegna in the Collection of Her Majesty the Queen at Hampton Court* (London, 1979), 172–74.

61. For the Antichrist, Antiochus, and idolatry, note, for the general background, Emmerson, *Antichrist*, 45; for contemporary allusions to the association, see Annio da Viterbo, *Ad beatissum papam Sixtum*, fol. 6v; and for the Orvieto Antichrist play, Tommaso, 374. The design of the rostrum

in the mural follows closely that of actual pedestals of the time (K. Weil-Garris, "The Pedestals: Michelangelo's *David*, Bandinelli's *Hercules and Cacus and the Sculpture of the Piazza della Signoria,*" *Römisches Jahrbuch für Kunstgeschichte* 20 (1983): 377–417.

62. For the coin pictured here (dated 64–66 A.D.), see Kent, *Roman Coins*, 285. For the *Congiarum*, note Brilliant, *Gesture and Rank*, 76–77; and, see Hamberg, *Studies in Roman Imperial Art*, 40, on the distinction between the rite and demonstrations of *Liberalitas*. As for Signorelli's knowledge of the type, note the discussion in Flavio Biondo, *Roma trionfante*, trans. L. Fauno (Venice, 1549), fols. 179 and 186ᵛf.

63. Biondo, *Roma trionfante*, fol. 189.

64. Orvieto was one of the first cities to establish such a bank (1463: L. Luzi, *Il primo Monte di Pietà* [Orvieto, 1868], 10–110). The early legislation speaks of the great cupidity of the Jewish usurers.

65. On the library and the attribution of the frescoes, see the brief comments of Fumi, *Il Duomo*, 172 and 369–70; and Carli, *Il Duomo*, 106 and 120–21 n. 25. L. Fumi was the first to suggest that Albèri had a role in the Cappella Nuova frescoes (*Orvieto* [Bergamo, 1919], 148). On Albèri, see A. A. Strnad, "Francesco Todeschini-Piccolomini: Politik und Mäzenarentum im Quattrocento," *Römische Historische Mitteilungen* 8–9 (1964/65–1965/66): 137–39 and 396–97.

66. On the earlier identification of the figure as Homer, see above, note 23. For the Cicero at Urbino, see Cheles, *The Studiolo of Urbino*, fig. 17, pp. 38, 40, 42 and 45. For the Uccello, note B. Degenhart and A. Schmitt, *Corpus der Italienischen Zeichnungen*, 1 pt. 2 (Berlin, 1968), cat. no. 299, pl. 277d, p. 379.

67. For the incunabulae of the Biblioteca Comunale, including reference to Albèri's *Philippics*, see C. Scaccia-Scarafoni, "La Biblioteca communale 'L. Fumi' di Orvieto ed i suoi incunabuli," *Accademie e Biblioteche d'Italia*, 5.1–2 (1931): 1–14. There is no contemporary illustrated edition of the book. M. Sander, *Le livre à figures italiens depuis 1467 jusqu'a 1530*, 1 (Milan, 1942), 348ff.

68. For the literary importance of Cicero during the late fifteenth century, see I. Scott, *Controversies over the Imitation of Cicero* (New York, 1910), 10f.; and for his literary and political significance, note H. Baron, "Cicero and the Roman Civic Spirit in the Middle Ages and Early Renaissance," *Bulletin of the John Rylands Library* 22, no. 1 (1958): 72–97. For reference to Cicero as a literary model for good preaching during the 1490s, see D. Guttièrez, "Testi e note su Mariano da Genezzano (d. 1498)," *Analecta Augustiana* 30 (1969): 141f.

69. Brilliant, *Gesture and Rank*, 21, 109, 120, and passim, on the *Acclamatio*.

70. Cicero, *Philippics*, ed. and trans. D. R. Schackleton Bailey (Chapel Hill, N.C., and London, 1986), Bk. 2.119, p. 99. The chief contemporary commentary on Cicero — *Orationes Philippicae*, ed. Francesco Maturanzio (Vicenza, 1488/9) — does not offer a theological interpretation of the text.

71. References to these abuses are scattered throughout. Note, in particular, Bk. 1.20–21 (p. 19); 1.25 (p. 21); and 2.22 (pp. 45–46).

72. One episode recounted in the *Philippics* refers specifically to the trial of two individuals for Caesar's assassination (Bk. 2.26, p. 49). Perhaps the scene alludes to, or was inspired by, this event. See also Bk. 13.27–32 (pp. 341–47).

73. Bk. 5.17 (p. 159).

74. Bk 5.18 (p. 159). Although not referring to the temple built by the Antichrist, but rather to the Temple of Solomon, Apocalypse 11:2 describes how the gentiles have the run of the portico of the temple and how two witnesses dressed in sackcloth will be there. The figures represented near the portico are possibly, again, Enoch and Elias. See Luzi, *Il Duomo*, 73–74.

75. See Bk 2.44 (p. 59) on Antony's "need for money."

76. Bk 14.8 (p. 363). It is possible that the scene represents the murder of Cicero. See below, note 77, on the possible relevance of such a portrayal to Signorelli's conception.

77. See note 76 on Luzi's (*Il Duomo*) identification of the figure and the scenes. I have not been able to find other contemporary portraits of Lucan with which to compare Signorelli's (Sander, vol. 2, 693). The earliest illustrated edition is dated 1511. The violence in the *Pharsalia* (Lucan, *The Civil War, Books I–X*, trans. J. D. Duff [New York, 1928]) is pervasive and it is difficult to suggest precise passages for the illustrations. I would, nevertheless, put forward the following possibilities: for the tondo above the portrait, Bk. CII, 11. 45ff., pp. 369ff. (the battle of Pharsalia is described), and, for the tondo to the right of Lucan, Bk. VIII, 11. 614f., p. 483 (the death of Pompey; this too is Luzi's belief). It is possible that the lost tondo, that which was below the portrait, dealt with the witch Erichtho, and the reanimation of a corpse (Bk. VI, 11. 414ff., pp. 335ff.); her magic contrasts with the true miracle of resurrection represented in the large mural above the Lucan grouping.

78. On the comparison of Cato's suicide with that of Lucan, see F. M. Ahl, *Lucan: An Introduction* (New York, 1966), 369ff.; and on Dante's own references to Lucan, see Ahl, 250. For Lucan's references to Cicero, also see Ahl, passim. For Cato as a hero of Quattrocento republicanism, see H. Baron, *The Crisis of the Early Italian Renaissance* 1 (Princeton, N.J., 1955), 62, 94–95, and 99.

79. See Ahl, *Lucan*, 44, on this parallel between the two writers.

80. *Summa theologiae*, col. 722.

81. Concerning Vincent's papalism and his Church-centered picture of the world, see F. Oakley, *The Western Church in the Later Middle Ages* (New York, 1979), 265–66, and 270. And for Annius, see Reeves, *The Influence of Prophecy*, 173–74, and 463–64.

82. For the millennial foundation of Annius's thought, see Reeves, *The Influence of Prophecy*, 173–74 and 463–64.

83. For the Joachite thrust of some of the sermons published as his in the early 1500s — these may be apocryphal — see O. Nicoli, "Profezie in Piazza: note sul profestimo popolare nell'Italia del primo cinquecento," *Quaderni storici* 41 (1979): 513.

Commentary on Stinger and Riess

JOHN O'MALLEY, S.J.

IN ADDITION TO addressing the theme of art and politics, these essays add a third element, which for this period of history is almost inevitable, religion. It is also important to note how close they are to each other geographically—Orvieto, an hour and a half from Rome; politically—they are both set in the old Papal State; chronologically—the frescoes of the Cappella Nuova were completed in 1504 and the ceremonies on the Capitol took place in 1513. The political and religious ideologies inspiring the Orvieto frescoes and the Capitoline ceremonies and other phenomena, however, could hardly be more different. This is a fact of importance.

Stinger has many things to say about the attention given to the Capitol in Renaissance Rome, but since he concentrates on the ceremonies of 1513, I will do the same. One of the striking things about this event is the clear evidence of the collaboration among humanists and artists/artisans in its production. We generally assume that, despite their professional jealousies, such collaboration in some form or other was the order of the day in Renaissance Rome, but we do not often have such well-documented evidence to ground that assumption. We have it here. The coordinating force behind that collaboration was without a doubt the pope himself and his court, members of which participated in the ceremony in various ways.

Even more graphically documented, however, is the ease with which the alliance, the interpenetration, of religion and politics—in this case, of papal and imperial aspirations—is taken for granted and exploited. This alliance or interpenetration is so foreign to our way of thinking that it is perhaps difficult for us to grasp how unquestioned it seems to have been in certain Roman circles. Its roots are many, deep, and complex, but three documents surely

were central to its anchoring — Virgil's Fourth Eclogue, Eusebius of Caesarea's general thesis about secular history as a providential "preparation for the Gospel," and the diffuse tradition that elements of the revelation to Israel had somehow been communicated to the gentiles. The political pretensions of the papacy, deriving from biblical and canonical sources first starkly propounded by Pope Gregory VII and then argued by canonists and papal apologists from the twelfth to the fifteenth centuries against kings, emperors, and councils, were given a new framework through the Renaissance recovery of classical, especially imperial, antiquity. It is that transformation that Stinger has illustrated for us.

In my opinion, there is an attractive side to the ways these myths work together. Even though the civic liberties of the Roman citizenry were doubtless suborned by the Leonine propaganda concerning the significance of the Capitol, a new sense of destiny and a new energy to build the city to surpass (*quanto magis*) its past greatness was made operative for the benefit of us all. Not by bread alone do we humans live, but by a sense of location in the universe and by hopes and dreams for a brighter future. Even in 1513 Rome's chief assets against its future were the monuments and memories of earlier accomplishments and the promise of an even more Golden Age to come.

This alliance of Rome and the church, of culture and religion, had theological implications as well that are not without their attractive side, in my opinion. That alliance more than implied that culture and religion were not enemies, but proposed *in actu exercito* that the best in human strivings supported and was reconciled with genuine religion. The idea was argued by Aquinas through his basic principle that grace does not deny nature but builds on it and was furthered by the humanists' reverence for pagan seekers after truth. "Saint Socrates, pray for us." In those aspects of their respective enterprises, scholasticism and humanism — both of which were strongly operative in Renaissance Rome — were reconciliatory and world-friendly in their deepest impulses. I have often speculated that these less exclusive interpretations of Christianity might have had an influence later in the century on somebody like Matteo Ricci, the Jesuit missioner to China, in his reverence for Confucianism and his attempts to coordinate it with Christian beliefs.

Easy harmonizations were the seamy side of such reconciliatory dynamics. These are what perhaps strike us most forcibly here — especially the easy harmonization of empire with church, of political power with pastoral office. If I were to apportion praise and blame, I would lay blame to a large extent on the humanists' doorstep. The scholastics — the very questing and dialectical nature of their method — were much better at analysis and at pursuing to their logical conclusions the component parts of any synthesis. This fact helps explain why the scholastics rather than the humanists were so consistently in trouble with the papacy for their doctrinal and ecclesiological conclusions.

Stinger makes a great deal of epideictic rhetoric — panegyric. That rhetoric was only one factor operative in the intellectual culture of Renaissance Rome, and it must not be treated as if it explains everything. Since I began to write on that subject about ten years ago, however, I have become more, not less, convinced of its importance for understanding the culture of papal Rome. In a society almost defined by its ceremonies, epideictic oratory was ceremonial discourse par excellence. Although it was just a literary form, its swift and broad adoption to replace earlier forms meant the introduction of a new language system, with all the shift in culture that such a replacement implies. A literary form, it promoted a new *forma mentis*, a new hermeneutics, a new way of constructing reality. It promoted, to use the fashionable term, a new *mentalité*. Evidence of the diffusion and appropriation of that *mentalité* can be seen in all the protracted and elaborate ceremonies on the Capitol, though they did not lack more medieval antecedents. In those ceremonies we have not simply epideictic oratory, but a multi-media panegyric, which has a demonstrable aesthetic affinity with the oratory.

We might further observe that this new *mentalité* suffered from the general and well-known "weakness for general ideas" endemic to much of humanism. It was more concerned with constructing an attractive synthesis and with putting unity into diversity (just as an oration put unity into the diverse elements that constitute the parts of a speech) than in criticizing the given. While it was supposedly the art of blame as well as of praise, it showed an almost constitutional incapacity radically to criticize the status quo, and directed its vituperation against accidental contingencies, not substantive

discrepancies. It was, indeed, a *forma mentis* that insulated its bearers against criticism of such discrepancies. It advocated a system even in the very act of criticizing it. It was, in theory and in fact, dogmatic oratory, for it assumed in any given instance agreement on basic assumptions. It was essentially serene and soothing, often seductive, never an incitement to revolution — or even to critical distancing. No accident that *pax et concordia* was one of the typical burdens of its eloquence. It would not lay the axe to the root.

From what Reiss tells us, we see clearly that a quite different tradition inspired the Orvieto cycle by Signorelli. This was the tradition of denunciation deriving from the prophets of Israel who railed against the abominations of the political and religious status quo, from the tradition of unworldly asceticism and withdrawal inspired by the Johannine Epistles and Gospel — "My kingdom is not of this world" — and from the apocalyptic tradition inspired by the Johannine Book of Revelations. In the Johannine tradition, of course, we have the appearance of the Antichrist, who seduces under the appearance of religion. Easy harmonizations are precisely what this tradition cannot abide. Whereas the humanists had a penchant for "general ideas" and the Thomist affirmed a coordination between nature and grace, the Johannine tradition of apocalypse was permeated with dualistic categories, with irreconcilable alternatives — light and darkness, truth and lie, freedom and slavery, life and death. True, this was not the radical dualism of the later Manichees or Albigensians, but it did provide scriptural warrant for it.

As we well know, apocalyptic denunciation of religious misrule and ungodly structures of church governance raged in certain circles in the late Middle Ages, and we particularly associate it with the convergence of Franciscan spiritualism and Joachite eschatology. It was such traditions of medieval preaching that were condemned and forbidden in 1516 in the decree "Supernae maiestatis praesidio" of the Fifth Lateran Council under Leo X.

Once again we are reminded of the complexity of the religious and literary traditions in Italy at the beginning of the sixteenth century — in their various medieval and Renaissance forms. We as yet have no sure formula that clarifies for us how they interacted, that accurately weighs their relative importance, and that even delineates for us what they all were. An uneasy juxtaposition of some of them appear in certain thinkers, of which Giles of Viterbo would be

a well-known example. Despite the excellent researches of the past twenty years, we are still only on the threshold of understanding Renaissance religion and theology. On the other hand, in the subjects presented by Stinger and Reiss we come face to face with two extremes.

Eschatology is, almost by definition, both fascinating and mysterious. The merit of Reiss's essay is that, while not dispelling our fascination, it is able to unravel a bit of the mystery of that surely eschatological cycle in Orvieto. The ultimate inspiration seems to have had Dominican rather than Franciscan mediation. We conventionally think of Dominican preaching and speculation as more sober than its Franciscan counterpart. There is no doubt that in papal circles Dominicans were consistently considered as the safer and more orthodox of the two. Nonetheless, Saint Vincent Ferrer and that curious forger, Annio da Viterbo, in different ways defy that mold. It is clear, in any case, that in the Antichrist fresco a Dominican is the orthodox counterpart to the Antichrist, and Reiss's identification of him with Saint Vincent is persuasive. The choice of a Dominican, a relatively recently canonized saint, already seems somehow to mitigate the radicality of the theme—but how? To what degree?

What seems clear is that the fresco presents a choice between true and false preachers. What is not so clear is the message of the true preacher. If the Dominican stands for the "authority of the church," how is that authority to be understood—especially in papal Orvieto? Is the "authority of the church" to be understood as the authority of a message altogether disdaining government, including the temporal government of the pope himself, or would it see in *that* authority an alternative to seemingly more secular politics? Or is it a statement that the temporal power of the papacy is the most diabolical of all? In other words, it would be helpful to have further clarification of the relationship between the "authority of the church" and "monastic ideals and obligations," for they are not necessarily synonymous. I fear that by the nature of the case we will not be able to arrive at such a determination, for apocalypse is by definition mysterious and opaque. Partly out of self-protection it must not be too clear and must, therefore, let the listeners or readers draw their conclusions.

Andrea Dandolo (1343–1354) and Visible History: The San Marco Projects[*]

DEBRA PINCUS

> *caput unum et quod princeps unus esset*
> Andrea Dandolo, *Cronaca brevis*[1]

RENAISSANCE DIARIST AND historian Marino Sanudo summed up the eleven-year reign of Doge Andrea Dandolo at the middle of the Trecento — 1343–1354 — as an enumeration of disasters: *"sempre quasi fu guerra, peste, e carestia."*[2]

The years preceding the Andrea Dandolo *dogado* had been marked by a growing political and economic stability that suggested an easy future. Venice had secured its first territorial possessions on the Italian mainland, Treviso and Bassano, establishing for itself secure food-yielding districts as a result of a treaty signed in 1339 with Mastino della Scala. These acquisitions led to the building in 1340 of the monumental state granaries prominently situated on the Grand Canal in pointed close proximity to the seat of government, the Palazzo Ducale. In 1342 an accord was signed with Genoa that suggested a stabilizing of relations with Venice's most serious maritime rival and its stalwart competitor in the crucial Eastern markets. Again in 1342 there was a renewal of Venice's treaty and commercial agreement with Byzantium under Emperor John V Palaeologus. And throughout the 1320s and 1330s, new efforts had been made toward welding the nobility, defined by the *serrata del Maggior Consiglio* of 1297 as the ruling class, into a cohesive working unit. A visual celebration of this working unit was found in the building, initiated in 1340, of the wing of the Palazzo Ducale to

house the ruling body's huge meeting chamber, the Sala del Maggior Consiglio.[3]

Elected doge in 1343, at the—striking for Venice—young age of thirty-six as a compromise candidate, Andrea Dandolo was faced with the unwelcome resumption of full-scale hostilities with Genoa and a fresh outbreak of uprisings in Zara, one of Venice's major outposts on the Adriatic, an uprising backed by Hungary and supported by North Italian factions. Natural calamities accompanied the political troubles. A series of storms and earthquakes punctuated the late 1340s, interrupting shipping and destroying large numbers of buildings. And, in 1348, the plague struck. Whole sections of the city were evacuated—Dorsoduro, S. Croce, Cannaregio. The 'noble core'—S. Marco and the Rialto—stood as an island, surrounded by deserted *sestieri* and menaced by bands of outlaws.[4]

Andrea Dandolo responded to the crises as an intellectual. A doge who came to office with a prominent history of involvement in the legal structure of the state, he was also attracted to the new humanist currents, currents that were given personal representation in mid-fourteenth-century Venice by no less a figure than Petrarch, with whom Dandolo was on close terms. Andrea Dandolo is the first scholar-doge of Venetian history, reputedly—although there seems to be some exaggeration in this—the first doge to have earned a doctorate. Doctorate or no, he appears to have spent a period of time in study at the University of Padua. His ties to humanist circles continued throughout his dogeship.[5] His Grand Chancellor Benintendi de' Ravagnani, who moved in the same circles as Petrarch, was Dandolo's close associate, perhaps even collaborator, throughout his reign.[6] Dandolo, in his double aspect of legal training and humanist attachments, brings together the two reigning, competing intellectual currents of the mid-fourteenth century in the Veneto: the scientific, law- and medicine-focused Aristotelian current, with its scholastic roots, and the pre-humanist current, involved with language, poetry, eloquence, and rhetoric, intrigued by large and compelling visions of history.

Well understood as a commercial and political crossroads, late medieval Venice has not been sufficiently recognized for what it also was—an intellectual crossroads. There is an incident that takes place in 1366 that, as Paul Oskar Kristeller has explicated it, allows us to see the confluence of intellectual currents in fourteenth-century

Venice with a rare kind of dramatic intensity. The *dramatis personae* included the aging humanist Petrarch himself, come to rest, as he saw it, in Venice — "the only haven of liberty" — after a life spent in wandering and in adapting himself to many different environments. In confrontation was a group of four men of affairs, well placed in Venetian society, who had been associated with Petrarch for some time in friendship and lively intellectual exchange. Among the group of four was the son of Doge Andrea, Leonardo Dandolo. The scene was a small dinner party held one evening in Venice at a time when Petrarch was absent from the city. In his absence, the discussion turned to Petrarch himself, and to a dissection of his talents. The considered opinion, arrived at after much deliberation, was that Petrarch was a decent man, a good man — but all the same, a man "without learning." We have Petrarch's own vivid recounting of the incident and his injured response in the essay "On His Own Ignorance and the Ignorance of Many Others."[7] In the brilliant reading of Kristeller, Aristotelian science meets up with pre-humanistic poetry.[8]

If this encounter was negative and one of rivalry, in the person of Andrea Dandolo the two strands come together in a creative and politically effective way. In line with humanist directions, but combining this with an Aristotelian sense of juridical proof, Andrea Dandolo, in the difficult period of the 1340s and 1350s, turns to literature and art as one of the ways of dealing with a crisis moment. In terms of the formulation of Venice's mature vision of itself, the scholar-doge — privy to both the scholastic and humanist traditions, committed to the greatness of Venice, steeped in its history — deserves a fresh look, and — I wish to argue here — a fresh evaluation in terms of his activity in the sphere of the visual arts.

The expression of Andrea Dandolo's talents and vision in the literary sphere has long been noted. Girolamo Arnaldi has analyzed Dandolo's achievement as a history writer within the framework that leads, in the sixteenth century, to the establishment of an official government position of public historiographer.[9] In turning to literature and art, Dandolo draws forward a number of earlier Venetian traditions, most important, the concept of a ducal-centered Venice. But Dandolo also strove for a larger vision — it is the humanist in him coming to the fore — to create an image of Venice in

which the deeds of a series of forceful, well-defined men have forged in time a highly developed state with complex laws and institutions. Dandolo's vision can be seen unfolding in his major literary work, his history of Venice, the *Chronica extensa*, begun shortly after he assumed the ducal office. In the *Chronica extensa* the doge is *the* moving force in the creation and development of the Venetian state, the ruler who functions to make the state great. The modern Italian social historian Giorgio Cracco has summed up the stance of Dandolo's history succinctly:

> The superiority of the doge to the nobility, the clergy, and the people is above all as an instrument. More important than the *doge* has become the *state*. The *Extensa* was written not so much to exalt the doge as the state — to put it more accurately: to exalt the state *through* the doge.[10]

Dandolo transformed the abstract ruler figure of the doge, already a standard part of the Venetian state tradition, into a series of distinct, dynamic personalities. It is the doge, seen from the point of view of a succession of historical figures, who shoulders the responsibility of realizing Venice's destiny. It can justly be said that Dandolo's particular sense of ducality set the basic terms for future forms of Venetian state image-making.

What has not been realized is the extent to which Dandolo's artistic patronage represented a complement to his literary production. It is here, I believe, that Dandolo goes beyond Petrarch in an expanded concept of rhetoric that exploits the visual as well as the literary. Dandolo develops what we have come to think of as a peculiarly Venetian sense of how image and text can function in a reciprocal relationship, operating in an eloquent and persuasive combination. The mind is engaged while the senses are dazzled and caught up in the drama and the emotional appeal of the image — often in Venice literally a glittering golden image.[11]

With the goal of understanding Dandolo's shaping of Venetian history more completely, and so that the visual component can be understood as a companion to the literary component, I want to concentrate on a small group of artistic projects. From several points of view, San Marco emerges as the embellishment project closest to Dandolo's heart. The church of San Marco, as the place where the relics of the patron saint were housed and, also, the personal chapel

of the doge — in that phrase coined by Roberto Cessi, and now become a touchstone in our dealings with the structure, the state church of Venice[12] — San Marco was the particular beneficiary of Dandolo's attention (Fig. 1). Dandolo clarified by pictorial additions two key spaces of the structure: one along the left, north, arm of the church, which became the Chapel of Saint Isidore; the second along the south flank, the Baptistery. And for the high altar there was the sumptuous re-installation of the Pala d'oro — the "golden altarpiece." These three — the Baptistery, the Isidore Chapel, and the Pala d'oro — are the three projects on which I shall concentrate in this essay.

What recent research has told us about the civic significance of baptisteries in thirteenth- and fourteenth-century Italy makes Dandolo's San Marco Baptistery project perhaps the most intriguing of his undertakings.[13] It was the space in which he was later to be buried, the last doge to be buried in San Marco. In about 1328, at a time when Dandolo was already active in government, the tomb of Doge Giovanni Soranzo was placed in the Baptistery of San Marco.[14] Then, during his tenure as doge, Dandolo took on the project of making the San Marco Baptistery one of the more important spaces of the church.[15] The Baptistery was pulled into the decoration scheme of San Marco by a full mosaic program, replacing an earlier fresco decoration. Two complex cupola programs were prepared. Above the font was placed a version of the Mission of the Apostles, showing Christ sending out the Apostles to baptize the gentiles. Above the altar was placed an apocalyptic vision of Christ in glory surrounded by the nine choirs of angels. The key scene of the Baptism of Christ and the Descent of the Holy Spirit was placed above the Soranzo tomb. The capstone of this comprehensive cycle is the grand mosaic over the altar (Fig. 2). Against an architectural backdrop, a modern note of fourteenth-century pictorial illusionism recently linked by one scholar to Assisi,[16] there is the Crucifixion of Christ with the Virgin and Saint John, extended by the Baptist on the right and Saint Mark on the left, with Byzantine figure style and drapery conventions prevailing for the religious figures. In still another style, a crisp reportorial mode that can be considered the visual equivalent of Venice's chronicle style, the mosaic is punctuated by three civic officials. Doge Andrea Dandolo himself, center front, at the foot of the cross — closer to Christ than the Virgin — in

crimson, ermine-trimmed robes and gold-banded ducal *corno*. On the far left is Dandolo's Grand Chancellor, the only non-noble — that is, citizen — member of the Venetian government, his ermine-trimmed hat his badge of office. At the far right, the head of the Avogadori, the constitutional watchdogs of the government — a figure that in the current literature has been erroneously identified as Dandolo's wife. The Avogadori was a usual first office for promising young nobles entering government service.[17] The member of this office is shown in red gown and fur-lined capelet, and wears the hood-type *capuzzo* still favored in the fourteenth century by Venetian nobility — in the fifteenth century the jaunty black beret takes over. The celestial rule of Christ is in the dome directly above. This is the earthly rule: the Venetian state, citizens and nobles, led by the doge. We are given a portrait of the state in its workings in present time.

The Baptistery project was paralleled by Dandolo's Chapel of Saint Isidore to the north, attached to the left transept arm of San Marco (Fig. 3).[18] The impressive barrel-vaulted space was created and a handsome tomb with the effigy of the saint was prepared. Isidore is another of those important Eastern military saints that Venice found it so convenient to appropriate. In this case, however, we are dealing with a saint whose remains were brought to Venice by a doge, Doge Domenico Michiel, whose *dogado* covered the years 1117–1129. Isidore's body was brought by Domenico Michiel to Venice from Chios in 1125, as the inscription above the altar spells out, and placed in San Marco, only to be lost and forgotten.[19] The relics were rediscovered during Dandolo's own reign — at which time the chapel was built and the mosaic decoration laid out telling in detail of Doge Domenico Michiel — full name, clearly labeled — and his role in the translation of the relics. A first effort to transport the relics of Isidore was made by the cleric Cerbano, operating in secret. In a telling addition to the known narrative of the translation, Cerbano is reproved by the doge for his undercover action (Fig. 4). It is the doge himself who then takes on the task of seeing to the open and ceremonious loading, and then the unloading at Venice (Fig. 5), of the saint's body — everything carefully labeled each time so the viewer knows who is who. The emphasis is on expressive faces and gestures — above all for the person of the doge — and a narrative flow. The focus is on telling a good story with convincing detail and

satisfying drama, and the message is that of ducal initiative in providing Venice with what was to become — thanks to Dandolo's management — an important addition to the Venetian arsenal of protector saints.

This kind of elaborate recounting of ducal history has no parallel in earlier projects. In these two mosaic campaigns — the last medieval mosaics added to the fabric of the church — Dandolo accomplishes a double goal: (1) intensifying the ducal character of the state church as a whole; and (2) making the doge the chief protagonist of Venice's past and present history. Some of this was already seen by Fritz Saxl in his important discussion of these works in his essay of the 1930s, in which he characterized Dandolo as "a guardian of tradition in Venetian art," yet, at the same time infusing "the old Venetian tradition with new blood."[20] For what is impressive about Dandolo is how he is able to insert and meld the new *within* the frame of tradition, creating the seamless picture of unchanging continuity that was always the Venetian ideal.

But the most stunning of Dandolo's San Marco projects was the reworking of the Pala d'oro — the golden altarpiece of San Marco's high altar.[21] The eighteenth-century engraving after Visentini is useful in the context of my discussion for it shows the Pala d'oro in function on the high altar of San Marco in a way that is not readily apprehensible in the present arrangement (Fig. 6). It is a mark of Dandolo's success that this object is generally considered Venice's most significant piece of Byzantine treasure, right out of the heart of the New Rome. In point of fact, we know surprisingly little about the origins of the Pala d'oro — and what little we know comes largely from Andrea Dandolo. There is no question but that the majority of the pieces are of Byzantine origin. Included, for example, is the portrait of the Byzantine empress Irene, labeled in Greek, perhaps originally created as a pair to a portrait of her husband, Emperor Alexis Comnenus — or what was originally a portrait of a Byzantine emperor, for what we now have is an *altered* companion panel that gives us a labeled image of the twelfth-century Venetian doge Ordelafo Falier, by tradition, donor of the first pieces that make up the golden altar.[22] But in its present form, the Pala d'oro is the result of the massive remounting, reworking, and reinstallation that was carried out by Dandolo, as noted specifically in the inscription, in 1345. Whatever form the Pala d'oro may have had previously, one

thing is certain: under Andrea Dandolo the object — expanded, set in a gold frame of gothic workmanship, and enriched with thousands of jewels — took on its present function as the principal ornament of the high altar of San Marco. Dandolo made sure that, as part of the reworking, the ducal history of the Pala d'oro was set forth — in two separate inscription blocks, set in the lowest tier to be good and visible (Figs. 7 and 8). In the reworking, the Pala d'oro became a piece that Venice possessed because of its doges, again, in terms of a line of succession that creates a living chain across the face of history. In handsome enameled gothic capitals we are told, in the first inscription block, that in 1105, when Doge Ordelafo Falier guided the city — *ducabat in urbe* — pieces of this altar were newly made, then to be restored in 1209 during the *dogado* of "you, Pietro Ziani" (Fig. 7). The second inscription block (Fig. 8) is devoted entirely to the work and praise of Dandolo, "honored by all," who in 1345 renewed this ancient altarpiece — *hec vetus pala* — with precious gems.[23] Certainly Dandolo's contribution is meant to amaze and dazzle, but at the same time it is presented as only the result of a long period of ducal involvement with this precious object.

The Dandolo program of visual history is richer and more sophisticated in its totality than can be analyzed here. Hugo Buchthal has made the case for the highly conscious, calculated manipulation of history — to the benefit of Venice — in Dandolo's involvement with historical manuscripts.[24] Pioneering work in the religious sphere is now available in the dissertation recently completed by Ranee Katzenstein of the Getty Museum.[25] Katzenstein has shown the sophisticated calculation at work in Dandolo's promotion and embellishment of key religious manuscripts. The work of these two scholars helps to confirm a key element of the Dandolo vision that deserves further exploration — Dandolo's interest in knitting together strands of both Eastern and Western association to entrench solidly in the Venetian image the double reference — an interplay that was to become a constant of Venetian artistic life until well into the fifteenth century.[26]

I want to end, however, by considering Andrea Dandolo's impact on Venetian artistic developments with a class of monuments that offers a particularly resonant combination of art and statesmanship, one that has been the focus of my own work, the ducal tomb. Andrea Dandolo's tomb, which, as we know from his

will, he was planning before his death, was placed in the Baptistery of San Marco (Fig. 9).[27] Dandolo's tomb draws on earlier ducal tomb traditions, but elaborates on them in ways that give new force to the ducal presence. It is noteworthy as the first Venetian ducal tomb to include an effigy. The addition of the effigy — the ruler made permanently visible — was thereafter to become a major element of the Venetian ducal tomb. Dandolo's effigy is, in fact, unusual in its ambitions, drawing, in a sophisticated way, on the physiognomy of the serene, joyous ruler, the kind of "hilaritas publica" incorporated earlier in the fourteenth-century effigy of Can Grande at Verona.[28] The type of canopy used as a shelter for the effigy brings the Venetian ducal tomb into line with mainland traditions and carries both an ecclesiastical resonance, coming from the tomb of Bishop Castellano Salomone in nearby and newly annexed Treviso,[29] and a rich-merchant resonance, coming from the tomb of Enrico Scrovegni in that competing urban center of the Veneto, nearby Padua.[30] The long inscription on Dandolo's tomb, detailing the events of his reign, anchors the tomb to the wall of the Baptistery to which it is appended. Continuing and enriching earlier ideas of association between the state and the Virgin, the Virgin is given a handsome throne room setting, and the Annunciation is connected with the tomb structure in a unified architectural format. Narrative panels, in the form of episodes from the life of Andrea's namesake, the Apostle Andrew, and Saint John the Evangelist, now enter the ducal tomb, panels that will evolve by the 1480s into the first full-blown biographical scenes of the Renaissance tomb, on the tomb of Doge Pietro Mocenigo.

The ducal presence that Dandolo developed and that we have been examining in San Marco soon moved beyond the civic center. It was a natural outcome of the Dandolo vision that the ducal tomb became a way of extending ducal presence throughout Venice and of giving expression to the political strength of the city. What I have termed here the Dandolo program of visual history seems to have inspired a major reworking of a tomb that dates about one hundred years before Dandolo's reign — the addition of a long, information-filled inscription to the tomb of Doge Jacopo Tiepolo, prepared shortly after his death in 1249, and used later in the thirteenth century for the interment of his son Lorenzo Tiepolo, also doge. The inscription, unparalleled in its detail by any thirteenth- or fourteenth-

century ducal tomb, is, I believe, to be dated to the second half of the fourteenth century on grounds of paleography and phrasing (Fig. 10). The tone of the Tiepolo inscription in which the active doge is stressed belongs to the Dandolo concept of ducality as laid out in both his history of Venice and in the projects developed for San Marco. "He gave the church everything it has," in reference to Jacopo Tiepolo as the founder of SS. Giovanni e Paolo, is a line that Dandolo himself might have written. The kind of ducal vision that Dandolo made tangible would appear to have put in motion a deliberate reworking of the past — something the Venetians were *never* reluctant to do.

The reworking of the Tiepolo tomb seems to have provided the keynote for turning the church of SS. Giovanni e Paolo into a ducal mausoleum, which it became shortly after Andrea Dandolo's death. One doge after another was buried there in increasingly elaborate tombs, displayed in full effigy, inscriptions detailing the events and accomplishments of the ducal reign: exactly what Dandolo had in mind, and now, on permanent, solid display.

POSTSCRIPT

As Edward Muir notes in his remarks, the attention to the Tiepolo tomb that I have posited here came in the wake of the conspiracy led by Baiamonte Tiepolo that brought disgrace to the Tiepolo family. But this should not overshadow the fact that Doge Jacopo Tiepolo was still esteemed as a figure of major importance. Because of his codification of the laws — and Dandolo's own *Chronica extensa* is quite eloquent on this point — for Andrea Dandolo he played a crucial role in Venice's history. Not surprisingly, Tiepolo's important law reform is given significant attention in the Tiepolo tomb inscription. The honor accorded to Tiepolo in the added inscription is an excellent demonstration, it seems to me, of the principle that Muir uses as the frame for his remarks — that concept, laid out fully by Kantorowicz, of the mortal body and the immortal office, which Muir has shown in his own work was actively operating in Venice. As he indicates, however, this should not blind us to the less-elevated realities of politics. Perhaps Jacopo Tiepolo was useful from this point of view as well. It may be that Jacopo Tiepolo, the populist

doge as he has been characterized by a number of historians, and who presided over Venice in its balmiest days, was more valuable as an ally than an enemy.

NOTES

*The material dealt with here forms part of my book, *The Tombs of the Medieval Doges of Venice*, covering the period 1250 through 1413 (Doges Jacopo Tiepolo to Michele Steno). I am grateful to the National Endowment for the Humanities and the Social Sciences and Humanities Research Council of Canada for support during the researching of this material. Access to the incomparable library of the Center for Byzantine Studies at Dumbarton Oaks during my period as a summer fellow in August 1988 allowed me to clarify several aspects of this discussion. Consultation with a number of individuals has been of great assistance in formulating these issues, and I would like to thank in particular JoAnne Gitlin Bernstein, Jack Freiberg, Julian Gardner, Ingo Herklotz, Michael Jacoff, Wendy Stedman Sheard, and Stephen Zwirn. The stimulating and generous response of Edward Muir to these ideas as originally presented at the Notre Dame conference has helped in the refining of a number of points, and I have added a postscript in order to discuss a specific issue raised by his remarks. And finally, a special thanks to my husband, Joseph Pincus, for giving me the benefit of his keen editorial eye.

1. *Andrea Danduli Chronica brevis*, ed. E. Pastorello, in *Rerum italicarum scriptores* (hereafter *RIS*), new series, XII, pt. I (Bologna, 1938), 353.

2. Marino Sanudo, *Vitae ducum venetorum*, in *RIS*, ed. L. A. Muratori, vol. 22 (Milan, 1733), col. 628.

3. The traditional view of the *dogado* of Francesco Dandolo (1329–1339) as a period marked by a lessening of political and economic tensions is reflected in G. Cracco, *Un "altro mondo": Venezia nel medioevo dal secolo XI al secolo XIV* (Turin, 1986), 128 ff. As Cracco points out, p. 130, the prosperity and good rule of the Francesco Dandolo reign was already being stressed in the fourteenth-century *Chronica brevis* of Andrea Dandolo. For a detailed discussion of the political events of this period, see S. Romanin, *Storia documentata di Venezia*, 3rd ed., vol. III (reprinted Venice, 1973), 80 ff.: treaty with Mastino della Scala, p. 96; treaty with Genoa, p. 107; treaty with John Palaeologus, p. 106 f. For depictions of the granaries, demolished after the fall of the Republic to make way for the royal gardens, see the illustrations in W. Wolters, *Der Bilderschmuck des Dogenpalastes* (Wiesbaden, 1983), figs. 3 and 4. Wolters, p. 16 n. 4, suggests that Filippo Calendario, the architect of the new wing of the Palazzo Ducale, may also

have been the builder of the state granaries. For the building campaign of the Sala del Maggior Consiglio, see W. Wolters, *La scultura veneziana gotica (1300–1460)* (Venice, 1976), 40 ff. and 172 ff. The long period of political adjustment that follows the *serrata del Maggior Consiglio* of 1297 is analyzed by S. Chojnacki, *The Making of the Venetian Renaissance State: The Achievement of a Noble Political Consensus, 1378–1420* (Ph.D. diss., University of California, Berkeley, 1968), esp. ch. 2, "The Fourteenth Century: Through Crisis to Coalescence," 58–121. Chojnacki sees the period of consolidation as taking up the better part of the fourteenth century.

4. For the difficulties of the Andrea Dandolo period, see Romanin, *Storia documentata*, III, 109 ff.; G. Cracco, *Società e stato nel medioevo veneziano (secoli XII–XIV)* (Florence, 1967), 395 ff; and R. Cessi, *La repubblica di Venezia e il problema adriatico* (Naples, 1953), 97 ff.

5. For a well-documented overview of the career of Dandolo, see E. Pastorello, introduction, *Andrea Danduli Chronica per extensum descripta*, in *RIS*, 2d ed., XII, pt. I (Bologna, 1938), i ff.; to be supplemented by E. Simonsfeld, "Andrea Dandolo e le sue opere storiche," *Archivio veneto* 14, pt. 1 (1877): 1–101 (a translation by B. Morossi of Simonsfeld's *Andreas Dandolo und seine Geschichtswerke* [Munich, 1876]). Various aspects of the cultural life of Dandolo's *dogado* are dealt with in the essays in *Petrarca, Venezia e il Veneto*, ed. G. Padoan (Florence, 1976); particularly to be noted in the context of this discussion are: L. Lazzarini, " '*Dux ille Danduleus*', Andrea Dandolo e la cultura veneziana a metà del Trecento," 123–56; and M. Murano, "Petrarca, Paolo Veneziano e la cultura artistica alla corte del doge Andrea Dandolo," 157–68. The most complete discussion of Dandolo's work as an historian is G. Arnaldi, "Andrea Dandolo Doge-Cronista," in *La storiografia veneziana fino al secolo XVI*, ed. A. Pertusi (Florence, 1970), 127–268. L. Lazzarini, in *Paolo de Bernardo e i primordi dell'umanesimo in Venezia* (Geneva, 1930), suggests that in his early years Dandolo may have been in close contact with the celebrated jurist of the University of Padua, Riccardo Malombra, advisor to the Venetian Republic in the period c. 1314–1330. For Malombra, see A. Gloria, *Monumenti dell'Università di Padova (1222–1318)* (Padua, 1884), 243–47.

6. For the life of Benintendi, see V. Bellemo, "La vita e i tempi di Benintendi de' Ravagnani Cancelliere Grande della Veneta Repubblica," *Nuovo Archivio Veneto* n.s. 23 (1912): 237–84, 24 (1912): 54–95. The Venetian cultural circle that included Petrarch and Benintendi is discussed by Lazzarini, *I primordi*, esp. ch. 3, "Gli amici del Petrarca a Venezia," 24–54, with additional bibliography. New information regarding the closeness of the relationship between Benintendi and Petrarch is given by N. Mann," '*O Deus, qualis epistola!*' A New Petrarch Letter," *Italia medieovale e umanistica* 17 (1974): 207–43. See also, N. Mann, "Benintendi Rava-

gnani, il Petrarca, l'umanesimo veneziano," in *Petrarca, Venezia e il Veneto*, 109–22.

7. *De sui ipsius et multorum ignorantia*, dedicated to Donato degli Albanzani. A convenient modern publication, with a facing Italian translation, is F. Petrarca, *Prose*, ed. G. Martellotti et al. (Milan and Naples, 1965), 710–67. A readily available English translation is provided in the collection, *The Renaissance Philosophy of Man*, ed. E. Cassirer et al. (Chicago and London, 1948), 48–133, with a useful introduction by Hans Nachod. Petrarch does not identify the four Venetians in his essay, but their names are known from a marginal note to a Petrarch manuscript in the Biblioteca Marciana in Venice: Leonardo Dandolo, the son of the doge; Zaccaria Contarini, also a member of the nobility; the merchant Tommaso Talenti; and the reigning intellectual of the group, the physician Guido da Bagnolo. See G. Voigt, *Die Wiederbelebung des classischen Alterthums*, 3rd ed. (Berlin, 1893), 87 ff.; and Nachod's introduction, p. 29 ff. For the details of Petrarch's life during this period, see E. H. Wilkins, *Petrarch's Later Years* (Cambridge, Mass., 1959), esp. in this context, 84 ff., 92, and 118.

8. P. O. Kristeller, "Il Petrarca, l'umanesimo e la scolastica a Venezia," in *La civiltà veneziana del Trecento*, ed. V. Branca (Florence, 1956), 149–78 (reprinted in *Storia della civiltà veneziana*, vol. II [Florence, 1979], 79–92). See also Kristeller, "Petrarch's 'Averroists': A Note on the History of Aristotelianism in Venice, Padua, and Bologna," *Bibliothèque d'Humanisme et Renaissance* 14 (1952): 59–65. For a discussion, focused on fourteenth-century Siena, of pre-humanist rhetorical culture as taking form in powerful visual statements, see Quentin Skinner, "Ambrogio Lorenzetti: The Artist as Political Philosopher," *Proceedings of the British Academy* 72 (1986): 1–56.

9. Arnaldi, "Andrea Dandolo Doge-Cronista," esp. 130–34.

10. Cracco, *Società e stato*, 414.

11. The value that Venice placed on visual data and its use of word and image in tandem would appear to be operating in an important way already in the thirteenth century. As Patricia Fortini Brown has pointed out in her essay, "Painting and History in Renaissance Venice," *Art History* 7 (1984): 263–94, the thirteenth-century chronicler Martino da Canal used the facade mosaics of San Marco as evidence of the Saint Mark *translatio*, thereby giving the visual image an equivalency to literary data. Venice's particular involvement with visual history in the fifteenth century is well developed by Brown in *Venetian Painting in the Age of Carpaccio* (New Haven and London, 1988).

12. R. Cessi, *Storia della Repubblica di Venezia*, vol. 1 (Messina, 1944), 37.

13. For a valuable overview of the civic significance of the baptistery in the communal period in Italy, see the studies by E. Cattaneo, "La *Basilica baptisterii* segno di unità ecclesiale e civile," *Ravennatensia* 7 (1979): 9–32; and "Il battistero in Italia dopo il Mille," in *Miscellanea Gilles Gerard Meerseman*, vol. 1, *Italia sacra* 15 (Padua, 1970), 171–95.

14. For the political associations attached to this area of the church prior to the construction of the Baptistery, see O. Demus, "Ein Wandgemälde in San Marco, Venedig," in *Okeanos. Essays Presented to Ihor Ševčenko on his Sixtieth Birthday* (Harvard Ukranian Studies 7 [1983]), 125–144. I am grateful to Michael Jacoff for bringing this article to my attention. For the tomb of Giovanni Soranzo, see Wolters, *Scultura veneziana gotica*, 156 and figs. 48 and 51. For Dandolo as *procuratore di San Marco* in 1328, see Pastorello, introduction to *Chronica extensa* (as in note 5 above), iv.

15. For the building of the Baptistery of San Marco, see O. Demus, *The Church of San Marco in Venice*, Dumbarton Oaks Studies 16 (Washington, D.C., 1960), 78 f.; and for the mosaics, S. Bettini, *Mosaici antichi di San Marco a Venezia* (Bergamo, 1944), 27–29; and R. Palluchini, *La pittura veneziana del Trecento* (Venice and Rome, 1964), 75–78, with additional bibliography.

16. M. Restle, "Das Dekorationssystem im Westteil des Bapisteriums von San Marco zu Venedig," *Jahrbuch der oesterreichischen Byzantinistik* [*Festschrift für Otto Demus zum 70. Geburtstag*] 21 (1972): 229–39.

17. For the red robes of the Avogadori, see C. Vecellio, *Degli habiti antichi et moderni* (Venice, 1590), 105, with facing illustration. For the nature of the office, see A. da Mosto, *L'Archivio di Stato di Venezia*, vol. 1 (Rome, 1937), 68 ff. For the identification of this figure as the Dogaressa, see Palluchini, *Pittura veneziana*, 75, followed by others.

18. For the building of the Capella di S. Isidoro in the fourteenth century, see Demus, *Church of San Marco*, 76. Discussions of the mosaics are to be found in Bettini, *Mosaici antichi*, 77; and Palluchini, *Pittura veneta*, 78 ff. For the tomb of Saint Isidore, see Wolters, *Scultura veneziana gotica*, 189–90, and figs. 310 and 315–19.

19. The history of the discovery and translation of the relics of Saint Isidore to Venice is given by Dandolo in his life of Domenico Michiel (*Chronica extensa*, ed. Pastorello, 234 f.). The lively flavor of the story as recounted in the San Marco mosaics may owe something to the account of the cleric Cerbano, whose *Translatio mirifici martyris Ysidori a Chio insula in civitatem Venetam* was written c. 1125. For a discussion of this text, see A. Pertusi, "Episodi culturale tra Venezia e il Levante nel Medioevo e nell'Umanesimo fino al secolo XV," in his *Venezia e il Levante fino al secolo XV* (Florence, 1974), parte prima, vol. 2, 331–60, esp. 342–48. As Pertusi points out, the chapel mosaics depart significantly from the Cerbano nar-

rative. It should be noted that the departures are crucial in highlighting the active role of the doge in the translation of the relics.

20. F. Saxl, "Petrarch in Venice," in *Lectures* (London, 1957), 139–49 (reprinted in Saxl, *A Heritage of Images* [Harmondsworth, Middlesex, England, 1970], 43–56).

21. For the numerous issues that the Pala d'oro presents, see *Il Tesoro di San Marco*, ed. H. R. Hahnloser, vol. 1, *La Pala d'oro* (Florence, 1965). The publication of this study generated two major essays: O. Demus, "Zur Pala d'oro," *Jahrbuch der oesterreichischen byzantinischen Gesellschaft* 16 (1967): 263–79; and J. Deér, "Die Pala d'oro in neuer Sicht," *Byzantinische Zeitschrift* 63 (1969): 308–44 (reprinted in *Byzanz und das abendlandische Herrschertum. Ausgewählte Aufsätze von Josef Deér*, ed. P. Classen [Sigmaringen, 1977], 251 ff.). An important analysis of the combining of Eastern and Western ideas in the program of the Pala d'oro is provided by M. Frazer, "The Pala d'oro and the Cult of St. Mark in Venice," *Acts of the 16th International Byzantine Congress*, in *Jahrbuch der oesterreichischen Byzantinistik* 32 (1982): 273–79.

22. For an entry into the complex issue of the imperial and ducal portraits of the Pala d'oro, see Hahnloser, *Tesoro di San Marco*, I, 5–9.

23. For full transcription of the Dandolo inscription blocks, see Hahnloser, *Tesoro di San Marco*, I, 9 f.

24. H. Buchthal, *Historia troiana. Studies in the History of Medieval Secular Illustration* (London and Leiden, 1971). But see Silvana Ozoeze Collodo's review of Buchthal in *Archivio storico italiano* 130 (1972): 553–61, for a critique of his use of Demus's Christian Imperial *renovatio* thesis, developed by Demus in the context of the thirteenth century, in application to the fourteenth century.

25. R. Katzenstein, "Three Liturgical Manuscripts from San Marco: Art and Patronage in Mid-Trecento Venice" (Ph.D. diss., Harvard University, 1987).

26. For a discussion of Dandolo's emphasis on Venice's role as guardian and protector of the Roman church in the East, see F. Thiriet, "Byzance et les Byzantins vus par le vénetien Andrea Dandolo," *Revue des études sud-est européens* 10 (1972): 5–15 (reprinted in Thiriet, *Études sur la Romanie greco vénetienne [Xe-XVe siècles]* [London, 1977], no. XVIII.) I have discussed Dandolo's activity in nurturing both Eastern and Western associations in the fourteenth century as part of the larger Venetian picture in "Byzantium and Rome as a Double Heritage in Venetian Cultural Politics," in *Rome: Tradition, Innovation and Renewal: Acts of the Canadian International Art History Conference in Honour of Richard Krautheimer and Leonard Boyle. Rome, June, 1987* (forthcoming).

27. Wolters, *Scultura veneziana gotica*, 190. I have dealt with Andrea

Dandolo's tomb in terms of larger patterns of fourteenth-century tomb presentation in "The Fourteenth-Century Venetian Ducal Tomb and Italian Mainland Traditions," in *Scultura e monumento sepolcrale del tardo medioevo a Roma e in Italia*: *Acts of the Convegno sponsored by the Istituto Austriaco di Cultura in Rome, and the Istituto della Enciclopedia Italiana, Rome, July, 1985* (forthcoming).

28. See C. Baroni, *Scultura gotica lombarda* (Milan, 1944), 51 f. and esp. fig. 72.

29. Wolters, *Scultura veneziana gotica*, 155.

30. Ibid., 161 f.

Piety and Politics in the Art of Giovanni Bellini

RONA GOFFEN

THE BELLINI FAMILY enjoyed a kind of monopoly of patrician patronage in Renaissance Venice: Jacopo, the father, worked in the Ducal Palace as a young man, probably as apprentice to Gentile da Fabriano, and in his maturity Jacopo seems to have dominated the field of official and semi-official commissions, rivaled only by his son Gentile. In the 1470s (Jacopo died in 1471), Gentile became the "state painter," as it were, occupied with the seemingly end-less project of decorating the Great Council Hall with murals illustrating the purposefully falsified history of the Serenissima. Mean-while, his cousin and Jacopo's adopted son, Leonardo, a miniatur-ist, illuminated official documents such the *promissioni ducali*, the oaths of office which each doge was obligated to sign at the time of his investiture. And Giovanni Bellini, the youngest and greatest member of the family, became the most subtle and compelling illus-trator of the myth of Venice and of its ruling class.[1]

Francesco Sansovino, in his *Dialogo di tutte le cose notabili che sono in Venetia*, particularly mentioned among Giovanni Bellini's works his paintings for the Republic, his altarpieces in San Giobbe and in San Zaccaria, and his Madonna, "alcune nostre donne molte belle e devote."[2] The murals that Bellini painted in the Maggior Consiglio have been lost: they were destroyed by fire in 1577, probably the result of politically motivated arson. However, something of Bellini's interpretation of the Venetian polity survives in other works by him, including some of the "very beautiful and very devout" Madonnas that Sansovino admired. In fact, Bellini's pictorial language is much the same whether the subject is sacred or secular, and appropriately

207

so, given the characteristic Venetian amalgam of piety and politics. The formulae that he devised for his sacred paintings he adapted for his portrayals of the patriciate, portraits that are not only depictions of individuals but indeed psychological characterizations of the ruling class. In this sense, his sacred work provides the prolegomenon for study of his secular imagery.

The *Madonna degli alberetti*, signed and dated 1487 on the parapet, is characteristic of Bellini's devotional imagery (Fig. 1). The Virgin Mother is seen half-length, the lower part of her body concealed behind the parapet. A cloth is suspended behind her, resembling the cloths with which earthly rulers were honored in order to remind us that Mary is Queen of Heaven. At the same time, the cloth of honor detaches the Madonna from the landscape setting and pushes her forward, toward the picture plane, demarcated by the parapet, where her Son is displayed and revealed to the beholder. The Infant seems to point with his feet at Bellini's signature, with one foot above the other, as though nailed to the Cross. Because of this and because his nudity is completely exposed, the Child reminds us of the Crucified Adult: nudity and self-sacrifice are conflated in this imagery.[3]

Cast shadows assert the reality of the presence of Christ and of his mother, his shadows on the parapet and on her neck, hers very conspicuous on the cloth of honor. The light that causes these shadows comes from somewhere in front of them, clearly from outside the painting, perforce from our world: the light that shines on Mary and her Child also shines on us. This light binds the two realms, that of the sacred beings with that of the worshipper before their image. At the same time, because they are large in the foreground, their great size enhanced by contrast with the small forms of the background, the Virgin and Christ seem almost to leave the pictorial realm in order to enter our own world.

Seemingly simple and straight-forward, Bellini's painting is ineffable and complex, both visually and psychologically. Mary and Christ have come before us to compel our contemplation and involvement. She regards her Child with an expression of extraordinary ambivalence: at once tender and yet wary, she is prescient and perhaps not entirely willing to accept the role that he, by taking cognizance of the beholder, is prepared to acknowledge. Are we to see in the way her large hands enfold the Child an embrace or a restraint?

Does he touch her hand with his fingertips to protest her grasp or to caress his mother? Does his right arm, which falls over her hand, imply his passivity in her arms, or his actively denying to raise that arm to bless us? They seem still, but their postures suggest action — movement just now completed and also imminent movement: the light that illuminates them will change, the shadows will change, Mary and Christ will not remain as they are.

The beholder never forgets that this is a sacred image, intended to inspire a contemplative mood of reverence. The original owners of Bellini's devotional images understood this, and tell us so in the words of their testaments. A painting originally intended for private devotion might become the altarpiece of the owner's funerary chapel, for example, where divine services would commemorate the donor's faith and benefit his soul; or a testator might bequeath a painting to a kinsman, with the request that he or she be remembered in the recipient's prayers.[4]

Perhaps the Venetian ruling class hoped for a similar kind of benevolent remembrance in offering sacred images by Bellini as gifts of state. In any case, their choices were surely intended both to reflect the piety of the Republic and to complement that of the royal recipients (just as modern-day state gifts of Steuben glass are intended to reflect secularity and expense). Thus Bellini's *Dead Christ with Figures* purchased in 1510 to be presented to King Louis XII (1462–1515) was a gift that was both prestigious and pious.[5] And, it seems, pleasing to the French taste as well, because five years later, the Republic commissioned Bellini to paint a *Madonna* for the sister of Louis's successor, François I (1515–47). Unfortunately, however, these are provenances without pictures.

The lost *Madonna* was commissioned by the Heads of the Council of Ten on October 31, 1515: "We have decided . . . to give to the most illustrious Lady of Alençon a picture in paintings of the image of the Glorious Virgin, this to be the most excellent and perfect as possible."[6] To be sure, there were already "some beautiful but old" Madonna paintings in the city, but desirous of satisfying the king's sister, the Ten decided "to have a new one made, in all beauty and perfection," and this to be done after learning the royal recipient's "wish and pleasure regarding the size and quality of the said painting, to be of the Glorious Virgin with her Son, and which figures she [the Lady of Alençon] would like to

be on either side, and of what size, and in sum, every other neces-
sary particular."

Perhaps the lady herself requested that the *Madonna* be painted
by Giovanni Bellini, possibly on the advice of her brother François,
an avid and knowledgeable patron of the arts. The *Madonna* must
have been a splendid work indeed, but nothing is known of the
painting except that it was close to completion when the Venetian
orator in France received a reassuring letter from a compatriot dated
January 15, 1516. "It will be a beautiful thing," the orator should
inform the king, "and very little is lacking to complete it perfectly."[7]

Whatever opinion the owner of this lost Madonna painting
may have had of Bellini's work—whether it was regarded as a
"collector's item" or as a devotional image—the fact remains that
the intimacy of his images suits them for private devotions. Gener-
ally somewhat smaller than lifesize, with the sacred beings in the
immediate foreground, the compositions require close scrutiny and
invite solitary contemplation, an exclusive and intense communica-
tion with the beholder: they are not addressed to an audience in a
public and secular setting, but to worshippers in the quietude of
prayer. The *Madonna degli alberetti*, for example, measures only 74
by 58 centimeters.

Despite this—or perhaps precisely because in Renaissance Venice
piety and politics were inextricably combined—private devotional
images were sometimes transformed into civic monuments, so to
speak. Bellini's recently restored *Madonna greca*, for example, a work
of the 1470s, was displayed in the office of the Regolatori alla Scrit-
tura of the Ducal Palace (Fig. 2).[8]

Even were it not for the Greek monograms of Mary and
Christ, the very arrangement of her mantle and the patterns of light
and shade on her face would justify the picture's popular name,
"Greek Madonna." Christ's right arm hangs helplessly over Mary's
(another Byzantine motif). In his left hand he holds a fruit, possibly
an apple, resting on her wrist. The image is a pathetic one: the tilt
of the Child's head, the sadness of his expression, the helplessness
of his posture, as though he were a marionette awaiting manipula-
tion—all are calculated to arouse the beholder's compassion. Mary,
too, is an affective figure and an introspective one, bending toward
her Son but looking beyond him, holding him in her great hands
with tenderness but distractedly, preoccupied by thoughts of their

fate, symbolized in the fruit that he holds at the center of the composition.

It is not known whether this Madonna was originally purchased or commissioned for the quasi-official purpose of decorating an office in the Palazzo Ducale or as a private devotional image, only later converted to public use, as some other images were transformed into altarpieces in churches. Perhaps the *Madonna*'s Byzantinizing qualities made it seem particularly appropriate for such a purpose in a state where the Byzantine East was esteemed as nowhere else in the West. In any case, the implication of sacred presence in the affairs of the state is the subject of another kind of Venetian devotional painting, in which the noble servants of the regime receive divine approbation not only as individuals, but *ex officio*, as it were, and the distinctions between the state and its officials are purposefully blurred. The votive picture of Doge Agostino Barbarigo, signed and dated in 1488, is a case in point (Fig. 3).[9]

Essentially identical compositions were commissioned by the doge's predecessors and by his followers as (obligatory) gifts to the Palazzo Ducale.[10] But Barbarigo commissioned this votive picture for his family palace, although the painting may well have been a replica or variant of a picture that the doge would have given to the Ducal Palace, where he was required to live during his tenure in office. Like the other ducal votive pictures that it resembles, this too may be understood in part as a monumentalization of the illuminations illustrating the manuscript *Promissione ducale*, the doge's written oath of office. In other words, the Barbarigo votive picture is both an official, political image, and an image of private devotion, a peculiar and characteristic Venetian hybrid of piety and politics.

Christ, standing on his mother's knee, turns toward his right, toward the direction of the light. The symbolic conflation of pictorial illumination and Christ's action is for the benefit of Doge Agostino Barbarigo, who kneels in prayer at the base of the throne to receive the Child's blessing. This is no formulaic gesture, but a benediction given personal and gracious import by the inclination of the Christ Child's head toward the doge.

Not only doges commissioned such pictures in Renaissance Venice; private citizens did so as well. But Barbarigo's votive picture glories in his rank: his ducal arms are displayed; St. Mark concerns himself with the doge's spiritual well-being; and above all,

his official garments were painted so splendidly by Bellini. The aggrandizing prominence with which Bellini endowed Barbarigo derives from his ducal robes, that is, from his official status in which the individual wraps himself, all but obliterating himself in the process of assuming his onerous — and glorious — responsibilities of office. The luxuriant ermine cape (*bavero*) that the doge wears over his mantle was a ducal garment worn only on solemn occasions when he "went in triumph" ("andata in trionfo").[11] Barbarigo's dogeship warrants his blessing and the solicitude of St. Mark, whereas his individual identity, represented by St. Augustine, is of secondary importance and to be put aside, literally overshadowed. The pattern of light and shade on the canopy of the throne summarizes Bellini's luministic division of the scene, with the implication of spiritual hierarchy.

At the same time, nothing in Barbarigo's expression suggests even awareness, much less the expectation, of divine favor, but rather only the unassuming prayer for such acknowledgment for his state more than for himself — which is one reason why Mark and not Augustine is the doge's sponsor. The other reason is (or was) a more personal one, an allusion to Marco Barbarigo, Agostino's brother and immediate predecessor in the dogate.[12] On his death bed, Marco is said to have disparaged his brother's character, and whether this was indeed the case or not, the truth remains that Agostino Barbarigo was in fact greatly disliked and mistrusted by his compatriots, who considered him ambitious and corrupt. Contrary to Venetian custom, Agostino Barbarigo insisted on the conspicuous obeisance of his people: they were required to kneel before the doge and to kiss his hand.[13] But here, in Bellini's painting, Barbarigo himself kneels before the Virgin and Child, and he receives both the posthumous forgiveness, so to speak, and the approbation of his deceased brother and predecessor Doge Marco in the person of St. Mark. Thus Bellini gave perfect expression to the stated ideal of the Venetian patriciate: the nobleman is the servant of the regime, his individuality is subsumed in his service to the state. Self-aggrandizement and the glory of the family are transmuted into Venetian piety and politics.

The self-serving and perhaps self-deceiving propagandistic import of this composition was addressed to the doge's personal circle of relatives, friends, and associates, that is, to an audience par-

ticularly receptive to this theorem. Neither an altarpiece nor a public commission, Giovanni Bellini's painting was made for the Barbarigo's family palace, and the doge himself mentioned the painting in his will, specifying its location in the crossing ("crozola"), that is, the intersection of the hallway on the piano nobile.[14] Thus Bellini's picture was a mural painting; and its function was decorative and votive, not liturgical.

In his bequest of the painting to the monastery where two of his daughters were nuns, Barbarigo assured that these original functions of Bellini's creation would change. Bequeathing the picture to the sisters of Santa Maria degli Angeli in Murano, and providing for a suitable enframement, Barbarigo requested that the nuns pray before it for his soul:

> Item. We order that our great pala that is in the crossing of our palace be sent to the aforesaid monastery of nuns of Santa Maria degli Angeli, this image of Our Lady with angels being well suited to be placed above the high altar of their church, but [with the provision] that our commissaries must have the painting adorned below, at the sides and above in such a way as would be to our satisfaction and to that of these venerable women. And the sooner the said altarpiece is put in place ["in opera"], the sooner we shall hope in the Blessed Virgin Mary as being our advocate before God, our Creator most high. And [we order] that neither our sons-in-law nor our daughters nor our nephews be permitted to place the picture either in our palace or in any other place except above the high altar of this most devout and religious monastery, whose nuns, we are certain, will always pray to God for our soul and for the souls of all our [kinsmen] who have passed from this life.[15]

Barbarigo's perpetual and official orison thus became the exemplar for continued prayer by his daughters and their sisters in religion for the benefit of his individual soul. Thus Venetian piety and politics were amalgamated and became one and the same thing.

The consummate illustration of this characteristic Venetian amalgamation is Bellini's greatest portrait, the *Doge Leonardo Loredan*, commissioned at the beginning of his dogate (1501–21), probably in 1501 or 1502 (Fig. 4).[16] This image is not a mere likeness: it is a visualization of the Venetian political credo. Bellini gave

expression to these beliefs by adapting the devotional imagery of his Madonna paintings and the civic idealism of his votive picture for Doge Barbarigo. We have seen how Bellini depicted the King and Queen of Heaven in his Madonna paintings, and how he depicted the Venetian head of state as their servant on earth. Here, in the portrait of Leonardo Loredan, Bellini characterizes the doge of Venice as a sacred being.

The very fact that Loredan's portrait is nearly frontal is noteworthy in itself. Although almost all portraiture associated with Bellini is three-quarter, four-fifths, or full face from the 1470s onward, as in the Jörg Fugger in the Norton Simon Museum, the profile was still preferred for depictions of doges, such as Gentile Bellini's *Doge Mocenigo* (Fig. 5) — even for portraits of Leonardo Loredan by other masters (Fig. 6).[17] This painting of Loredan by Carpaccio confirms that it was Giovanni Bellini who endowed the doge with greatness, at least aesthetically speaking: Bellini created the perfect Venetian nobleman in his portrait, saw in Loredan or invested in him qualities that were either invisible to Carpaccio or which he was incapable of representing. In reality, Bellini's protagonist was something of a scoundrel, and an inquest held to examine Loredan's financial dealings after the doge's death in 1521 eventually fined his estate 2700 ducats.[18] But we must not let unpleasant reality intrude on our understanding of the myth of Venice any more than Bellini did in creating Doge Loredan.

The conservatism of the regime is reflected in such ducal portraits as Carpaccio's: the insistence on the profile, especially during Loredan's dogate, must be seen as a purposeful archaism at a time when other Venetian nobles were commonly portrayed full-face (but perhaps not quite frontal) or three-quarter view, Bellini's portrait of a *Senator* in Padua being a case in point.[19] Bellini's *Loredan* was evidently one of the first nearly frontal independent portraits of a reigning doge. Frontality was more often associated with sacred characters, not with portraits of mortal men and women (Figs. 1 and 2). Moreover, it is not merely the essential frontality of the face that distinguishes the doge's portrait from its fifteenth-century predecessors and from other portrayals of Loredan himself: it is the self-possession and tranquility of his character, portrayed with such conviction by Bellini. We are reminded that the traditional epithet for the doge of Venice was "Serene" — and this despite the fact (or in

denial of the fact) that Loredan assumed the dogate at a time of desperate struggle in the war with Turkey. The combination of Loredan's expression and his near-frontality endows his portrait with a quality akin to that of sacred images. Dürer's famous *Self-Portrait* of 1500 exploits more complete frontality and facial expression in much the same way, although with more overt reference to depictions of Christ and with a different, entirely personal purpose. And likewise Bellini, in his group portrait of Doge Loredan with four of his counsellors, signed and dated in 1507, made the allusions to sanctity still more explicit (Fig. 7). In this work, the doge is completely frontal and central in the composition, and his right hand seems to be blessing. This action seems to allude to sacred imagery, while in the Loredan, the nearly frontal, half-length figure behind a parapet reminds us of the timeless ideal of Bellini's Madonna paintings, and the manipulation of the drapery and the cut of the figure recall the tradition of reliquary busts. To be sure, implications of permanence are appropriate for portraiture in general, given the Renaissance credo that a man might live on in his image, to paraphrase Alberti. But Bellini goes beyond this; his implications of sanctity in the ducal portraits are entirely apposite vis-à-vis the subject's public life, referring to the rhetoric — verbal and visual — of the Serene Republic. Bellini's formula is especially suitable for his independent portrait of the doge, because the doge, the elected "first among equals" of the Venetian governing aristocracy, was endowed with spiritual as well as political authority.[20]

This sacral character is explicitly visualized in the garments that Loredan (and all other doges) wore, essentially immutable despite the changes of fashion: the tight-fitting cap, the pointed ducal corno, and the mantle with its round buttons. The earliest surviving images of Loredan's predecessors show them dressed essentially as he is, and all of his successors also dressed in the same way, including Lodovico Manin, the last doge, who served until Napoleon disposed him in 1797 and ended a thousand years of Venetian history.

Bellini adjusted details of Loredan's costume and of the figure itself to endow the portrait with lifelikeness and with energy. For example, the pose is asymmetrical, the row of buttons is irregular, and the ties of the ducal cap move, thereby conveying the impression of the doge's mobility. Thus Bellini leads us to understand that the doge has the power of movement, and this movement is achieved

without disturbing Loredan's hierarchic stasis, which endows him with a timeless dignity implying immortality. In his characterization of the doge, Bellini has thus combined — and combined harmoniously — the self-contradictory elements of stasis and movement, transitoriness and permanence, individuality and idealism.

Perhaps no regime has ever been better served, and today, when one tends to regard the aristocratic Venetian system with fascination commingled with democratic disapproval, Bellini's art remains to convince us of the reality and goodness of the myth: Venetian noblemen were truly noble, they did subjugate individual will to the needs of the state and their people, they were deeply pious and profoundly selfless in pursuit of the good, and they willingly put aside personal concerns and emotions in order better to fulfill their sacred political duties. So we are told, and so they themselves seemed to believe, at least more often than not.[21] That was the ideal, the self-defined, self-created myth of Venice, and it found its noblest personal expression in Bellini's portraiture, just as their spirituality was most compellingly visualized in his sacred images, which have the power to make believers of us all.

NOTES

1. What follows here is adapted from my book *Giovanni Bellini* (New Haven and London, 1989), but in this essay I have made different comparisons and juxtapositions in order to emphasize Bellini's role as illustrator of the Venetian regime.

2. Published in Venice, 1563, unpaginated, but on what would be p. 27.

3. See L. Steinberg, *The Sexuality of Christ in Renaissance Art and in Modern Oblivion* (New York, 1983); and Rona Goffen, "Renaissance Dreams," *Renaissance Quarterly* 40 (1987): 682–706; and also C. W. Bynum, "The Body of Christ in the Later Middle Ages: A Reply to Leo Steinberg," *Renaissance Quarterly* 39 (1986): 399–439.

4. The Rimini *Pietà* and the *Virgin and Child* in the church of the Madonna dell'Orto in Venice are examples of private devotional images transformed into altarpieces by their owners' testaments, and a lost *Christ* belonging to Elena Trevisan is an example of such an image bequeathed to a kinsman who is asked to pray for the testator's soul. For these and other examples, see Goffen, *Giovanni Bellini*, 66–88.

5. See, *I Diarii di Marino Sanuto*, ed. R. Fulin et al. (Venice, 1879–1902), v. 10, col. 150, April, 1510. See also G. Zorzi, "Notizie di arte e di artisti nei diarii di Marino Sanudo," *Atti dell'Istituto Veneto di Scienze, Lettere ed Arte, Classe di scienze morali e lettere* 119 (1960–61): 484.

6. Archivio di Stato, Venice (hereafter ASV), Capi del Consiglio de' Dieci, Lettere, Filza 16, [anno] 1515, no. 383:

> Die ultimo octobre 1515. . . . Habiamo deliberato, attento quello che circa cio ne scrivesti ne li superiori zorni, donar à la Illustrissima Madonna de Lanson [Alençon] uno quadro de pictura de la imagine de la gloriosa Verzene, questo piuii excellente et perfecto che esser el possi: et poiche in questa nostra cita [città] ne habiamo pur ritrovati alcuni pulcherimi, ma vechii et alcuni hanno varie oppositione, iusta li appetiti de quelli li hanno visti, consistendo questa cosa ne la voluta et desyderio de chi l'ha à goder, et desyderando nuy imprimis satisfare à la Excellentia sua, habiano deliberato pel dicto effecto farne far uno novo in tuta belleza et perfectione. Et perho volemo et commettemovi che . . . debiate far intender questo desyderio et invention nostra à la prefata Illustrissima Madama cercando intender el suo voler et piacer circa la grandeza et qualita de detto quadro. Lo esser de la gloriosa S. Verzene cum el fiolo, qual figure la voria li fusseno dai canti, et de qual grandeza, et in summa ogni altra particularita necessaria. Nel che userete ogni possibile diligentia per modo che quanto primum intendiamo el tuto, et possiamo metter in executione el desyderio nostro.

See also, G. Ludwig, "Nachrichter über venezianische Maler," *Italienische Forschungen* 4 (1911): 90.

7. ASV, Procuratori di San Marco de Citra, Misti, busta 57 (the Commissaria of Francesco Badoer, fasc. x–xxii), fasc. xxii, b:

> Magnifico et Cl.mo Domino Joanni Baduerio doctori et equiti, oratori veneto ad Christianissimam Majestatem Francorum proficiscenti. In Placentia. . . . Solicito etiam la perfection del quadro de la Ill.ma sorela del Cristianissimo che in vero sara bela cosa. El maistro è Zuan Bellin et pochissimo li mancha à compirlo perfectamente. . . . Duc. Venetiis Die xv Januarii [1515 *m.v.*, i.e., modern 1516]. Servitor et Compadre G[aspare] a Vidua.

See also Goffen, *Giovanni Bellini*, 96; and Ludwig, "Nachrichter," 90.

8. For the provenance, see S. Bottari, *Tutta la pittura di Giovanni Bellini*, I (Milan, 1963), 37. N.B. the small *Madonna and Child* cited by Boschini in the Tribunale in the "Suprema stanza" of the Heads of the Council of Ten in the Palace; perhaps this is the same painting? See A.

M. Zanetti, *Descrizione di tutte le pubbliche pitture della città di Venezia e isole circonvicine, o sia Rinnovazione delle Riche Minere di Marco Boschini* [1674] (Venice, 1733), 114.

9. Barbarigo was doge from 1487 to 1501. His painting was restored by Ottorino Nonfarmale. See F. Valcanover et al., *La pala Barbarigo di Giovanni Bellini*, Quaderni della Soprintendenza ai Beni Artistici e Storici di Venezia, 3 (Venice, 1983), passim, and especially the technical report by L. Lazzarini, "Le analisi di laboratorio," 23–28.

10. According to Staale Sinding-Larsen, the custom of hanging doges' votive pictures in the palace council rooms evidently began with Leonardo Loredan, doge 1501–21; *Christ in the Council Hall, Studies in the Religious Iconography of the Venetian Republic*, Institutum Romanum Norvegiae, Acta and Archaeologiam et Artium Historiam Pertinentia, 5 (Rome, 1974), 30–42. But N.B. a payment to Gentile Bellini on January 22, 1487 (1486 *m.v.*) for the canvas for a painting of Doge Marco Barbarigo, Agostino Barbarigo's brother and immediate predecessor in the dogate; ASV, Provveditori al Sal, busta 61, fol. 149v (new fol. 120v), published by G. B. Lorenzi, *Monumenti per servire alla storia del Palazzo Ducale di Venezia*, pt. 1 (Venice, 1868), 101.

11. For the ducal insignia, see Sinding-Larsen, *Christ in the Council Hall*, 156–58.

12. Edward Muir suggests that we may see an inherent dynastic threat here in the dual role of St. Mark as patron of the Republic and as the onomastic saint of the doge's brother and predecessor in the dogate. It seems to me that this is consistent with what we know of Agostino Barbarigo's character and ambition.

13. See M. Brunetti, "Due dogi sotto inchiesta: Agostino Barbarigo e Leonardo Loredan," *Archivio Veneto-Tridentino* 7 (1925): 283.

14. ASV, Notarile, de Floriani, busta 416, c. 6: July 17, 1501, with a codicil of August 15. I published this document in "Icon and Vision: Giovanni Bellini's Half-Length Madonnas," *Art Bulletin* 57 (1975): 511.

15. ASV, Notarile, de Floriani, busta 416, c. 6:

Item, nui hordinemo che la pala nostra granda ch'è in la crozolla del palazo la sia mandada al monastero de santa Maria di Anzolli predetto, et per esser ben conforme quela figura di nostra Dona coi anzolli ad esser messa sopra al suo altar grande de la sua gesia, ma che i nostri chomissari la debia farla adornarla sì de sotto chome da i ladi et de sopra per modo che la sia ben adornatta per contento nostro et de quele venerabilli done. Et quanto plus presto sarà messa tal palla in opera, tanto plus speremo in la beata Verzena Maria, habia esser nostra avvochata apresso el nostro summo chreator Idio. Et che nostri

zeneri, nì nostre fie, nì nostri nevodi non posino demeterla nì in la chasa grande nostra nì in altro luogo salvo sopra l'altar grando de quelo devotissimo et religioso monastero; la qual semo zerti che in ogni tempo la habi a pregare Idio per l'anima nostra e de tuti i altri nostri che sono pasatti de questa vita.

N.B. the doge's provisions for appropriate framing and his use of the word "pala," "altarpiece," to describe the painting, even though it was commissioned as a mural and not employed as an altarpiece until after his death.

16. Martin Davies, *The Earlier Italian Schools*, National Gallery Catalogues, 2d. rev. ed. (London, 1961), 55–56, no. 189.

17. For Giovanni Bellini's portraiture, see Goffen, *Giovanni Bellini*, ch. 3, passim.

18. *I Diarii di Marino Sanuto*, 4 (Venice, 1880), ed. Nicolò Barozzi, cols. 143–44. After the doge's death, the inquisitors and the *correttori della promissione ducale* examined his records for two years before reaching their conclusion in May 1523. See A. da Mosto, *I dogi di Venezia nella vita pubblica e privata* (repr. Milan, 1966), 266–75, esp. 272 ff.

19. See Goffen, *Giovanni Bellini*, 204 and fig. 154.

20. N.B. *inter alia* the placement of the doge's throne beneath the throne of Christ and Mary as King and Queen of Heaven in the Great Council Hall of the Ducal Palace, and the doge's role in the ritual celebration of the marriage of the sea, celebrated on the feast of the Ascension (the *Sensa*). In these and other ways, the beholder is encouraged to associate Venice with the Virgin and the sea, and, by implication, her Lord with the doge. For the sacral character and ritual functions of the doge, see G. Fasoli, "Liturgia e ceremoniale ducale," in *Venezia e il Levante fino al secolo XV*, ed. A. Pertusi, 1 (Florence, 1973), 261–95; Goffen, *Giovanni Bellini*, 104 and 210; *idem, Piety and Patronage in Renaissance Venice: Bellini, Titian, and the Franciscans* (New Haven and London, 1986), 140–41, 143–44, and 148–49; E. Muir, *Civic Ritual in Renaissance Venice* (Princeton, N.J., 1981), 84–85, and 130–34; and S. Blake Wilk (McHam), *The Sculpture of Tullio Lombardo, Studies in Sources and Meaning* (New York and London, 1978), 108–19.

21. See D. E. Queller, *The Venetian Patriciate: Reality versus Myth* (Urbana and Chicago, 1986).

Commentary on Pincus and Goffen

Edward Muir

In their previous research Debra Pincus and Rona Goffen have already given us sophisticated readings of politically significant works of art as seen through Venetian eyes, studies in which they have shown full awareness of subtle nuances of meaning and the difficulties of interpretation.[1] The two essays presented here with equal capability examine works of art in light of their potential political meanings, connecting evidence in the works themselves with evidence from their contexts, such as the known views of the patron or the cultural traditions of Venice. These two kinds of evidence, internal and external, usually lead to such different conclusions that when they do point in the same direction, we may feel justified in assuming we have the correct interpretation.[2]

Explanations of this sort find a fertile field in Venetian studies since one so often finds convergences between works of art and other expressions of Venetian culture. In examining the city's art, rituals, political theory (or what passes for it), vernacular literature, and even music, Venetianists have often connected the apparent messages to the "myth of Venice," that construct of Venetian propaganda which depicted the ruling nobility as especially devoted to the civic virtues.[3] Once the connection has been made to the myth, often by coordinating the internal configurations of artistic objects or texts with the well-known tenets of the myth, one has an understanding of what Venetian culture seems to mean.

Explanations of this sort, in which I have also indulged, are not always adequate in taking into account the complexities of either aesthetics or social and political contexts. On the one hand, one must be able to explain the stylistic and iconographic traits of a work of art before one attaches an interpretation to it that comes

from external evidence, and on the other, the myth of Venice and the political world it describes are not as simple as they once appeared. Not only does the myth often mask internal conflicts and irresponsible behavior (as Donald Queller has demonstrated in great detail), but it was itself an element in the on-going struggle through which individual patricians, families, and factions adapted the imagery of the myth to serve their private ends.[4]

Both essays build their explanations, in part, on the recognition that the crux of Venetian politics lies in representations of the doges. More than anything else, the institution of the dogeship distinguished Venice from other regimes because in this office Venice found a way to reconcile the sharing of power characteristic of a republic with the cohesive authority provided by a charismatic prince. Perhaps the most vital political debate within the conformist, conservative ruling class of Venice can be found in the depictions of the doges, images that were often statements of personal ambition in conflict with constitutional principles. Two questions raised by these essays attract particular interest. First, how are we to understand the doge's two bodies, i.e., the mortal, individual, ambitious, often unvirtuous politician who, as the capstone of his career, got himself elected doge, and the eternal, universal, transcendant, moral office of the dogeship.[5] In analyzing the doge's two bodies, we must avoid confusing the man for his office, the doge for the dogeship. This is a very old fallacy, one which has helped many servants of Roman popes and American presidents find patronage. The second question is the closely related one of what does it mean for a doge, or any other mortal for that matter, to be a sacred person?

Pincus's essay addresses itself to the problem of the doge's two bodies, a distinction that was still being worked out in Venetian political thought. Andrea Dandolo is an especially good example for analysis because he was certainly among the half dozen most influential doges in the entire history of the republic.[6] In pointing out how Dandolo appropriated tradition and refashioned it to elevate the office of the doge, she has provided us with some particularly powerful insights. In his historical writings, Dandolo was a part of the philo-ducal chronicle tradition that begins in the thirteenth century and is best exemplified by Martin da Canal, who publicized, in particular, the preeminence of Jacopo and Lorenzo Tiepolo and whom Dandolo directly copied in his own chronicle.[7]

The reinterpretation of history was the paramount means by which the cult of the ducal office emerged, and I find particularly intriguing Pincus's suggestion that in his construction of the *pala d'oro* Dandolo fashioned the entire history of the panels as an illustration of the role of ducal patronage. The reworking during Dandolo's dogeship of the Tiepolo tomb to include an inscription extolling Doge Jacopo's achievements as a patron of the basilica may also reveal the influence of the Canal chronicle. However, the timing of this reworking is puzzling since the name Tiepolo had been a synonym for treason since the failure of Baiamonte Tiepolo's conspiracy of 1310, which led to the founding of the Council of Ten and the proscription of the clan. If Pincus is correct in suggesting that Dandolo was the author of the inscription, one must ask why he would risk using such a dangerous name to elevate the ducal office? Was Dandolo trying to rehabilitate the Tiepolo name? Did Dandolo purposely choose the Tiepolo doges because he saw them as princes worthy of emulation? Was Dandolo willing to risk looking like a potential tyrant by associating himself with predecessors who had glorified the ducal office, even confused the eternal office with its mortal incumbents?

In answering these questions we ought to keep in mind Pincus's contribution of a previously unrecognized principle of Venetian government: the only unambiguously good doge was a dead doge. Living doges were always a problem, because the politician doge was a threat to the power-sharing of the ruling class as a whole; he was a potential prince on the mainland model especially when he employed the regal attributes of his eternal office to serve his own temporal ends. The Tiepolo doges of the thirteenth century may not have presented the threat their living descendants did because they served more as exemplars of the eternalness and moral perfection of the office than as actual historical personages.

If this line of thought is correct, then the handling of Dandolo's own death becomes particularly intriguing. Dandolo was the last doge buried in San Marco and the first to have an effigy on his tomb. In later centuries and in other locales—England, France, Lorraine, Tuscany, and Prussia—effigies employed in funeral ceremonies helped illustrate the separation between the prince's two bodies, his dead corpse and his immortal office.[8] Before the seventeenth century, with the sole exception of the funeral of Giovanni

Mocenigo in 1485 when the corpse went bad before the funeral could be held, Venetian doges did not have effigies displayed at their funerals, a situation which raises the question of how Venetians separated the doge's two bodies at the death of an incumbent.[9] Part of the answer to this question can be found in the interregnum ceremonies, but Pincus's work raises the interesting issue of the meaning of the tomb effigies. Did the effigy of Dandolo on his tomb exemplify the separation of man and office or did it confuse them, and if so is this why Dandolo was the last doge buried in San Marco? To envision how a doge's conflation of his two bodies could be deemed dangerous in the mid-fourteenth century, one only need recall the fate of Andrea Dandolo's immediate successor, Marin Falier, who went too far, and as a result literally lost his head and had his name obliterated from official Venetian records.

Goffen's analysis of Bellini's votive painting of Agostino Barbarigo raises similar issues. I do not doubt her reading of the internal evidence of the painting but wish to explore how we ought to understand that reading in light of external evidence. She describes the votive picture of the Ducal Palace as an "official, political image, and an image of private devotion." From the point of view of the doge's two bodies, I would suggest, these images were quite the opposite: the political aspects of the pictures were unofficial, and they became, therefore, an area where individual doges as politicians stretched the legal limits of their self-expression, whereas in their devotional capacity they followed an official convention about the relationship between the office of the doge and his saintly or divine patrons. The political image was privately conceived and the devotional one publicly ordained. Indeed, are we certain that doges had an obligation to provide such paintings for the Ducal Palace rather than an inclination to do so in order to memorialize themselves within the tradition of official devotions? Although apparently never intended for the Ducal Palace, Agostino Barbarigo's votive painting is a particularly revealing case. As Goffen points out, he was an unpopular and pretentious man. In his personal deportment, his patronage of the *Scala dei Giganti*, his self-glorification in the coronation ceremony, and the image of him conveyed in the Bellini painting, Agostino regularly associated himself with the charismatic character of the eternal dogeship. The mere presence of Saint Augustine, no matter how overshadowed he may be, in Bellini's

painting seems to indicate Doge Agostino's self-advertisement rather than self-obliteration. If Goffen is correct in reading the presence of Saint Mark as a reference to Agostino's dead brother, Marco, who preceded Agostino as doge, then the painting had to have been particularly subversive since it had dynastic implications. Certainly Sanudo understood the Barbarigos in these terms, and the extensive legislation passed after Agostino's death to prohibit such self-display by future doges indicates that many patricians were more horrified by the political implications of the Barbarigos' patronage than were impressed by their pious devotions.[10]

The discussion of Bellini's famous portrait of Leonardo Loredan raises the second issue I wish to discuss. What does it mean when one says that in this portrait Bellini depicted the doge as a sacred being? Many scholars have commented upon the apparent sacrality of the doge, including myself (*mea culpa*), but the idea ought to be examined as closely as possible, and especially with an eye toward defining the relationship between the doge's two bodies. Doges were certainly often depicted in pious veneration of saints, but are there any examples where the doge himself is venerated? If not, can one consider the doge sacred in his person as well as in his office?

I can imagine four ways—there certainly may be more—in which doges might have been considered sacred. First, they might have worked miracles as did the Kings of France and England who cured scrofula with their touch.[11] I know of no examples, however, of doges working miracles except in the hagiography of the very early and nearly forgotten saint-doges. Second, doges might have been seen as rulers chosen by God to usher in the Millennium as had happened to so many unlikely candidates for second Charlemagne status. There were occasional millenarian fantasies in Venice, although it could never compete with Florence in this respect.[12] During the great North Italian vogue for prophecies in the early sixteenth century, the destiny of Venice contrasted with Florence's glory as a New Jerusalem since the prophets predicted the collapse of La Serenissima's empire.[13] Doges played no special role in two millenarian movements later in the sixteenth century, those of the Venetian Virgin and of the artisan prophet, Benedetto Corazzaro, who believed a member of the Priuli family would save the world.[14] Third, doges might perform sacred functions as did priests when they celebrated the sacraments. Byzantine emperors were under-

stood in this way, and the Venetian doges certainly owed some of their imagery to Byzantine traditions, but in the late fifteenth and sixteenth centuries neither was the ducal office understood as a priestly one nor were the doges anointed at their coronations.[15] The doge had special *jus patronatus* rights over San Marco, but nobles everywhere had similar rights. Fourth, a doge might be sacred in the sense of being saintly because of his personal piety. Goffen's comparison of Bellini's portrait of Loredan and Dürer's self-portrait suggests that we might look in this direction. Although she points out Leonardo Loredan was far from a saint, he probably participated in the contemporary European fashion among the educated for internalizing piety rather than relying solely on outward conformity to liturgical and sacramental devotions. The process of internalization involved the imitation of Christ, also exemplified in Dürer's depiction of himself as if he were Christ and found in the famous Venetian correspondence from these years between Gaspare Contarini and his youthful friends, Tommaso Giustiniani and Vincenzo Querini, all of whom were fascinated with finding the best names for the inward emulation of Christ.[16] If this line of thought is correct, then the spiritual mood of Loredan's portrait may be less specifically Venetian than universally Erasmian. Since the imitation of Christ transformed piety into the pursuit of personal sanctity, the genius of Bellini's portrait may be that he found a novel way of combining Venetian traditions of a divinely mandated office with recent concerns for personal spirituality.

NOTES

1. D. Pincus, *The Arco Foscari: The Building of a Triumphal Gateway in Fifteenth-Century Venice* (New York: 1976): *idem*, "Christian Relics and the Body Politic: A Thirteenth-Century Relief Plaque in the Church of San Marco," in *Interpretazioni veneziane: Studi di storia dell'arte in onore di Michelangelo Muraro*, ed. E. Rosand (Venice, 1984): 39–59; R. Goffen, *Piety and Patronage in Renaissance Venice: Bellini, Titian and the Franciscans* (New Haven and London, 1986).

2. See the comments on these two kinds of evidence in C. Ginzburg, "Mostrare e dimostrare: Riposta a Pinelli e altri critici," *Quaderni storici* 50

(1982): 702–27. See also M. Baxandall, *Patterns of Intention: On the Historical Explanation of Pictures* (New Haven and London, 1985).

3. The literature on the myth is now quite vast. For a useful survey, see D. E. Queller, *The Venetian Patriciate: Reality versus Myth* (Urbana and Chicago, 1986), 3–28. For the visual arts, see D. Rosand, "Venetia Figurata: The Iconography of a Myth," in *Interpretazioni veneziane*, 177–96.

4. Queller, *The Venetian Patriciate*. Also see the important new study by Denis Romano, *Patricians and Popolani: The Social Foundations of the Venetian Renaissance State* (Baltimore and London, 1987).

5. On the doge's two bodies, see my *Civic Ritual in Renaissance Venice* (Princeton, N.J., 1981), 271–73.

6. For another example of her work on ducal tombs, see "The Tomb of Doge Nicolò Tron and Venetian Ruler Imagery," in *Art the Ape of Nature: Essays in Honor of H. W. Janson*, ed. L. F. Sandler and M. Barasch (New York, 1981), 127–50.

7. Martin da Canal, *Les estoires de Venise: Cronaca veneziana in lingua francese alle origini al 1275*, ed. A. Limentani (Florence, 1972).

8. R. E. Giesey, *The Royal Funeral Ceremony in Renaissance France* (Geneva, 1960). Professor Giesey is preparing an extended comparative study of the use of funeral effigies in the above listed countries.

9. A. da Mosto, *I Dogi di Venezia nella vita pubblica e privata* (Milan, 1966), lxv.

10. Marin Sanudo, *I Diarii*, ed. R. Fulin et al., 4 (Venice, 1880), 113. M. Brunetti, "Due dogi sotto inchiesta: Agostino Barbarigo e Leonardo Loredan," *Archivio veneto-tridentino* 7 (1925): 289–95.

11. M. Bloch, *The Royal Touch: Sacred Monarchy and Scrofula in England and France*, trans. J. E. Anderson (London, 1973).

12. On Florence as a center for prophecies, see D. Weinstein, *Savonarola and Florence: Prophecy and Patriotism in the Renaissance* (Princeton, N.J., 1970); and O. Niccoli, "Profezie in piazza: Note sul profetismo popolare nell'Italia del primo Cinquecento," *Quaderni storici* 41 (1979): 514–15.

13. See, for example, J. Lemaire de Belges, *La légende des Vénitiens* in his *Oeuvres*, ed. J. Stecher, 3 (Louvain, 1885), 361–64.

14. M. Kuntz, "Postel and the Venetian Virgin: Millenarian Ideas and the Ospedaletto of San Giovanni and Paolo," and J. Martin, "The Sect of Benedetto Corazzaro," paper delivered at the Sixteenth Century Studies Conference, October 30, 1987, Tempe, Arizona.

15. On the early history of the ducal election and coronation, see A. Pertusi, "Quedam regalia insignia: Ricerche sulle insegne del potere ducale a Venezia durante il Medioevo," *Studi veneziani* 7 (1965): 64–80.

16. J. B. Ross, "Gasparo Contarini and his Friends," *Studies in the Renaissance* 17 (1970): 192–232.

Contributors

JOSEPH R. BERRIGAN is a Professor of History at the University of Georgia. He is the translator and editor of Mussato's *Ecerinis* and Loschi's *Achilles* (1975) and Rolandino's *Chronicles of the Trevisan March* (1980). He has published widely on medieval historiography and Latin literature in such journals as *Studies in Medieval and Renaissance History, Traditio*, and *Manuscripta*.

D'ARCY JONATHAN D. BOULTON is a Visiting Assistant Professor of History at the University of Notre Dame. He is the author of *The Knights of the Crown: The Monarchical Orders of Knighthood in Later Medieval Europe, 1325–1520* (1987), as well as numerous articles on medieval and Renaissance heraldry.

JULIAN GARDNER is Foundation Professor in the History of Art at University of Warwick. He is the author of more than two dozen articles on late medieval sculpture and painting in such journals as the *Zeitschrift für Kunstgeschichte, Burlington Magazine, Journal of the Warburg and Courtauld Institute*, and *Römisches Jahrbuch für Kunstgeschichte*. His book *Papal Tomb Sculpture in Italy and Avignon 1200–1400* is due for publication in 1990.

RONA GOFFEN is Distinguished Professor of Art History at Rutgers, the State University of New Jersey, and co-editor of *Renaissance Quarterly*. Among her publications are *Piety and Patronage in Renaissance Venice: Bellini, Titian, and the Franciscans* (1986), *Spirituality in Conflict: Saint Francis and Giotto's Bardi Chapel* (1988), and *Giovanni Bellini* (1989). In addition, Goffen is co-editor of a volume of essays, *Life and Death in Fifteenth-Century Florence* (1989), and the author of articles in such journals as the *Art Bulletin, Arte Veneta, Gazette des Beaux-Arts*, and *Renaissance Quarterly*.

227

JOHN LARNER is Titular Professor of History at the University of Glasgow. Larner studied at New College, Oxford, and was Rome Medieval Scholar at the British School at Rome. He is the author of numerous articles and books including *The Lords of Romagna* (1965), *Culture and Society in Italy 1290–1420* (1971), and *Italy in the Age of Dante and Petrarch* (1980).

EDWARD MUIR is Associate Professor of History at Louisiana State University and the author of *Civic Ritual in Renaissance Venice* (1981, 1984), which won the Herbert Baxter Adams and Howard R. Marraro Prizes. He has also published *The Leopold von Rank Manuscript Collection of Syracuse University: The Complete Catalogue* (1983), and several articles on relations between the arts and ritual in Renaissance Italy. He has just completed a book entitled *Mad Blood Stirring: Vendetta and Factions in Friuli during the Renaissance.*

JOHN O'MALLEY, S.J., is Professor of Church History at the Weston School of Theology, Cambridge, Mass. His field of research is the religious culture of the Renaissance, in which he has published a number of books and articles relating to the papal court, Erasmus, the history of rhetoric and preaching, and similar topics. His publications include *Giles of Viterbo on Church and Reform* (1968), *Praise and Blame in Renaissance Rome* (1979), and *Rome and the Renaissance* (1981).

DEBRA PINCUS is Associate Professor of Art History at the University of British Columbia. She has published numerous articles on the political imagery of Venice, with a focus on the late medieval and early Renaissance periods. Her work has appeared in numerous festschrifts and periodicals such as the *Art Bulletin* and *Burlington Magazine*. She is the author of *The Arco Foscari: The Building of a Triumphal Gateway in Fifteenth-Century Venice* (1976), and is currently preparing a study of the medieval Venetian ducal tomb.

JONATHAN B. RIESS is Chairman and Professor of Art History at the University of Cincinnati. He has published numerous articles on various aspects of late medieval and Renaissance art

and art theory, and is the author of *Political Ideals in Medieval Italian Art* (1981), a study of the decoration of duecento town halls. Riess is currently completing a book on Luca Signorelli.

CHARLES M. ROSENBERG is Chairman and Associate Professor of Art History at the University of Notre Dame. He has published numerous articles on court patronage in journals such as the *Art Bulletin, Renaissance Quarterly*, and *Schifanoia*. He is the author of *An Annotated Bibliography of Fifteenth-Century North Italian Painting and Drawing* (1986).

CHARLES L. STINGER is Professor of History at the State University of New York at Buffalo. A former Fellow of Villa I Tatti, the Harvard University Center for Renaissance Studies in Florence, Italy, he is a specialist in the cultural and intellectual history of Renaissance Italy. He is the author of *Humanism and the Church Fathers: Ambrogio Traversari (1386–1439) and Christian Antiquity in the Italian Renaissance* (1977), and *The Renaissance in Rome* (1985), which was awarded the Howard R. Marraro Prize.

RICHARD C. TREXLER is Professor of History at the State University of New York at Binghamton. His books include *Public Life in Renaissance Florence.* (1980), *Naked Before the Father: The Renunciation of Francis of Assisi* (1989), and *Europe on Top: Homosexuality and the Conquests of America, 1400–1700* (forthcoming). His articles are collected in *Church and Community, 1200–1600. Studies in the History of Florence and New Spain* (1987), and *Potere, Famiglia, Sessualità a Firenze nel Rinascimento* (1989).

JOANNA WOODS-MARSDEN is an Assistant Professor of Art History at the University of California, Los Angeles. She has published widely on the patronage of Renaissance princes in journals such as *Art History, Arte Lombarda, Master Drawings, Renaissance Studies*, and *Art Journal*. Her most recent publication is *The Gonzaga of Mantua and Pisanello's Arthurian Frescoes* (1988).

Illustrations

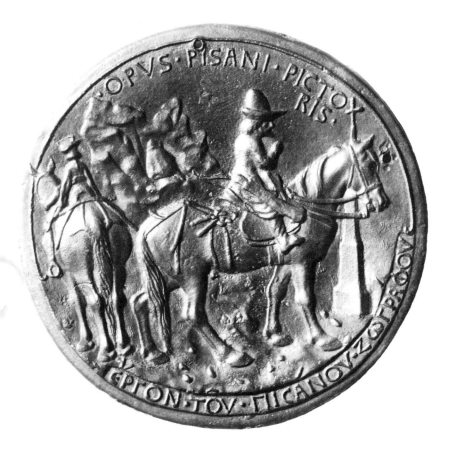

Woods-Marsden, Figure 1
Pisanello, Medal of Emperor John Palaeologus, bronze, 1439, reverse,
Museo Nazionale del Bargello, Florence.

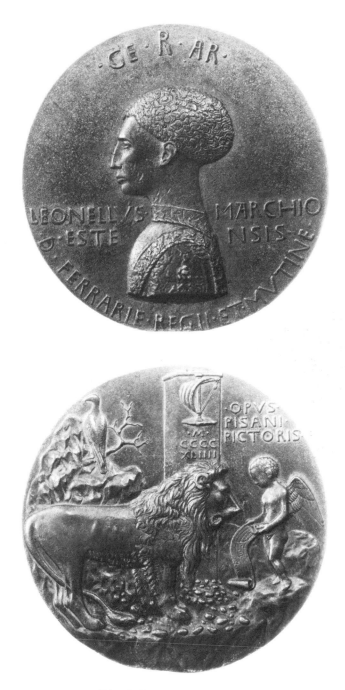

Woods-Marsden, Figure 2
Pisanello, Medal of Leonello d'Este, bronze, 1444, obverse and reverse,
Kress Collection, National Gallery of Art, Washington (Photo: National
Gallery of Art).

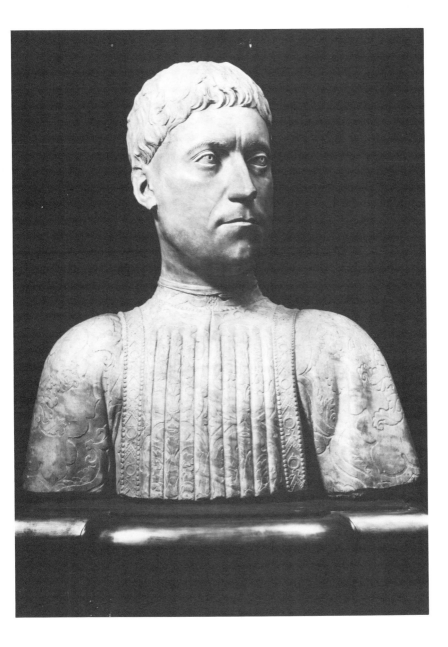

Woods-Marsden, Figure 3
Mino da Fiesole, Bust of Piero de' Medici, marble, 1453, Museo
Nazionale del Bargello, Florence.

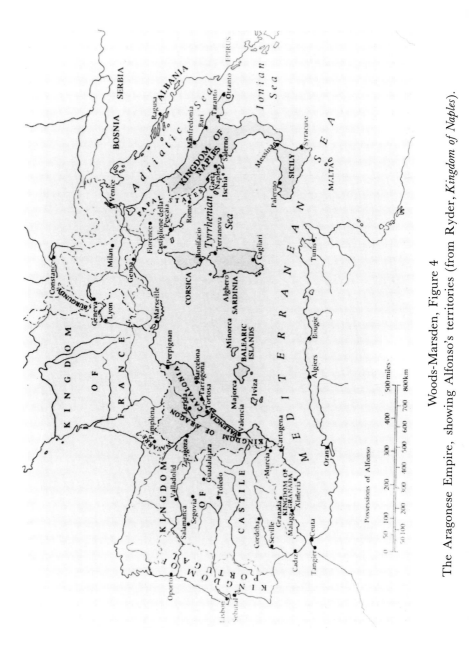

Woods-Marsden, Figure 4

The Aragonese Empire, showing Alfonso's territories (from Ryder, *Kingdom of Naples*).

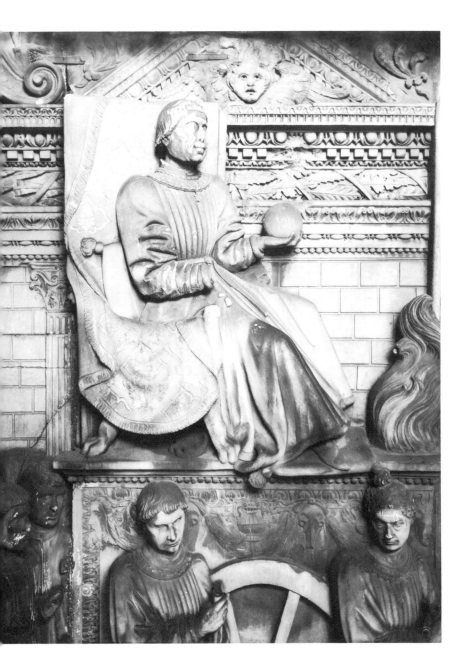

Woods-Marsden, Figure 5
Triumphal Arch, Castelnuovo, Naples, 1452 on. Detail of triumphal procession showing King Alfonso seated on the Siege Perilous.

Woods-Marsden, Figure 6
Cicero, *Epistolae ad Familiares*, Paris, Bibliothque Nationale, MS. Lat.
8533, f. 80. Detail of the border showing Alfonso's emblem of Siege
Perilous.

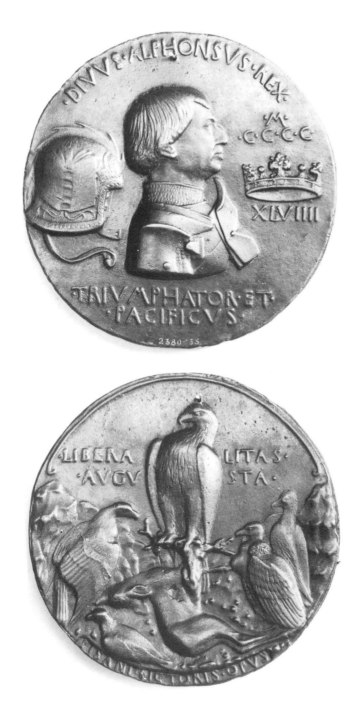

Woods-Marsden, Figure 7
Pisanello, Medal of King Alfonso, bronze, 1449, obverse and reverse,
Victoria and Albert Museum, London.

·DIVVS·ALPHONSVS·
·REX·

·M·
·CCCC·
·XLVIII·
·III·

·TRIVMPHATOR·ET·
·PACIFICVS·

Woods-Marsden, Figure 8
Follower of Pisanello, copy after a preparatory drawing for obverse of
medal of King Alfonso, Cabinet des Dessins, Louvre, Paris (Photo: Doc-
umentation photographique de la Réunion des musées nationaux, Paris).

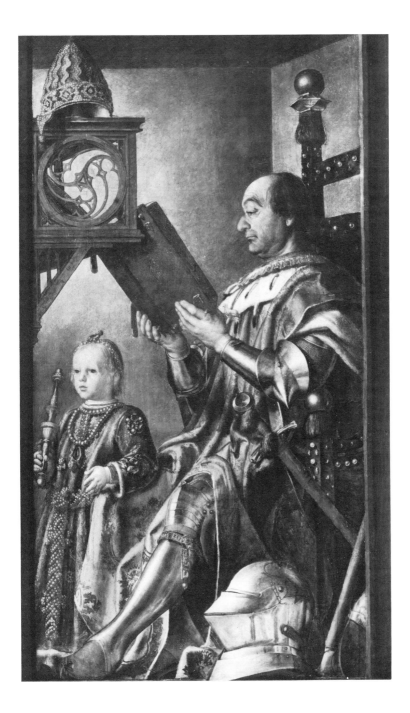

Woods-Marsden, Figure 9

Joos van Ghent, *Double Portrait of Federico da Montefeltro and his son Guidobaldo*, panel, c. 1476, Galleria Nazionale delle Marche, Urbino.

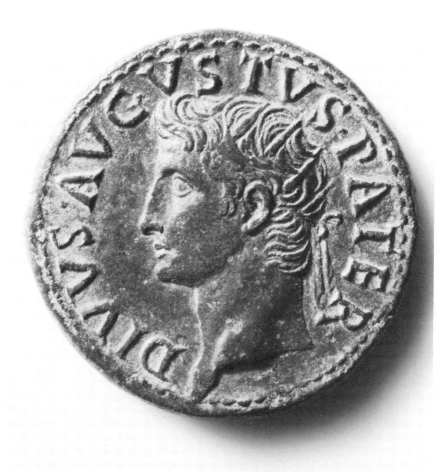

Woods-Marsden, Figure 10
Dupondius of Augustus minted under Tiberius, c. 25 A.D., British
Museum, London (Photo: Hirmer).

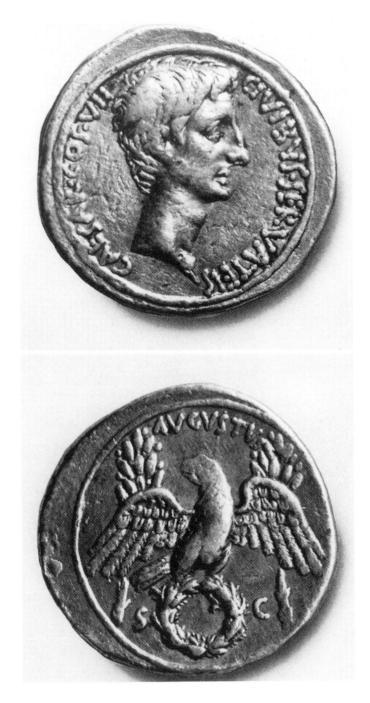

Woods-Marsden, Figure 11
Aureus showing Octavian with eagle clasping an oak wreath and
laurel branches, c. 27 B.C. (from Kent, *Roman Coins*).

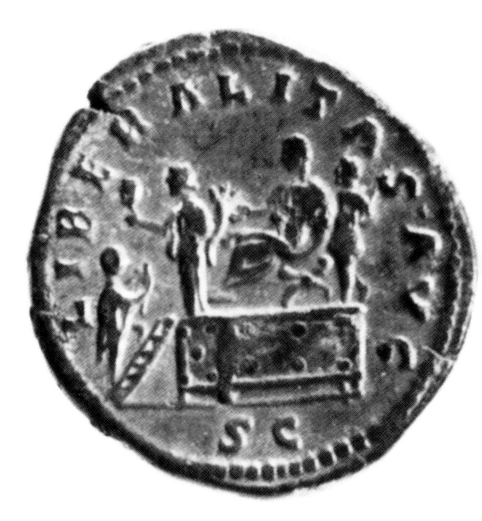

Woods-Marsden, Figure 12
Sesterius minted under Marcus Aurelius, showing *Liberalitas Augusti*,
175 A.D., British Museum, London (Photo: British Museum, London).

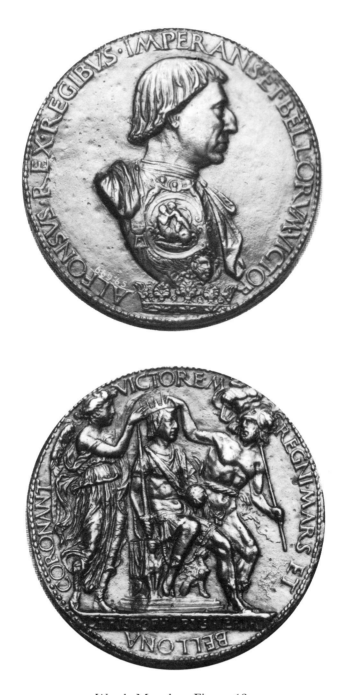

Woods-Marsden, Figure 13
Cristoforo di Geremia, Medal of King Alfonso, bronze, c. 1458,
obverse and reverse, Victoria and Albert Museum, London (Photo:
Victoria and Albert Museum, London).

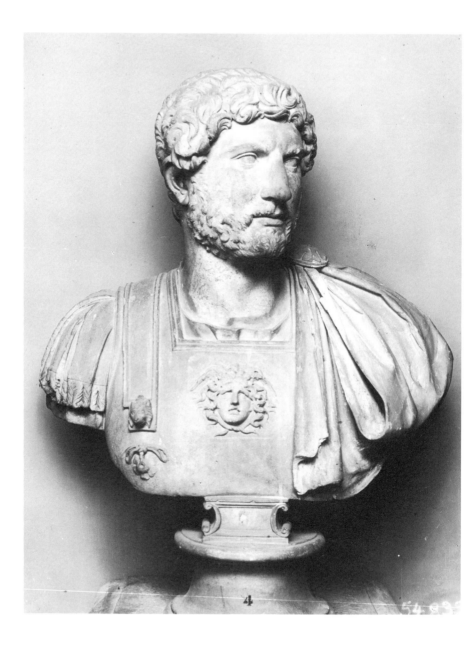

Woods-Marsden, Figure 14
Bust of the Emperor Hadrian, marble, 2nd cent. A.D., Palazzo
dei Conservatori, Rome (Photo: Deutschen Archaologischen
Instituts, Rome).

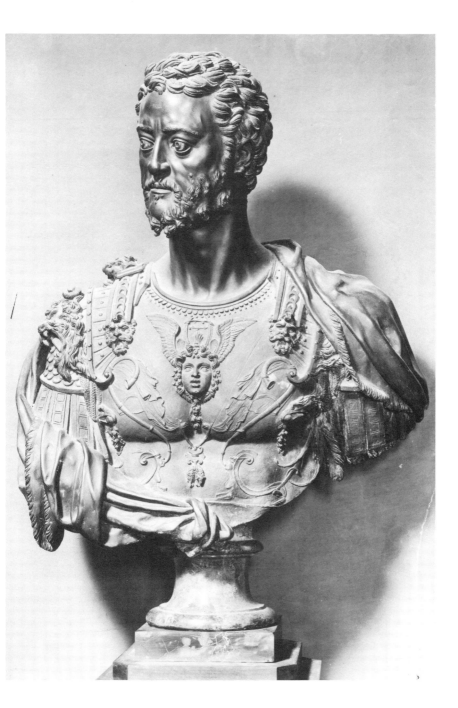

Woods-Marsden, Figure 15
Benvenuto Cellini, Bust of Cosimo I de' Medici, bronze, c. 1545,
Museo Nazionale del Bargello, Florence.

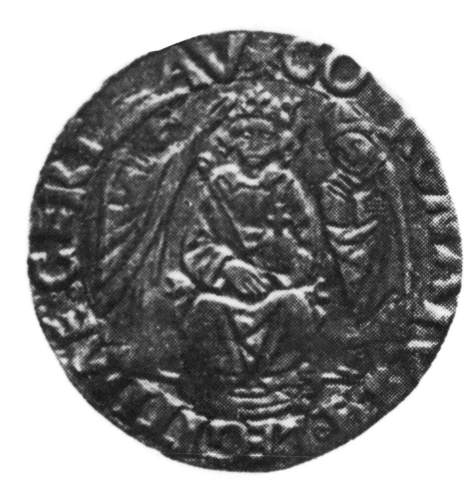

Woods-Marsden, Figure 16
Coin, Naples, c. 1460.

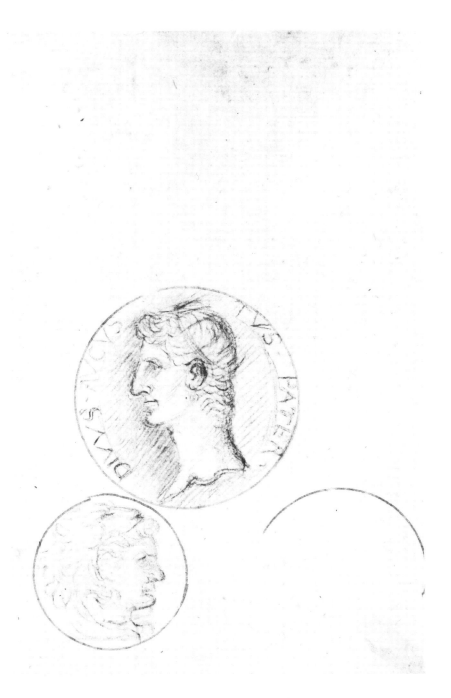

Woods-Marsden, Figure 17
Follower of Pisanello, sketch of Augustan coin, Cabinet des Dessins,
Louvre, Paris (Photo: Documentation photographique de la Réunion
des musées nationaux, Paris).

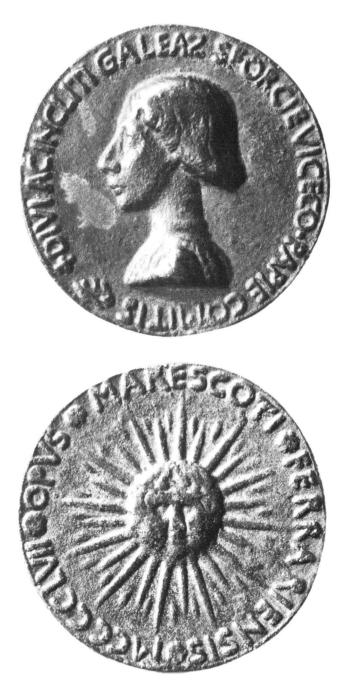

Woods-Marsden, Figure 18
Marescotti, Medal of Galeazzo Maria Sforza, bronze, 1457,
obverse and reverse, British Museum, London (Photo: British
Museum, London).

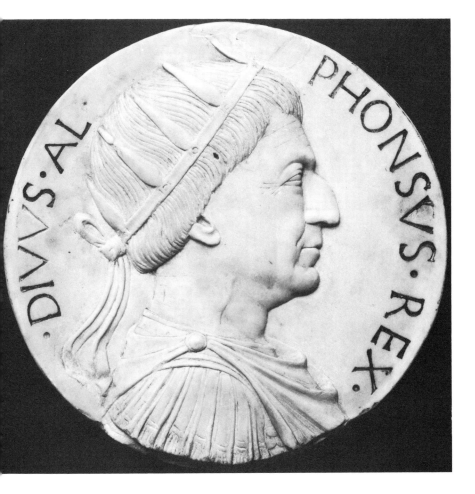

Woods-Marsden, Figure 19
Medallion of King Alfonso, marble, c. 1455–58, Victoria and Albert
Museum, London (Photo: Victoria and Albert Museum, London)

Trexler, Figure 1
Fresco, Cloister, S. Maria, Vezzolano (Piedmont), c. 1354 (Photo:
Museo Civico d'Arte, Turin).

Trexler, Figure 2

Tomb of Doge Giovanni Dolfin, SS. Giovanni e Paolo, Venice, c. 1361 (Photo: Debra Pincus).

Trexler, Figure 3

Baldassare degli Ubriachi recommended by the magus Balthasar, Lintel relief,
Chiostro Grande, Santa Maria Novella, Florence, c. 1365–78 (Photo: Art Resource).

Trexler, Figure 4
Jacopo da Verona, *Adoration of the Magi*, fresco, Bovi Chapel, Church
of San Michele, Padua, 1397 (Photo: Susan MacMillan Arensberg).

Trexler, Figure 5
Baldassare degli Ubriachi, Ivory Altarpiece, Certosa, Pavia, c. 1396
(Photo: Art Resource).

Trexler, Figure 6
Anovelo da Imbonate, *Investiture of Gian Galeazzo as Duke of Milan*,
Missal, Biblioteca capitolare, S. Ambrogio, Milan, MS. Lat. 6, folio
8 (Photo: Biblioteca capitolare di S. Ambrogio, Milan).

Trexler, Figure 7
Baldassare degli Ubriachi, *Balaam is Inspired, and Blesses Israel*, Ivory
Altarpiece (det.), Certosa, Pavia (Photo from G. A. Dell'Acqua,
Embriachi [Milan, 1982], p. 69).

Trexler, Figure 8
Giovanni da Modena, *History of St. Petronius*, fresco, Bolognini Chapel,
S. Petronio, Bologna (Photo: Franco Ragazzi).

Trexler, Figure 9

Giovanni da Modena, *Journey of the Magi*, fresco, Bolognini Chapel, S. Petronio, Bologna (Photo: Franco Ragazzi).

Trexler, Figure 10

Benozzo Gozzoli, *Star of Bethlehem*, fresco, Chapel, Medici-Riccardi Palace, Florence (Photo: Andreas Beyer).

Gardner, Figure 1
Pietro di Oderiso, Tomb of Pope Clement IV, San Francesco, Viterbo
(Photo: GFN).

Gardner, Figure 2
Choir, Cathedral, Narbonne (Photo: Marburg).

Gardner, Figure 3
Seal of Archbishop Gui Foucois (Photo: Archives Nationales).

Gardner, Figure 4
Papal Palace, Viterbo (Photo: Author).

Tombeau de Pierre, De Pierre de Montbrun Archevéque de Narbonne, qui est dans la Chapelle de S.ᵗ Pierre de L'Eglise Cathedrale de S.ᵗ Iust & S.ᵗ Pasteur de la dite ville.

C'est Archevéque étoit aussi Chanoine de S.ᵗ Iust & S.ᵗ Pasteur de Narbonne, & fut éleu par Son Chapitre l'an 1272. Il fit travailler à la nouvelle Eglise, que Maurin Son Predecesseur avoit commencée en la mesme année, mourut le 3.ᵉ de Iuin 1286. & fut enterré dans la dite Chapelle de S.ᵗ Pierre qu'il avoit faite edifier.

Voüy Son Epitafe qui est contre la muraille de ladite Chapelle de S.ᵗ Pierre.

FELIX PRÆLATVS|HEV QVAM CITO MORTE VOCATVS|
MENTE DEO GRATVS|HIC CARNE IACET TVMVLATVS|
NOBILIS EX GENERE|SET NOBILIOR PIETATE|
PRÆFVIT HIC VERE|SIMILIS TIBI PETRE BEATE|
NOMINE NON TANTVM|SET ET ORDINE PLVS LABORANTVM|
PAR CONREGNANTVM|SIT CVM DOMINO DOMINANTVM|
DICTVS DE MONTEBRVNO FVIT|INDEQVE NATVS|
DVRA FERENS SPONTE|VIXIT SINE LABE REATVS|
QVOD SATAGENDO PIE|BIBIT HIC DE FONTE SOPHIÆ|
DIFFVDIT PATRIÆ|MARTHÆ MEMOR ATQVE MARIÆ|
ANNO MILLENO BIS CENTENO OCTVAGENO|
BIS TERNO CHRISTI CHRISTVS REQVIEM DEDIT ISTI|
ANTE DIES MENSIS IVNII LVX TERTIA LVXIT|
CVM NARBONENSIS RADIVS DE CORPORE FLVXIT|
VT LVX PONTIFICVM TRIBVS ILLVXIT QVASI LVSTRIS|
MORIBVS ILLVSTRIS DOMINVM LVCRATVS AMICVM|
OBTINET VT STATVIT QVINTINI FESTA BEATI|
VT CITIVS MERITVM CHRISTI MORIENS REPERIRET|
PRESBYTEROSQVE DVOS QVI SVNT HIC PERPETVATI|
ORDINAT HIC OBITVM DIE MORTIS QVANDO REDIRET|

C'est luy qui a fait faire tout le quartier du Palais archiepiscopal de Narbonne qui est du côté du gardin. Et qui fit refaire la Chapelle de la Magdeleine qui est dans l'ancien Palais.

Gardner, Figure 5
Tomb of Archbishop Pierre de Montbrun, Narbonne Cathedral, Drawing done for Roger de Gaignières (Photo: Bibliothèque Nationale).

Gardner, Figure 6
Oratory of Pierre de Montbrun, Archepiscopal Palace, Narbonne
(Photo: Jean Pauc).

Gardner, Figure 7
Crucifixion, Santa Prassede, Rome (Photo: GFN).

Gardner, Figure 8
Enthroned ecclesiastic, Oscott Psalter, London, British Library, Add.
MS. 54215 (Photo: British Library).

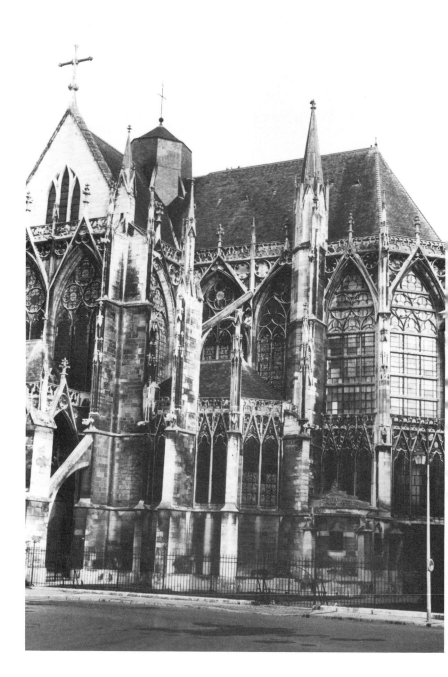

Gardner, Figure 9
Choir, Saint-Urbain, Troyes (Photo: Author).

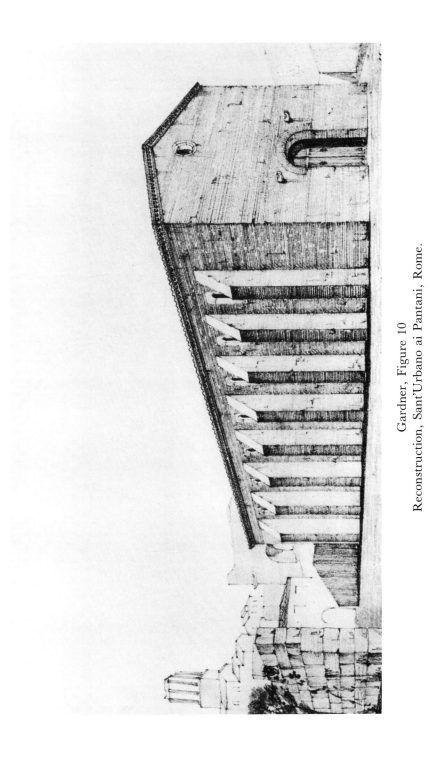

Gardner, Figure 10
Reconstruction, Sant'Urbano ai Pantani, Rome.

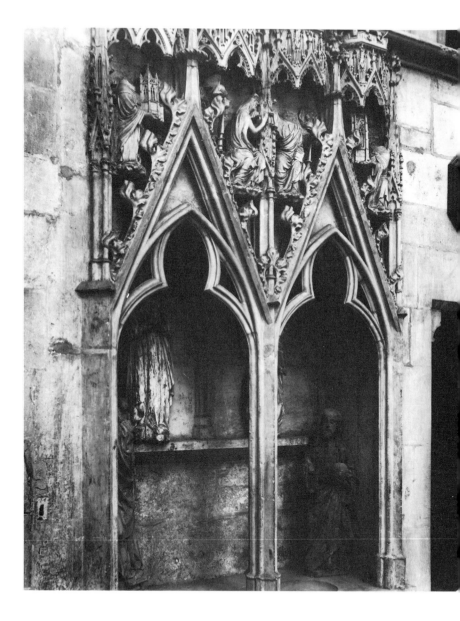

Gardner, Figure 11
Piscina, Saint-Urbain, Troyes (Photo: Author).

Gardner, Figure 12
Pietro Cavallini (assisted), *Standing Saint*, Santa Cecilia in Trastevere,
Rome (Photo: GFN).

Gardner, Figure 13
Tomb of Isabelle d'Aragon, Cathedral, Cosenza (Photo: Author).

Gardner, Figure 14
Chapelle de la Trinité, Cathedral, Béziers (Photo: Author).

Gardner, Figure 15

Filippo Rusuti, *Enthroned Christ*, Facade, Santa Maria Maggiore, Rome (Photo: Valentino Pace).

Gardner, Figure 16
Enthroned Christ, Bible of Jean de Papeleu, Paris, Bibliothèque de
l'Arsenal, MS. 5059, folio 1 (Photo: Bibliothèque de l'Arsenal).

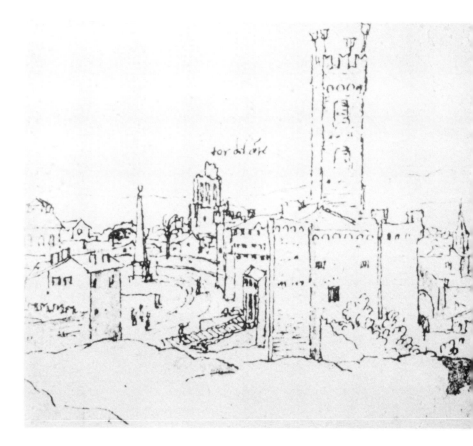

Stinger, Figure 1
Marten van Heemskerck, Panorama of Rome, Detail with the Palazzo
del Senatore and the Campidoglio from Monte Caprino looking North,
drawing, c. 1534–6, Kupferstichkabinett, Staatliche Museen, Berlin.

Stinger, Figure 2

Marten van Heemskerck, View of the Campidoglio from the Aracoeli, drawing, c. 1535–6, Kupferstichkabinett, Staatliche Museen, Berlin.

Stinger, Figure 3
Detail of Figure 2.

Stinger, Figure 4
Plan of the Capitoline Theater from the Codex Coner, drawing,
London, Soane Museum (after Bruschi).

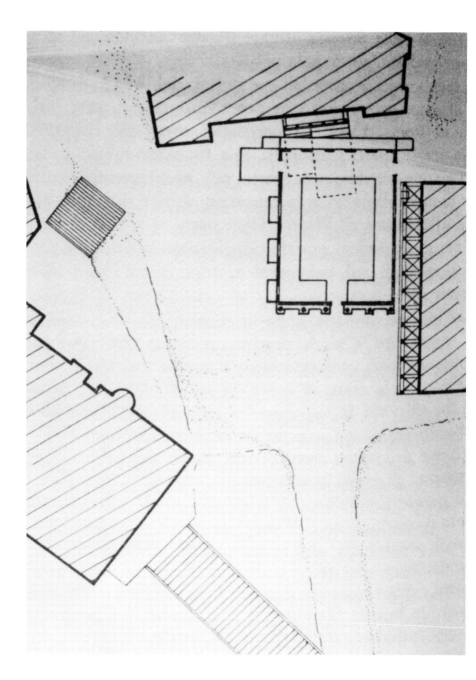

Stinger, Figure 5
Plan showing the approximate placement of the Capitoline Theater
in relation to existing buildings on the Campidoglio (after Bruschi).

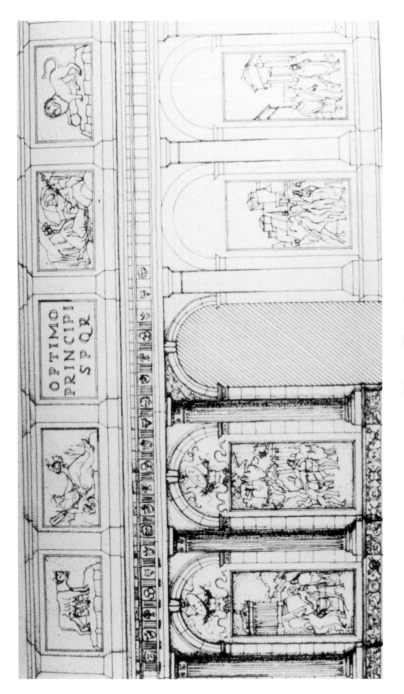

OPTIMO PRINCIPI SPQR

Stinger, Figure 6

Reconstruction of the facade of the Capitoline Theater (after Bruschi).

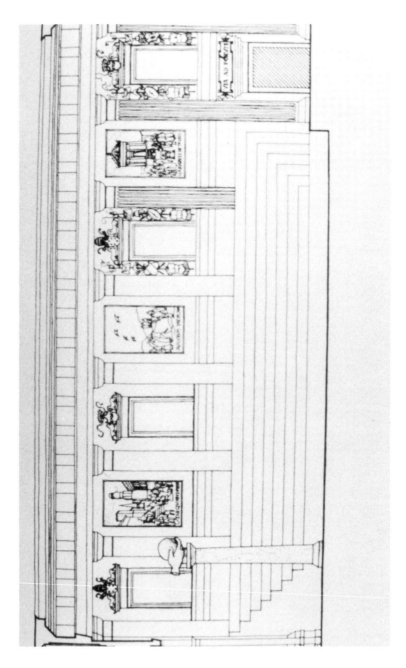

Stinger, Figure 7

Reconstruction of a longitudinal section of the Capitoline Theater (after Bruschi).

Stinger, Figure 8

Reconstruction of the interior of the Capitoline Theater (after Bruschi).

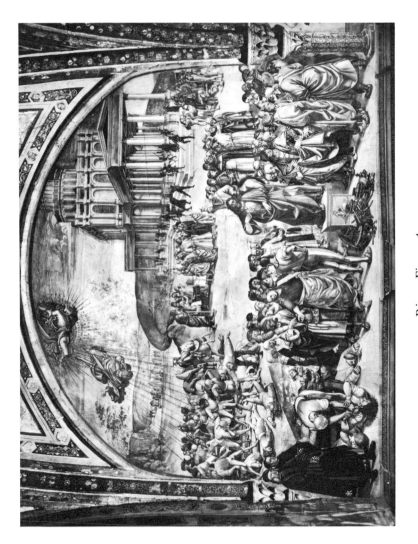

Riess, Figure 1

Luca Signorelli, *Rule of the Antichrist*, Cathedral, Orvieto, 1499–1504 (Photo: Anderson).

Riess, Figure 2
Luca Signorelli, Cappella nuova (general view), Cathedral, Orvieto,
1499–1504 (Photo: Anderson).

Riess, Figure 3
Luca Signorelli, *Cicero with Scenes from the "Philippics"*, Cathedral,
Orvieto, 1499–1504 (Photo: Author).

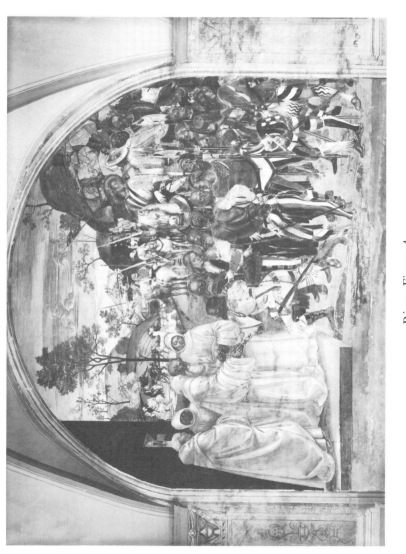

Riess, Figure 4

Luca Signorelli, *St. Benedict Recognizes and Welcome Totila*, Monte Oliveto, 1497–98 (Photo: Anderson).

Riess, Figure 5
Colantonio (?), *St. Vincent Ferrer*, San Pietro Martire, Naples, c. 1459
(Photo: Author).

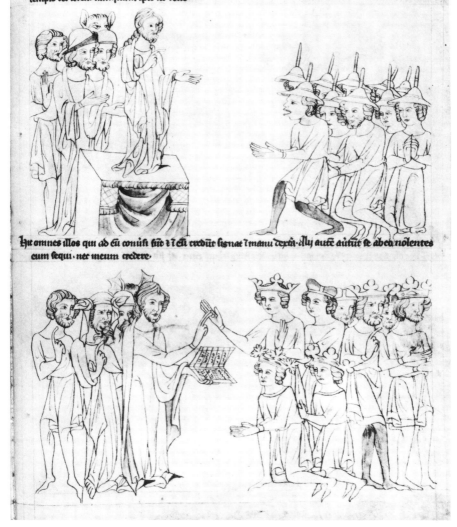

Riess, Figure 6
Velislav Bible, *Preaching of the Antichrist*, Prague University Library,
MS. XXIII, fol. 132 (Photo: Biblioteca Apostolica Vaticana).

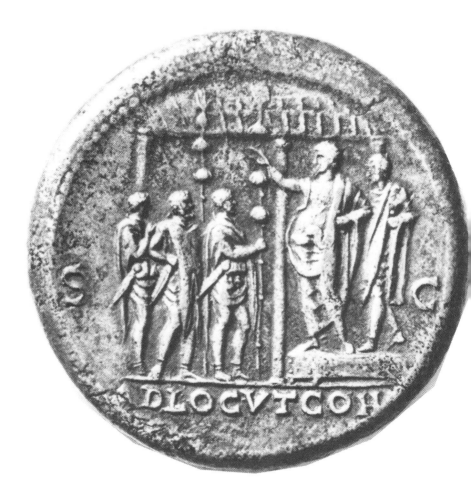

Riess, Figure 7
Nero, *Adlocutio*, 66–68 A.D., British Museum, London
(Photo: Michael Pirrocco).

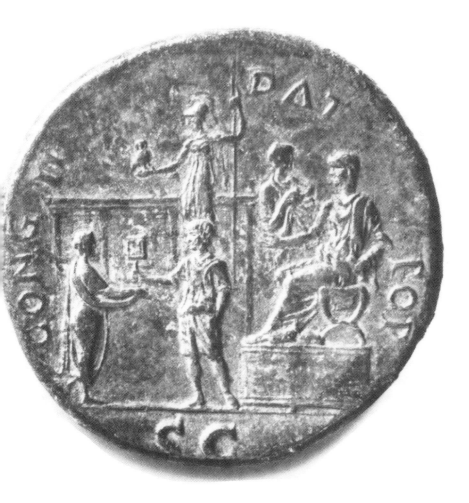

Riess, Figure 8
Nero, *Congiarum*, 64–66 A.D., British Museum, London
(Photo: Michael Pirrocco).

Riess, Figure 9
Luca Signorelli, *Cicero*, Cathedral, Orvieto, 1499–1504
(Photo: Lucio Riccetti).

Riess, Figure 10

Follower of Luca Signorelli, *Cicero*, Cathedral, Orvieto, c. 1503 (Photo: Lucio Riccetti).

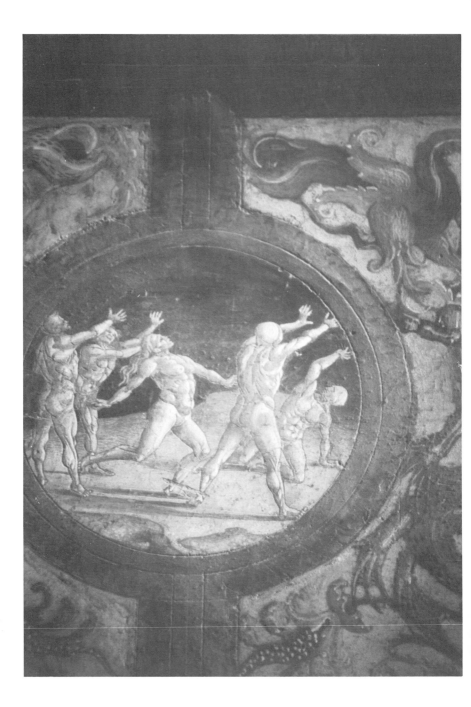

Riess, Figure 11
Luca Signorelli, *Scene from the "Philippics"*, Cathedral, Orvieto,
1499–1504 (Photo: Lucio Riccetti).

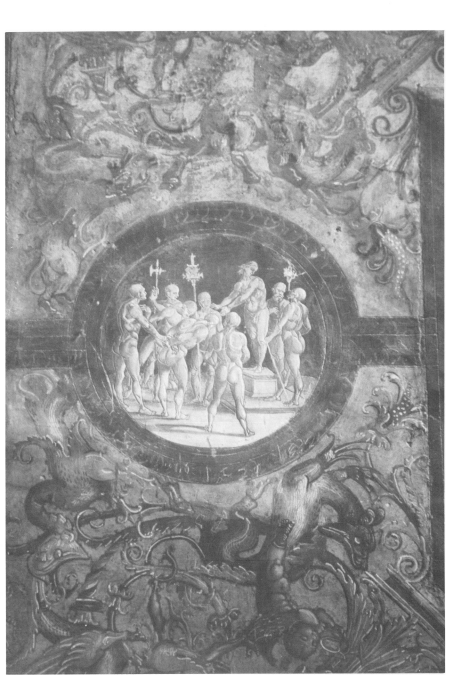

Riess, Figure 12
Luca Signorelli, *Scene from the "Philippics"*, Cathedral, Orvieto, 1499–1504 (Photo: Lucio Riccetti).

Riess, Figure 13
Luca Signorelli, *Lucan with Scenes from the "Pharsalia"*, Cathedral,
Orvieto, 1499–1504 (Photo: Anderson).

Pincus, Figure 1
Groundplan of San Marco, with the projects of Doge Andrea Dandolo
marked.

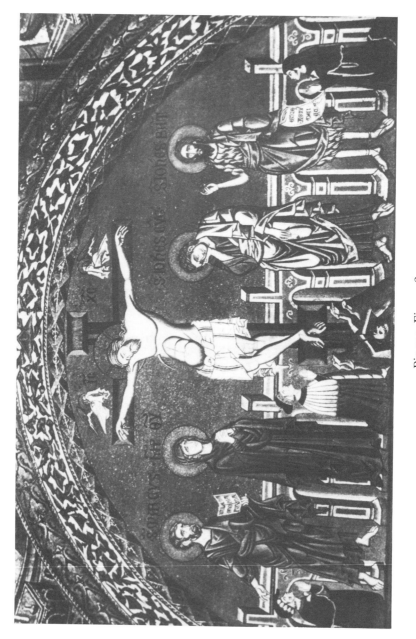

Pincus, Figure 2

Crucifixion, mosaic, Baptistery, San Marco, Venice (after Bettini, *Mosaci antichi di S. Marco*).

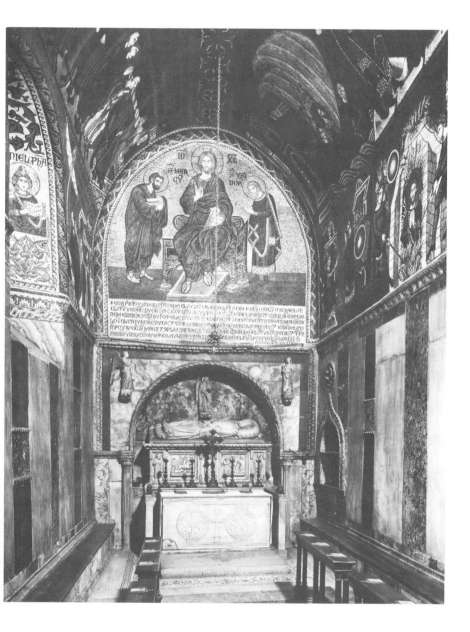

Pincus, Figure 3
Chapel of S. Isidore, San Marco, Venice (Photo: Alinari).

Pincus, Figure 4

The cleric Cerbano is reproved by Doge Domenico Michiel for attempting to transport the relics of Saint Isidore in secret,
Chapel of S. Isidore, San Marco, Venice (after Bettini, *Mosaici antichi di S. Marco*).

Pincus, Figure 5

Doge Domenico Michiel supervises the reception of the relics of Saint Isidore at San Marco,
Chapel of S. Isidore, San Marco, Venice (after Bettini, *Mosaci antichi di S. Marco*).

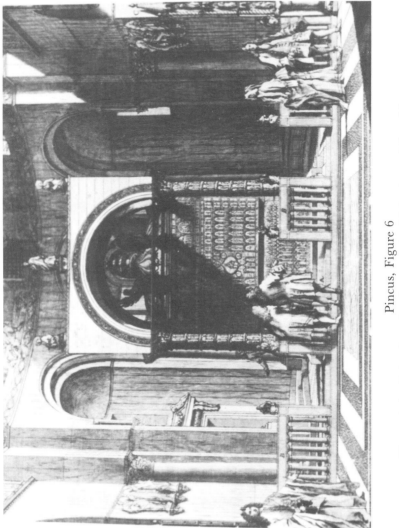

Pincus, Figure 6

View of the Pala d'oro in place on the high altar of San Marco, engraving after a drawing by Antonio Visentini (after Hahnloser, ed., *Pala d'oro*).

Pincus, Figure 7
First inscription block of the Pala d'oro, San Marco, Venice
(Photo: O. Boehm, Venice).

Pincus, Figure 8
Second inscription block of the Pala d'oro, San Marco, Venice
(Photo: O. Boehm, Venice).

Pincus, Figure 9

Tomb of Doge Andrea Dandolo (1343–1354), Baptistry, San Marco, Venice (Photo: Alinari).

Pincus, Figure 10

Inscription from the tomb of Doges Jacopo (1229-1249) and Lorenzo (1268-1275) Tiepolo, exterior facade, SS. Giovanni e Paolo, Venice. (Photo: Author).

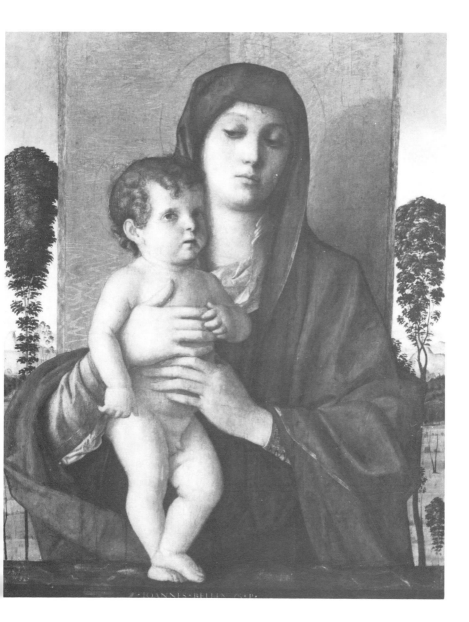

Goffen, Figure 1
Giovanni Bellini, *Madonna degli alberetti*, Galleria dell'Accademia, Venice
(Photo: Soprintendenza ai Beni Culturali, Venice).

Goffen, Figure 2
Giovanni Bellini, *Madonna greca*, Pinacoteca di Brera, Milan (Photo:
Soprintendenza ai Beni Culturali, Milan).

Goffen, Figure 3

Giovanni Bellini, Votive picture of Doge Agostino Barbarigo, San
Pietro Martire, Murano (Photo: Soprintendenza ai Beni Culturali, Venice).

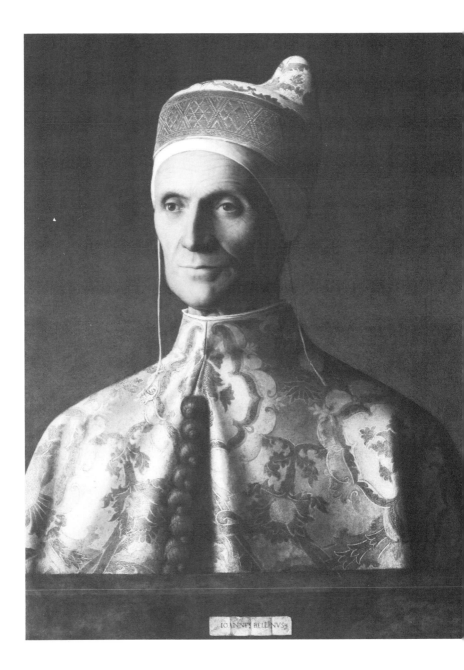

Goffen, Figure 4
Giovanni Bellini, *Doge Leonardo Loredan*, National Gallery, London
(Photo: National Gallery, London).

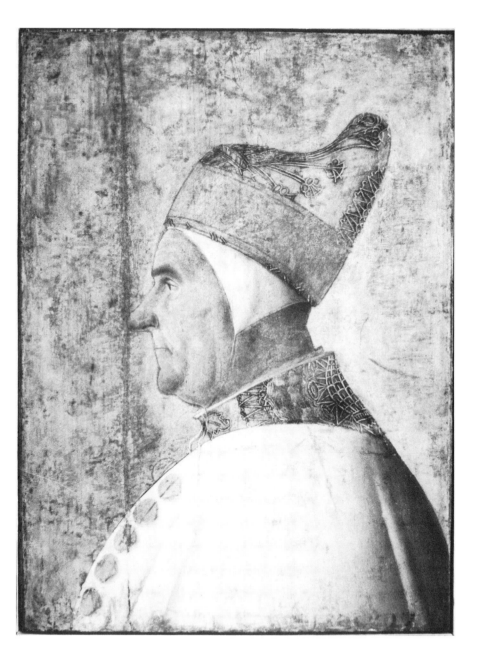

Goffen, Figure 5
Gentile Bellini(?), *Doge Giovanni Mocenigo*, Museo Correr, Venice
(Photo: Author).

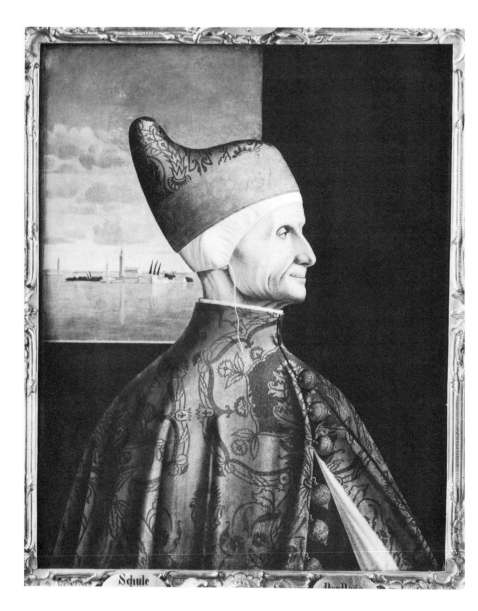

Goffen, Figure 6
Attributed to Vittore Carpaccio, *Portrait of Doge Leonardo Loredan*,
Gemäldegalerie, Dresden, destroyed (Photo: Alinari/Art Resource).

Goffen, Figure 7

Giovanni Bellini and Assistants, *Doge Leonardo Loredan and his Counsellors*,
Berliner Museen, East Berlin (Photo: Staatlichen Museen zu Berlin, Gemäldegalerie).